Monasticism and the Arts

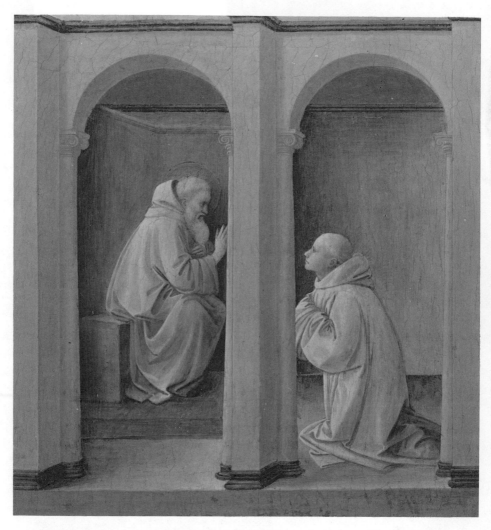

Fra Filippo Lippi, *St. Benedict orders St. Maurus to the Rescue of St. Placidus*, detail. *Courtesy of the National Gallery of Art, Washington, D.C., Samuel H. Kress Collection.*

Monasticism
and the Arts

Edited by *Timothy Gregory Verdon*

with the assistance of *John Dally*

Foreword by *John W. Cook*

SYRACUSE UNIVERSITY PRESS 1984

This volume has been published with the generous assistance
of the Samuel H. Kress Foundation and the Raskob Foundation
for Catholic Activities.

Library of Congress Cataloging in Publication Data
Main entry under title:

Monasticism and the arts.

 Bibliography: p.
 Includes index.
 1. Christianity and the arts—Addresses, essays,
lectures. 2. Monasticism and religious orders—Addresses,
essays, lectures. I. Verdon, Timothy Gregory.
II. Dally, John.
BR115.A8M66 1983 246 83-17897
 ISBN 0-8156-2291-0
 ISBN 0-8156-2292-9 (pbk.)

Manufactured in the United States of America

This book is respectfully dedicated to the memory of two men who in life never met:

Dom Anselm Strittmatter, O.S.B.,
monk of St. Anselm's Abbey,
Washington, D.C.,
and
Charles Seymour, Jr.,
teacher of art history,
Yale University

Foreword

This book is intended for students of the humanities, particularly in the history of religion and the history of art. The essays comprising it explore, from a variety of viewpoints, the relationship between organized religious life in Western civilization and the art forms this has fostered. The book and the symposium from which it grew reflect the intense interest felt today in all areas of humanistic study in the role of religious belief in the evolution of culture.

A cross-disciplinary effort such as this is indebted to the insights of those anthropologists, social scientists, and psychologists concerned with the reintegration of aspects of our culture that have come to be artificially separated from each other in specialized academic disciplines. One indication of interest in this form of integration is the proliferation of humanities programs at major universities in the United States in recent years. Another is the publication of excellent studies in academic art history which focus on context and meaning, such as Jerome Pollitt's *Art and Experience in Classical Greece* and Michael Baxendall's *Painting and Experience in Fifteenth Century Italy.* In the area of religious studies, increased concern for liturgical scholarship has fostered keen interest in the arts, both at the level of philosophical consideration of their symbolic function and aesthetic import as well as in actual usage. Yale University's program in religion and the arts is one effort within an academic community to address these issues.

Thus when Timothy Verdon approached me in April 1979 to suggest a collaboration between Yale and St. Anselm's Abbey in Washington, D.C., to mark the forthcoming fifteen-hundredth anniversary of the birth of St. Benedict, I responded with enthusiasm. A collaboration between an

academic institution and a religious community offered the opportunity for an open, critical, and creative exchange of ideas. Professor Verdon and I saw the centenary of the father of Western monasticism as a chance to integrate separated disciplines and to provide a forum for dialogue. It seemed to us that we had a significant opportunity to initiate a series of studies concentrated on the life and influence of St. Benedict and, on the occasion of his sesquimillennium, to review in the broadest terms the place of religious faith in the historical interpretation of culture and its artifacts. The larger goal of the symposium and of this book, therefore, is to suggest a methodological framework that scholars in several humanistic fields may share. Monasticism as a way of life and as an influence spanning nearly seventeen centuries of Western history is able to provide a vehicle for this ambitious effort.

The year 1980 saw many celebrations of St. Benedict's birth: There were several specialized conferences for monks and students of monastic history in the United States and in Europe. A new annotated translation of the *Rule of St. Benedict* was prepared by a team of American Benedictine monks and sisters. Special exhibitions included "The Benedictines in Britain" at the British Museum, one at the Bodleian Library, Oxford, and an exhibit at the National Gallery of Art in Washington, D.C., entitled "Monastic Themes in Renaissance Art." Of these events, the Yale–St. Anselm's symposium was perhaps the broadest in historical scope and in the range of subject matter considered. This book, which includes thirteen of the thirty papers given in the six days of the conference, illustrates the point. It combines new scholarship with classic statements on the central themes of our subject in such a way as to serve the purposes of specialists as well as students.

The preparation of these papers for publication as a unified volume has been coordinated by Timothy Verdon, with the assistance of the Reverend John Dally, until 1982 my colleague in the Yale Divinity School Religion and Art Program. Professor Verdon wrote the introductory essay and the short comments preceding each chapter, which provide rich insight into the way the parts of the book relate to the whole. The taxing editorial work that goes into a collection of essays by different authors was divided between Verdon and Dally. As always in such an undertaking, however, two or three people are not solely responsible for the final product, and it is a pleasant duty for all of us who have played a part in preparing *Monasticism and the Arts* to express gratitude to the institutions and individuals who made the symposium and the book possible.

We are grateful to Abbot James Wiseman, O.S.B., and the monks of St. Anselm's Abbey, Washington, D.C., and to Dean Leander Keck and the

students of the Yale Divinity School. Also at Yale we want to express gratitude to Provost Georges May and to Susan Miles and Carol Plantinga in the Religion and Arts Office. In Washington, D.C., thanks are due to Giles Constable and the staff at Dumbarton Oaks, Harvard University's Center for Byzantine Studies, which sponsored one session of the conference, and at the National Gallery of Art, to the Director, J. Carter Brown; to Douglas Lewis, Curator of Sculpture; and to Frances Smyth and Margaret Bouten. At the Catholic University of America, our thanks go to President Anthony Pellegrino. Also in Washington, D.C., Mrs. Jouett Shouse and the Reverend Michael Farina of the Paul VI Institute for the Arts deserve recognition.

The symposium "Monasticism and the Arts" was made possible by grants from the Henry Luce Foundation and the National Endowment for the Humanities. This book has been published with the assistance of grants from the Samuel H. Kress Foundation and the Raskob Foundation for Catholic Activities. The editors wish to express special appreciation to Mary Davis, who retired recently as Vice President of the Kress Foundation, for her encouragement and support.

New Haven, Connecticut JOHN W. COOK
Summer 1983 *Director, Religion and Art Program*
 Yale Divinity School

Contents

Monasticism and Christian Culture

Timothy Gregory Verdon

For most of the seventeen hundred years of Christian monastic history, monks have been artists or patrons of the arts. In some respects, that fact should seem strange, since by their way of living monks reject what the New Testament calls the "gratification of corrupt nature, gratification of the eye, the empty pomp of life" (1 John 2:16).[1] The disciplines of the cloister: prayer, work, and study; and its renunciations: celibacy, obedience, and poverty—these seem at variance with the exaltation of sense experience implicit in the visual and performing arts. Yet it is in monastic ritual, in monastic chant, and in the architecture, sculpture, and painting of monasteries, that historians of theater, music, and the visual arts today locate the origins of post-Antique Western culture.

This is a paradox, but a familiar one, and close to the heart of Christianity as a religious system. Christians believe that an entirely spiritual God has chosen to express himself to humankind through material creation, ultimately becoming a physical creature himself. "Expression" is perhaps the central concept, for traditional Christianity has thought of God in terms we might apply to a creative artist seeking the best way to communicate his vision. As the new Testament presents it, this *Deus artifex* became dissatisfied with an initial "spiritual" approach—verbal messages to the Old Testament prophets—and changed to a more plastic medium. The Evangelist John asserts that "The Word was made flesh, he lived among us, and we saw his glory" (John 1:14).[2] Nor was God content to engage only the faculty of *sight* in his human public; what he elicited, according to St. John's description of how the early Church perceived

1

Christ, was more a kind of total sense experience: "something ... that we have heard, and we have seen with our own eyes, that we have watched and touched with our own hands: the Word, who is life ... made visible" (1 John 1:1–2a). St. Paul put it more simply when he called Christ the icon or image of the unseen God (Colossians 1:15), and elsewhere extended that figure to include Christ's followers as well, who he says are "God's work of art, created in Christ Jesus to live the good life" (Ephesians 2:10).

These scriptural metaphors suggest the deeper connection between monasticism and the arts. Monasticism renders visible and tangible a particular intensity of Christian life. The monk seeks to be, like Christ, an icon or image of God's beauty, and the monastery is that quiet place where, with the help of like-minded companions, the work can be perfected—a kind of atelier of the soul. The classic Western formulation of communal monastic life, the *Rule for Monks* of St. Benedict of Nursia (c. 480–c. 547), explicitly invokes this analogy when it compares the cloister to an artist's workshop, conceiving the whole life of monks as a creative process.[3] Here Benedict echoed an older tradition, which envisioned the life of all believers adorned "with the gold leaf of good works ... and the mosaics of enduring faith."[4] The difference with monks, in St. Benedict's mind, is one of degree: monks channel the totality of their human energies into plying this spiritual craft, their tools the moral precepts of Christian life, *instrumenta artis spiritalis* (RB 4:75).

Benedict's meaning in these passages was figurative, but it should not surprise us that the figures of speech became literally true: that monasteries became in fact foyers of the creative arts, as the saint elsewhere (RB chapter 57, "The Artisans of the Monastery") made it plain he expected. An atmosphere of creativity in one "medium" naturally promotes creativity in others, and life in the cloister provided an ideal context for the production of Christian art. By excluding nonreligious distractions, by immersing the artist in Scripture texts and sacramental actions that gave his faith color and form, and by providing a devout, knowledgeable audience, the monastic milieu could foster a heightened sensitivity to the essence of Christian belief. Nor was the benefit of this special insight restricted to monasteries, for the silence and withdrawal of the few attracted, rather than repelled, the many; monastic history bears frequent witness to the fascination that monks held for society at large. Long before Alcuin taught or Anselm wrote, the citizens of Alexandria went out to the desert to hear St. Anthony, and Romans brought their sons to St. Benedict. And when the golden age of monastic culture dimmed, the ideal of prayerful solitude remained a paradigm for the active religious orders of the late Middle Ages and the layfolk to whom they preached.[5] It is no exaggeration to say that the formal achievements of monks—their art and architecture,

their liturgical and devotional practices, their organizational structures and educational, agricultural, and even mercantile methods—molded the cultural consciousness of Europe. Still more, however, the image of monastic life itself as a creative social choice touched the imagination of Western society in a manner so basic as to confound definition. In the monastic venture, many of our civilization's highest aspirations found a focus.

The unique access that monasticism thus affords to broader issues in cultural history has often not been understood. There is a tendency to see monastic culture as a medieval phenomenon rather than one coextensive with Christian civilization through the ages. No one contests the right of ninth- to thirteenth-century monasticism to be considered the high point of a main line of development, and the greatest number of chapters in this book quite naturally deals with topics in medieval monastic art history. The whole picture is bigger, however, and an important contribution which the present volume has been designed to make is an expansion of the field of inquiry to include Patristic monasticism on the one hand, and the Renaissance "aftermath" on the other. Standing back from the fait accompli of high medieval monasticism, several essays trace the monastic movement and its art to their fluid beginnings in the eastern Roman world of the third, fourth, and fifth centuries, the same period that saw the individuation of a Christian style in literature and the arts. What emerges is not the impression of a monastic "order" separate from the rest of Christian society (an impression the great English and French abbeys of the tenth and eleventh centuries often give), but a grasp of the affinities between monastic ideology and the wellsprings of Christian social thought. Other chapters in the book illustrate the longevity of monastic influence beyond the Middle Ages, and its translation by the mendicant orders into forms accessible to the urbanized society of fifteenth- and sixteenth-century Italy. A final chapter devoted to monastic architecture in twentieth-century America completes the trajectory, suggesting the protean flexibility of monastic culture and a continuity of spirit in the monastic milieu across the centuries.

Another contribution which this volume makes is to situate academic art history firmly in the region of lived experience, a need perhaps felt especially by educators. Those who teach virtually any aspect of cultural history know the frustration of having students grasp the "what" of an event or development without seeing the "why." Historical facts (or artifacts) are often competently classified, but the more fundamental process of motivation and choice by which certain facts (and artifacts) were plucked from the category of the possible and became real, the proper subject of history—that remains mysterious. To some extent, of course, it cannot be otherwise. Apart from a kind of detailed, privy infor-

mation from diarists and chroniclers of which there are too few examples, it is impossible to reconstruct with confidence the complex scaffolding of feeling and decision hidden by history's façades. Even professional historians, for all that they may feel a special sympathy with their particular period of expertise, are cautious about assuming they understand it. And no Frankish knight or Renaissance prelate survives to tell us firsthand what it felt like, what it *meant*, to go on Crusade or to commission a monumental tomb. With monks, however, the situation is different. Upwards of thirty thousand men and women on five continents still live in monasteries according to the *Rule* of St. Benedict, as Benedictine, Cistercian, Trappist, Camaldolite, and Olivetan monks, nuns, and sisters.[6] The external structures of their way of life have undergone some notable modifications since the sixth century, but the spiritual and intellectual core is astonishingly consistent. And probably more than any other body in Western society, they are given to pondering the meaning of their position in an ongoing tradition.

It is therefore a particular advantage of this collection to include three essays by Benedictine monks, in the opening section of the volume and in its concluding chapter. These reflect the origin of the book in a symposium jointly sponsored by Yale University and St. Anselm's Abbey, a Benedictine monastery in Washington, D.C. (although the contributing monk-scholars belong to several monastic communities, in the United States and in Europe), and they underscore the conviction of the authors and editors of this book that the nature of our subject calls for more than a conventional academic approach. Monastic life, as distinguished from membership in a guild or service in a government, is not merely one of several institutional cadres to which its members belong; nor even like a human family is it chiefly the emotional and economic base for outward-directed activity. Monastic life is the embodiment of a total private and public existence, the locus of all the hopes and fears, joys and sorrows of men or women who within the monastery's walls live out their lives of prayer and reflection together. It seemed especially desirable, therefore, to "enclose" the more purely academic portions of the text with chapters that could suggest the peculiar weight and density—the texture, as it were, and the feel—of the thing itself.

The final contribution which it is hoped this book will make to the understanding of monastic art and history has to do with what might be called the role of imagination in monasticism. This would seem to be two-fold. Monastic life elicits an effort of imagination, within the context of Christian religious belief, first from those who embrace it and become monks. And then, paradoxically, it calls for a similar effort from those

who do not—that is, from the rest of society. A man or woman who renounces the legitimate *bona* of life in society, and goes apart to seek God in silence and prayer, needs a considerable capacity for moral and social imagination to persevere in believing "things that no eye has seen and no ear has heard, things beyond the mind of man, all that God has prepared for those who love him" (1 Corinthians 2:9).[7] In his (often difficult) relationships with brethren in the cloister, only imagination enables a monk to live out the years convinced that "in so far as you did this to one of the least of these brothers of Mine, you did it to Me" (Matthew 25:40).[8] And it is by an analogous act of imagination that those who do *not* enter monasteries have opted historically to see monks as sages and seers, rather than as threatening dissidents on the margin of the system. From the hundreds who went out into the Egyptian desert to ask Abba Anthony for "a word," to the hundreds of thousands who today read the books of Thomas Merton, Christian society has chosen to believe that reclusion does not signify rejection, and that monastic silence is bright with God's wisdom for all. Moving in its simplicity, this conviction points toward that deepest function of monasticism within the imaginative life of the Church: as symbol, investing everything in its purlieus with holiness.

The interaction of such habits of mind and perception with esthetic stimuli—their reciprocal influence—has tremendous power. It is a common experience of visitors to monasteries as well as of monks that, in the meditative calm of the cloister, imagination imbues the very surroundings with some of the purpose and dedication of the monastery's inhabitants. The humblest object may suddenly be perceived as a sign disclosing the solidarity between man and the sacred, a ladder rising from earth to heaven. St. Benedict went so far as to insist that in the monastery common utensils should be treated like sacred vessels of the altar (RB 31:10). This is the realm of sacrament, where the surface of reality becomes transparent to reveal an infinite prospect, and in this context works of art assume a unique dignity. A *Pietà* carved on an altar table or the *Last Supper* frescoed on a refectory wall are more than embellishment. In this context they are functional objects, imparting and nourishing the faith from which they spring. The specific artistic choices which generate them and which are the normal province of art history are here interwoven in a larger fabric of meaning, part of a higher order of choice. Before drawing attention to several of the characteristic patterns of monastic art history, therefore, or discussing the organization of chapters in this volume, it will be helpful to illustrate more fully the meaning of monasticism and its place in Christian culture.

THE MONASTIC IDEAL AND CHRISTIAN CULTURE

Monks have always been considered the "professionals" of religious life. This term is ambiguous and needs to be understood in several senses, some colloquial, others specialized. At one level, for example, monks are traditional experts at producing the kind of ecclesiastical ceremony described later in this Introduction and in several of the book's essays. The character of their way of life, with its emphasis on communal worship, has made this expertise a natural development. Monks have tended spontaneously to employ a variety of creative media as aids to expression, and in a typically stable monastic community—whose members neither leave nor are transferred, but remain together for life—a kind of intellectual and artistic commune often grows up. Thus the presence of singers in a community may foster both the composition of music and the production of beautiful choir books, and theological considerations may favor a certain style or kind of subject matter in the visual arts.[9] Yet men and women do not form monastic communities primarily to express their ideals through art. Rather the art is a by-product of the ideals: an instrument and a fruit of that patient, loving collaboration required of people who believe themselves called for a common purpose by a higher power. As with religious art generally, monastic art is but one expression of a more inclusive act of imagination, of a given vision of what it means to be human.

This suggests a more specialized sense of the term *professional.* In the language of organized religious life, men and women who commit themselves by vow to live as monks and nuns are said to have "made profession" or "be professed." The meaning is that they have publicly and irrevocably declared their adherence to a system of beliefs and have accepted responsibility for the way they live out this commitment. A colloquial analogy would be to doctors or lawyers who "profess" dedication to some ideal—healing or justice—and are held societally responsible for living up to it. The prestige and influence which monasticism has enjoyed in the Christian Church is rooted in the acceptance by monks and non-monks alike of the importance of the ideal implied in monastic profession.

Finally, related to both the above is the sense in which we commonly use the term *professional* to distinguish those who exercise with special mastery some universally accessible activity. Theoretically everyone may run or sing or write, but only a few are professionals. This designation connotes someone who is devoted to developing certain skills and, at the same time, one whose expertise is linked to a psychic identification with

the skills themselves, an identification so deep that we attribute the individual's success to a calling or vocation—a kind of inescapable drive with which he or she has but to cooperate. In this sense, monks are set apart by their vocation as professional practitioners of Christianity, but their example and leadership are on a path open to all, however unskilled. This sense of special role in a common endeavor is the source of the enormous symbolic potential of monastic life in Christian cultural history, and along with the meaning of the monastic ideal requires explanation.

Monasticism is a paradigm of Christian life, the ultimate expression of a particular system of values. The system exalts obedience, chastity, poverty, fraternal service, and humility; its exemplar is Christ, who "did not cling to his equality with God, but emptied himself... and became as men are; and being as all men are ... was humbler yet, even to accepting death, death on a cross" (Philippians 2:6–8). Historically, monks have expressed these values in many ways, some quite spectacular. Early monastic literature abounds in descriptions of extreme ascetic feats: of days and nights spent in prayer, of near suicidal fasting, and acts of physical and psychological abnegation that to modern sensibilities seem deliberately masochistic.[10] The chief monastic expression of Christian values, however, has been more simple.

The means adopted by the mainstream of Christian monks to imitate Christ in becoming "as men are ... and humbler yet" has generally been a communal life with like-minded men or women: the so-called "holy koinonia" (from the Greek *koine*, "common"). This "cenobitic" or community way of life originated in Egypt and Syria alongside the other main form of Christian monasticism, the eremitical or solitary life, in the late third and early fourth centuries. In theoretical discussions communal monasticism has often been seen as an inferior version of the solitary life, a mitigation at best serving to prepare people for the hermitage. Yet in practice the great legislators of the monastic movement agree in favoring the communal model over hermit life. Both St. Basil in the East and St. Benedict of Nursia in the West dwell upon the spiritual and psychological perils of eremitism, and since the fifth century, if not earlier, cenobitic monasticism has far outweighed the eremitical in numbers and influence.[11] St. Augustine of Hippo (354–430), one of the early promoters of monasticism in the Latin Church, went so far as to define the concept *monk* in light of community living. Commenting on the first verse of Psalm 132(133), "How good and how pleasant it is, when brothers live as one," Augustine asks, "Why then should we not call monks by this name? For *monos* is 'one.' Not just one in any way, for an individual in a crowd is 'one,' but, though he can be called one when he is with others, he cannot be *monos*, that is, 'alone,' for *monos* means 'one alone.' Hence those who

live together so as to form one person, so that they really possess, as the Scripture says, 'one mind and one heart,' who have many bodies but not many minds, many bodies but not many hearts, can properly be called *monos*, that is 'one alone.'"[12]

 This text from Augustine is important. The "Scripture" he refers to is a passage in the Acts of the Apostles (4:32–35) which tells how, after Jesus' death, the early Christians were "united heart and soul; no one claimed for his own use anything that he had, as everything they owned was held in common." This and a related passage of Acts (2:42–47) describe the first Christian community in Jerusalem going daily to the Temple for prayer, meeting privately for the "breaking of bread" and communal meals, and accepting the authority of the Apostles. Now, through seventeen centuries, virtually all Christian monastic life has modeled itself on these structures: daily worship sevices, shared Eucharist and meals, a common purse, and obedience to constituted superiors. In light of these texts, the early monks called their way of life *Apostolic*, and held themselves to be direct successors of the first generation of Christians. They also understood, however, that the ideal picture of Christian community life in Acts was not intended for a discrete group within the Church, but for all believers. What we see in St. Augustine's commentary, therefore, is an already developed form of that tendency to distinguish between those who live their Christian commitment to the full—the "professionals"—and those who do not.

 It should be remembered that the end of the pagan persecutions in the fourth century drastically changed the social position of the Christian community. From a dedicated minority united (in part, at least) by common oppressors, the Church suddenly became a state religion to which all were expected to belong. The rise of monasticism at this period should to some extent be understood as an attempt by serious believers to preserve the identity and fervor of an earlier period.[13] As the monastic movement gained strength, though, gradually and perhaps inevitably monks and non-monks came to feel that authentic Christian life on the pattern set in the New Testament was fully possible only in monasteries, and there developed that peculiar relationship between the monastic order and Christian society which persists to this day: a relationship of exemplary microcosm to macrocosm. That is, while all are called to realize the ideal of Christian life presented in the Acts of the Apostles, practically speaking only a few devote themselves to this endeavor full time, and it is to these that the others look for guidance and inspiration.

 The communitarian vision, therefore, is the point of intersection between monasticism and the life of the wider Church. We might illustrate

that fact by looking at a cultural "document" produced in the monastic milieu, which incorporates two forms of monastic art from two quite different periods. This is a panel by Fra Filippo Lippi depicting an event from the life of St. Benedict (Figure 1). Both the literary source on which

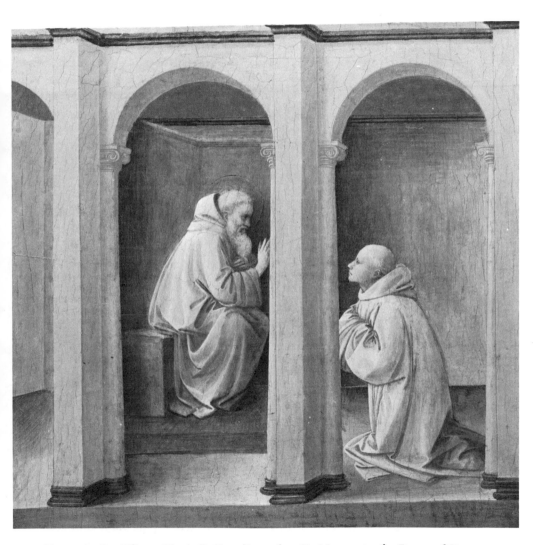

Figure 1. Fra Filippo Lippi, *St. Benedict orders St. Maurus to the Rescue of St. Placidus. Courtesy of the National Gallery of Art, Washington, D.C., Samuel H. Kress Collection.*

the painting depends, the early seventh-century account of Benedict's life and miracles by Pope St. Gregory the Great (a masterpiece of early medieval hagiography), and the fifteenth-century painter's interpretation of the episode, were fashioned as teaching instruments; both have the distinctive flavor of monastic ideology.[14] St. Gregory says that after Benedict founded his first monastery, in the hills near Subiaco, his influence spread in the surrounding countryside and beyond. "Pious noblemen from Rome ... came to visit the saint, and left their sons to be schooled in the service of God." One day, one of these boys fell in the lake while fetching water. Still in the monastery, St. Benedict saw the accident in a vision and called an older boy to hurry and save the child. The older boy was named Maurus, the younger Placidus. "What followed was remarkable indeed, and unheard of since the time of St. Peter the Apostle! Maurus asked for the blessing [scene on viewer's left in Figure 1], and on receiving it hurried out to fulfill his abbot's command. He kept on running even over the water till he reached the place where Placidus was drifting along helplessly [scene on viewer's right]. Pulling him up by the hair, Maurus rushed back to shore, still under the impression that he was on dry land. It was only when he set foot on the ground that he came to himself and realized that he had been running on the surface of the water."[15]

The patrons who commissioned this painting were Benedictine monks or nuns, and the painter too belonged to a religious order.[16] To both, the deeper meaning of St. Gregory's story would have been clear: in the context of community life, we "save" our brothers or sisters through service prompted by the obedience of faith. Those for whom this panel was made would probably have read the message in light of St. Benedict's description of obedient monks in his *Rule:* "Such people as these immediately put aside their own concerns, abandon their own will, and lay down whatever they have in hand, leaving it unfinished. With the ready step of obedience, they follow the voice of authority in their actions. Almost at the same moment, then, as the master gives the instruction the disciple quickly puts it into practice in the fear of God; and both actions together are swiftly completed as one" (RB 5:7–9). And Lippi's interpretation of the scene also constitutes an ideological statement: those cool white figures in adjacent bays of an arcade become a visual epitome of monastic life. Each in his place, separate from the other yet united by a gaze that bespeaks the bond of deep faith, these are visibly people striving to "live together so as to form one person," with "one mind and one heart." The elder, in the posture of a teacher, of one who transmits the wisdom of a tradition, blesses (the name *Benedict* derives from the word *to bless, benedicere*). The younger strains forward to listen, his whole being

animated by trust. Again, words from St. Benedict's *Rule* would have echoed in the minds of the patrons, the beautiful exhortation in verse 1 of the Prologue: "Listen, my son, to the master's instructions, and attend to them with the ear of your heart. This is advice from a father who loves you."

These texts and this painting communicate more than a private experience, however, or one reserved for monks. "Brother" Filippo's visual parable represents a social ideal: community living grounded in trust and service. The mythic apparatus obviously would have had most explicit appeal for men and women in monastic communities, as the citations from Augustine, Benedict and Gregory the Great imply. But even without such specialized background, any Christian might grasp the image's core of meaning and relate it to the struggle to live at peace with his or her neighbor. As Mircea Eliade has observed, "We do not have the right to conclude that the message of symbols is confined to the meanings of which a certain number of individuals are fully conscious, even when we learn from vigorous investigation of these individuals what they think of such and such a symbol belonging to their own tradition. Depth psychology has taught us that the symbol delivers its message and fulfills its function even when its meaning escapes awareness."[17] Here Lippi's vivid rendering of a particular kind of intense human relationship evokes structural affinities with that archetypal image of Christian brotherhood in Acts. The specifically monastic elements do not obstuct a more general appreciation, but serve as "tensive" symbols, drawing life "from a multiplicity of associations, subtly and for the most part subconsciously interrelated," and thus able to tap vast reservoirs of semantic, historical, and cultural energy.[18] The ordinary believer kneeling before the altarpiece of which this panel was a small part could, through the prism of monastic experience, achieve an insight into his or her own role in the fellowship of the Christian Church.

The function of monasticism within the larger system of Christian life, then, is that of symbolic environment. Monks and non-monks "inhabit" this environment differently, but for both it can promote a dynamic awareness of other creative manifestations related to the system: what may amount to a practical identification with the symbols. On this characteristic rests the special force of the arts in monastic life, and it is important to grasp how it works. Again, an illustration will be helpful—in this case, not an example from the plastic arts, but the "stage directions" for part of a typical monastic ceremony.

Imagine a cloister passage in the half-light of early morning. Repeated strokes of a bell are heard, and two columns of robed figures

begin their slow procession into the church. A voice intones the chant, which all take up, *Hi sunt qui venerunt de tribulatione magna* ... (the entrance antiphon for the feast of a martyr saint, "These are they who have survived the great tribulation, who have washed their robes in the blood of the Lamb"). The monks pass through ranks of laypeople toward the church's eastern end where the sun, risen now, brings alive a *Crucifixion* in stained glass on the window above the altar. As they reach the altar, each pair of monks in the double file makes a profound bow, and the columns separate to right and left. Last comes the priest, in blood-red vestments and alone (Figure 2). He mounts to a dais behind the altar and, turning to face monks and people, extends his arms in a ritual gesture. The priest's crimson vestment echoes the deeper hues of the window above him, and his posture repeats that of the Crucified as he pronounces the opening formula: "The Lord be with you ... "

Such a rite is not unique to monasteries. Any Christian celebration of the Eucharist could begin in much the same way, and the laypeople in our scenario would recognize the several elements of the rite as well as the monks did. Nevertheless, the perceptions of the two groups would differ in a number of respects, only the most obvious of which has to do with the distinction between performer and spectator. All in the church might identify with the occasion, the feast of a martyr, inasmuch as all Christian life entails self-sacrifice and in that respect has analogies with the sacrifice of the martyrs. The monks, however, would associate themselves explicitly and literally with the saint of the day, monastic theology having accustomed them to see the asceticism of their way of life as a spiritual continuation of the physical sacrifice of life of the early martyrs.[19] They would understand "These are they who have survived the great tribulation" as a reference to themselves as well as to the martyrs, seeing the cloistered tranquility of their life as a foretaste of final "survival" in heaven.[20] The reference to "robes washed in the blood of the Lamb" would strike closer home for them, since monks wear distinctive garb and on this occasion one of their number actually wears red vestments. And so on throughout the rest of the mass ritual—the Scripture readings, the bread and wine, the expressions of mutual forgiveness and fraternal communion. These familiar signs would resonate with special intensity, performed by men or women formally committed (and known to be formally committed) to "share in the sufferings of Christ that we may deserve also to share in his kingdom" (RB Prologue:50).

It is clear that works of art incorporated into the dramatic rhythm of such a rite participate in the cumulative psychological effect of the whole. The stained glass representation of Jesus' death, which in a

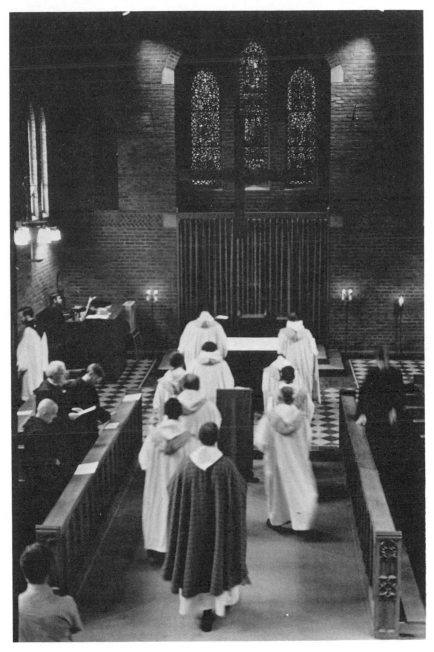

Figure 2. Entrance procession to daily Eucharist, St. Anselm's Abbey, Washington, D.C. *Photo by J. Mroczek*

museum would be merely a stray fragment of Christian religious culture, has quite another impact here. Illuminated by the morning sun, it acts as a focus for the advancing columns of monks, revealing the meaning of the life they are about to celebrate symbolically on the altar, the sacrifice figured in bread and wine. To the extent that the viewer, monk or layperon, gives himself to the many-layered implications of Jesus' sacrificial death for others, such a work of religious art in context can tansform him. When the music stops and the books are closed, after the procession has left the church, this *Crucifixion* remains as a silent record of privileged moments of self-knowledge and dedication. For the layperson, it is part of the total symbol constituted by monastic community life: a liminal experience of his or her own deepest Christian aspirations. For the monk, who returns to the church repeatedly during the day—under stress perhaps, angry at a brother or resentful of a superior—such an image can disclose to memory a perspective in which the painful realities of life are articulated into a whole. It can unify, give meaning, heal.[21]

To ascribe such efficacy to a work of art may seem exaggerated; in fact it is a sober analysis of how religious symbols "work." *In situ*, works of religious art are not analyzed but meditated upon, and what the preceding paragraph described in schematic terms is, in the lived experience, a more fluid process: a gradual movement from hint to hint as the monk daily encounters an art work in the context of prayer. He sings Psalms and listens to Scripture, hears sermons and participates at Mass before the work of art, and—inevitably, it seems to me—the kinds of reactions suggested here crystallize in his imagination. This does not happen by magic, and has little to do with the noticn of "salvation through beauty" current in the late nineteenth century. It harks back to an older idea, one as old as monasticism itself, bound up with the development in the Patristic Church of that complexus of symbolic words, actions, and objects known as sacraments. Indeed, works of religious art function in a manner analogous to the primary Sacraments and acquire a measure of their efficacy. The splendid buildings, the music and precious vessels adapted to worship, the books and vestments which surround a monk's intimacy with God—all these are called into existence to express and assist the most basic human options. And like Baptism or the Eucharist, they can help to actually bring about the ideal conditions which they signify: of order, harmony among men, and interior nobility.[22] By the normal interaction of human psychology and esthetic sensibility with the mysterious component of spiritual choice in the individual, the work of art acquires power: first, to alter perception, and then—with time, across a lifetime in the monastery, perhaps—to change the heart.

A moving description of this process, and one which focuses precisely on the dimension of affective response, may be found in St. Augustine, who, after his conversion, lived as a monk until called to be Bishop of Hippo.[23] Augustine says:

> The presentation of truth through signs has great power to feed and fan that ardent love, by which, as under some law of gravitation, we flicker upwards or inwards to our place of rest. Things presented in this way move and kindle our affection far more than if they were set forth in bald statements. ... Why this should be, is hard to say: ... I believe that the emotions are less easily set alight while the soul is wholly absorbed in material things; but when it is brought to material signs of spiritual realities, and moves from them to the things they represent, it gathers strength just by this very act of passing from the one to the other, like the flame of a torch, that burns all the more brightly as it moves.[24]

MONASTIC HISTORY AND THE ARTS

The "material signs" with which monks have expressed their faith through the centuries are too varied and numerous to admit of easy classification, nor is this Introduction the place to attempt a catalog of monastic achievements in the arts.[25] It will be helpful, however, to illustrate from history a few features of the monastic contribution to European culture, characteristic themes or patterns that sketch the background of the specialized studies which follow. And while it is true that this book deals with the visual arts, the point of departure for Christian and monastic history and art history must be sought elsewhere. The "signs of spiritual realities" to which St. Augustine was referring in the passage quoted above were not in the first place plastic, but literary images: the allegorical structures that undergird Christian imagination. One should begin, therefore, with the written word.

When Charlemagne visited the Abbey of Monte Cassino in A.D. 787, he was shown a manuscript of the *Rule* of St. Benedict which the monks believed to be the very text written by their founder more than two centuries before.[26] This belief went back at least to the middle of the century, when Pope Zachary (741–52) sent the manuscript to the rebuilder of Monte Cassino, Abbot Petronax of Brescia, calling it "the Rule that Blessed Father Benedict wrote with his own holy hands." The belief that the manuscript was autograph may have been older, though. A contempo-

rary Carolingian source, Paul the Deacon, says that when the monks of Monte Cassino fled the Lombard invasion in the late sixth century they took a text of the *Rule* with them to Rome. Leo of Ostia, a twelfth-century chronicler, asserts that this went to the Lateran monastery, from which it could plausibly have passed into the papal library in the Lateran palace. Thus it is conceivable that the manuscript Pope Zachary sent to Monte Cassino was indeed the original. At all events, modern philologists agree that the textual tradition stemming from the Monte Cassino codex originated in the age of St. Benedict.

This manuscript was lost, probably in the late ninth-century war with the Saracens in southern Italy. Its form was preserved, however, through a most instructive sequence of events. Charlemagne requested an exact copy of the venerable document, which was duly prepared and sent to him at Aachen with a covering letter stating that the copy had been made from the codex "which St. Benedict wrote with his own holy hands." The Aachen text, (now also lost) was in its turn copied around 820 by two monks sent from the Abbey of Reichenau, Brothers Grimalt and Tatto. Grimalt later became abbot of the monastery of St. Gall, and brought either the first copy or a rescript with him to that community in 840. It is the St. Gall manuscript that has survived (Sangallensis 914), and bound into the same volume with it in the monastic library at St. Gall is Grimalt and Tatto's letter to the librarian at Reichenau, stressing that the text of the *Rule* which they are sending him "has been copied from that exemplar which was copied from the very codex that the blessed Father took care to write with his own sacred hands."[27]

Several features of monastic civilization stand out in this account. Most striking, perhaps, is the role of tradition: the process of handing on a way of life by the physical replication of revered prototypes. Many essays in the present volume illustrate this principle in regard to monastic architecture and pictorial art, and art historians have come to rely upon it much as paleographers do to reconstruct lost original "documents" from contemporary copies. A related feature is the profound veneration accorded St. Benedict of Nursia, who serves as a kind of human document to be copied by monks down the ages. This near mythic stature of Benedict is the creation of St. Gregory the Great, from whose *Life* of the saint the story of Maurus and Placidus, told above, was taken. St. Gregory, himself a monk until elected Pope, fully intended his Benedict to be a role model: after praising the *Rule* for its "discretion and clarity of language," Gregory says that the author's life could not have differed from his teaching.[28] The two texts, Gregory suggests, are complementary, and in fact his *Life* of Benedict was used in medieval monasteries in conjunction with the *Rule* as

a manual for novices.[29] It is Gregory's Benedict whom the monks of Cluny celebrate in the music studied by Ruth Steiner, and who in Dante's *Paradiso* laments the decline of monastic fervor, as Peter Hawkins shows.

Another fact that emerges from our page of monastic history somewhat colors the emphasis on tradition: that is the internationalism of the monastic movement. The repeated transplanting of monastic life— from East to West, from South to North, from the old world to the new— and the survival of monastic life through dramatically changing historical conditions, necessarily entailed adaptations, innovations, compromises. St. Benedict seems to have expected this, for the *Rule* which Charlemagne saw in his travels, and which Grimalt and Tatto traveled to copy, makes considerable allowance for varying regional needs and customs (e.g., RB 34, 39, 40, 41, 55). Indeed, Benedict's *Rule* is itself in the first place a creative adaptation to sixth-century Italian circumstances of the harsher spirituality of Eastern Patristic monasticism, just as Pope St. Gregory's literary portrait recasts data from the *Lives* and *Sayings* of the Egyptian monks for a European audience. It may be that when Gregory praised the *Rule* of Benedict for its "discretion," he had in mind precisely this elasticity. In his famous instructions to St. Augustine of Canterbury, whom he had sent with forty monks to evangelize England, the same pontiff urged respect for local pagan customs and their incorporation, wherever possible, into Christian religious practice.[30] The history of monastic art abounds in instances of similar flexibility in adapting to regional styles, period taste, and the esthetic preferences of powerful patrons.

Flexibility and traditionalism help explain a third facet of monastic culture apparent here, and that is the appeal monasticism had for universalist institutions such as the Papacy and the Holy Roman Empire. The popes not only made gifts to monasteries, like Zachary, and promoted monasticism in their writings, like Gregory the Great, but actively spread the practice of monastic life by using monks as missionaries. From Gregory's initial monastic mission to Britain in 596–97 sprang a rich harvest, as English monks set out during the next two hundred years to evangelize and "monasticize" Northern Europe—St. Willibrord in the Low Countries, and Sts. Boniface and Willibald in Germany being the best known examples. In the same way, popes from the twelfth to the fourteenth centuries used the Cistercians to convert the pagans of Prussia and the Baltic area. Such missionary activity constituted a unique network for the transmission of style in all branches of the arts, as the necessary impedimenta of liturgical practice—music, vestments, illuminated texts, and other artifacts—migrated North. A classic instance of this process is provided by the English monk St. Benet (Benedict) Biscop (d. 689), who began his

monastic career at Lerins, in Provence, but returned to England to found two monasteries in his native Northumbria, at Wearmouth and Jarrow. On several journeys back to Gaul and Rome, Benet Biscop engaged the services of craftsmen and artists, including glass makers from Gaul and an arch-cantor of the Vatican basilica, named John, to teach the Northumbrian monks sacred chant "as it was sung at St. Peter's, Rome."[31] An element of homogeneity was introduced in this fashion into European religious usage, as Roman models gradually replaced the local ritual practices of southern France and Ireland. This was not the rigid uniformity of the seventeenth-century Counter Reform, but it had an analogous symbolic function of creating a sense of Church that was unified and universal.

Rome had other associations for the medieval mind, and monasticism became linked to these as well. Charlemagne was interested in the *Rule* of Benedict because he recognized in its centuries-old authority and international reach an instrument to realize his vision of Christian empire. The Palace School he founded at Aachen, under the English monk Alcuin of York, had as its goal the creation of a universal culture, accessible to men from the most varied backgrounds. The monastic system was to provide the means to achieve this goal, and the reform and standardization of monastic observance became an essential element of the Carolingian *renovatio*. It was finally accomplished after Charlemagne's death by his son Louis the Pious and his adviser for religious affairs, St. Benedict of Aniane, who in 817 made the *Rule* of Benedict obligatory for all monasteries in the Empire.[32] Brothers Grimalt and Tatto belonged to the first generation of this reform movement, sent to the Imperial school at Aachen to receive the authentic version of the text, be instructed in its official interpretation, and to carry these back to their brethren.

In the visual arts, the Carolingian reform found expression in an ideal layout for monasteries, apparently drawn up in the circle of Benedict of Aniane himself. The same abbot of Reichenau who about 820 sent Grimalt and Tatto to Aachen also sent a copy of the new authorized monastic plan to the community at St. Gall, where it is still preserved.[33] The St. Gall Plan shows a carefully organized complex of outbuildings surrounding a central core: guest houses, farm buildings, workshops, and servants' quarters arranged on the fours sides of a large monastery church with, on its southern flank, a cloister yard formed by the monks' dormitory, refectory, and storage rooms. This arrangement fuses Mediterranean elements of design with Germanic features found in other Carolingian monasteries, such as the slightly earlier Abbey of St. Richarius (St.-Riquier) at Centula. An eleventh-century commentator's observation that the monastery at Centula was built in accordance with the *Rule* of St.

Benedict provides a key to the development of much monastic architecture.[34] Just as Gregory the Great believed that St. Benedict's life could not have differed from his *Rule*, so any highly specific interpretation of the *Rule* favored a regularization of the physical setting in which its prescriptions were to be lived out. Later efforts at standardization in the monastic milieu would also foster more or less official architectural styles. This was true of the Cluniac movement and still more of the Cistercians, whose architectural ideal is discussed by Otto von Simson in Chapter 5.

It should be stressed that these developments would very much have surprised St. Benedict himself, who modestly assessed what he had written as "a little rule for beginners" (RB 73:8). As Aidan Kavanagh points out in Chapter 2, the *Rule* of Benedict is a frank distillation of earlier monastic sources; unlike the contemporary sixth-century *Rule of the Master*, which it reproduces verbatim in significant portions, Benedict's work did not claim either absolute authority or divine inspiration. Up to the period of the Carolingian reform, in fact, the norm of monastic life in Europe remained a pluralism in which various forms of legislation and practice coexisted, often in the same monastery. The closest thing to uniform monastic observance in the seventh and eighth centuries was the widespread use of the Rule of St. Columban, propagated by Irish missionaries in Scotland, Northern England, France, Switzerland, and the Italian Appenine. The masterpieces of monastic art of this period belong to an independent Celtic tradition: intricately stylized book illumination and abstract sculptural decoration with little or no debt to Mediterranean prototypes. The Lindisfarne Gospel book and Book of Kells are among the best known works of this distinctively northern monastic culture.[35]

St. Benedict would have been surprised as well by the social position of medieval monasteries. The protection and patronage of popes and emperors represented an inversion of the social equation which Benedict envisioned, with monks no longer on the fringe of society but at its center. It was perhaps inevitable that as the legal, economic, and educational institutions of Antiquity crumbled, the Church should step in and stable monastic communities with libraries and literate members become training grounds for the ecclesiastical administrators who in many cases doubled as civil rulers. The Carolingian reform confirmed this tendency. It meant, however, that the human makeup of monastic communities changed as the ruling class was drawn to the cloister, and it entailed a transformation of the external setting suited to this new role in the feudal Establishment. The primitive simplicity of monastic liturgy described by St. Benedict gradually gave way to elaborate ritual forms appropriate to metropolitan or court churches; these in turn called for bigger and more

sumptuously appointed buildings, designed to satisfy wealthy benefactors or to incorporate the dynastic symbolism of princes—as Hill, Cahn, and Crosby illustrate below.

The most conspicuous example of these tendencies was the Abbey of Cluny, in southern Burgundy. Mother house, at its height in the tenth and eleventh centuries, of nearly fifteen hundred abbeys, priories, and granges from Spain to Germany and the British Isles, Cluny was a country without borders.[36] Where Charlemagne had sought to incorporate the monastic system into his empire, Cluny in a sense replaced that empire and was exempt from feudal and ecclesiastical obligations to all except the pope. In the aristocratic, Cluniac interpretation of the *Rule*, work took second place to public worship, the antiphonal chanting of the Divine Office in which the community passed more than half its waking hours. The staggering scale of the Abbey Church at Cluny, in its final twelfth-century form, was intended to provide a setting for the never-ending processions and rituals of hundreds of resident and visiting monks. Moreover, in its varying stages of evolution, the mother church of this large congregation exerted far-reaching influence on the creation of an international Romanesque style.[37] Cluny was destroyed in the French Revolution, but the splendor of its painted and carved decoration can be judged from surviving Cluniac monasteries, such as Berzé-la-Ville and Moissac.

The period of Cluny's greatest magnificence saw a sharp reaction in Italy and France: a movement of return to the simplicity of pre-Carolingian monasticism. New orders arose, in most cases still using the *Rule* of St. Benedict but with an ascetical and often eremitical emphasis that harks back to Patristic times or to Celtic customs. The most successful of the new forms of Benedictine observance was founded by Robert of Molesmes and Stephen Harding in 1098 at Cîteaux, about fifteen miles south of Dijon.[38] The Cistercians, called "White Monks" because of the unbleached wool of their habits, sought to distinguish themselves from the black-robed monks of Cluny in virtually every detail of life. They restored St. Benedict's balance of manual labor with liturgical prayer and reading (see Jean Leclercq's chapter), simplified the liturgy, and laid great stress on contemplative silence and poverty. The distinctive Cistercian taste in architecture, book illumination, and other art forms, to which several essays in our volume are devoted, was a considered statement of the austere interiority at which the new order aimed. It also represented a conscious rejection of the Cluniac esthetic of adornment, as we know from the Cistercians' most eloquent spokesman, St. Bernard of Clairvaux. As a centralized, carefully controlled reform movement, the Cistercians were able to enforce their standards of taste to a degree never before seen in Europe.[39]

In the thirteenth and fourteenth centuries, other forms of religious life developed which were not strictly speaking monastic.[40] The objectives of the new orders corresponded to changed conditions in lay society and the Church; their members did not remain within monastery walls, but went out to preach and teach. Yet in other respects, new groups like the Franciscans were natural heirs of the older monastic system. It is in a way symbolic that St. Francis received the land on which he and his followers first settled, his beloved "Portiuncula" (little portion) below Assisi, from a local Benedictine community. Both Franciscans and Dominicans would take over the basic structures of conventual life—the internal organization of the community and daily horarium, for example—from the *Rule* of Benedict. To be sure, the mendicant concept of an absolutely centralized order, with a single superior after the pope, was foreign to St. Benedict's belief in autonomous local communities, but it was a shift for which the Carolingian, Cluniac, and Cistercian reforms had paved the way. In like manner, the existing Cistercian style in architecture, unadorned and functional, provided a viable international exemplar for the new orders, which enlarged the scale of monastic prototypes to accommodate the urban masses to whom they ministered.[41]

In time, the new forms of organized religious life exerted a reciprocal influence upon the old. The subjective emotion-laden spirituality of the later Middle Ages had been born in the monastic ambient: in the writings of St. Bernard, as von Simson points out in Chapter 5. It took final and concrete form, however, in the popular preaching, religious drama, and pictorial realism favored by the Friars, especially in Italy; William Hood's chapter discusses a late instance. This emotional pietism became a powerful tool in the ministry to the poor of Europe's newly enlarged cities, and by the fifteenth century was inextricably interwoven with the "objective" liturgical piety of the older monastic orders. Marvin Eisenberg's chapter gives an instance of a contemplative monastic community functioning in an urban setting in a manner analogous to that of the Mendicants. Similarly, fifteenth- and sixteenth-century reforms of monastic life drew upon Franciscan and Dominican, rather than older monastic organizational models.

In the arts this led to a gradual blurring of the distinction between monastic and nonmonastic styles. The architecture and decoration of great abbeys of the baroque age, such as Kremsmünster and Melk in southern Austria, have a theatrical exuberance more attuned to Jesuit piety than to what we think of as *pax monastica*. A recognizable "monastic" style would not reappear until the nineteenth century, and then as a pastiche, part of the Romantic revival in Europe and America that with equal gusto produced Gothic government buildings and Romanesque

warehouses. It should be remembered, however, that monastic life had been weakened by the rationalism of the eighteenth-century Enlightenment and all but eradicated in much of Europe in the Napoleonic wars and subsequent reorganization of national states. The archeologism of the mid-nineteenth-century monastic renaissance, guided by men like Abbot Prosper Guéranger of Solesmes and the Wolter brothers of Beuron, was a step in the process by which monks have recaptured their historical identity as contemplatives.[42] The often deeply spiritual architecture of today's monastic communities, which Kevin Seasoltz illustrates in the concluding chapter of the book, is an original expression of that identity.

THE ORGANIZATION OF THE BOOK

The chapters of this volume develop through specific instances many of the themes introduced above. They fall more or less naturally into three categories: those which present the historical ambient of monastic life and art; those which discuss specific works of art created by and/or for monastic communities; and a few which examine the influence, in the later Middle Ages and Renaissance, of monastic spirituality upon the art of the wider Christian community. The order of material in the book corresponds to these three large areas, with an epilogue on contemporary developments in monastic art. The individual chapters have been organized in roughly the chronological order of their topics, with a few exceptions. It has been the editors' effort to create a feeling of logical movement from one chapter to the next, such as to some extent seems implicit in the material itself, and a short prefatory paragraph has been provided for each chapter to suggest its "place" within the larger whole. Nonetheless, the book remains a collection, unified in overarching concept but richly diverse in the emphases and methodologies of the contributing scholars.

The volume opens with a study of the characteristics of monastic art in the period of its individuation, relating an important monument of early Greek monastic art to other cultural phenomena in the early Church. There follow two chapters by Benedictine monks: the first analyzes the influence upon Western monastic spirituality of the early Greek sources introduced in Chapter 1; the second discusses the theory and practical dynamics of artistic creativity in medieval European monasteries. Seven chapters then treat aspects of medieval European monastic music and liturgy, architectural theory and symbolism, book illumination, and stained

glass production (considered with regard both to technique and iconography). The historical portion of the book concludes with chapters on the dissemination of monastic spirituality in works of literature and art directed to a lay audience. Two of these chapters deal with Renaissance topics, adding considerably to the growing fund of knowledge about the role of Christian themes in fifteenth- and sixteenth-century Italy.

The final essay, or epilogue, articulates in modern terms the most basic concerns of artists and patrons in the monastic milieu today. This chapter, by Father Kevin Seasoltz, O.S.B., a monk of St. Anselm's Abbey, Washington, D.C., might well be read right after the Introduction. The author's discussion of monastic architectural programs of the last three decades provides a contemporary "translation" of the esthetic sensibility apparent in the historical material which comprises the rest of the book. In other respects, Father Kevin's chapter fittingly closes this volume, stressing as it does perennial traits of the monastic artist: reverence for a given place, the sense of collaboration with brethren present and past—of cooperation, indeed, with an ancient, ongoing tradition—and an understanding of the art which he creates or commissions as formative of human personality.

NOTES

1. The English version is from the translation of the New Testament by Ronald Knox, first published in 1946. Other Scriptural citations in this Introduction use the *Jerusalem Bible* translation. Throughout the book, the preferences of individual chapter authors, in the matter of which of the available Scripture translations to use, have been respected.

2. The most succinct statement of this understanding of the Incarnation as a fulfillment of Old Testament prophecy, and indeed of all prior creation, is perhaps in Chapters I and XI of the epistle to the Hebrews.

3. The term St. Benedict uses for the monastery is *officina*, and he would have his monks work at their spiritual craft *"die noctuque incessabiliter"*; see the *Rule* of St. Benedict, chapter 4, verses 75–78.

It will be appropriate here to say a word about available translations and editions of the *Rule*. The passages quoted in this Introduction use a new translation of the *Rule* of St. Benedict prepared by a group of American Benedictine monks and sisters, *RB 1980, The Rule of St. Benedict in Latin and English with Notes*, edited by Timothy Fry, O.S.B., and others (Collegeville, Minn.: The Liturgical Press, 1980), hereafter referred to as *RB 1980*. *RB 1980* is now beyond doubt the best source for English readers, and its rich notes, superb introductory essays, and carefully prepared indexes make it a basic tool for monastic studies in any language. It was the present author's privilege to work closely for several years with one of *RB 1980's* associate editors, the Reverend Mark Sheridan, O.S.B., of St. Anselm's Abbey, Washington, D.C., and the first part of this Introduction draws freely on Father Mark's insights, as does my overall view of monasticism.

RB 1980 appeared in print after the preparation of most of the chapters here, however, and the authors use a variety of older translations. Since the reader too—unless he or she is near an up-to-date religious studies library—may not have access to *RB 1980*, or may be personally familiar with one of the older translations, the editors have decided in this case, as in that of Scripture citations, to maintain the preferences of individual contributors. The standard abbreviation for the *Rule* of St. Benedict is RB.

4. St. John Chrysostom, *Supplementum, Homelia 6, De precatione*, in Jacques Paul Migne, ed., *Patrologiae Cursus Completus, series Graeca*, 242 vols. (Paris: Migne, 1857–67), 64:462–66. St. Benedict probably drew directly on Chrysostom's slightly younger contemporary, John Cassian, for his use of this figure of speech. See *RB 1980*, p. 186, and more generally, Aidan Kavanagh's chapter, below.

5. See below, the chapter by William Hood, and Timothy Verdon, "Monastic Themes in Renaissance Art" (Washington, D.C.: National Gallery of Art, 1980).

6. This figure, from a recent edition of the *Annuario Pontificio* issued by the Vatican, does not include Orthodox monks or Carthusians.

7. St. Benedict quotes this verse relating to man's visual faculty in the passage where he compares the monastery to an artist's workshop, RB 4:77.

8. St. Benedict quotes this text in reference to the care of sick brethren in the monastery, RB 36:3.

9. On the development of a collaborative community style, see Jean Leclercq's chapter, below; on the direct influence of theology on style and iconography, see especially von Simson, Crosby, and Lillich.

10. See Kavanagh's chapter, below. The considerable literature of early Christian asceticism is studied in relation to the monastic movement by Mark Sheridan: *RB 1980*, pp. 11–64. For a brief survey in paperback, see David Knowles, *Christian Monasticism* (New York: McGraw-Hill, 1967).

11. On St. Basil's criticism of the eremitical life, see *RB 1980*, pp. 32–34, with full bibliography.

12. *Ennarationes in psalmos* 132,6. Translation taken from *RB 1980*, pp. 62–63. One of the useful tools *RB 1980* makes available to students is a list of patristic and ancient works upon which St. Benedict drew, directly or indirectly. The list indicates the most readily available English translations of standard patristic source material. See *RB 1980*, pp. xxi–xxxi.

13. See Knowles, *Christian Monasticism*, pp. 10–12; full bibliography given in *RB 1980*, pp. 14–16.

14. For an analysis of the place of Gregory's *Dialogues* in the tradition of hagiographical literature, see the recent and by all counts best edition of that work, with abundant annotation and an extensive introduction: *Grégoire le Grand: Dialogues*, edited by Adalbert de Vogüé, with French translation by P. Antin, 3 vols., Sources Chrétiennes nos. 251, 260, 265 (Paris: Editions du Cerf, 1978, 1979, 1980), vol. 1. In a talk given at Mount Saviour Monastery, Pine City, New York, early in 1978, Father de Vogüé developed his image of the *Dialogues* as a literary altarpiece like those of the early Middle Ages, in which a large-scale icon of the saint is surrounded by numerous small scenes depicting related events. His point was the in Gregory's four *Dialogues*, only the second, the *Life of Benedict*, is devoted to a single personality. The other three each tell stories of many holy men of the period, and serve to "frame" the greatness of the central figure, St. Benedict of Nursia.

In English, see *Gregory the Great: Dialogues*, trans. by O. Zimmerman, O.S.B., Fathers of the Church no. 39 (New York: Fathers of the Church, Inc., 1959), and the more available *Life and Miracles of St. Benedict* (St. Gregory's Second Dialogue), trans. O. Zimmermann, O.S.B., and Bernard Avery, O.S.B. (Collegeville, Minn.: The Liturgical Press, 1949). See

also M. Avery and M. Iguanez, *La Vita di San Benedetto: miniature cassinesi del secolo undicesimo illustranti la vita di San Benedetto* (Monte Cassino: Sasaini, Roma, 1934). On the National Gallery panel by Lippi, see Fern Rush Shapley, *Paintings from the Samuel H. Kress Collection: Italian Schools, XIII–XV Centuries* (London: Phaidon, 1966), pp. 107–108.

15. See the Second Dialogue, chapter 7; English translation taken from *Life and Miracles of St. Benedict*, pp. 20–22.

16. The painting is thought to have been a predella panel either for the altarpiece which Vasari reports as begun in 1443 for a chapel in the convent church of the Murate, in Florence, or for an altarpiece done for the Olivetan Benedictines at Arezzo, of around 1445. See Shapley, *Italian Schools*, pp. 20–22.

17. Mircea Eliade, "Methodological Remarks on the Study of Religous Symbolism," in M. Eliade and J. M. Katagawa, eds., *The History of Religions, Essays in Methodology*, 6th ed. (Chicago: University of Chicago Press, 1973), p. 95.

18. I have borrowed the notion of "tensive symbols" from literary criticism: see Philip H. Wheelwright, *Metaphor and Reality* (Bloomington, Ind.: Indiana University Press, 1962), p. 94. On symbolism in the religious context, see most recently Avery Dulles, S.J., "The Symbolic Structure of Revelation," *Theological Studies* 41, no. 1 (1980): 51–73, who cites Wheelwright (p. 56). A more fundamental consideration of the role of symbolism in Christianity is provided by Karl Rahner, S.J., *Theological Investigations*, vol. 4, trans. D. Bourke (London: Longman and Todd, 1966), pp. 221–52, "The Theology of the Symbol."

19. See *RB 1980*, pp. 14–15, and E. E. Malone, "Martyrdom and Monastic Profession as a Second Baptism," in A. Mayer, J. Quasten, and B. Neunheuser, eds., *Vom Christlichen Mysterium: Gesammelte Arbeiten von Gedächtnis von Odo Casel, O.S.B.* (Düsseldorf: Patmos, 1951), pp. 115–34.

20. A good overview of monasticism as the "angelic life" is given by Claude Peifer, O.S.B., *Monastic Spirituality* (New York: Sheed and Ward, 1966).

21. On these properties of the religious symbol, see Eliade, "Methodological Remarks," pp. 99–100. The basic insights here are broadly Jungian in character; see the work by Victor White, O.P. (a theologian disciple of Jung), *God and the Unconscious* (Cleveland: Meridian, 1952), pp. 233–34, and generally see Dulles, "Symbolic Structure," pp. 61–65.

22. Two recent texts which can serve as an introduction to the enormous literature of sacramental theology are: Bernard Cooke, *Ministry to Word and Sacraments: History and Theology* (Philadelphia: Fortress, 1980), especially chapters 29, 30, and 33; and C. Jones, G. Wainwright, and E. Yarnold, S.J., eds., *The Study of Liturgy* (New York: Oxford University Press, 1978), particularly the essays in part two.

23. See the excellent biography of Augustine by Peter Brown, *Augustine of Hippo* (Berkeley and Los Angeles: University of California Press, 1967), pp. 115–37, especially.

24. *Epistola 55* 11, 21, cited in *ibid.*, p. 263; the translation here is Brown's.

25. A well-organized overview of the development of medieval monastic art is George Zarnecki, *The Monastic Achievement* (New York: McGraw-Hill, 1972). Zarnecki provides a good range of illustrations and a helpful short bibliography.

26. The material given in this and the following paragraph is presented in greater detail, with commentary and bibliography, in *RB 1980*, pp. 103–107.

27. *Ibid.*, p. 106.

28. See the Second Dialogue, chapter 36; the English translation here is that of Zimmermann and Avery, *Life and Miracles of St. Benedict*, p. 74. On Gregory's *Dialogues*, see again note 14, above.

29. Sister Joan Braun, O.S.B., of St. Scholastica Priory in Duluth, discussed the use of illustrated manuscripts of St. Gregory's *Life of Benedict* for teaching purposes in fourteenth-

and fifteenth-century German and Austrian monasteries, in a paper given at the National Gallery of Art on March 22, 1980, during the Washington, D.C., portion of the symposium "Monasticism and the Arts." She has kindly suggested the following bibliography: P. Wilhelm Fink, "Wann sind die Verse des Benediktuslebens 'Bis Bini ...' entstanden?" in *Studien und Mitteilungen zur Geschichte des Benediktiner-Ordens und seiner Zweige* 61 (1947–48): 126–34; P. Michael Huber, "Die 'Vita illustrata Sancti Benedicti' in Handschriften und Kuperstichen," in ibid. no. 48 (1930): 82; and Elisabeth Dubler, *Das Bild des heiligen Benedikt bis zum Ausgang des Mittelalters* (Munich: Gebr. Heichlinger, 1953), p. 53.

30. See Henri Daniel-Rops, *The Church in the Dark Ages*, trans. Audrey Butler (New York: Doubleday, Image Books, 1962), p. 301; Bede the Venerable gives the full text of Gregory's letter to Abbot Melitus, with the instruction to communicate it to Augustine: Bede, *A History of the English Church and People*, I, 30, trans. Leo Sherley-Price, Penguin Classics (Baltimore, Md.: Penguin Books, 1965), pp. 86–87.

31. Bede, *English Church and People*, 4, 18, pp. 231–32. For the extraordinary quantities of liturgical and devotional objects which Benet Biscop brought back from Rome and which Bede, a monk of Jarrow in the late seventh and early eighth centuries, must have known from direct experience, see Bede's *History of the Abbots of Wearmouth and Jarrow*, trans. J. E. King (Cambridge, Mass.: Harvard University Press, 1954), 2:401–15. See also C. Davis-Weyer, ed., *Early Medieval Art, 300–1150*, Sources and Documents in the History of Art (Englewood Cliffs, N.J.: Prentice-Hall, 1971), pp. 72–75.

32. See *RB 1980*, pp. 121–26; on the part played by monasticism in Carolingian imperial ideology, see T. Noble, "The Monastic Ideal as a Model for Empire: The Case of Louis the Pious," *Révue Bénedictine* 86 (1976): 235–50.

33. Walter Horn presented a wealth of material on the St. Gall Plan in a paper delivered at Dumbarton Oaks on March 21, 1980, the first day of the Washington, D.C., portion of the symposium "Monasticism and the Arts." See Walter Horn and Ernest Born, *The Plan of St. Gall: A Study of the Architecture and Economy of, and Life in a Paradigmatic Carolingian Monastery* (Berkeley and Los Angeles: University of California Press, 1979).

34. Hariulf, *Chronique de l'abbaye de Saint Riquier*, 3,3, in Ferdinand Lot, ed., *Collection des textes pour servir à l'étude et à l'enseignement de l'histoire* (Paris: Picard, 1894), pp. 54–56; see also Davis-Weyer, *Early Medieval Art*, pp. 93–94.

35. See Zarnecki, *Monastic Achievement*, pp. 20–23, and more fully Peter Harbison *et al.*, *Irish Art and Architecture: From Prehistory to the Present* (London: Thames and Hudson, 1978).

36. On Cluny, see Joan Evans, *Monastic Life at Cluny, 910–1157* (1931; reprint ed., Hamden, Conn.: Archon Books, 1968), and more recently N. Hunt, ed., *Cluniac Monasticism in the Central Middle Ages* (Hamden, Conn.: Archon Books, 1971).

37. See Kenneth J. Conant, *Carolingian and Romanesque Architecture, 800–1200*, 2nd ed. (Harmondsworth, England: Penguin Books, 1966), pp. 107–25; more fully, see Joan Evans, *Cluniac Art of the Romanesque Period* (Cambridge: At the University Press, 1950).

38. Two excellent studies on Cistercian life and history in English are Louis Lekai, *The White Monks* (Okauchee, Wis.: Our Lady of Spring Bank, 1953), and B. Lackner, *The Eleventh-Century Background of Cîteaux* (Washington, D.C.: Cistercian Publications, 1972).

39. See Zarnecki, *The Monastic Achievement*, pp. 69–94, and Conant, *Carlingian and Romanesque Architecture*, pp. 126–34. For an exception to the strict enforcement of Cistercian taste, see Walter Cahn's chapter, below. And generally, on Cistercian spirituality and esthetics, see the chapters by von Simson, Hill, and Lillich.

40. On the rise of the Mendicant Orders, see Richard Southern, *Western Society and the Church in the Middle Ages* (Harmondsworth, England: Penguin Books, 1970), pp. 214–99.

41. A standard example is the affinity in plan between the huge Franciscan preaching basilica in Florence, Santa Croce, begun in 1294, and the Abbey church at Fossanova, consecrated in 1208. Fossanova was the first Cistercian monastery in Italy.

42. Although many local studies exist, a comprehensive history of the nineteenth-century revival of monastic life and culture remains to be written. For an overview, see *RB 1980*, pp. 133–36.

Chapter 1

"Real Presence" in Early Christian Art

William Loerke

In the Introduction it was suggested that monasticism developed in the early Christian era as a way for devout believers to enter personally into Christ's life—what in the late Middle Ages would be called the "imitation" of Christ and what, nearer the source, the *Rule* of St. Benedict called "sharing" Christ's sufferings in order to share also in his kingdom (RB Prologue:50). In this opening chapter of the book, Professor William Loerke relates the beginnings of monastic art to an analogous "sacramental" phenomenon in early Christian culture, the veneration for the *loca sancta*, the "holy places" of Christian history. He traces the stages by which, in the fifth and sixth centuries, Christian artists in search of this participatory immediacy "passed through the words of the Gospel to the deed itself" to achieve a new and distinctively Christian style. Professor Loerke compares one of the earliest monuments of monastic art, the *Transfiguration* mosaic in the apse of the abbey church of St. Catherine, at Mount Sinai, with a contemporaneous treatment of the same subject for a non-monastic church at Ravenna, to suggest the transforming influence of monastic spirituality upon the new experiential style.

William Loerke is Professor of Art History at Dumbarton Oaks, Harvard University's Center for Byzantine Studies in Washington, D.C., and teaches in the Medieval Studies Program and the School of Architecture of the Catholic University of America.

"Ipsa rerum dignitas ... exprimitur,
ut Pascha Domini non tam preateritum
recoli quam praesens debeat honorari."

St. Leo the Great, Sermon 64, 1.[1]

29

SYMBOL AND HISTORICAL EVENT

A phenomenon whose appearance marks an important development in early Christian art is the capacity to create from the Biblical text an image of an event. The earliest art of the Christians, symbolic in character, does not attempt to do this. The signs, symbols, and abbreviated excerpts which we find in catacomb painting and on the sarcophagi allude or refer to events rather than represent them. In the fifth and sixth centuries, however, we find events depicted as if caught in a moment of time, their action incomplete. Viewers who know the story are drawn into the action of the scene and thereby into its "presence." In this process, they change from observers of a picture to eyewitnesses of a deed.

The art of the early Church spoke in signs, stories, and visions. In complexity, it ranged from symbolic reference to narrative description and theological interpretation. In the symbolic and abbreviated images of catacomb painting and sarcophagi, the earliest art of the Christians, a dove with a branch in beak may stand for deliverance from death. A nude male reclining under a vine may stand for salvation. These visual excerpts of well-known stories refer to Biblical events without representing them.[2] By calling a word or brief title to mind, they recall the text associated with the event to those who already know it; they do not offer a vivid image of the event. Some miniatures, however—in the sixth-century Sinope Gospels, for example—show deeds represented in *statu nascendi*, in the moment of happening. In some cases such a miniature may simply reflect an exact reading of the text. For example, in the Sinope Gospel miniature of the Cursing of the Fig Tree (folio 30v), some leaves are shown withered, others not.[3] In this way the miniaturist showed that the tree began to wither the moment the curse was pronounced, as it says in St. Matthew's account (Matthew 21:19–20), which may be read on the same page. In the Healing of the Two Blind Men (Figure 1.1), sight has returned to one eye of one of them—the beginning but not the end of the miracle. To say that this miniaturist illustrated the text is to miss what he has done. He has visualized the miracle as unfolding in time, has represented the act of the miracle in mid-career. He has passed through the words of the Gospel to the deed itself, visualizing it as a present and suspenseful drama. The close observer of this miniature apprehends the deed without the intervention of words or symbols: he or she enters its presence directly.

This capacity to pass through the text to the event itself opened further possibilities to the painter. He could now consider and record its

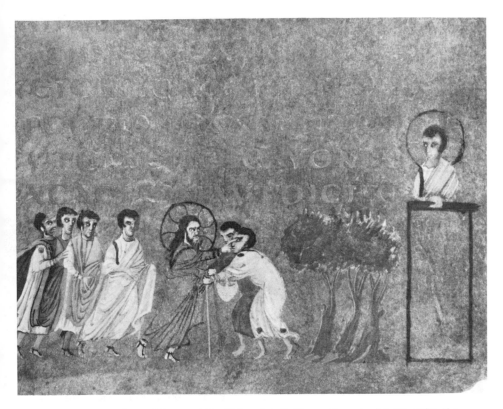

Figure 1.1. *Healing of the Two Blind Men*, detail, Sinope Gospels, fol. 29. *Bibliothè-que nationale, Paris.*

effect upon an eyewitness, thereby expanding the bare perception of the event to include an emotional response. For example, Matthew's text says that John the Baptist's disciples came to the prison and bore his body away. In addition to this bare fact, the Sinope painter registered their fear and shock at the sight of the decapitated corpse (Figure 1.2). The Moggio pyxis in the Dumbarton Oaks collection depicts the difference between a conventional and a reacting witness (Figure 1.3).[4] Behind Moses, who receives the Law, stand two witnesses, who raise their right arms in a conventional gesture widely used in early Christian art (and, indeed, down to our own day). At their feet, however, a third witness has flung himself to the ground, shielding his eyes from the brilliant light of Sinai.

Figure 1.2. *Herod's Feast*, Sinope Gospels. Fol. 10ᵛ. *Bibliothèque nationale, Paris.*

What are the sources of this new experiential approach to the events matter-of-factly recorded in the Gospels? One source may be the vivid presentation given events in the sermons of eloquent preachers. Another and more striking source was the new experience to be gained in Palestine.

Events in the life of Christ were fixed to specific sites in Palestine through the interest and lavish support of imperial patrons: Constantine in the fourth century, Eudocia in the fifth, and Justinian in the sixth.[5] By constructing *memoria* (commemorative churches) at the holy places, imperial and private donors were lifting events in the life of Christ out of the gospels and into the real world of the pilgrims, who could now experience their presence in a new way. This phenomenon gave Christian art the possibility of developing its own history, independent, to a degree, of the Biblical text. An art of symbols, or of abbreviated descriptions used like

Figure 1.3. *Moses Receiving the Law,* Moggio Pyxis. *Courtesy of the Dumbarton Oaks Collection, Washington, D.C.*

symbols, remains captive to the descriptive and interpretive word, which stands like a veil between the event and its representation. Spreading these events over the topography of Palestine—transforming Hadrian's *Aelia Capitolina* into the *Holy City of Jerusalem* of the Madaba map[6]—removed that veil. For the first time, large numbers of Christians could see the sites whose names they had learned. When they arrived, they read or heard on the spot the relevant text and visualized the event *in situ*. The impact of this experience upon the pilgrim could well have been more striking than that of the recovery of Pompeii upon the "classical" world of the eighteenth century.

In the *loca sancta*, text met place in a confrontation systematically (i.e., liturgically) organized by the Jerusalem Church. We know this from the account of the late fourth-century pilgrim Egeria and from the early Armenian Lectionary.[7] The text and prayers of the services, "appropriate to the day and place," as Egeria repeatedly says, led the pilgrim to visualize and inhabit the event in the presence of which he stood.[8] That pilgrims in fact did this, with or without the aid of the liturgy, is clear from St. Jerome's description of the nun Paula's visits to the holy places. In the grotto at Bethlehem, she "swore she saw with the eyes of faith the Child, wrapped in swaddling clothes, lying in the manger." Prostrate before the cross, she adored "as if she discerned the Lord hanging thereon."[9] Paula's experience before the cross, datable to the end of the fourth or beginning of the fifth century, some twenty-five years earlier than the oldest extant representation in art of Christ's body upon the cross, suggests that this *locus sanctus* confronted the Christian with the fact and actuality of the Crucifixion and helped overcome any reluctance to represent Christ on the cross.[10]

The holy places spoke not only to private devotion but also to theological contoversy. Since they witnessed to both the human and the divine nature of Christ, Pope St. Leo the Great called upon them in his battle against the monophysitism of Eutyches. Writing to Juvenal of Jerusalem in 454, Leo rejoiced that Juvenal was now a defender of the faith, and went on rather pointedly: "Although it is not allowed to any priest not to know what he preaches, far more inexcusable is this ignorance in any Christian living in Jerusalem, where he is brought to the knowledge of the power of the gospels, not only by the eloquence of the pages, but also by the witness of the places themselves. ... Defend the preaching of the holy places of the gospels, among which you live."[11]

The chief effect of the *loca sancta* upon the pilgrim was to emphasize the actuality and historicity of the event. Fixing the event to a place immediately raised the question of what it looked like as it happened—more accurately, as it *was happening*. The *loca sancta* created the progressive past tense in early Christian art. Unlike liturgical rites, sermons, or theological treatises, the holy places concentrated attention on the event for its own sake. From this emerged a vivid awareness of it, as in the mind of a pilgrim like Paula. An official image of the event soon followed in the *memoria* itself.[12] These images, conforming both to Biblical text and to topographical reality, formed a new category in early Christian art, differing in a basic way from the art of the catacombs and

Figure 1.4. Interior of wooden reliquary box, ex-Sancta Sanctorum, the Vatican.

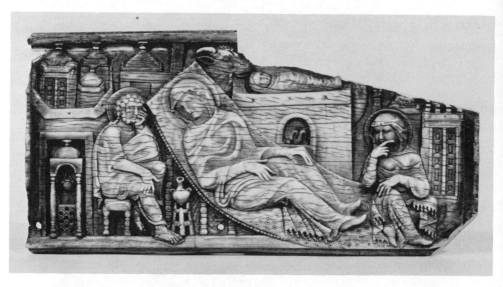

Figure 1.5. Nativity plaque. *Courtesy of the Dumbarton Oaks Collection, Washington, D.C.*

sarcophagi. The primary function of these images was to help the pilgrim to enter into the presence of the event.

The key monument for the retrieval of these images is a framed reliquary box from Palestine, now in the Vatican (Figure 1.4).[13] Five simply framed scenes are painted on the underside of the lid: Christ's Nativity, Baptism, Crucifixion, Resurrection, and Ascension. These compositions bear a close relation, long recognized, to certain miniatures in the sixth-century Rabbula Gospels, and also to certain lead ampullae brought from the Holy Land as souvenirs by pilgrims.[14] The fact that the same basic composition can appear in a variety of media, in private and public works of art, gave rise to the hypothesis that the original image had acquired its renown and authority as a prototype because of its location in the *locus sanctus* of its subject. In a brilliant study, Kurt Weitzmann has confirmed this assumption by showing that an identifying detail would survive through several pictorial versions emanating from the same *locus sanctus*. For example, the manger of the Nativity scene on the lower left portion of the lid of the Vatican reliquary box (Figure 1.4), is represented as an altar with a niche. This altar with its niche appears as if in masonry on the ivory carving of the Nativity in the Dumbarton Oaks Collection (Figure 1.5). In

the niche can be seen the relic of the swaddling clothes, a detail present in other examples as well, as Weitzmann points out.[15] Perhaps this relic contributed to Paula's vision of the Child wrapped in swaddling clothes. These details transport us to Bethlehem, upper left in the ivory, to the Grotto with its baldachin, lower left, and to our theme, "real presence" in early Christian art. The historical reality in time and place of events otherwise chiefly known in the annual cycle of the liturgy—this is the central message of the *loca sancta*. Images which fix the event to its place by specific details are therefore not so much reminders of a liturgical feast as certifiers of an historic reality, brought vividly to the viewer's attention.

The desire to transform the viewer of a work of art into a witness of an event in progress animated Asterius of Amasea in his description of the paintings in the *martyrium* of St. Euphemia. This early Christian writer speaks of the "sudden motion" of a court stenographer in the scene of Euphemia's trial; of "drops of blood flowing from her lips" in the torture scene; of the painter, in the final image, "lighting a fire, thickening the flame with red color, glowing here and there, the virgin standing in the midst."[16]

In and out of Palestine, commemorative churches, the *memoria* and *martyria,* had a special and obvious rationale for the images placed in them. They also created a new category of ecclesiastical structures, each with its own unique pictorial image or cycle of images. In the fifth century, numerous churches in Rome, Ravenna, and Saloniki acquired fresco and mosaic cycles unique to themselves. The Roman Church in particular, in spite of hostile comments and acts, lavishly installed grand cycles in fresco and mosaic. Neither the sack of Alaric, the threat of Attila, nor the pillage of Genseric stopped work on the cycles, partially preserved in Sta. Pudenziana, Sta. Maria Maggiore, St. Paul's Outside the Walls, and St. Peter's. This burst of artistic activity in the face of impending disaster measures the importance of these pictorial cycles for their time. They owed much to Pope Leo, still archdeacon to Xystus III when the mosaics of Sta. Maria Maggiore were installed and named with the Empress Galla Placidia in the dedicatory inscription on the triumphal arch of St. Paul's. He restored the mosiac in the apse of St. John's at the Lateran "after the sack of the Vandals" (455–61), and through donors provided for the façade mosaic of St. Peter's.[17] So far as their content can be known, each of these Roman cycles was unique, no matter that some scenes might be common to several. Like the *loca sancta* and the *martyria*, the basilicas of Rome each carried its own pictorial witness.

The emphasis on actual experience is evident in many of these Roman cycles. Behind the earliest of them stands Jerusalem of the *loca*

Figure 1.6. *Annunciation*, Triumphal Arch, S. Maria Maggiore, Rome, 432–440. *Courtesy of the Dumbarton Oaks Collection, Washington, D.C.*

sancta: a Jerusalem, that is, contemporary with the setting of the mosaic itself. In the mosaic in the apse of Sta. Pudenziana (402–417), the colonnaded street, the various buildings, rocky Golgotha, and the imperial, jeweled cross rising from a jeweled crown—all these details concretely identified a known and knowable city.[18] This composition transported the early fifth-century Roman viewer to the scene of the event as he or she might have visited it in early fifth-century Jerusalem. Similarly, in the triumphal arch mosaics of Sta. Maria Maggiore (432–40), the angel of the Annunciation, turning from Mary to Joseph, compelled the viewer to enter into the momentariness of an unfolding event (Figure 1.6). And in the enigmatic scene of the Presentation in the Temple, the postures and glances of the principal figures project an air of expectancy, especially noticeable in the figure of Simeon, "*waiting* for the consolation of Israel" (Luke 2:25) (Figure 1.7). The figures are caught in uncompleted actions, detached, as if they were reflecting about their roles.[19] This characteristic, apparent in other scenes on the arch as well, effectively brings the viewer into the temporal progress of the event.

 This stress on unfolding action well served the aim of Leo the Great, repeatedly expressed in his sermons, to make the gospel narrative vivid and present. For Leo, the annual celebration of a liturgical feast was a service not only in memory of a past event, but also in honor of an event made present: *ipsa rerum dignitas ... exprimitur, ut Pascha Domini non tam praeteritum recoli quam praesens debeat honorari* (Sermon 64, 1). He was confident that the history of Christ's Passion, for example, was "so fixed" in the hearts of his hearers "that for each listener the reading itself makes a kind of vision" (Sermon 70, 1). The language of the Gospels is "so open and lucid, that for committed and devout hearts to hear what is read is to see what was done" (Sermon 52, 1). "Hold the sequence of events so

Figure 1.7. *Presentation*, Triumphal Arch, S. Maria Maggiore, Rome, 432–440. *Courtesy of the Dumbarton Oaks Collection, Washington, D.C.*

plainly in mind as if you had reached them all in bodily sight and touch" (Sermon 69, 3).[20] It is not difficult to imagine Leo as the active promoter of these pictorial cycles.

The grandest of these cycles, that in the nave of St. Paul's Outside the Walls, may have overwhelmed its viewers, but it also involved them in a detailed and densely illustrated life of St. Paul and of the Patriarchs (Figure 1.8). An imperial donation, St. Paul's was completed in 402, severely damaged about 440, and was restored by Leo by 450.[21] The frescoes in the nave are known through seventeenth-century copies, which reveal medieval restorations of different dates. The most extensive of these was by Pietro Cavallini, carried out between 1277 and 1290. He began at the triumphal arch and stopped at the sixteenth column.[22] Scholars have seen in the copies of the remaining frescoes stylistic traits datable to c. 700, and iconographic characteristics appropriate to the thought of Leo. St. Paul's nave, scaled to the Basilica Ulpia in Trajan's Forum, ran three hundred feet in the clear. Its colonnades, set eighty feet apart, carried thin walls perforated by clerestory windows centered over each intercolumniation; the windows measure eight by sixteen feet each. The walls carried a coffered ceiling about one hundred feet above the floor. In this grand central nave, about thirty feet of wall space below the sills of forty clerestory windows was reserved for a double band of frescoes. Their vertical frames corresponded to the axes of the twenty columns of each arcade. Allowing for the frames, each panel was about ten feet wide and twelve high. There were forty-two such panels on each wall; Old Testament on the left, New on the right, reading from the triumphal arch where the cycles began—six hundred feet of painting, twenty-four feet high. The statistics put this cycle on a par with the reliefs of the columns of Trajan and Marcus Aurelius.[23]

Figure 1.8. Nave, S. Paolo fuori le Mura, Rome, 395–450. *Courtesy of the National Gallery of Art, Washington, D.C.*

On this Roman imperial scale, Leo's aim of close visual engagement of the viewer in the Biblical narrative was still maintained—as may be gauged by the fact that two of those ten-by-twelve-foot panels were devoted to one story, the Sacrifice of Isaac: one for the Journey, the other for the Sacrifice. So too in the cycle of the Life of Paul, two panels were assigned to present the details of the transfer of Paul from Jerusalem to the custody of the Governor Felix:—one showing the Roman tribune ordered to take him to Felix, the other his reception by Felix. Both the history of the patriarchs and the life of St. Paul, on opposite walls, were thus presented and read in close detail, though the totality was nothing less than a continuous narrative of Christian world history seen in a single, unifying, architectural framework of epic dimensions.

When, in such settings, Leo the Great urged his hearers to visualize the gospel story, it was not to help them remember the texts. He was

confident they knew the texts. He wanted the events present to their sight so they could respond directly to them and emotionally inhabit them. He was concerned that his hearers, who knew these events only as annual readings of Scripture in the liturgy or as celebrations of the sacraments, would fail to grasp them as real deeds if they did not see them represented. To achieve this actuality, Leo urged upon his congregation a mental, visual, and moral exercise in which a cycle of images on the walls of a basilica would play an important role.

This exercise closely parallels the scheme of memorization well known to students of rhetoric from the days of Cicero. The art consisted of fixing ideas to images and images to places.[24] The public speaker, having mastered his material, assigned striking images or brief verbal headings to various sections of his speech. He then entered a building—house, basilica, or theater—and visualized these images and notes attached to appropriate parts of the structure. During delivery, he mentally retraced his path through the building. As he encountered each image in its place, he visually secured both the substance and the correct order of his speech. Like Pope Leo's hearers, he both knew the text and used the images disposed round about in the architecture to keep the sequence of his speech in mind. Martianus Capella, Leo's contemporary through whom this art descended to the Middle Ages, recommended that images of things (*species rerum*) should be placed *"in locis illustribus."*[25] This is precisely what the well-lighted upper clerestory walls of fifth-century basilicas provided for their new cycles. Both professors of rhetoric and Pope Leo stressed orderly arrangement as essential to successful memorization. Embedded in this Roman educational framework, the sudden proliferation of monumental cycles in the fifth century assumes a Roman-Christian character.

Thus craftsmen of the fifth and sixth centuries created images of striking immediacy for Christian believers, who concentrated on a single event in the *loca sancta* or read more broadly in the historical cycles of the basilicas. The next step was more difficult: to carry this sense of being an eyewitness beyond earthly events into the representation of a vision or theophany such as Christ's Transfiguration. This subject was particularly challenging to early Christian artisans or to those who prepared the designs they followed. To represent it at all required an art capable of displaying, or suggesting, a vision of the figure of Christ in successive states, human and divine. That this was brilliantly achieved in the mid-sixth-century mosaics of the apse of St. Catherine's, Mt. Sinai—indeed, that the challenge arose at all—should be attributed to the special role which the Transfiguration played in Greek monasticism.

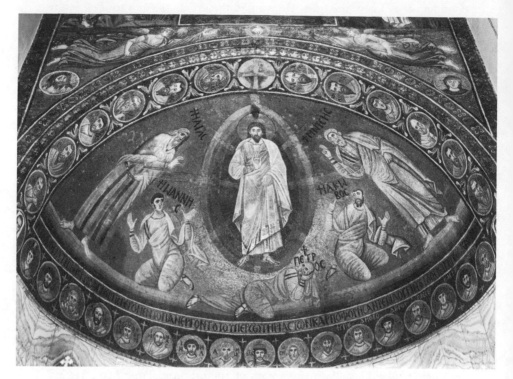

Figure 1.9. *Transfiguration*, Apse Mosaic, St. Catherine's, Sinai, 550–565. *Courtesy of the Michigan-Princeton-Alexandria Expedition to Sinai.*

THE MONASTIC VISION

The mosaicists in the monastic church at Sinai concentrated on presenting the vision of the Transfiguration as it was seen and experienced by Peter, James, and John. Every viewer of this work, including countless generations of monks, must be immediately struck by the central visual fact: the power of the transfiguring light, the *dynamis* of the *doxa* (Figure 1.9).[26] The master mosaicist found the pictorial means which enabled him to capture the immediacy of this vision (*to horama*, in the Greek of Matthew 17:9), in which Christ's face "shone like the sun," his garment became "white and glistening," "white as snow, such as no fuller on earth can whiten them" (Luke 9:29; Mark 9:3); in which Elias and Moses, appearing in "their *doxa*, spoke of the departure (*tēn exodon*) which he would

accomplish in Jerusalem" (Luke 9:30–31); in which a bright cloud "over-shadowed them," so that the disciples "fell on their face" in fear, then suddenly "looked around and saw no man" (Mark 9:7–8).

As presented in the Sinai mosaic, the entire vision floats on a gold ground. The cloud "overshadows" Christ in the form of an oblong, rounded aureole animated by four concentric bands of blue, the tones of which rise from dark to light from figure to edge. Christ's garment is an unearthly white, its shadows in the folds invaded by the lighter blue of the aureole. From deep in the center, behind the figure of Christ, rays of light proceed outward, expanding in breadth, to touch all participants. Trans-parency of the rays is effected by keeping them a tone lighter than the various blues of the aureole through which they pass, becoming white as they leave its perimeter. Upon reaching the garments of Peter and James, they transform the color of what they touch. In this way, the mosaicist has described both the light of the *doxa* and its transfiguring power. The heavy, serious gaze of Christ directs the import of the event upon the viewer who, by the time he has visually grasped the whole composition, has also fully entered into its presence. This intense image does not merely represent but transmits, one is tempted to say, the experience of the Transfiguration.

What made this innovative mosaic possible? Though the tesserae and craftsmen came to Sinai at the Emperor Justinian's command and expense, we need not assume that the composition did as well. Justinian quite likely also supplied tesserae and craftsmen for the slightly earlier mosaic of the Transfiguration in the apse at S. Apollinare-in-Classe, near Ravenna,[27] where a totally different composition with completely different aims was set (Figure 1.10). It seems more sensible to accept each composi-tion as a local creation than to read them both as witnesses to the art of Constantinople. At Classe, no effort was made to depict the vision as described in the Gospels. Rather, the physical facts of the vision were translated into symbols in order to present a theology of the Transfigura-tion. In the process, the description of the event itself dropped from sight.

It is instructive to examine the mosaic in S. Apollinare-in-Classe (547–49) for its contrast with that at Sinai (550–65). The history of art yields few such sharp contrasts in contemporary works devoted to the same subject. In the episcopal basilica of Ravenna, dedicated to its patron saint, eschatology in symbolic language dominates. An *opaion* opens onto a starry cosmos transfigured by a jeweled cross, which is named at the top by the anagram *IXΘYS* and defined at the foot by *SALUS MUNDI*, both in letters that are themselves transfigured by tesserae of varied colors. On axis with this clipeate cosmos stands the martyr saint of the church in the

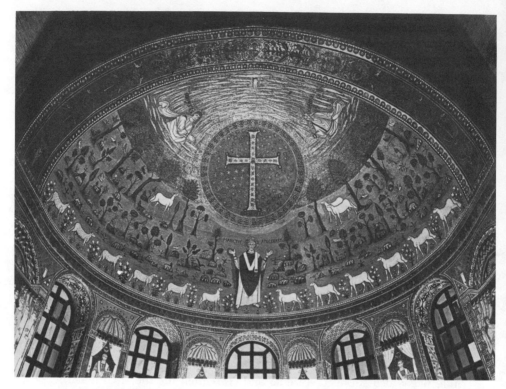

Figure 1.10. *Transfiguration*, Apse Mosaic, S. Apollinare in Classe, Ravenna, ca. 548. *Courtesy of the Dumbarton Oaks Collection, Washington, D.C.*

midst of a Paradise recalling those of catacomb painting. The three Apostles are also in Paradise rather than on Mount Tabor, and appear as sheep—that is, as having already made their final witness of martyrdom. Above the clouds flanking the *opaion* appear Elias and a youthful Moses, both in half-figure. In the *opaion*, the jeweled cross transfigures the cross of Golgotha, the subject of the conversation between Elias, Moses, and Christ, and validates this sacrifice to the end of time and of the cosmos. At the very center of the cross—also the center of the cosmos—a small portrait of the long-haired, bearded, historical Christ registers his human nature, a concrete Palestinian reality amid symbolic elements.[28]

The S. Apollinare composition breaks natural barriers of time and space through radical shifts in scale between Moses, the bust of Christ, the apostolic lambs, and the martyr saint. The cross appears to float vertically,

independent of the curve of the apse, reinforcing the effect of the *opaion* as a window breaking through the masonry of the basilica. The entire composition makes the farthest leap from a terrestrial description of an historical event or vision to a theological statement of the consequences beyond time of the event or vision. Indeed, to speak of a timeless event is a contradiction in terms, yet this mosaic presents that paradox as a complex but graspable reality. Symbols and paradoxes apart, a strong personal note is struck by the direct, steady gaze of the saint, standing in the foreground, and of Christ, seen in bust in the far distance. But here as elsewhere in Ravennate art, the viewer must engage in a visual-verbal dialectic. Flowers must be translated into Paradise, sheep into apostles, stars into the cosmos, and the cross, with its inscriptions, into victory over eternal death: in short, tesserae into theology. Knowledge and time are required to read these disparate categories of images in search of the central theme amid spatial and temporal dislocations.

By contrast, the sharp focus on the event itself at Sinai, where the entire conch of the apse is reserved for the Transfiguration, is fitting for a *locus sanctus* at the foot of Mt. Sinai, adjacent to the site of Moses' vision of God in the burning bush. It is the *locus* of St. Catherine's and the presence of its monastic community that account for the program of the church's apsidal mosaics. The Moses and Elias shown in mosaics here recall the nearby sites of the theophanies they experienced. Two of those theophanies in fact are shown in rectangular panels above the apse-conch: the Call of Moses, upper left (Figure 1.11) and the Giving of the Law, upper right. In each of these panels, differently from the conch itself, space was found for the appropriate mountain: Horeb left and Sinai right. Elias belongs to the left side of the Transfiguration here, because his cave, where Jahweh revealed himself in the "gentle breeze" (I Kings 19:9–12), was on Mt. Horeb—which is represented in the panel above the apse on that side.

This sense of place also determined that the roundel of St. John the Baptist was placed in the spandrel on the observer's left, next to the figure of Elias in the apse, for both John and Elias had become models of ascetic monasticism. Moreover, immediately after the Transfiguration, during the walk down the mountain, Christ had identified John the Baptist as the "Elias" who was to precede the Messiah and who had, indeed, already come (Matthew 17:12–13). The roundels of the Baptist and of the Virgin (in the opposite spandrel) are linked by a common gold ground to the Lamb in the blue nimbus with interior gold cross at the crown of the arch. The Lamb, together with the nimbed gold cross in the border of the apse—both of them on axis with the figure of Christ in the conch—marks the subject of the conversation at the Transfiguration, the "departure he

Figure 1.11. *Call of Moses*, mosaic panel, St. Catherine's, Sinai, 550–565. *Courtesy of the Michigan-Princeton-Alexander Expedition to Sinai.*

would accomplish in Jerusalem." It is the equivalent of the jeweled cross in the *opaion* at Classe, but only in subject, not in visual impact. At Sinai the apsidal mosaic presents exclusively the act of Transfiguration in the aureole and its effect upon the Apostles; the connection with the Crucifixion has been kept only in small symbols at the perimeter of the conch. At Classe, the conch mosaic hides the Transfiguration beneath symbols of its eschatological significance.

 In concentrating directly on the vision of the Transfiguration, the designer of the mosaic at Sinai was serving a fundamental aim of Greek

monasticism, discussed by Aidan Kavanagh in Chapter 2. That aim was to help the monk pass through a series of stages of spiritual growth leading to a vision of the Godhead—or as much of a vision as could be attained by the purified human intellect and by the soul engaged in intense contemplation and prolonged periods of prayer. Evagrius Ponticus (345–99), John Climacus (c. 570–c. 670), and Maximus the Confessor describe this discipline in varying ways.[29] What seems central to it is the act of passage: *diabasis*, to use Maximus' term—passage from the *words* of Scripture to the *deeds* described, from contemplation of material natures to immaterial ones, from thinking in words to prayer which goes beyond words.[30] At this point, with "thoughts suppressed" and "intelligence made deaf and dumb," the spirit may see its own state as similar "to the sapphire, clear and bright as the sky, what Scripture calls the 'place of God' (Exodus 24:10–11) seen by the elders on Mt. Sinai."[31] This place is perceived as immaterial and flooded with "light without form."[32] This spiritual context explains the absence of landscape in the apse at Sinai, where the aureole floats on a gold ground and the five figures barely rest on abstract stripes of yellow and green tesserae. Nothing in this "close-up" of the vision impedes its swift entry into the mind's eye or its re-evocation in the monk's cell.

About seventy-five to eighty years after the mosaic was set, Maximus the Confessor gave the Transfiguration an imaginative and profound interpretation. He saw Christ in this vision as a symbol of himself, a manifestation of the hidden in the visible, in which the luminous garments at once clothe the human nature and reveal the divine. The event was not a fixed image, but an unfolding drama.[33] The brilliant garments of Christ, the changing tones of blue in the aureole, and the transparencies in the rays of light coming from the aureole, suggest a hidden force coming into view—the visual analogue of Maximus' interpretation. By exhibiting the very action of the vision, this mosaic could continue to function in the spiritual discipline of succeeding generations of monks. John Climacus, elected Abbot of Mt. Sinai in the 640s, seems to transmute the aureole and its rays into an image of the theological virtues: faith, hope and love. "I see the first," he wrote in the final chapter of his *Scala Paradisi*, "as a ray; the second as light; and the third as a sphere—the whole forming one radiance and splendor."[34]

Thus a firm theology and a strong monastic discipline governed this representation of Christ's Transfiguration. These conceptual and experiential disciplines, focused on a single event, carried the mosaicist well beyond the traditional limits of his craft. The resulting composition does not "quote" classical sources for Biblical purposes, nor is it content to be a

visual reminder of a Biblical text. The mosaic at St. Catherine's monastery goes beyond description to project and stimulate an experience. In this creative response to a difficult challenge, the designer of the composition anticipated a stricture uttered by Sinai's famous Abbot. In his *Letter to the Shepherd*, John Climacus observed that "it is a shame for masters of teaching to copy others, as it is for painters to do nothing but reproduce ancient paintings."[35] In the epiphanic vision of the Transfiguration, the event's past (the prophets), its present (the Apostles), and its future (Christ's "departure" in Jerusalem) merge into an all-embracing present: a *presence*. The mosaic in the apse at Sinai evokes this vision as present, fulfilling both the aim of Pope Leo, quoted at the head of this chapter, and the Christian perception of time expressed by St. Augustine: "Nor do we properly say, there are three times, past, present, and to come; but perhaps it might be properly said, there *are* three times: a present time of past things; a present time of present things; and a present time of future things. For indeed there are three such as these in our souls; and elsewhere I do not see them."[36]

In the monastery church at Sinai, this mosaic brings the vision and its "times" to the eye and to the mind of the ascetic contemplative, in the physical setting of the daily liturgy. For monk and community, it becomes a part of what St. Benedict, in the *Rule* he wrote just a few years before the mosaic at Sinai was set, called the *Opus Dei*, the work of God (RB 43:3).

NOTES

I wish to thank Timothy Verdon for his initial interest in this paper and for clarifying discussions; also Irene Vaslef, Librarian at Dunbarton Oaks, for her assistance.

1. *Tractatus* 64, 1, *Sancti Leonis Magni Romani Pontificis Tractatus Septem et Nonaginta*, ed. A. Chavasse, Corpus Christianorum, series Latina no. 138 A (Turnhout: Brepols, 1973), p. 389. "The very grandeur of these matters ... is so vividly described that the Passion of the Lord, not so much contemplated as past, ought rather to be honored as present."

2. See E. Dinkler, "Abbreviated Representations," in K. Weitzmann, ed., *The Age of Spirituality: Late Antique and Early Christian Art* (New York: Metropolitan Museum of Art, 1979), pp. 356–448. The classic text for many of these examples is Clement of Alexandria, *Paedagogos* 3, 59, 2; for a convenient selection of them, see W. Käch, *Bildzeichen der Katakomben* (Olten: Walter, 1965). The nudity of "Jonah" under the gourd vine is not fully explained by the reference to the Endymion myth (for which, see H. Sichtermann and G. Koch, *Griechische Mythen auf Römischen Sarkophagen* [Tübingen: Wasmuth, 1975], pp.

27–30, plates 16–19), for Endymion is most often shown partially draped. Dionysus under the vine offers a closer parallel: see Dinkler, "Abbreviated Representations," p. 402, Figure 58. The nudity, obviously wrong for Jonah himself, may refer to the soul of the deceased, which is naked without the clothing of its body and prays to reach a place of refreshment, like Jonah's, after death and before the resurrection: see A. Stuiber, *Refrigerium interim: Die Vorstellung vom Zwischenzustand und die Früchristlichen Grabkunst* (Bonn: Hanstein, 1957), pp. 136–51. The Midrashic background of Jonah as an allegory of the soul is noted by J. Fink, *Bildfrommigkeit und Bekenntnis das Alte Testament, Herakles und die Herrlichkeit Christi an der Via Latina in Rom* (Vienna: Böhlau, 1978), pp. 70–73.

3. A. Grabar, *Les peintures de l'Evangeliaire de Sinope*, Bibliothèque Nationale supplement grecque 1286 (Paris: Bibliothèque Nationale, 1948), Plate 5.

4. See K. Weitzmann, *Ivories and Steatites*, Catalogue of the Byzantine and Early Medieval Antiquities in the Dumbarton Oaks Collection, 3 (Washington, D.C.: Dumbarton Oaks, 1972), nos. 18, 31–36, and Plate 16b.

5. See F.-M. Abel, *Histoire de Palestine* (Paris: Gabalda, 1952), pp. 267–72 (Constantine), 334–37 (Eudocia), 359–63 (Justinian). See also J. Wilkinson, *Egeria's Travels* (London: Society for the Preservation of Christian Knowledge, 1971), pp. 36–53.

6. See M. Avi-Yonah, *The Madaba Mosaic Map* (Jerusalem: Israel Exploration Society, 1954); see also K. Wessel and M. Restle, eds., *Reallexikon zur byzantinischen Kunst* (Stuttgart: Hiersemann, 1963–73), s.v. "Jerusalem."

7. See Wilkinson, *Egeria's Travels*, pp. 54–88 (Egeria on the Jerusalem liturgy), 253–61 (old Armenian Lectionary), and 261–77 (comparative table relating readings of both to the Holy Places). For Egeria's text, see *Itinerarium Egeriae*, edited by E. Francheschini and R. Weber, Corpus Christianorum, series Latina no. 175 (Turnhout: Brepols, 1965).

8. *Itinerarium Egeriae* 25,5; see also Wilkinson, *Egeria's Travels*, p. 126.

9. St. Jerome, *Epistula* 108, 9: in F. Stummer, *Monumenta historiam et geographiam Terrae Sanctae illustrantia*, Florilegium patristicum, fasc. 41 (Bonn: Hanstein, 1935), p. 32.

10. The oldest examples of the corpus on the cross in the West are the plaque of an ivory box in the British Museum, discussed in W. F. Volbach, *Elfenbeinarbeiten der Spätantike und des frühen Mittelalters*, 3rd ed. (Mainz: Römisch-Germanisches Zentralmuseum, 1976), no. 116, p. 82, plate 61, dated around A.D. 420–30?; and a panel of the wood doors of Sta. Sabina, in Rome, discussed in W. F. Volbach and G. Hirmer, *Frühchristliche Kunst* (Munich: Hirmer, 1958), p. 63, plate 103, dated around A.D. 432. In the East, the oldest example appears to be the miniature of the Crucifixion in the Rabbula Gospels, dated by colophon to A.D. 586. On the problem as a whole, see K. Wessel, "Die Entstehung des Crucifixus," *Byzantinische Zeitschrift* 53 (1960): 95–111, and E. Sauser, *Frühchristliche Kunst, Sinnbald und Glaubensaussage* (Innsbruck: Tyrolia Verlag, 1966), pp. 270–78.

11. St. Leo the Great, *Epistulae contra Eutyches Haeresim, Para Secunda*, edited by C. da S. Tarouca (Rome: Universitas Gregoriana, 1935), p. 136, Letter 53, 4 February, 454.

12. Objects preserving some of these images are listed in Weitzmann, *Age of Spirituality*, pp. 564–91; for the present state of the question, see idem, "*Loca Sancta* and the Representational Arts of Palestine," *Dumbarton Oaks Papers* 28 (1974): 36–39.

13. See P. Lauer, *Le trésor du Sancta Sanctorum*, Monuments et mémoires de l'Academie des Inscriptions et Lettres, Fondation E. Piot, no. 15 (Paris: Presses universitaires de France, 1906), p. 97; and C. R. Morey, "The Painted Panel from the Sancta Sanctorum," *Festschrift Paul Clemen* (Bonn: F. Cohn, 1926), pp. 150–67.

14. C. Cechelli, G. Furlani, and M. Salmi, *The Rabbula Gospels* (Olten: Urs Graf, 1959), plates 19–27. On the lead ampullae, see André Grabar, *Ampoules de Terre Sainte* (Paris:

Klincksieck, 1958); and R. Garrucci, *Storia dell'arte cristiana*, 6 vols. (Prato: Giachetti, 1873–81), 6:46–55, plates 433–35.

15. Weitzmann, *"Loca Sancta* and the Representational Arts," pp. 36–39.

16. Asterius of Amasea, *Homily II, On Euphemia*, in J. P. Migne, ed., *Patrologiae Cursus Completus, series Graeca*, 242 vols. (Paris: Migne, 1857–67), 40: 336–37 (hereafter referred to as Migne, *Patrologia Graeca*, with relevant volume and page numbers).

17. See Richard Krautheimer, *Corpus Basilicarum Christianarum Romae* 5 (Vatican City: Pontificio Istituto di Archeologia Cristiana, 1977), p. 99; *ibid.*, p. 10; *ibid.*, p. 173.

18. E. Kitzinger, *Byzantine Art in the Making* (London: Faber and Faber, 1977), p. 43 with n. 53.

19. For a radical reinterpretation of this Presentation, see S. Spain, "The Promised Blessing: The Iconography of the Mosaics of Sta. Maria Maggiore," *The Art Bulletin* 61 (1979): 535.

20. See A. Chavasse, ed., *Sancti Leonis Magni Romani Pontificis Tractatus*, p. 389, 426, 307, 421. See further, Dom Maria Bernard de Soos, *Le Mystère liturgique* (Münster, 1958), 53ff.

21. Krautheimer, *Corpus Basilicarum*, p. 99.

22. See S. Waetzold, *Die Kopien des 17: Jahrhunderts nach Mosaiken und Wandmalereien in Rom* (Vienna: Schroll, 1964), p. 56; G. Matthiae, *Pietro Cavallini* (Rome: DeLuca, 1972), pp. 39–52; P. Hetherington, *Pietro Cavallini* (London: Sagittarius Press, 1979), pp. 92–95, with a reconstruction of this cycle in Figures 124, 125, and p. 100.

23. Krautheimer, *Corpus Basilicarum*, pp. 151–53 and 155–56, gives these dimensions.

24. Cicero says, "Constat, igitur, artificiosa memoria ex locis et imaginibus" (*Ad Herennium* 3, 16, 29, Loeb Classical Library [Cambridge, 1954], p. 208); cf. also *idem*, *De Oratore* 2, 86, 351–54; Quintillian, *Institutio oratoria* 11, 2, 17–22. See Frances Yates, *The Art of Memory* (1966; reprint ed., Chicago: At the University Press, 1972), pp. 1–26.

25. Quoted in Yates, *The Art of Memory*, p. 51.

26. See William Loerke, "Observations on the Representation of 'Doxa' in the Mosaics of Sta. Maria Maggiore, Rome, and St. Catherine's, Sinai," *Gesta* 20:1 (1981): 15–22. For the mosaic as a whole, see George H. Forsythe and Kurt Weitzmann, *The Monastery of St. Catherine at Mount Sinai: The Church and Fortress of Justinian* (Ann Arbor, Mich.: University of Michigan Press, 1973), Plates 103 ff. Until the appearance of Professor Weitzmann's definitive study, the reader is referred to his paper, "The Mosaic in St. Catherine's Monastery on Mount Sinai," *Proceedings of the American Philosophical Society* 110 (1966): 392–405.

27. See F. W. Deichmann, *Ravenna, Hauptstadt des spätantiken Abendlandes, 1. Geschichte und Monumente* (Wiesbaden: Steiner, 1969), p. 100; for a description and analysis of the mosaic, see pp. 261–76. Claudia Müller, "Das Apsismosaik von S. Apollinare in Classe: Ein Strukturanalyse," *Römische Quartalschrift* 75 (1980): 11–50, appears to demonstrate a method rather than to offer new data or insights.

28. For a survey of monuments representing Christ as long-haired and bearded, see Wessel and Restle, *Reallexikon zur byzantinischen Kunst*, s.v. "Christusbild."

29. See H.-G. Beck, *Kirche und theologische Literatur in byzantinischen Reich*, 2nd ed. (Munich: Beck, 1977), pp. 346 (Evagrius), 436 (Maximus the Confessor), 451 (John Climacus). Further on Evagrius, see C. Baumgartner, ed., *Dictionnaire de spiritualité ascetique et mystique* 4 (Paris: Beauchesne, 1961), pp. 1731–41; on Maximus, see P. Sherwood, *The Earlier Ambigua of St. Maximus the Confessor* (Rome: Orbis Catholicus, Herder, 1955), pp. 33–40, and Alan Riou, *Le monde et l'Eglise selon Maxime le Confesseur* (Paris: Beauchesne, 1973), pp. 103–21. On John Climacus, see W. Völker, *Scala Paradisi: Eine Studie zu Johannes Climacus*

(Wiesbaden: Steiner, 1968), and Placide Deseille, *S. Jean Climaque, L'Echelle Sainte* (Begrolles-en-Mauge: Abbaye de Bellefontaine, 1978).

30. See Sherwood, *Earlier Ambigua of St. Maximus*, p. 10.

31. See *Evagrius Ponticus, The Praktikos, Chapters on Prayer*, trans. John Eudes Bamberger, O.C.S.O. (Spencer, Mass.: Cistercian Publications, 1970), p. xci.

32. The phrase is Evagrius', quoted in C. Baumgartner, ed., *Dictionnaire de spiritualité ascetique et mystique* 2 (Paris: Beauchesne, 1950), p. 1777.

33. Riou, *Le monde et l'Eglise*, p. 114.

34. John Climacus, *Scala Paradisi* 31, 1, in Migne, *Patrologia Graeca* 88: 1156a; see Deseille, *S. Jean Climaque*, p. 305.

35. Deseille, *S. Jean Climaque*, p. 324.

36. Augustine, *Confessions* 11, 20, Loeb Classical Library (London, 1931), p. 253.

Chapter 2

Eastern Influences on the Rule of Saint Benedict

Aidan Kavanagh, O.S.B.

The beauty of monastic asceticism in individual holy men and women was perceived by their fellow Christians from the third century on, first in Egypt and Syria and then on European soil. Monasticism has been more than a sporadically recurrent phenomenon, however. It has been a movement in the Church, with a history stretching from that time to this, because the early masters did not conceal the "secrets" of their art, but set down in handbooks or manuals (often called "Rules") the insights gained from their struggles to live the spiritual life. In this chapter, Father Aidan Kavanagh analyzes the theoretical foundations of Christian asceticism in Jewish religious custom and late Antique Greek thought. He then shows how the monastic "idiom for living" grew out of the common language of early Christian life—much as Loerke, in the preceding chapter, stressed the evolution of a "monastic style" in art from developments within the wider context of early Christian culture. Using some of the early sources introduced by Loerke, Kavanagh goes on to trace the influence of this Greek "art of contemplation" on the monastic doctrine formulated in Italy in the sixth century and which, through the *Rule* of St. Benedict, would descend to the medieval West.

Aidan Kavanagh is a monk of St. Meinrad Archabbey, Indiana, and Professor of Liturgics in the Yale Divinity School.

Through his Rule for Monks, St. Benedict of Nursia has come to be considered the father of monasticism in the West. The time and place for which Benedict wrote, however, were far less "Western" than we who stand on this side of Benedict of Aniane and the ninth-century Carolingian Renaissance are often prepared to appreciate. Not only was St. Benedict not a modern Western man, he

was not even a medieval one. The last emperor of Old Rome was deposed by the Ostrogoths only shortly before Benedict's birth, and the saint's life was almost exactly contemporary with that of the greatest ruler of the New Rome in the East, the Emperor Justinian. St. Benedict's world thus lay squarely inside the immense symbolic gravitational field of the ancient Empire, a field expanded by the greatest pope of the age, the imperial Leo I, who had been dead not a generation when Benedict was born around 480.

It was an era of tremendous upheaval, a time when old things were not yet dead, when new things were conceived but not yet born, a time of perpetual emergency. The style of Christianity St. Benedict knew was one a modern westener must inevitably find it hard to imagine. Benedict lived through thirteen papacies, all of them short and relatively obscure, several occupied by married men, one being the great-grandfather of the future Gregory I, another the son of a pope and an exile under his own father's successor. The last decade or two of St. Benedict's life passed amid the waves of Byzantium's final military attempts to hold East and West together in one empire, and even the monastery he founded, Monte Cassino, was swept away by Lombard violence scarcely a generation after his death, not to be rebuilt until well into the eighth century.

In such circumstances, it is perhaps not surprising that the sources of influence upon his Rule that St. Benedict explicitly acknowledges are all Eastern in derivation. In Chapter 73 Benedict lists his sources as being, in addition to the Hebrew and Christian scriptures, John Cassian's *Institutes and Conferences*, which are rooted in Egypt, and the "Rule of our holy Father Basil," which probably refers to St. Basil of Cappadocia's several ascetical letters governing the lives of urban monks, condensed into rule-like form. The added mention of something Chapter 73 calls the "Lives of the Fathers" almost surely means the lives of Egyptian monastic masters and may be an allusion to Palladius' *Lausiac History.* No doubt Benedict knew the contemporary (anonymous) Italian *Rule of the Master* as well, even if he does not say so, since he used parts of it verbatim.

My purpose in this chapter is to comment on two Eastern sources of influence on the *Rule* of St. Benedict which Benedict himself did not acknowledge but which may have been even more influential than those he did. The first of these sources is the Middle-Eastern roots of monasticism itself in the pre-Christian and earliest Christian eras. The second is the more proximate influence of the developed ascetical doctrine of the fourth century desert master, Evagrius of Pontus. Through Evagrius, it seems, the eastern Semitic and Hellenistic attitudes concerning monastic asceticism were mediated to the West.

The roots of early Christian monasticism are Jewish. Until the discovery of the Dead Sea Scrolls at Khirbet Qumran from 1947 through 1956, and the ruins of the Essene-like communities nearby, about the only figures that could assist our modern grasp of some Jewish ascetical ideals were John the Baptist and the prophets, in whose footsteps John seems consciously to have walked. The prophetic tradition swam against the stream of ordinary expectations in Israel. Prophets often brought Israel the bad news of the Covenant's cost and of Israel's perilous disobedience to it. This being the case, it was soon perceived to be a good idea for one who felt called by God to prophesy in Israel to make no long-term commitments, since the life of a prophet tended to be brief or troubled or both. If the prophet's burden to Israel was the message that Yahweh was a deity who was jealous and not to be trifled with, Israel's response to its prophets was that they had better live lightly and outside town.

The prophet's calling involved a radical asceticism lived on the edges of conventional culture and in tension with it, a life that was not exclusively individualistic but was often lived in groups and could also be taken on by whole communities of men and women at Qumran and elsewhere. This way of life clearly seems to have influenced the ascetic Essene communities that flourished in Palestine prior to and after the time of Christ. Some scholars also declare it the direct parent of Christian monasticism, since the ascetical resemblances between the two ways of life are strong. A more cautious analysis suggests, however, that the Essene phenomenon gave rise not to Christian monastic communities directly but to the style and structure of the earliest Jewish-Christian *churches*. These churches, which were concentrated in Palestine, northern Arabia, and Egypt, seem to have been the direct inheritors and exploiters of that prophetic asceticism which Essene communities had rendered structural and communal in form. Daniélou thinks that such churches in turn provided the inspiration for later communities of Christian ascetics or "monks" and furnished definite patterns for ordering the total lives of these monastic communities, in a manner analogous to the ways in which Essene communities had influenced the earliest Christian churches prior to A.D. 100.[1]

So closely did some primitive Jewish-Christian churches resemble Essene ascetical communities that Eusebius mistook Philo of Alexandria's description of Essene ascetics or *therapeutae* for a description of "the first preachers of the gospel teaching and the customs handed down by the apostles from the beginning."[2] The same description could just as well be mistaken for one of communities of Christian monks living in the deserts of the Transjordan, Syria, and Egypt in the fourth century. So far as fourth- and fifth-century authors such as Eusebius, Cassian, and Palladius are

concerned, primitive Jewish Christianity had by then so receded before the advance of Hellenistic Christian idioms that they could perceive something of the former, even if unknowingly, only in the monastic communities Jewish Christianity had spawned. To understand primitive Christian monasticism therefore neessitates one's entering into idioms which were genetically Semitic and far more accessible to early writers such as Origen and Clement of Alexandria, Tatian, Pseudo-Barnabas, Ephrem of Syria, Melito of Sardis, and even Clement of Rome and Hermas than they were to Greek or Latin writers of the time. It is not surprising that the Semitic idioms of both early Jewish Christianity and the most primitive strata of Christian monasticism strike us as alien.[3]

One can point out some salient features common to both. There is first a fierce and pervasive asceticism, given to spectacular exploits in such virtuosi as Anthony of Egypt and Simon the Stylite, which hagiographers from Palladius to Gregory the Great (and beyond) dwell on in often distressing detail. Secondly, there is a relentless stress on celibacy yet with a frequent approval of "spiritual marriage" between male and female ascetics involving degrees of intense personal intimacy we today might find difficult to bear even from spouses.[4] Thirdly, there is steady emphasis on objective "purity" from syncretistic absorptions with anything (especially pagan persons, attitudes, buildings, books, and rites) which might sully one's relation with and concentration upon God alone—an emphasis one encounters today in Muslim fundamentalism. Fourthly, there is a focus upon gnosis, that is, upon a deeper knowledge of the world and its Source than is regularly available to the non-ascetical person of whatever walk of life. Fifthly, there is a certain apocalyptic cast to the way in which worldly events are interpreted. This correlates, sixthly, with a manner of sensing the pure ascetical life as "angelic," as lived by those who stand as "messengers" from the Source of all things to those who have ears to hear. Finally, there seems to be a discernible thread connecting the evolution of primitive Christian ministerial roles in church and monastic communities with some of the ministerial roles (such as the presbyter) in Essene communities as set forth in the Qumran "Community Rules."[5]

Perhaps the foregoing will be sufficient to suggest the extraordinary nature of such a way of living, whether in primitive Jewish-Christian churches or in primitive monastic communities. This factor alone may account for the appearance, between the middle of the third century and the beginning of the fifth, of a series of ascetical masters in Egypt whose mission seems to have been a regularization of ascetical life. One thinks of Anthony (d. 356, at the age of 105!), Pachomius (d. 356), and Makarios, surnamed significantly *politikos* (d. 390). These ascetics produced Rules in one or another form whose purpose was to bring order into the commu-

nities of Christian ascetics in the Egyptian desert, which had populations as large as seven thousand monks. But perhaps the most important of them all was one who wrote no formal Rule, but who distilled Christian ascetical theory into a coherent system acceptable to Hellenistic Christians both East and West: Evagrius of Pontus.

This rather sharp-tongued Greek from eastern Anatolia had enjoyed an impressive career. He was ordained lector by Basil of Cappadocia and deacon by Gregory of Nazianzus, was colleague to Gregory of Nyssa at the second Council of Constantinople, and became known during a brilliant career as archdeacon of that city by the rather cumbersome sobriquet "destroyer of heretical nonsense." But he left it all for asceticism, becoming first a companion in the ascetical life in Jerusalem with Rufinus and the awesome Roman lady Melania; the waspish Jerome referred to them as the "unholy trinity." From there Evagrius took up monastic life in western Egypt amid barely literate and Origenistic Copts. Here he wrote the first extensive treatises on Christian spirituality. After his death on Epiphany in 399, his small group of disciples, including Palladius and John Cassian, was expelled from Egypt. His spiritual and ascetical synthesis spread west through Cassian to Benedict, as we have seen. In the East his synthesis was simply taken over by the Syrian and Armenian churches, spreading even into Nestorian Persia whence, disguised as the work of Isaac the Syrian and others, it entered Constantinople. Here it was vastly influential on the spiritual theology of Maximus the Confessor, John Climachus, Symeon the New Theologian, and on Gregory Palamas, one of the founders of the spiritual school known as hesychasm, from which school that major distillation of Eastern Orthodox piety, the *Philocalia*, derived (the Russian version of which contains the whole of Evagrius' basic work on ascetical rudiments, the *Praktikos*). There can be no doubt that Evagrius stands at the fountainhead of Christian commentary on the ascetical life for both East and West, for Moscow and Constantinople as well as for Monte Cassino and Rome.[6]

Evagrius saw prayer and the spiritual life as one and the same discipline consummating in the high artistry of contemplation. While the demands of the discipline are so staggering that only full-time ascetics can truly master its requirements (this due to the fallenness of human nature and its consequent disorder), it is a discipline open to all, required of all, and made accessible to all by the example, wisdom, and passion of full-time ascetics, whose lives are thus spent in service of all. Ascetics blaze the trail all must follow, but they do not walk it alone.

The trail begins with practical discipline of oneself by which a certain initial ordering of basic passions is brought about. This stage is not asceticism: it is merely the first necessary preparation for asceticism. The

second stage Evagrius calls *theoria physike* or "contemplation of nature."
Here one struggles to know the world as it truly is by studying and reflect-
ing on holy scripture, the structured order of the universe, natural phe-
nomena, and the symbols in which all creation is expressed by language
and one's culture. *Theoria physike* does not stop, however, with natural
knowledge and poetic insight. It must result in a morality, a manner of life
commensurate with such knowledge and insight. Here the practical disci-
pline that was preparatory for asceticism is recapitulated on a higher level,
and the effort, struggle, and frustration encountered previously are inten-
sified. The intractability of one's own passions is at this point encountered
as the intractability of the created world—its things, its language, its
concepts, its social patterns.

　　　The third stage Evagrius calls *theoria tes hagias triados* or "con-
templation of the Holy Trinity." For him, this is synonymous with *the-
ologia*—not "theology" as an academic discipline but as the supreme,
calm, steady regarding of the Godhead as it is in itself. The knowledge of
this sort of prayer and contemplation is effortless because it is simple
(*gnosis ousiodes*): it circles peacefully, quietly, closer in to God than God's
own external attributes. Its quality is the "apathy" of possession: its source
is in God himself, its end is total union (*henosis*) in God, what in the West
would come to be termed the "beatific vision."

　　　Yet to stare too intently at Evagrius' descriptions of the three
stages in the spiritual life would be to miss the key that runs through all
three stages. This key is his concept of *apatheia*. Only partially, and there-
fore misleadingly, translated as "apathy," this psychic quality is for Evag-
rius the primary result of each stage of spiritual development. It is not a
transient tranquility of respite in the spiritual struggle as some later West-
ern writers have seen it. Even less is it merely a passive quietism. Rather,
apatheia for Evagrius is a dynamic and abiding equilibrium of lucid
clarity that comes about, in its initial degree, as we said, as the ordering of
basic passions associated with the first stage of the discipline. It then
appears in a heightened manner when the ascetic's "contemplation of
nature" progresses into a morality, a manner of life at peace with creation.
Apatheia finally consummates itself in the contemplation of God in and
for his own sake, the "apathy" of possession mentioned above. This
dynamic and abiding equilibrium of lucid clarity is the strand that knits
all three stages together into a continuum of life under grace and enables
one stage to evolve into its successor. It furthermore knits all else together
in the ascetical life. Evagrius says: "The fear of God strengthens faith, my
son, and continence in turn strengthens this fear. Patience and hope make
this latter virtue [that is, continence] solid beyond all shaking, and they

also give birth to *apatheia*. Now this *apatheia* has a child called *agape* who keeps the door to deep knowledge of the created universe. Finally, to this knowledge succeed theology and the supreme beatitude."[7] *Apatheia* is the Evagrian word Cassian later translated into Latin as *puritas cordis*, purity of heart.

This text synthesizes Evagrius' ascetical doctrine, a doctrine drawn out of a tradition that wends its way back deep into the Jewish roots of the gospel and is here catalyzed by a mind having access to the best that classical Greek culture had to offer on the glories of the "examined life." I think it is the key to understanding the core of the spirituality represented in Benedict's own monastic vision. The spirituality is that laid out in the twelve degrees of humility contained both in Chapter 7 of the *Rule* of Benedict (RB) and in Chapter 10 of the anonymous *Rule of the Master* (RM), the two documents being of approximately the same date and provenience in central Italy.[8] On this matter of spiritual doctrine, RM must be looked at not only as cognate with RB: the former, being throughout more detailed than the latter, may perhaps give us clues to the background only presumed by RB and stated in it more tersely. My conclusion, therefore, begins with a brief résumé of RM and sets the stage for what I wish to point out.

RM opens with a prelude of "themes" which appear to be condensed homiletical catecheses on baptism. This is highly significant since it puts initiation into the Christian community of the Church at the center not only of all Christian living but of all monastic living as well. The monk's principles of knowledge or *gnosis* derive therefore not from exotic or alien sources but from Saint Paul's gnosis of Christ dead and rising still in the whole Church by baptism (Romans 6). The monk, RM implies, is simply a baptized Christian whose witness or *martyria* is identical with the witness of every other baptized Christian. The monk's ministry or *diakonia* among his or her baptized peers in faith is to manifest the costs and radical conditions of Christian discipleship in Christ for all.

Both witness and ministry are common to all Christians, including monks. But the *mode* of monastic witness and ministry in and for the community of the baptized is peculiar. It is to be that of a *homo spiritalis* who has attained a high degree of spiritual discipline and insight by the practice of asceticism, the most distinguishing quality of which is *puritas cordis*—Cassian's phrase for Evagrius' concept of *apatheia*. This purity of heart is absolutely primary in RM. Striving for this dispenses one from all other ascetical practices, such as manual labor, and subordinates them all to itself.

The organic linkage between the fundamental ascetical doctrine

contained in RM 10 and RB 7 may be shown to have its origin in Evagrius' ascetical synthesis by tracking the way his *apatheia* ("*puritas cordis*" in Cassian, the Master, and Benedict) enables the ascetical doctrine of the two monastic Rules to unfold. If this is true, then the twelve degrees of humility are not just a random list of pious attitudes and activities but a closely articulated gloss on Evagrius' first five ascetical virtues in the very order in which he listed them in the text quoted above.

"The fear of God strengthens faith," says Evagrius. RM 10 and RB 7 make the first degree of humility "the fear of God," and they expand at length on what this means. "And continence in turn strengthens this fear." RM and RB expand on this by making the second and third degrees of humility to be basic activities of the one who is continent. These activities are: not loving one's own will and foregoing one's own self-will by becoming obedient to another person. "Patience and hope make this latter virtue [continence] solid beyond all shaking." RM and RB make patience and hope, together, the fourth degree of humility. "And they also give birth to *apatheia*." RM and RB give detail to Evagrius' *apatheia* by listing the remaining eight degrees of humility, painting, as it were, a moral icon of the apathetic as one who owns up to his or her own faults (5), is content with the simplest of things (6), acknowledges his or her self as lowest of the low (7), does only what is bidden (8), is reticent in speaking (9), slow to laughter (10), gentle of speech (11), and manifestly humble (12). These are detectable symptoms of that dynamic and abiding equilibrium of lucid clarity for which the monastic Father must look in his disciples as they begin their lives of peculiar witness and ministry to the whole of the baptized community.

Benedict clearly expects all of this not as the consummation of spiritual endeavor but as the first "rudiments of the monastic life." He says that his is but a "little Rule for beginners" (RB 73), in other words, a *praktikos*. What lies beyond all this he does not go into. But recourse, again, to Evagrius' text may provide a clue. Remember his saying: "Now this *apatheia* has a child called *agape* who keeps the door to deep knowledge of the created universe." This sounds as though Evagrius is referring to his second stage of ascetical life, *theoria physike*, the contemplation of nature: knowledge of the world, of holy scripture, the physical and natural sciences, human art, literature, and culture, and the attainment of a moral manner of life congruent with such knowledge. This suggests that the ascetic, the Christian monk, cannot proceed to consummate the spiritual life without developing the highly ascetical discipline of learning. Evagrius here is rejecting the sort of holy ignorance he seems to have found among some desert monks of his day.

In his *theoria physike*, perhaps Evagrius begot through Benedict and his "Schools of the Lord's Service" the force that would drive monks into the arts and letters, thus civilizing Europe and, ultimately, producing the medieval and modern university. It cannot go unnoticed that Evagrius sees none of this taking place without that *agape* which is the "child" of this first stage of *apatheia*, nor can it be forgotten that Benedict concludes his twelve degrees of humility with a panegyric on love. Both Evagrius and Benedict put *agape* at the end of one's basic ordering of the passions, and at the beginning of what we today call the intellectual life—a move of the most profound pedagogical importance.[9] The love of learning and the desire for God are good qualities for teachers to have, qualities from which their students stand to profit.

"Finally," Evagrius concludes, "to this knowledge succeed *theologia* and the supreme beatitude." Clearly, the reference is to his *theoria tes hagias triados*, the contemplation of the triune deity. Here, the rudimentary symptoms of *apatheia* listed in the last eight degrees of humility in RM and RB are absorbed into an *apatheia* so total that only mystics have the courage to attempt putting it into words. Mere activity is consumed in pure Act itself; morality is lost in the Good. Language begins to go erotic or antinomian or counterproductive: "The blankness of the Unnamed brings apathy; to be apathetic is to be still."[10] These words of the legendary Taoist sage Lao-tzu are precisely the sort of thing one usually finds a spiritual master saying. They are the sort of thing one does not, however, find in a monastic rule; both RB and RM avoid them all. Mystics do not.

In Benedict's Holy Rule the emphasis is on that "purity of heart" or *apatheia* appropriate to beginners in the ascetical life, a stage corresponding to Evagrius' basic ordering of the passions. If the twelve degrees of humility are viewed as a series of glosses on Evagrius' notion of what constitutes the *apatheia* appropriate to Benedict's "little Rule for beginners," it is possible to suggest in turn that the further *apatheia* which makes possible the contemplation of the natural universe, or *theoria physike*, is the work appropriate to those who are mature in monastic life. Finally, the *apatheia* of possession, in the contemplation of God in himself, or *theoria tes hagias triados*, is appropriate to those who no longer need the help of a Rule or of others. These, RB 1 says, are the anchorites or hermits, "those who not in the first fervour of their conversion, but after long probation in a monastery, having learnt in association with many brethren how to fight against the devil, go out well-armed from the ranks of the community to the solitary combat of the desert."

Benedict's *Rule* thus appears to give concrete organizational form to Evagrius' ascetical synthesis, a synthesis which in turn gave intelligible

voice to the basic drives of Jewish and Jewish-Christian asceticism, recasting those basic drives into categories accessible to non-Semitic Christian piety and moderating their more eccentric aspects from a gentile point of view. Moreover, the *theoria* of Evagrius and the *regula* of Benedict together built a positive and an accessible asceticism into the very center of baptized Church life, subordinating asceticism as one powerful ministry to that life at large. In this position, monastic asceticism would help to drive the Christian churches into a future where they would absorb the best of the old and would author whole new cultures during the medieval period in both East and West.

NOTES

Note: References in this chapter to the text of the *Rule* of St. Benedict are to *RB 1980: The Rule of St. Benedict in Latin and English with Notes*, ed. Timothy Fry, O.S.B., *et al.* (Collegeville, Minn.: Liturgical Press, 1980).

1. J. Daniélou, *The Theology of Jewish Christianity*, ed. and trans. John A. Baker (London: Darton, Longman and Todd, 1964), p. 352. Also his "Christianity as a Jewish Sect" in *The Crucible of Christianity*, ed. Arnold Toynbee (New York: World, 1969), pp. 275–82.

2. *Ecclesiastical History* 2:17, in G. A. Williamson, *Eusebius: The History of the Church from Christ to Constantine* (Baltimore: Penguin Books, 1965), p. 98.

3. Antique Greeks had the same difficulty. See Peter Brown, *The World of Late Antiquity* (London: Thames and Hudson, 1971), p. 98.

4. This tradition had not wholly died out as late as the fifth century, as can be seen in the relations between St. Mary of Egypt and the presbyter Zosimus. See H. Leclerq, "Marie L'Égyptienne," *Dictionnaire d'archéologie Chretiénne et de liturgie* 10 (pt. 2, 1932), cols. 2128–36.

5. See Daniélou, *Jewish Christianity*. Also A. Vermes, *The Dead Sea Scrolls in English* (New York: Penguin Books, 1965), pp. 53–68 passim.

6. See *Evagrius Ponticus: The Praktikos Chapters on Prayer*, ed. John Endes Bamberger, Cistercian Studies 4 (Spencer, Mass., 1970), pp. xxiii–xciv.

7. From the "Letter to Anatolius," in Bamberger 14.

8. See *The Rule of the Master*, trans. Luke Eberle with an introduction by Adalbert de Vogüé (Kalamazoo, Mich.: Cistercian Publications, 1977), pp. 131–39, and especially de Vogüé's helpful comments, pp. 43–72.

9. So, too, Augustine in his essay on the instruction of candidates for baptism, *De Catechizandis Rudibus*, 8–10. See F. van der Meer, *Augustine the Bishop*, transl. B. Battershaw and G. R. Lamb (New York: Sheed and Ward, 1961), pp. 453–67.

10. Holmes Welsh, *Taoism: The Parting of the Way* (Boston: Beacon Press, 1957), p. 48.

Chapter 3

Otium Monasticum as a Context for Artistic Creativity

Jean Leclercq, O.S.B.

Jean Leclercq takes the theme of the book a step further, illustrating the specific ways in which monastic ascetic and community life influenced the arts in the cloister. Drawing upon his vast erudition in the literature produced by medieval monks, Dom Jean gives a vivid description of the intellectual and existential setting in which monastic artists worked and articulates the monk-artist's understanding of himself as a co-worker with God in disposing Nature's resources. He also presents in compelling fashion the traditional vision of the monastery as that place in which the most basic issues of human culture, work and leisure, admit of creative resolution.

Jean Leclercq is a monk of the Abbaye St.-Maurice et St.-Maur, Clervaux, Luxembourg, and has lectured at the Pontifical Gregorian University, Rome. His classic study of monastic culture, *The Love of Learning and the Desire for God*, first printed in 1961, remains an essential tool of medieval studies.

LEISURE AND WORK

By the mere fact of including under one title words relating to leisure on the one hand and artistic creativity on the other, a paradox is posed which is a perennial problem for historians of monasticism and culture. For the paradox peculiar to the monastic institution is that while its members turn their backs on the world they nevertheless influence it, assisting in its transformation and in

63

the creation of those "utopias" which project idealized pictures of what the world could or should be.[1]

We have here not just another instance of the rather general human problem or how to reconcile leisure—ease and freedom in the use of time—with work, technology, and productivity.[2] A vast research project would be needed were we to attempt to consider the synthesis of leisure and creativity in Christian monasticism down through the ages and in many lands. Yet it can be said that in spite of many changes according to time, place and institution, there have been in the West certain constant and universal elements which even today remain alongside that which is variable. While the proportions between the elements of monastic culture have differed, the elements themselves remain unchanged.

They may be summed up as follows. First, *the need to work* in some way or other, either by manual labor or intellectual work, alone or with more or less help from others (e.g., the servitors of the monastery or the nonclerical monks by whatever name they are called). Second, *the need for leisure*, understood in the way we shall clarify further on. And third, *the union of these two elements*, work and leisure, resulting universally in works of art. These may be of a literary nature, works of one or another of the plastic arts, or objects of beauty in some other medium. There is great variation from time to time and place to place in regard both to the number of works and the proportion between the objects executed in the different media. But the fact remains that wherever there is monasticism, there we find beauty, and beauty of a specific kind. History proves the truth of this. But what is the explanation of this fact?

It lies in certain basic convictions. We intend to trace here not the chronological evolution of these ideas, but what we might call their doctrinal genetics. It is really a question of illustrating these considerations by reference to the sources, by quotations, and by a study of the symbols used. Little consideration, therefore, will be given to tracing the development of ideas, or to detailing actual practices in different cultures. Many specific papers and overall studies have already appeared from that point of view.

Our first task is to determine a precise meaning for that particular type of leisure which in classical Latin is called *otium*.[3] Christian tradition likewise has loved to describe it as rest *(quies)*, idleness *(vacatio)*, sabbath *(sabbatum)*,[4] and to evoke it by means of poetic symbols borrowed from the Bible, such as the bed or couch *(lectulus)*, watchful sleep, habitual inactivity, and a secluded and hidden life *(vita ombratilia)*.[5] All these terms and images, together with the vocabulary deriving from them, could involve—for better or worse—a certain ambiguity. It is easy enough to say

briefly what monastic *otium* is not: it is not the idleness of the rich and powerful (the Italian *far niente*); it is not the "no work" attitude typified today by strikes or "slow-downs." It is not a flight from the harsh reality inherent in the human condition and imposed on all, including monks and nuns. What is it then?

Otium connotes a whole complex of attitudes and activities best designated by the word *hesychasm*, a term drawn from the Eastern Christian tradition. This term is to be understood concretely and practically as repose of spirit *(quies mentis)*, a concept rich in meaning (but distinct from the meaning hesychasm gradually acquired in the fourteenth and following centuries through the influence of the speculative theology of Gregory Palamas, a monk of Mount Athos, and through the controversy it provoked).[6] This reposeful spirit is conditioned by asceticism, fostered by the peaceful life of the cloister *(quies claustralis)*, and is conducive to interior silence, peace of heart, and calm contemplation *(quies contemplationis)*. The substance of this reality has been described, often very beautifully, by a great many who have experienced it. It is active, dynamic, involved; at the same time it is a grace and a habitual psychological attitude. So complex is hesychasm that a whole litany of characteristics would not exhaust its qualities. It is well-informed, balanced, religious, holy, spiritual, studious; it is interior, total, perpetual; it is diligent, sustained, productive, vigorous, and delectable. It is characterized by stability, to which it is sometimes thought to be assimilated, for it is the opposite of constant change and indeed the remedy for human changefulness. It is serenity.[7] It does not preclude the interior movements of the human spirit but directs them toward a transcendent goal: to God, in whose eternity they may share even now.

There is much more to monastic life than *otium*, however. It must not be idealized as if it were present beatitude; nor should we consider it apart from labor, that other exigency of all human life, whether Christian or monastic. And a difficult point that must be made and understood is the relationship between work and asceticism, both many-faceted realities. The chief sphere of monastic labor is self-control, the pursuit of inner peace, self-transcendence. Just as athletes are forever striving to do a little better than they previously thought possible, by prudent expenditure and constant control of their energies, so monks must ever seek to transcend themselves.[8] This is only achieved by a series of practices which are known in the monastic tradition as watching, fasting, awareness of the presence of God, and stilling of the passions. *Otium* of course cannot prevent evil passions from reawakening fairly often—sometimes very often. At such times one must be prepared to do combat, to be wounded, and to cleanse

and dress the wounds that continually reopen. Therein lies the whole purpose of compunction and discipline.[9]

The struggle is all the more keenly felt because one of the deepest forms of suffering derives from that tranquility itself which endows monastic life with such excellence. Ennui, boredom *(taedium)* is an ever-present possibility.[10] Contemporary psychologists are trying to prove such feelings to be potentially valuable, but where life is dedicated to seeking God, to waiting upon encounter with him, the longing for the less strenuous life we have left behind, or for the joys of heaven that still lie ahead can breed disgust with existence itself—as certain monks have not hesitated to confess: *si te praesens vita fastidiosa sit* ... [11] A remedy for this boredom is work, an essential component of monasticism and one of the weapons of ascetic warfare. Monasticism never developed a work ethic *(Arbeitsethos)* for its own sake, as a value enabling monks to "fulfill" themselves, as we might say today. Yet the idea of self-realization is implicit in the *Rule* of Benedict and in other ancient texts, and we are warranted in commenting on them in that sense.[12] For the tradition, however, work is above all a means of subsistence and a way of salvation. The twelfth-century dispute between Cluniacs and Cistercians over the relative value of manual labor as opposed to other work focused on this problem.[13]

From the outset all were agreed that manual labor—that is, work performed chiefly by the limbs and muscles of the body—is the primary, elementary form of monastic work. The ancients had no qualms about giving concrete examples of the type of task they performed. Cassiodorus, for instance, listed such work as "the cultivation of gardens, work in the fields, and the gathering in of the fruits of the orchard." Later St. Bernard was to write about monks "tilling the soil, felling trees, carrying manure." And it was a commonplace for hagiographers to depict nuns building their own monasteries, "mixing the cement with their virginal hands." In the ninth century, Hildemar, in one of the two oldest commentaries on the *Rule* of St. Benedict, declared categorically that "profitable fulfillment of the task of reading is impossible without first fulfilling the law of manual labor."[14]

In his as yet unpublished *Quaestiones*, written in the midthirteenth century, the first Cistercian to take a Master's degree at the University of Paris, Guigo, Abbot of Aumône, formulated some distinctions which help to simplify our ideas and give order to the wealth of known historical facts. For him, the obligation of manual labor is more or less binding according to the Rule observed. One of the reasons given for his study was to arouse interest in work among those who entertained a false notion of leisure. Yet in his view not all monks are bound to manual

labor; some are permitted to devote themselves to higher modes of activity. Contemplation is thought to be a better work, but it does not preclude work of a more menial kind undertaken to provide the monk's own livelihood or to benefit others. However, activity is not to be restricted to manual labor only, for there is yet another type of work: namely, study (*studium*, or more often *studia*). This includes the activities of reading and writing, which presuppose at one and the same time both leisure and work, so that one can speak just as easily of *otium* or of *studium scribendi et legendi*.[15]

Clearly the modern monastic motto *ora et labora*, "pray and work," built upon a facile Latin word-play, is fallacious.[16] By omitting the world *lege*, "read," it passes over an element of monastic activity never absent from the tradition. "When you are sitting in your cell," Isaac of Scete said, "pay attention to three things: manual labor, meditating the Psalms, and prayer." Isidore of Seville echoed this teaching: "The servant of God must read, pray and work without ceasing."[17] In the thirteenth century, St. Edmund of Abingdon epitomized the authentic tradition in a verse which the sixteenth-century Abbot of Monserrat, Garcia Cisneros, would quote on two occasions. Its conclusion provides a remedy for boredom:

> *Nunc lege, nunc ora*
> *Sacra vel in arte labora*
> *Sic erit hora brevis*
> *Et labor ipse levis.*

("Now read, now pray or work at [some] holy art; thus will time pass quickly, and work itself seem light.")[18] This verse is of interest as it introduces the word *art*, even "sacred art" (*ars sacra*).

We shall return to a full consideration of these terms, but for now it will be helpful to sum up what has been said concerning the connotations of *otium*. *Otium* denotes, firstly, all those dimensions of prayer which in all Christian life, and particularly for monks, constitute what is known as "the contemplative life." These include psalmody or the Divine Office, the celebration of the cycle of the mysteries of salvation, reading accompanied by meditation, private prayer, and—most important of all—the celebration of the Eucharist. *Otium* also presupposes and includes asceticism, which has two principal external manifestations: the practice of the virtues and work. Thus on the one hand *otium* implies the practice of virtue in order to overcome vice (the "active life," as it is sometimes

called in the original sense of the phrase), and on the other implies work as a form of asceticism, whether the work be manual or intellectual. Strictly speaking, though, there is no purely manual work. All monastic activities involve the use, in different ways and to a greater or lesser extent, of the whole being, body and spirit, not just the hands.

In order to show that all this is not merely a theoretical synthesis, somewhat artificially contrived, let us examine some of the many texts in which we see these ideas exemplified and personalized in the lives of specific individuals. The Life of St. David of Menevia, written in the tenth century, and that of St. Gregory, Abbot of Burtscheid, written about 1150, provide examples which will suffice here, even though by summarizing them we lose much of the rich traditional vocabulary and word cadences. St. David's time was spent in all those forms of activity customarily met with in monastic life: manual labor, farm work, an assured tranquility, leisure, control of his thoughts, vigils, prayer, reading, and copying man-uscripts.[19] St. Gregory's day went much the same: "After the psalmody and Mass, he used to work at reading or writing or in cultivating the fields. ... He had the reputation of being an excellent copyist and of being competent in more than one of the other arts. From time to time he would interrupt his work to lessen weariness and give himself up to the interior leisure of contemplation, of waiting on the Lord."[20]

These "snapshots," so to speak, of two monks' lives could have been taken equally from other monastic biographies or serve as models of them all. Still more revealing is the evidence they furnish of a common program constant throughout monastic tradition. And one notes that the specific activities, prayer and asceticism, have not been confused. Today we sometimes read or hear it said that "to work is to pray: Work is Prayer" *(laborare est orare).* But such, it seems, was not the mind of the ancients. Rather than speaking of a synchronization of the two, they speak of alter-nation. The monk goes from prayer to work, from reading to writing. However, there is real unity between these distinct activities. All tend toward restfulness and occupy the time of "leisure."

Monastic *otium,* then, might be compared to a road along a ridge running between two precipices. On the one side there is *otiositas,* not working at all or doing insufficient work. On the other, there lies *negotium,* whose very name tells us that it is the negation of *otium.* We are in the presence of a reality that paradoxically reconciles work and rest, two concepts which in themselves would seem contradictory. Hence we have such expressions as leisure that is laborious, busy, and even very busy *(otium laboriosum, negotiosum, negotiosissimum).*[21] The delicate balance between work and rest can be held only by means of asceticism and with

the help of God. Once it is attained, making due allowance of course for weakness and even failure, it bestows that liberty of spirit which is the goal not only of all monastic life but of all Christian life as well. Thus the concepts of *otium* or *quies* and that of *libertas* are associated, just as in English "leisure" and "free time" are related. And it is because of this association that the arts practiced in leisure time are called the "liberal arts," from a play on the two meanings of *liber.* The word can denote a child, boy, or free man, and it can be understood as "book" (*livre*, in French; *libro*, in Spanish and Italian). In the twelfth century, Adam of Perseigne suggested both meanings when he advised an abbot to give his monks (i.e., his "children," his spiritual dependents) a liberal education: *"erudire liberos tuos; vere liberos tuos si liberales illas artes didicerint* ("educate your children; they will truly be your free ones if they uphold the liberal arts"). This association also evokes a whole series of variations on the notion of a "book of life" which we must learn to read.[22]

But unless a book is first written, it cannot be read. So it is that the transcribing of books finds a place among monastic activities, whether it be undertaken as work or leisure. The copying of manuscripts is likewise numbered among the "laborious" arts which foster freedom both in those who cultivate them and in those who profit by them. We shall return to this theme below.

ART AS CREATION

We should define more exactly the terms *ars* and *artifex.* The first is most often used in regard to a skill of the practical order and as such is to be distinguished from *scientia.* It endows its possessor with a capacity to produce something, but this production will be a work of art, the work of an artist, only if it is carried out in accordance with the theoretical laws which govern all human activity, mechanical or otherwise.[23] There is no sharp distinction between those called "artists" and those we would call "artisans." Both produce works governed not by the spontaneous forces of nature but by the spirit. This norm can be applied to all manufacture provided that at every step the procedures used are controlled by the "rules of art." This applies preeminently to those "liberal" activities which presuppose the presence of a certain openness of spirit and a certain flexibility in the use of time. Under the label "art" are included therefore such activities as writing, spinning, weaving, painting, architecture, and the

composition and performance of works of music: in a word, all that goes toward transforming any reality of the material order into a work born of the spirit.

The production of a work of art therefore is surely a work of creation, a continuation of the creative activity of God, the creator and artist from whom everything comes into being. "Creator and artist": these two titles are applied to God in the Epistle to the Hebrews (11:10), *"cuius conditor et artifex Deus."* In that phrase God is depicted as creator and constructor of that City of cities longed for by Abraham, our father in faith and the exemplar for all who leave everything behind and go forth to seek God. But God is an eternal artist, forever engaged in the act of creating his masterpiece. Before the Epistle to the Hebrews was written, the Book of Wisdom (7:21) called his wisdom the "artificer of all," the teacher of all things. Again (8:6), it says: If prudence renders service, who is a better craftsman than Wisdom, the designer of the universe?" And in the same book it is Wisdom who guides the ship that a craftsman's skill has constructed (14:2).

Such biblical concepts we naturally find restated by the Fathers of the Church. One recurrent expression is *artifex Deus*, attributed alike to the Father, to Christ, and to the Holy Spirit. Not only is God *artifex*, *opifex*, *creator* and *conditor* of all angelic and human life, he is definitely and absolutely *the* Artist of artists, the Artisan of all artisans, supreme above all *(artifex magnus* and *summus).*[24] The writers of the Middle Ages took up this notion and made it still more precise. "Because the Holy Spirit is the artist," wrote Ermenricus of Elwangen, "he can add whatever he wishes to the work of his hands." Hrostvita praises "the wonderful science (knowledge) of him who designed and made the world," the Artist overflowing with goodness, *bonus artifex.* And in the Life of St. Hildegarde, we read that "the virtues too are likewise the creation of the supreme artist's hand."[25] A monk of St. Germain of Auxerre wrote that "everything which, before time began, existed already in the will of the divine artist, has been created outside him, in time, according to the disposition of the Creator's art,"[26] and Erigena echoed this, borrowing an analogy from what happens in the spirit of a human artist: "Consider with the eyes of the soul that the many rules of an art are a unified whole in the thought of the artist and live in the spirit of him who lays them down."[27]

Thus whether one speaks of God's role in the work of creation, or of the part of humans in furthering it, artistic creativity is distinct from all that is natural and spontaneous. Art enhances nature. This applies to everything that calls for effort and is conducive to the "refinement" of both the work itself and its creator. Order, the organization of means and

methods, is presupposed. Human genius is required to think, foresee, invent, and make decisions on the appropriate use of materials and tools. The spontaneous comes from nature, but art is born of humans given freedom by God the creator of all to arrange nature's resources in new patterns. In artistic creation there is always embodied the element of choice, of novelty, of the unexpected, and consequently of the wonderful and surprising. Like everything else in humans, subject as they are to sin, this creative capacity can be used for good or evil, to free them from passion or to hold them captive to it. Yet because artistic creativity always implies a certain ordering of means and composition of material, the artist's activity universally bestows on nature of higher value, a supplementary beauty. This holds not only for the work but for the artist as well. God endows the artist with a wonderful capacity to make his or her own life a work of art, as the artist's nature is refined through asceticism and by developing the gifts bestowed by God. And it is precisely "culture" that enables the artist so to improve upon nature; for the word *culture*, often found in association with the work and names of holy monks and sometimes even with God's name and Christ's, designates all forms of work and *industria*—from agriculture to the knowledge of divine realities and the cult of divine things.[28]

THE LAWS OF ARTISTIC CREATION

The work represented by the production of manuscripts clearly exemplifies the spiritual and humbly practical character of all cultural activities. We are accustomed to admiring the perfection of the calligraphy and the beautiful embellishment of books produced in monasteries. We are less accustomed to thinking of this art form in terms of hard work and all that is involved in the organization of a scriptorium, as well as in submission and suffering on the part of the scribes. Yet only in a life where prayer and asceticism had reconciled *otium* with *labor* could the kind of collaboration upon which medieval monastic scriptoria depended have been possible.

Recent detailed research in regard to the scriptoria of several abbeys has called attention to these aspects of book transcription. At Cluny, in a manuscript forming part of a historic collection of the work of scribes in the second half of the eleventh century, Monique-Cécile Garand has identified seven, possibly even nine, scribes by their letter formation.

These scribes are not usually known by name, but even where we do have a copyist's name we may know little or nothing else about him. The copyists were not in every case monks of Cluny itself, but they had a bond with it, having come there to work from many regions in France, Italy, and Germany. They were attracted by Cluny's rich cultural and international character and stayed for varying lengths of time.[29] From the style of the drawings and details of embellishment of the manuscript we can form some idea of the psychology of the team of monks working in the scriptorium. We get the impression that "all was carried out as if X ... had gradually imposed his style on a director of works anxious to maintain a unity in the appearance" of the whole. There is in fact a real harmony in work that resulted from so much joint effort. Nevertheless, it is possible to glimpse the individual taste of the workers by means of the flourishes on their initials when these were added. Similarly, "within the common framework, the copyists were granted a certain freedom with regard to the details on the layout of the pages."[30] The freedom given copists at Cluny has been noted also by François Avril.[31]

In connection with the scribes working at Malmesbury in the first half of the twelfth century, Rodney Thomson has distinguished forty-five hands among those whom he chooses to call "assistants" of the historian William. "He had to find his scribes from among those monks who were willing to help out, even for a leaf or a column. ... We notice frequent changes of ink, the scribes apparently working in short bursts sometimes separated by long periods of inactivity. Variations of skill and organization are reflected in all these things." And Thomson notes that little by little the copyists, "some of them not very calligraphic," improve and make progress. At the end, "None of these hands is highly skilled, but all are better."[32] Thus, although most of the books coming from this composite workshop are not beautiful manuscripts, works of spendor, all were practically useful in promoting the *otium* of the community and its cultural life. That was all they aimed at being. Among the scribes there were some artists, but only some. Yet despite the fairly limited number of real "professionals" in the groups of copyists working in twelfth-century monastic scriptoria, the beauty, harmony, and poetry of their floral decoration—whether true to life or not—contribute to the sober distinction and good taste of the more expertly executed initials.[33]

All this certainly reflects a definite way of life. These manuscripts so simple in style do not come exclusively from the Cistercian world, to which a monopoly on that virtue has sometimes too readily been attributed. They belong to that traditional monasticism later to be called Benedictine. The point is that the same monastic characteristics of discre-

tion and moderation are evident from a close study of works of art originating in different localities and in successive historical periods—whatever certain outstanding scholars may declare in their polemics and
despite ideas projected on the past by recent historians. Anglo-Saxon manuscripts of the tenth and eleventh centuries, for example, have a remarkable resemblance to some of those coming from Cîteaux, in Burgundy,
subsequent to the time of St. Stephen Harding. On the other hand, at
Durham, Reading, and elsewhere—as at Cluny, Fleury, or Saint-Martial—
there is a style proper to the individual monastery, a "house style."[34] Only
very patient studies like those being currently pursued will enable us to
abandon generalizations in this field.

For the present, the few observations made above allow us to
discern some of the laws governing the creative arts as exercised by monks.
Fraternal collaboration is much the same today as it was in the Middle
Ages or at the time of the Maurists. The devoted and helpful collaboration
given me by my *confrères* at Clervaux and at the Monastery of St. Jerome in
Rome is of the same kind as that which we know existed at Cluny and
Malmesbury. In the latter case, a great deal depended on the presence of
the dynamic historian-monk, William, who was able to sustain initiatives
and encourage his willing helpers to persevere in the work. There as
elsewhere, however, this disinterested labor by a small group would not
have been possible without the atmosphere of leisure and of asceticism
and work which was the very air breathed by whole communities of
monks about whom we know nothing. These anonymous ones are the
unknown soldiers, so to speak, without whom no battle is won nor any
work accomplished. Collaboration indeed presupposes anonymity, charity,
humility, organization, and obedience. Such were the exigencies and, in
that sense, the laws which governed the creative arts of monasticism in the
Middle Ages.

REALISTIC IMAGINATION

Monastic life as actually lived day by day could not but leave its impress on
the familiar, common, and constantly used images which conferred graciousness on leisure and yet stimulated the monks to asceticism in the
midst of work and sometimes of weariness. What then were the favorite
images and themes of monastic art? Two sources of information provide
the answer: the works of art themselves and the written texts in which

monks spoke of their motivations. The evidence of both these points in one direction, and it is possible to divide the imagery used throughout the tradition into two very important categories. The first category is concerned with the goal of all human striving, the utopia we would like to see become reality here and now, for which we long and which we hope to receive as a gift in the future. We speak, of course, of heaven. It is the thought of heaven which evokes all the descriptions and paintings of Paradise, of the Jerusalem on high, of the complete and glorious communion of saints, and all that we include under the name of life eternal. This future life remains unknown to us, but the Bible provides symbols of its blessedness. In the Bible we find heaven represented analogously as the Tabernacle wherein stood the Ark of the Covenant, and the Temple where God abode and where he revealed himself to Ezekial, Isaiah, and others. There is also the symbol of the City revealed in the Apocalypse: Zion, the Golden City, the heavenly Jerusalem, true homeland of all peoples, the world of the angels, the Kingdom where the Risen Christ is seen in all his glory, surrounded by his court.[35]

Is this all just a beautiful dream, a form of escapism? The hymn *Urbs Jerusalem beata* sets out very clearly that there is a price to be paid for entry into this city of the Blessed. The Jerusalem on high is a city of beauty constructed by the Church in this world by means of all the labors which the builders undergo in the formation of living stones. Those stones which are to become forever a part of the sacred edifice are placed in position by the Supreme Artist only after they have been completely processed: hewn, shaped, polished, and fitted together.[36]

The very authors who have been the most fervent, sometimes the most prolix, in expatiating on devotion to heaven have also been the ones who were most realistic when it came to setting out the conditions on which a foretaste of Paradise is gained even here on earth. This is especially true of Peter of Celle. He and others like him provide the second category of symbols found in medieval monastic art. In his *De disciplina claustrali*, Peter displays a splendidly rich, creative imagination; while writing of "angelic discipline," of "the royal chamber," and "the hall of the treasury," he is by no means unmindful of sin and its effects, or of the fact that monastic life is frontier warfare. "The cloister is situated on the borders between angelic purity and the impurity of the world," he states. There the monk experiences a certain rest, but it is not yet the unending sabbath rest. It is the time and place for work. A principal image which Peter employs in this book is a comparison of the cloister to the Cross, that necessarily narrow gate opening out onto the Resurrection.[37]

For Peter of Celle, the monastery is a place of transit. There one

passes through temptations and by a dark journey reaches the Paschal mystery of Christ's death and resurrection. The chief role of the cloister is to be the place where we weep for our sins and work to heal the wounds they have left in us. Only in this context does he go on to mention the blessed in heaven, for between them and us stretches the *stadium* symbolizing asceticism and the strict training to be undergone if we are to transcend ourselves. After the *stadium* we enter the "inner court" where the husks of worldliness are stripped off and we are interiorly cleansed. Thus Peter of Celle symbolized detachment, purification, and the other painful exercises *(laboriosa officia)* of the ascetic life. If this program is followed, however, life in the cloister becomes a sanctuary, a place of repose after labor, an interval of peace and quiet after effort. The movement is cyclic and is forever beginning anew.[38]

Again and again we come across the image of the Cross where, like Jesus, we are voluntarily between two "thieves"—for Peter, symbols of the common life of the monastery and its attendant difficulties. Constantly there crops up the word "peace," but by now we are aware of the renunciations it demands. The cloister is also likened to the marketplace of Tyre, where wealth may be amassed—in this case, a wealth of toils. "Perhaps when so disguised the unassuming figure of monastic discipline is not very attractive," he says. Its practices do in truth include silence, ascetical and penitential exercises, reading, confession of sins, prayer which is sometimes "laborious," meditation on death, and communion in the body and blood of the Lord, the nourishment of eternal life. Yet for Peter these diverse images, observances, and sacraments constitute a coherent whole: a great work which is an imitation of the work of Christ and a sharing in it. Thus it is fitting that his final chapter should be devoted to the Eucharist, that sacrament which makes present Christ's life, death, and resurrection.[39]

Such then is the total context within which monastic creativity can be developed. To neglect any element of this complex reality we call *otium* is to lose sight of the balance of forces which preserve its vitality. Without leisure and asceticism, there can be no interior freedom; without reading and prayer there is nothing of the dynamism of the creator. But the subtle blending of all these components results in peace and joy with, as the overflow, a very real beauty. For beauty has first to exist in our spirit and in our convictions before it can be born in works of art. It is found in monastic texts as well as in monuments. It is perceptible in the lifestyle of

monks as well as in their monastic buildings.[40] We could not appreciate the deep meaning of the final great church at Cluny without the office for the Transfiguration, or for the Feast of St. Benedict, which Ruth Steiner discusses in Chapter 4, and the illuminated pages and musical notation that enshrine them. Nor is it possible to understand fully the abbey church of St. Peter of Reims without some knowledge of the treatises of Peter of Celle, which are products of the same spirit. For the hesychasm of the treatises was the common treasure of all monks; the books and buildings were products of milieux differing in locale but homogeneous in their fundamental characteristics.[41] The result is a pure, simple, peaceful style of art. It is neither tragic nor exuberant, like the art bred in other schools of spirituality. Rather it is calm and brings a sense of peace because it is conceived by those who, at the price of laborious leisure, strove to be at peace with themselves.

NOTES

This paper was translated from the French by Sister Gregory, O.S.B., Pennant Hills, Australia.

1. See Walter M. Gordon, "The Monastic Achievement and More's Utopian Dream," *Medievalia et humanistica* 9 (1979): 199–214.

2. In that regard, see Nels Anderson, *Man's Work and Leisure* (Leyden: Brill, 1974).

3. See J. M. André, *Recherches sur l'otium romain*, Annales litteraires de l'université de Besançon no. 52 (Paris: Les Belles Lettres, 1964), and *idem, L'otium dans la vie morale et intellectuelle romaine* (Paris: Université de Paris, 1966).

4. The history and connotations of these terms are studied in Jean Leclercq, *Otia monastica. Etudes sur le vocabulaire de la contemplation au moyen age*, Studia Anselmiana 51 (Rome: Orbis Catholicus, Herder, 1963).

5. These terms are commented upon in Jean Leclercq, *Chances de la spiritualité occidentale* (Paris: Editions du Cerf, 1966), pp. 279–328.

6. See T. Spidlik's article, "Esicasmo nel monachesimo occidentale," in G. Pelicia and G. Rocca, eds., *Dizionario degli Istituti di Perfezione*, 6 vols. to date (Rome: Edizioni Paoline, 1974–), 3: cols. 1306–12.

7. See the Index of Words in Leclercq, *Otia monastica*, pp. 181–83, For the stability of the hesychast, see Hughes de Flavigny's statement: "Mens enim eius, quae procellosis actuum motibus concitabatur, ab internae sapientiae quiete et stabilitate disiungebatur" ("For his mind, which is stirred up by the tempestuous movement of action, becomes detached through the calm and stability of interior wisdom"). (*Chronicon*, 2 edited by H. G. Pertz, in *Monumenta Germaniae Historica, Scriptores* 8 [Hannover: Hahnsche Buchhandlung, 1848], pp. 446–47). In a forthcoming study on *stabilitas* and related terms, I will cite other examples. Finally, the words *quies, stabilitas,* and *mutari* are brought into relationship in Peter of Celle's *De conscientia*: see Jean Leclercq, *La spiritualité de Pierre de Celle (1115–1183)* (Paris: J. Vrin, 1946), p. 227.

8. The symbol from athletics, originating with St. Paul (1 Cor. 9:24; 2 Tim. 4:7), has been employed in the monastic tradition from first to last. Peter of Celle himself devoted to this topic a chapter of his *De disciplina claustrali*. See *L'école du cloître (De disciplina claustrali)*, edited by G. de Martel, Sources chretiennes no. 240 (Paris: Editions du Cerf, 1977), pp. 188–92: "Comparaison entre le cloître et le stade."

9. For example, see Smaragdus, *Diadema monachorum*, 1, in Jacques Paul Migne, ed., *Patrologiae Cursus Completus, series Latina*, 221 vols. (Paris: Migne, 1884–65), 102: 595 (hereafter referred to as Migne, *Patrologia Latina*, with relevant volume and page numbers).

10. See S. Wenzel, "Acedia 700–1200," *Traditio* 22 (1966): 73–102, and *idem, The Sin of Sloth: Acedia in Medieval Thought and Literature* (Chapel Hill, N.C.: University of North Carolina Press, 1967). For the change from the beginning to the end of the Middle Ages in the concepts of *acedia* and *taedium*, of tepidity and of disinclination to that of idleness and refusal to work, see the interesting pages of R. Ricard, "En Espagne: jalons pour une histoire de l'acédie et de la paresse," *Revue d'ascétique et de mystique* 45 (1969): 27–45; see also P. Charles Dumont's perceptive comments in reviewing this article in *Collectanea Cisterciensia* 9 (1971–75): 89–90, n. 217.

11. See Antoine de La Garanderie, *La valeur de l'ennui* (Paris: Editions du Cerf, 1969). In his appendix dealing with "L'ennui à travers les temps de l'antiquité grecque jusqu'à Pascal," pp. 93–94, the author jumps from Cassian to St. John of the Cross. Ennui in the Middle Ages, therefore, remains to be studied. On medieval monastic tedium, see Jean Leclercq, "La rencontre des moines de Moissac avec Dieu," in *Moissac et l'Occident au XI siècle. Actes du colloque internationale de Moissac, 3–6 Mai, 1963* (Paris: M. Didier, 1964). On the matter of *taedium* at Cluny, see idem, *Aux sources de la spiritualité occidentale* (Paris: Editions du Cerf, 1964), p. 165; for tedium in Cistercian life, according to Galland of Rigny, see idem, *Analecta monastica* 1, Studia Anselmiana no. 20 (Vatican City: Libreria Vaticana, 1948), pp. 169–74.

12. On the history and bibliography of work, see J. Gribomont, A. de Vogüé, and M. Zimmermann, "Lavoro," in Pelicia and Rocca, eds., *Dizionario degli Istituti di Perfezione*, 5, cols. 515–27; on the monastic work ethic, see F. Prinz, *Frühes Mönchtum im Frankenreich* (Munich and Vienna: Oldenbourg, 1965), pp. 532–40.

13. See Leclercq, *Otia monastica*, pp. 94–95.

14. See Cassiodorus, *Institutiones* 1, 28, 5, edited by R. A. B. Mynors (Oxford: Clarendon Press, 1937), p. 71: "Nec ipsum est a monachis alienum hortos colere, agros exercere et pomorum fecunditate gratulari." St. Bernard says: "Fodere terram, silvam excidere, stercora comportare," *Epistola* 1, 4, in *Sancti Bernardi opera*, edited by J. Leclercq and H. Rochais, vol. 7, *Epistolae* (Rome: Editiones Cistercienses, 1974), p. 4. Another list of the kinds of work on the land performed by the Cistercians is found in the letter written by a novice of Clairvaux, Pierre de Roye, chapter 9: see Migne, *Patrologia Latina* 182:711b. On nuns, see the texts cited by A. Poncelet, "Les biographies de Ste. Amelberge," *Analecta Bollandiana* 31 (1912): 404–5; and for Hildemar see *Expositio Regulae ab Hildemaro tradita*, edited by R. Mittermüller (Ratisbon: Pustet, 1880).

15. Guigo of Aumône, *Quaestiones*, Ms. lat. 14891, fol. 209, Bibliothèque Nationale, Paris; on this author and his work generally, see Pierre Michaud Quantin, "Guy de l'Aumône, premier maître cistercien de l'université de Paris," *Analecta S. Ordinis Cisterciensis* 15 (1959): 194–219. On *studia*, see J. Leclercq, "Les études dans le monachisme du X au XII siècle," in *Los monjes y los estudios* (Poblet: Abadia, 1963), pp. 106–17; see also Leclercq, *Otia monastica*, pp. 77–78 and 182.

16. See Jean Leclercq, *Etudes sur le vocabulaire monastique du moyen âge*, Studia Anselmiana 48 (Rome, Orbis Catholicus, Herder, 1961), pp. 14–144: "Ora et labora." Prinz, *Frühes Mönchtum*, p. 523, recognizes the late appearance of this formula. The older view was

expressed by Maur Wolter, *Praecipua ordinis monastici elementa* (Bruges: Desclée, DeBrouwer, 1880), p. 481, calling "ora et labora" "vetus clarissimaque illa monachorum tessera," but in none of the texts which he cited is the formula actually found. E. von Severus, "'Ora et labora': Gedanken zu einer benediktinischen Devise," *Liturgie und Mönchtum* 28 (1961): 38–43, and H. Herwegen, "Weltarbeit und klosterlichen Ideal," *ibid.*: 44–60, both insist on spiritual reading *(lectio)* as the necessary complement of prayer and work.

17. For Isaac of Scete, see the *Regulae* edited under the name of St. Anthony in J. P. Migne, *Patrologiae Cursus Completus, series Graeca,* 242 vols. (Paris: Migne, 1857–67), 40: 1072b (hereafter referred to as Migne, *Patrologia Graeca*). See also J. N. Sauget, "La double recension arabe des 'Preceptes aux novices' de l'abbé Isaac de Scéte," in *Mélanges Eugène Tisserant,* 7 vols. (Vatican City: Biblioteca apostolica vaticana, 1964), 3:299–356. See also Isidore of Seville, *Sententiae* 3, 19, in Migne, *Patrologia Latina* 83: 694.

18. See the extract from Matthew Paris' *Life of St. Edmund* in C. H. Lawrence, ed., *St. Edmund of Abingdon* (Oxford: Clarendon Press, 1960), p. 243; for bibliography and commentary on this text, see Leclercq, *Etudes sur le vocabulaire,* p. 144.

19. See William Jenkins Rees, ed., *Lives of the Cambro British Saints* (London: Longman and Company, 1853), pp. 127–28: "Vita Sancti David."

20. *Vita S. Gregorii Porcetensis,* in C. de Smedt et al., eds., *Acta Sanctorum, Novembris* 2 (Brussels: Socii Bollandiani, 1894), p. 464, n. 4.

21. This formula, in the superlative, was used and developed by Blessed Paul Giustiniani. See Jean Leclercq, *Alone With God: A Guide to the Hermit Life* (London: Hodder and Stoughton, 1962), pp. 81–96.

22. See Leclercq, *Etudes sur le vocabulaire,* pp. 100–103; *ibid.,* pp. 122–28; *ibid.,* p. 65, no. 39. See Adam of Perseigne, *Sermo in festivitate S. Benedicti abbatis,* edited by D. Mathieu, in *Collectanea Cisterciensia* 4 (1937): 108–9. On the relationship between reading and writing, see Jean Leclercq, "Aspects spirituels de la symbolique du livre au XII siècle." in *L'homme devant Dieu. Mélanges Henri de Lubac* (Paris: Aubier, 1964), pp. 63–72.

23. See A. Ernout and A. Meillet, *Dictionnaire étymologique de la langue latine* (Paris: Klincksieck, 1932), p. 72; see also the texts given in Otto Prinz, *Mittellateinisches Wörterbuch* (Munich: C. H. Beck, 1967), s.vv. "ars" and "artifex."

24. See the texts given in E. R. Curtius, "Zur Literaturästhetik des Mittelalters," *Zeitschrift für Romanische Philologie* 58 (1938): 17–21, "Deus artifex."

25. See Ermenricus, *Epistola ad Grimaldum,* 12, in H. G. Pertz, ed., *Monumenta Germaniae Historica, Epistolae* 5 (Berlin: Weidman, 1925), p. 547; Hrostvita, *Sapientia sive passio virginum Fidei, Spei, Karitatis,* 3, 22, in *Hrosvithae opera,* edited by H. Homeyer (Munich: Schöning, 1973), p. 363; Geoffrey and Thierry, *Vita Hildegardis Bingensis,* 1, 3, in Migne, *Patrologia Latina* 197; 93. The idea of God as *artifex* had been used in connection with Baptism in the fifth century, by Victor of Vita: "Et ut hic panis de furno, ita et ego per officia sacramentorum divinorum artifice Deo de fonte mundus ascendi" ("And like this bread from the oven, so I came up from the [Baptismal] font, cleansed by the working of the holy sacraments; and the workman was God"), *Historia persecutionis Africanae provinciae,* 1, 21, edited by Michael Petschenig, Corpus Scriptorum Ecclesiasticorum Latinorum no. 7 (Vienna: G. Geroldi, 1881), p. 10.

26. *Expositio in Apocalypsim,* 2, 4, in Migne, *Patrologia Latina* 117:1013.

27. See John Scotus Erigena, *Homélie sur le Prologue de S. Jean,* edited by E. Jeanneau, Sources chrétiennes no. 151 (Paris: Editions du Cerf, 1969), pp. 250–51; n. 2 refers to some formulas of the same kind.

28. On this range of meanings, see for example, the author of the *Vita S. Iltuti,* 11, in C. de Smedt et al., eds., *Acta Sanctorum, Novembris* 3 (Brussels: Socii Bollandiani, 1910),

p. 228: "De institutione culturae. … Colit et seminat, metit et vivit proprio labore. Statuit operarios cultores per agros; agriculturae semina multiplicant" ("With regard to the institution of culture. … He tilled and sowed, reaped and lived by his own labor. He set workers to cultivate the fields, and the seeds of farming multiplied"); or again the rhetorical questions posed in Peter the Deacon's *Prologus … in explanatione brevi (Regulae S. Benedicti),* in *Florilegium Casinense* 5 (Montecassino: Abbazia, 1984), p. 165: "Quid enim in misterio scripturarum nisi Christus ostenditur? Christi cultura monstratur? Christus architectus probatur?" ("For what is revealed in the mystery of the Scriptures if not Christ? If not the culture of Christ? What is proved, if not Christ as architect?") See also the *Vita S. Carileffi,* in Jean Mabillon, ed., *Acta Sanctorum Ordinis Sancti Benedicti,* 11 vols. (1668; reprint ed., Mâcon: Protat, 1934),1: 644: "ardentem circa Dei culturam affectum" ("a burning love for the culture of God").

The formula "cui quod arti defuit, natura sub ministravit, et quod natura minus habuit, industria adiecit" ("where art fell short, nature provided [what was missing], and what nature had less of, industry provided"), *Epistolae Ratisbonnenses,* 11, in N. Fickermann, ed., *Briefsammlungen der Zeit Heinrichs IV* (Weimar: Böhlau, 1950), p. 330, recalls that of William of Malmesbury regarding the lands reclaimed by the monks of Thorney: "Mutuum certamen naturae et cultus, ut quod oblivisatur illa, producat iste" ("There was a reciprocity between nature and culture, for what one forgot, the other provided"), *De Gestis Pontificum Anglorum,* 5 vols., edited by N. E. S. A. Hamilton (London: Longman and Company, 1870), 4: 236. One can readily understand why monasteries were known as *"cultura"* (in French, *"la couture"*); a list of monasteries so called is given in L. H. Cottineau, *Répertoire topobibliographique des abbayes et prieurés* (Mâcon: Protat, 1935).

29. See Monique-Cécile Garand, "Le scriptorium de Cluny, carrefour d'influences au XI siècle: le manuscrit Paris, B. N., Nouv. acq. lat. 1548," *Journal des savants* (Oct.–Dec. 1977): 257–83. See especially pp. 267, n. 22; 272; and 282.

30. *Ibid.,* pp. 278 and 283.

31. See J. Vezin, "Un martyrologe copié à Cluny à la fin de l'abbatiat de Saint Hugues," in Guy Cambier, ed., *Hommages à André Boutémy* (Brussels: Latomus, 1976), pp. 494–12; and previously, *idem,* "Une importante contribution à l'étude du scriptorium de Cluny à la limite des XI et XII siècles," *Scriptorium* 21 (1967): 312–20. The last is a review of Meyer Shapiro, *The Parma Ildefonsus: A Romanesque Illumnated Manuscript from Cluny, and Related Works* (New York: College Art Association of America, 1964).

32. See R. M. Thomson, "The Scriptorium of William of Malmesbury," in M. B. Parkes and A. G. Watson, eds., *Medieval Scribes, Manuscripts and Libraries: Essays Presented to N. R. Ker* (London: Scolar Press, 1978), pp. 117–42; see especially pp. 128–32.

33. See J. J. C. Alexander, "Scribes as Artists in Twelfth-Century England," in Parkes and Watson, *Medieval Scribes,* pp. 87–116.

34. *Ibid.,* p. 103.

35. See the texts and bibliography given in G. Loddolo, "Il tema simbilico del Paradiso nella tradizione monastica dell'Occidente latino (secoli VI–XIII): lo spazio del simbolo," *Aevum* 51 (1977): 252–88. See also Leclercq, *Aux sources de la spiritualité,* pp. 126 and 148 f.

36. The Vesper hymn for the Feast of the Dedication of a Church, in the Monastic Breviary, has the line: "Tunsionibus, pressuris expoliti lapides suis coaptantur locis per manus artificis" ("Stones polished by the pressure of repeated blows are fitted into their positions by the craftsman's hand").

37. See Peter of Celle, *L'école du cloître,* pp. 153–60.

38. *Ibid.,* pp. 162 and 192.

39. *Ibid.*, see especially pp. 206, 217, 233, and 282–317.

40. Texts on the cult of beauty at Cluny are given in Leclercq, *Aux sources de la spiritualité*, pp. 171–73.

41. On the character of the iconography and architectural embellishment at Moissac, for example, and on the coordination of eschatological and historical themes, see Jacques Hourlier, "La spiritualité à Moissac d'après la sculpture," in *Moissac et l'Occident au XI siècle*, pp. 71–80.

Chapter 4

The Music for a Cluny Office of Saint Benedict

Ruth Steiner

The role of Scripture and liturgy in molding the monastic imagination, introduced in Chapter 1 by William Loerke and Chapter 3 by Jean Leclercq, is developed by Professor Ruth Steiner. She discusses the dramatic content of the texts and music used for the Feast of Saint Benedict at the most magnificent and influential monastery of eleventh-century Europe, Cluny. Her chapter documents the richness of the Divine Office as celebrated by monks in the Middle Ages, that unending cycle of chanted "hours" to which the monks of Cluny and of the hundreds of monasteries affiliated with Cluny gave the greatest portion of their time. She evokes the grave beauty of a monastic night service where, in the darkened choir, the monks alternated periods of Psalm-singing (the nocturns) with meditative listening to lessons from Scripture and monastic history—including, here, St. Gregory's account of the emergence of Benedict of Nursia in the troubled age of the Lombard invasions.

Ruth Steiner is Professor of Music at the Catholic University of America and has served as a member of the editorial board of the *Journal of the American Musicological Society.*

For monastic communities of the Middle Ages, music and worship were inseparable: singing was a medium of prayer. Observance of the Divine Office entailed hour after hour of chanting. What was this music like? How was it written down? In what forms has it been preserved? An examination of a Cluny office for St. Benedict will provide answers for these questions, and also cast light on a related subject—how monks thought about music, the kinds of ques-

tions they raised, the ways in which they gave expression to their under-
standing of it.

"Fuit vir vitae venerabilis gratia benedictus et nomine ... " ("He
was a man of venerable life, blessed in grace as in name"). Thus begins the
biography of St. Benedict written by Gregory the Great less than fifty years
after Benedict's death.[1] In medieval antiphonals from Benedictine houses,
this line stands out like a headline, for it begins the first of the Matins
responsories on the feasts of St. Benedict. There is a large initial letter, and
often the first few words are written in capitals.

Matins, or "vigils," as St. Benedict called it, is the first part of the
Divine Office, the series of daily worship services which he called *opus Dei*
("the work of God") and over which he said nothing should take prece-
dence in the life of monks: *"Nihil operi Dei praeponatur."*[2] On major
feasts, the Matins service in a monastery consisted of an introductory
portion and three large sections, called *nocturns* (see Table 4.1.).[3] The first
two nocturns began with six psalms and antiphons, the last with canticles
and a single antiphon. All three nocturns continued with four lessons,
each of which was followed by a responsory: thus there were twelve
lessons and twelve responsories in all. The lessons of the first and second
nocturns, and sometimes of all three, were usually drawn from the same
source: a continuous long text which the responsories separate into sec-
tions.[4] The point at which one lesson was separated from what follows is
the point at which those taking part in the service were given an oppor-
tunity to reflect on its meaning, consider its implications, and make asso-
ciations between it and parallel ideas in other texts. Often the text of the
responsory that follows a particular lesson seems to have been selected or
composed in such a way as to encourage this kind of reflective meditation
during its musical performance.[5]

The Matins services for feasts of St. Benedict in medieval man-
uscripts are quite varied, both in the chants that are given and in their
arrangement.[6] If the relationsip between lessons and responsories in a
particular Matins service is to be studied, one must have a source in which
the lessons are given in full—thus a breviary, rather than an antiphonal.
In the pages that follow here, two services will be compared. One is that
for the Transitus of St. Benedict (March 21) in a eleventh-century breviary
of St. Martial de Limoges (Paris, Bibliothèque Nationale, lat. 743).[7] The
other is the service for the Translation of the Relics of St. Benedict (July 11)
in a late eleventh-century Cluny breviary now in the same library (lat.
12601).[8] This manuscript was taken from Cluny to another monastery in
the twelfth century. There it received some additions and corrections, but
these are minor, especially in the section to be considered here.

TABLE 4.1

Matins for the Feast of the
Translation of the Relics of St. Benedict (July 11) in the MS Paris, B. n., lat. 12601
(Cluny, *ca.* 1075), fols. 55ᵛ–58ᵛ

Antiphon and Ps. 94
Hymn: Christe sanctorum decus

(First nocturn)
Ant. Fuit vir, with Ps. 1
Ant. Ab ipso puericie, with Ps. 2
Ant. Dum in hac terra, with Ps. 4
Ant. Liberiori genere, with Ps. 5
Ant. Relicta domo, with Ps. 8
Ant. Recessit igitur, with Ps. 10
 Lesson 1, and Responsory: Fuit vir
 Lesson 2, and Responsory: Santus Benedictus
 Lesson 3, and Responsory: Inito consilio
 Lesson 4, and Responsory: Domine, non aspicias

(Second nocturn)
Ant. Compassus nutrici, with Ps. 14
Ant. Expetitus a fratribus, with Ps. 20
Ant. Cumque sibi conspicerent, with Ps. 23
Ant. Inito consilio, with Ps. 63
Ant. Tunc ad locum, with Ps. 64
Ant. Tantam gratiam, with Ps. 91
 Lesson 5, and Responsory: Cumque sanctus Benedictus
 Lesson 6, and Responsory: Intempesta noctis hora
 Lesson 7, and Responsory: Pater sanctus, dum intentam
 Lesson 8, and Responsory: Sanctissime confessor Christi

(Third nocturn)
Ant. Hic itaque, with canticles
 Lesson 9, and Responsory: Dum beatus vir
 Lesson 10, and Responsory: Beatus vir qui
 Lesson 11, and Responsory: Erat vultu placido
 Lesson 12, and Responsory: O beati viri Benedicti

TABLE 4.2

Responsories in the first two nocturns of Matins for the Transitus of St. Benedict (March 21), in a breviary from St. Martial of Limoges, Paris, B. n., lat. 743, fols. 104r–106r

R. 1: Fuit vir, from prologue
R. 2: Sanctus Benedictus, from I
 (How a Broken Cleaning-Vessel Was Repaired)
R. 3: Inito consilio, from III
 (How a Glass Vessel Was Broken by the Sign of the Cross)
R. 4: Domine, non aspicias, from XXXII
 (How Benedict revived a Corpse)
R. 5: Cumque sanctus Benedictus, from XXXIV
 (How Benedict Saw the Departure of His Sister's Soul from Her Body)
R. 6: Pater sanctus, dum intentam, and
R. 7: Intempesta noctis hora, from XXXV
 (About the Way That the World Was Gathered Up Before Benedict's Eyes
 and About the Soul of Germanus, Bishop of Capua)
R. 8: Sanctissime confessor Christi (a prayer not derived from the vita)

 The service in the St. Martial manuscript has as lessons in the first two nocturns excerpts from St. Gregory's Life of St. Benedict. The series begins with the prologue and continues without omissions nearly to the end of the first chapter, reached in the seventh lesson. For the eighth lesson, the thirty-seventh chapter of the Life is read, complete except for its final sentence. The responsories that alternate with these lessons have texts drawn from the same source, but the selection is different, as may be seen in Table 4.2, where the roman numeral after the opening words of each text indicates the chapter of the Life from which they are drawn. Thus the texts that are heard in the first two nocturns of this service are all—except for the last—from the very beginning of the Life; most of the responsories come from sections of it that are not read in Matins (see Table 4.2).
 The effect of combining these responsories, which evoke later episodes in the Life with the reading of the first two of its sections, is not unlike that of the flashback in films. Juxtaposing events in an order other than that of chronology implies that the order in which they occurred is secondary in importance to the events themselves. In the matins service, St. Benedict's life becomes something to be experienced all at once. This effect is enhanced when one's attention is drawn by the arrangement of things to notice the same motif in different parts of the Life. For instance,

the third responsory in this office tells how the sign of the cross caused a vessel that held poisoned wine to shatter. It is preceded by a lesson that describes Benedict's nurse weeping over a vessel that she had borrowed and permitted through innocent negligence to fall and break.

When the responsories are compared with the sections of the Life on which they are based, it is evident that there is more selection and reworking of the text in some than in others. This is done, it appears, to make the sung texts concise and to give them good rhythm and clear phrasing. The indications are that any text that was sung was memorized; if so, the parts of the Life to which these chants correspond would be the ones that were known best.

To turn to the Cluny beviary, the feast of St. Benedict that it contains is that of July 11, the Translation of the Relics. The responsories in the first two nocturns are the same as in the St. Martial Office, though the order of the sixth and seventh is reversed. But the lessons are drawn from a different source: the account of the Translation that was written by a monk of Fleury-sur-Loire, perhaps one Adrevald, in the ninth century.[9] The main events it describes are thought to have taken place in the seventh century. In the first nocturn, the lessons begin by describing the Lombard invasion of Italy and its terrible aftermath. Then they summarize the history of Fleury-sur-Loire from its founding. In the second nocturn, the fifth lesson describes the formation of an expedition consisting of a group of monks from Fleury, led by one Aigulphus (Ayoul), and a group of clerics from Le Mans. They intend to rescue the relics of St. Benedict and St. Scholastica, which they believe—as a result of having read Gregory the Great's Life of St. Benedict—must be somewhere in the ruins of Monte Cassino, which had been laid waste by the Lombards. They reach Rome, and go together to pray in St. Peter's. Those from Le Mans decide to linger in Rome for a while to visit the other holy places; but Aigulphus decides to press on to Monte Cassino. Then there is a pause for a responsory. In the sixth lesson, Aigulphus, alone at Monte Cassino and looking for some sign of what he is seeking, is approached by an old man who urges him to reveal the reason for his journey. Aigulphus hesitates, but after reflecting, he explains, in the seventh lesson, why he has come. The old man counsels him not to sleep that night, but to keep watch; and, he says, "When you see a place of this solitude shining with a brilliant light, like a snowy mountain, zealously note the place; for there is to be found what will put an end to your concern." The climax of the story is thus a vision of a bright light shining to mark the place where the remains of Benedict and Scholastica rest. The pause at the end of the old man's words is marked by the responsory *Pater sanctus*, the last in the series of three that sing of other

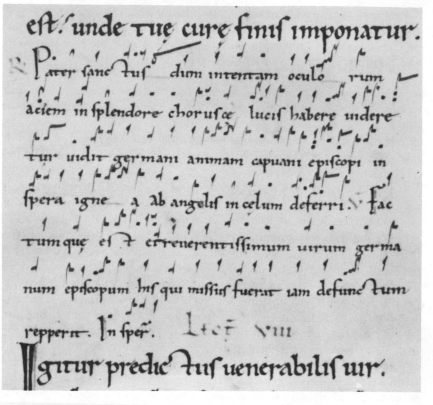

Figure 4.1. Detail from the responsory "Pater sanctus." Lat. 12601, fol. 58ʳ. *Bibliothèque nationale, Paris.*

visions experienced by another monk—St. Benedict himself. The eighth lesson concludes this part of the narrative: Aigulphus sees the miraculous light, finds the relics, and prepares to bring them back to France.[10] Perhaps the rest of the account, describing his return, was read later in the day.[11] The lessons for the Sunday within the octave, and on the octave of the feast, are from the beginning and end of a sermon about St. Benedict by Odo of Cluny, who was the second abbot there, from 927 to 942.[12] In fact, the whole sermon is given; perhaps the rest of it was divided up and read on intervening days.

The responsory *Pater sanctus* thus has a crucial position in the service. If it had been preserved only in this source, there would be no way to transcribe it into staff notation (see Figure 4.1). The musical notation

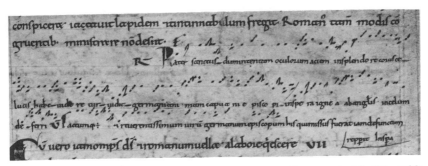

Figure 4.2. Detail from the responsory "Pater sanctus." Lat. 743, fol. 105ᵛ. *Bibliothèque nationale, Paris.*

employed at Cluny consists of neumes—signs that show for each syllable how many different notes there are and whether the melody rises or falls. But the transcriber needs to know how large each interval is, and the relation of the pitch at which one syllable is sung to that of the next. For that one might turn to the St. Martial manuscript (see Figure 4.2). The careful arrangement of the notes there, above and below a dry-point line, makes it possible to know when an interval in the melody is a second, or a third, and so on. But to show more precisely whether each of these is major or minor, a clef is needed. (One is implied by the formula given for the verse of this responsory, but not written.[13]) A twelfth-century antiphonal of St. Maur-des-Fossés (near Paris), lat. 12044, gives the chant in staff notation with clefs (see Figure 4.3). When its reading is matched syllable by syllable with what the Cluny source shows, variants are evident, but not too many of them.[14] A transcription is given in Figure 4.4.

In this melody are heard several turns of phrase that are common among responsories that end, as it does, on the note E, that employ the same musical formulas in their verses, and that have approximately the same range.[15] (Medieval music theorists speak of such responsories as belonging to mode 4; for a fuller discussion of modes see below.) In Figure 4.5, phrases from *Pater sanctus* are compared with some from responsories for St. Stephen; the chants may be said to be as alike and as different as monks who wear the same habit. The melodies are cut from the same cloth, of one design, and then tailored to fit each text. The material that is most likely to be borrowed consists of the groups of notes that set the last few syllables of a phrase. One effect of this is to make the phrasing in these chants clear and graceful, and thus it helps in the effective conveying of the text. But music can do more than this. It can help us to recognize that

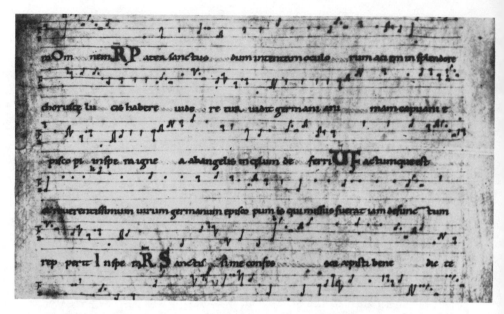

Figure 4.3. Detail from the responsory "Pater sanctus." Lat. 12044, fol. 159ʳ. *Bibliothèque nationale, Paris.*

what is taking place is not an ordinary event, but a celebration. With or without words, music can stir the emotions and give expression to feelings and thoughts in ways that go beyond what words alone can do. This is evident in *Intempesta noctis hora* (see Figures 4.6 and 4.7). At the beginning there is the same kind of relation between text and music as there was in *Pater sanctus*—on each syllable a single note, two or three notes, or (in some cases) a longer series of notes. But on the word *omnem* there is a melisma—a chain of notes. The text here relates that "St. Benedict saw the whole world *(omnem mundum)* gathered up as if in a single ray of the sun."

Gregory the Great follows his account of this miracle with an explanation. His text is set up as a dialogue, and Peter, who has been asking Gregory about St. Benedict, asks, "How can the whole world become visible to a single man?" Gregory replies:

> To a soul that beholds the Creator, all creation is narrow in compass. For when a man views the Creator's light, no matter how little of it, all creation becomes small in his eyes. ... To say that the world was gathered

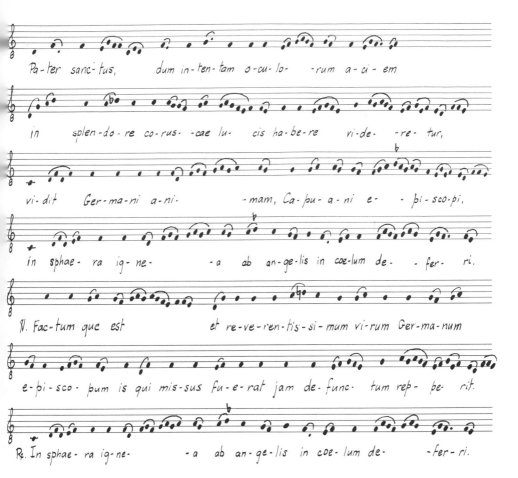

Figure 4.4. Responsory "Pater sanctus." Lat. 12044, fol. 159ʳ. *Bibliothèque nationale, Paris.*

together before his eyes does not mean that heaven and earth shrank, but that the mind of the beholder was expanded so that he could easily see everything below God since he himself was caught up in God.[16]

What Gregory has described is religious ecstasy, something that for Peter had to be explained in words. Perhaps in the chant the melisma is meant to evoke the same sense of ecstasy, of the excitement of the event itself.[17]

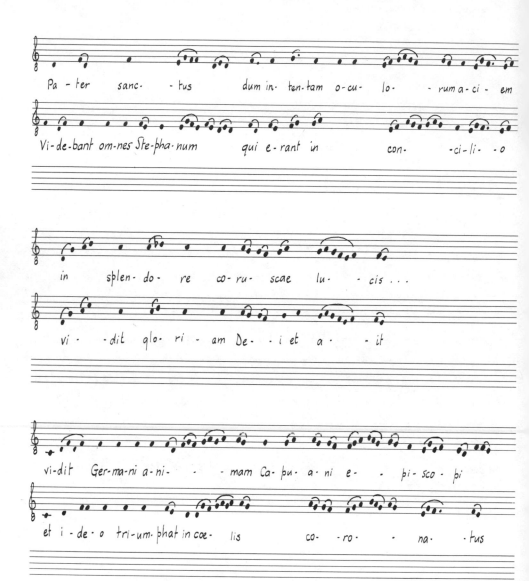

Figure 4.5. Responsory "Pater sanctus" (for St. Benedict). Lat. 12044, fol. 159ʳ. *Bibliothèque nationale, Paris.*

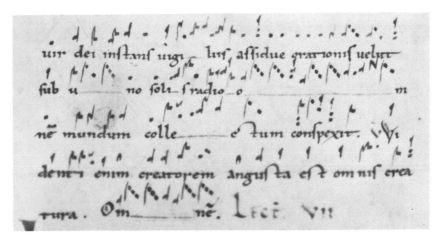

Figure 4.6. Detail, composite, from the responsory "Intempesta noctis hora." Lat. 12601, fols. 57ᵛ–58ʳ. *Bibliothèque nationale, Paris.*

In the third nocturn, both in the Cluny breviary and in that from St. Martial, the lessons are drawn from still another source, the commentary of St. Jerome on the Gospel according to St. Matthew, chapter 19. The first three responsories differ in the two sources, but the last is the same, *O beati viri.* Musically it belongs to the same family of mode IV responsories as *Pater sanctus.* But after the verse the end of the responsory is written out a second time—"*aeterne vite coniunctus est,*"—this time with a long melisma on "coniunctus" (see Figure 4.8). In certain manuscripts the chant appears without this melisma; in the St. Martial breviary, the chant itself is at the top of a page with an ordinary ending, but in the lower margin the melisma is added in a different hand. It appears that the melisma was an afterthought, added later to enrich the music and the service.

Now in certain medieval ecclesiastical centers, the desire to enrich Gregorian chant led to the invention of a dramatically new musical language, that of polyphony. It was this invention that opened the way for those later developments in Western European art music that made it distinctive, utterly unlike the music of other cultures. To be sure, there is no hint of polyphony in the sources under discussion here. But in adding a melisma to this chant, the copyists or compilers are responding to the same impulse as that which prompted the development of polyphony. Hence identifying precisely what music is involved, and how it is handled,

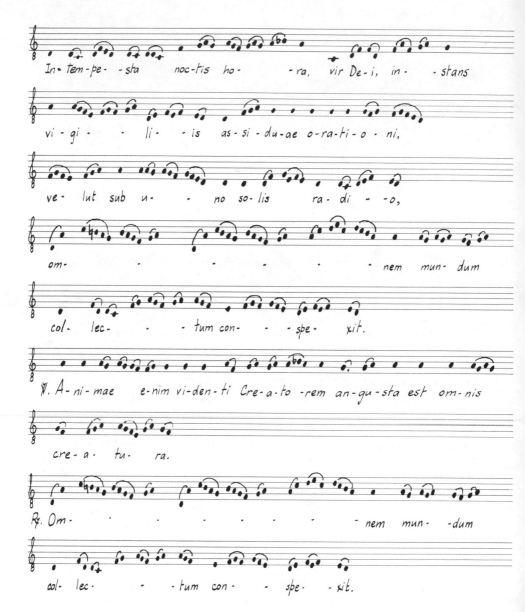

Figure 4.7. Responsory "Intempesta noctis hora." Lat. 12044, fols. 158ᵛ–159ʳ. Bibliothèque nationale, Paris.

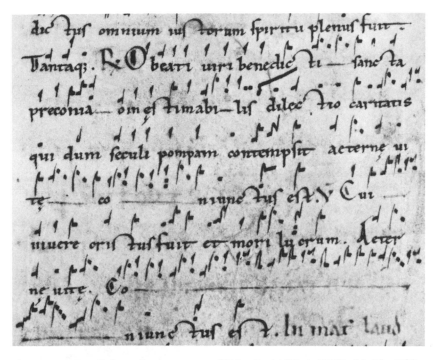

Figure 4.8. Detail from the responsory "O beati viri." Lat. 12601, fol. 58ᵛ. Biblio-théque nationale, Paris.

becomes of more than casual interest. At Cluny the melisma is in five sections, of which all but the first and last are repeated: the form might be represented as *a bb cc dd e*. At St. Martial, the melody is about the same, but section *b* is stated only once (see Figure 4.9). At Nonantola (Rome, Bibl. V. E., Sess. 96), the version is similar to that of Cluny, though the notation is quite different; this is a tenth-century source (see Figure 4.10). From San Salvatore del Monte Amiata, near Siena, an early eleventh-century source (Rome, Bibl. Casanatense, 1907), again shows essentially the same reading as Cluny, though here the melisma is incorporated in the respond the first time through (see Figure 4.11). A twelfth-century anti-phonal from the monastery of San Eutizio at Norcia (Rome, Vallic. C 5) gives the melisma with a different *b* section (See Figure 4.12). In all of these sources the repeat of section *d* is not exact; it is varied a little. But in lat. 12044 the second statement of it is exactly like the first. There is also the melisma—which may once have been intended to convey things that

Figure 4.9. Detail from the melisma for the responsory "O beati viri." Lat. 743, fol. 106ᵛ. *Bibliothèque nationale, Paris.*

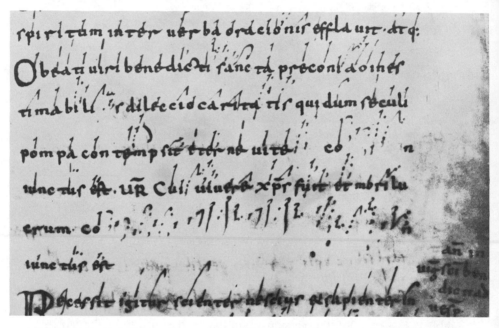

Figure 4.10. Detail from the responsory "O beati viri." Sess. 96, fol. 316ʳ. *Biblioteca nazionale centrale Vittorio Emanuele II, Rome.*

could not be put in words—has been given words, one syllable for each note of the melody (see Figure 4.13). The matter of form in responsory melismas has been exhaustively studied by Thomas Forrest Kelly;[18] for present purposes, it is sufficient to note that the tendency to regularity was stronger in some places than in others, and particularly at St. Maur-des-Fossés. Melismas like this one are added to responsories on major feasts in

Figure 4.11. Detail from the responsory "O beati viri." *Biblioteca Casanatense, Rome.*

a number of medieval antiphonaries and breviaries, and texts (called *prosulae* or *prosae*) are often supplied for them.[19]

The preceding has been intended as a brief introduction to the music of Cluny and to the context in which it was heard. It seems appropriate next to take up the way in which music was studied there. In the Middle Ages, as now, work in the field of music theory had both a speculative and a practical side. A great deal of attention was given to the *modes* of ecclesiastical chant. It is these modes that are represented on the capitals of two columns in the apse at Cluny, where inscriptions identify the modes symbolized by each of the carved figures.[20] What is the connection between these and the treatment of the modes in the liturgical manuscripts and works on music theory of the time?

It is hard to answer this simply, for we do not know just what the term *mode* meant in the Middle Ages. The definitions provided by the medieval music theorists are in some ways not to the point, and too many exceptions have to be made in their application.[21] According to medieval writers, all chants of one mode end on the same note, have comparable ranges, and use essentially the same scale. These characterizations leave some things unexplained—the very close connections among some chants of the same mode (and sometimes also the different modes), and the use of certain combinations of intervals in one mode and not in another where it seems they would be equally correct. A mode must be, then, something like a family of chants; but precisely what the term meant at different times and places is a central question in current chant research.

In liturgical manuscripts, references to the modes take several forms, but most often they occur in connection with psalmody. In the Matins service for St. Benedict (refer again to Table 4.1) there are twelve

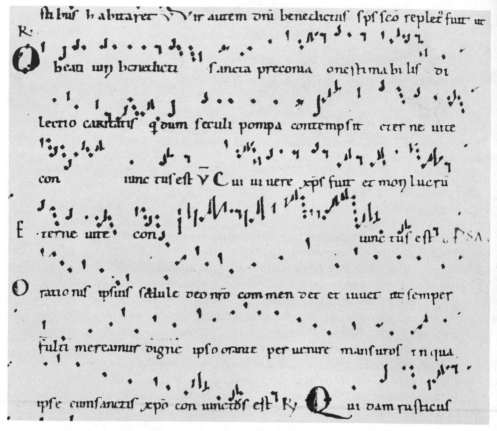

Figure 4.12. Detail from the responsory "O beati viri" with its melisma and prosa. C5, fol. 99ᵛ. *Biblioteca Vallicelliana, Rome.*

psalms. Each is preceded and followed by an antiphon. The psalms themselves are chanted to formulas (called "psalm tones") which give each verse of the psalm the same beginning, the same musical pattern at a division between phrases in the middle, and the same ending. In a psalm, the number of syllables varies from one verse to the next, so the formulas must be flexible; they have certain notes ("reciting tones") that can be repeated as often as necessary to accommodate the text.

How many of these formulas were there? The Cluny manuscript itself does not show, for after each of the antiphons it gives only the *incipit* (opening words) of the psalm to follow, but no musical notation. The

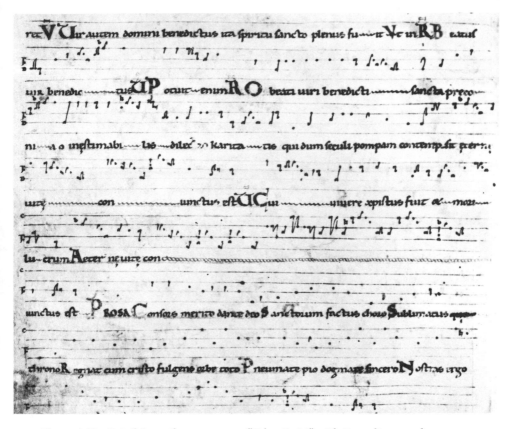

Figure 4.13. Detail from the responsory "O beati viri" with its melisma and prosa. Lat. 12044, fol. 159ᵛ. *Bibliothèque nationale, Paris.*

same is true in other manuscripts—for example, lat. 12584, the earlier of the St. Maur-des-Fossés antiphonals. But most Office manuscripts do contain references to specific psalm tones of one kind or another. One such reference appears in an eleventh-century manuscript that comes from Nonantola (a monastery near Modena) and contains a copy of the old Cluny customary.[22] Among its other contents is a list of incipits of the texts to be sung in the Divine Office, arranged in the order of the liturgical year. Beside the incipits of the antiphons in each service there are the numbers of the tones to be used for the psalm with each antiphon (see Figure 4.14). It is thus evident that there is a system of psalm tones—as it

Figure 4.14. Detail from text incipits of antiphons and psalms for Matins of the Translation of St. Benedict, with numbers for the psalm tones in the margin. 54, fol. 72ʳ. *Biblioteca Casanatense, Rome.*

happens, eight different musical formulas—worked out in such a way that reference to it can be made with numbers.[23] For the psalm introduced by *Dum in hac terra*, tone 1 is to be employed; for the psalms with *Liberiori genere* and *Relicta domo*, tone 8; for *Recessit igitur*, tone 4. In lat. 12044, the later antiphonal of St. Maur-des-Fossés, a procedure is followed that is standard in later manuscripts: the musical incipits of the psalm tones follow the antiphons, and they are followed in turn by the terminations—the patterns used at the end of each verse of the psalm, which may vary according to how an antiphon begins.

We do not know quite how this system came into being. Its essential features appear fully developed in the earliest sources containing references to it from the eighth and ninth centuries.[24] Medieval music theorists wrote about the system of the psalm tones as part of the larger system of the ecclesiastical modes: the mode of an antiphon determines the choice of psalm tone to be combined with it. These theoretical works drew on three sources: direct observation of the melodies in the repertory, a study of ancient Greek writings on music interpreted and summarized in Latin by Boethius at the beginning of the sixth century, and, if terminology is a good indicator, the modal system of Byzantine chant, though the extent to which this last was known in the West in the ninth century, and how it was understood, is something we cannot know.[25]

All of the manuscripts referred to above present chants in the order in which they occur in the liturgy; but these repertories are sometimes presented in another arrangement. There are in certain sources long lists of antiphons—all of those for which one psalm tone is to be used, then all of those for the next, and so on. These are known as tonaries; they are the result of an immense labor of analyzing and classifying melodies carried out by individuals whom we would now identify as specialists in the theory of music. Occasionally one of them explains his reasons for undertaking such work. Regino of Prum, at the beginning of the tenth century, wrote to his archbishop: "When frequently in the dioceses of your church, the choir singing the melody of the psalms resounded with voices in confusion because of disagreement of tone, and when I had seen your Reverence often disturbed by this sort of thing, I seized the Antiphonary; and, considering it diligently from beginning to end through the order, I distributed the antiphons which I found written in it according, as I think, to their proper tones."[26]

What can he mean by "voices in confusion"? Suppose that one day two singers disagreed on the mode of a certain antiphon, one thinking it mode VI, the other, mode VIII. When they went on to the psalm, they

would have chanted two different tones. The result would have been disaster—a series of dissonances so strong that the monks who heard them would probably have stopped singing to try to find out what had gone wrong. The service would have been interrupted, the atmosphere of worship at least partly dispersed. It was clearly desirable to avoid such confusions, and the obvious way was to obtain an authoritative statement of the mode of every antiphon in the repertory—precisely what Regino supplied.

But tonaries have a value beyond the practical aid they offer. Their compilers have had to come to grips with basic issues concerning the materials of medieval liturgical music, and how these are organized and drawn on in the chant repertory. Thus tonaries are of great interest, and Michel Huglo's 1971 study of them is a major contribution.[27] As he points out, some tonaries list every antiphon for a particular psalm tone, organizing them into subgroups if the psalm tone has more than one possible ending. Others give only a sampling. Among these, some do not limit themselves to Office antiphons, but also include responsories, and those Mass chants for which there are verses sung to formulas of their mode. Others even include chants for which no modal formulas are required. These seem to have been drawn up by a teacher (a music theorist) who wanted to present a general picture of a mode through a series of examples of it.[28] (Is there perhaps a parallel between this and a grammar book in which sample phrases are used to demonstrate certain possible constructions?) A student would use such a tonary to become familiar with openings or turns of phrase characteristic of chants in a particular mode, thereby acquiring increasing mastery of the repertory as a whole. (Perhaps a list of the antiphons of one mode is in some ways like a list of the verbs of one conjugation.)

In tonaries and in treatises on music that take the same kind of approach to the repertory, it is hard to avoid the impression that the modes came first, and then all these chants; and yet from certain characteristics in the music itself, we know that this cannot have been the case. Of course, the composition of Gregorian chants continued into the eleventh century, and indeed until much later, and the composers of the later chants knew quite well what they could and could not do in the system. Sometimes they even stressed its features in their works—as, for example, when they wrote the chants for new Offices in such a way that the first of them was in mode I, the second in mode II, and so on.[29] (Much later both Bach and Chopin would produce masterpieces working from a similar point of departure.) But the earlier repertory of Gregorian chant, that in

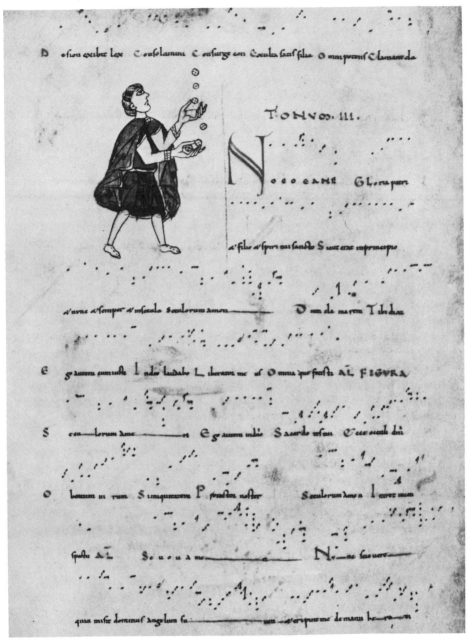

Figure 4.15. Tonary, mode 3. Harley 4951, fol. 298ᵛ. *British Library, London.*

Figure 4.16. Cluny, capital depicting mode 3. *Photo Wim Swaan.*

use up to the ninth century, was the work of men who approached the composing of music in a different way. The theoretical system devised after the fact to interpret it and to put it in order was not entirely success-ful. Rules that are generally valid fail to explain what happens in certain melodies. For such melodies, the manuscripts give an unusual range of

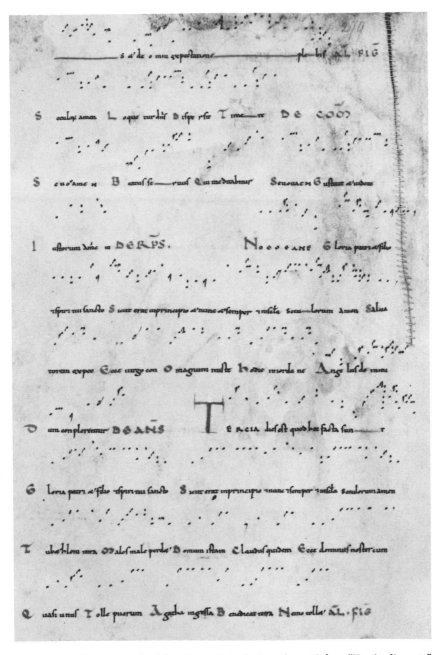

Figure 4.17. Tonary, mode 3 (continued), including the antiphon "Tercia dies est." Harley 4951, fol. 299ʳ. *British Library, London.*

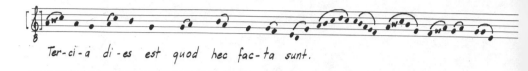

Figure 4.18. Model antiphon for mode 3. Harley 4951, fol. 299ʳ. *British Museum, London.*

variant readings, reflecting the efforts of medieval editors to correct them and bring them into line.[30]

It is quite rare to find in a tonary an illustration at the beginning of the presentation of each of the modes. Yet a whole series of illustrations occurs in the tonary (now unfortunately incomplete) of a gradual from Toulouse (British Library, Harley 4951) that dates from around 1000.[31] It has a picture of a juggler at the point where mode III is introduced. (See Figure 4.15; on the Cluny capital for mode III, shown in Figure 4.16, there is a seated figure holding a lyre.) The music it gives for mode III begins with a characteristic formula that is sung to nonsense syllables, *Noeoeane.* Next comes the melody to be used for the verses and the catalogue of introits of that mode. There follow incipits of selected mode III introits, grouped according to the cadence formulas (some of them quite elaborate) to be employed in their verses, and a version of the introit for the feast of SS Peter and Paul, *Nunc scio vere,* that includes melismas (melismatic tropes) not ordinarily found in that chant.[32] On the next page (see Figure 4.17), selected communions are presented, grouped as the introits were. *Noeoeane* is repeated and followed by the melody to be used for verses of Office responsories of mode III; this is followed in turn by the incipits of several responsories of that mode.

The rubric "DE ANS" then introduces the chant *Tertia dies est quod haec facta sunt,* the model antiphon for the mode. (It is transcribed in Figure 4.18.) This is not a liturgical chant, though it has a New Testament text (Luke 24:21: "It is now the third day since these things happened"). It is one of a series of antiphons, each of which has a text that begins with the ordinal number of its mode—"*Primum quaerite regnum Dei*," "*Secundum autem simile est hoc*," and so on—and is intended to demonstrate musically some features of that mode. In this tonary each of the model antiphons is followed by its neumes and a melisma that might be added to any antiphon of the mode.[33] Apparently these melismas were

Figure 4.19. Tonary, end of the mode-3 chants and beginning of those of mode 4. Lat. 1118, fol. 107ᵛ. *Bibliothèque nationale, Paris.*

popular at Cluny—perhaps too popular, for in his *Statutes* Peter the Venerable finds it advisable to limit their use.[34]

The Cluny capitals are dated at around 1090 by Professor Kenneth Conant. In a study of them and their relation to music, Kathi Meyer demonstrated that the inscription for mode III alluded to the text of the antiphon *Tertia dies est* as it stands in its biblical context.[35] The same procedure is followed in the inscriptions for all but one of the other modes. In the inscriptions, the numeral is always retained and made to refer directly to the mode. Thus the mode is linked through the model antiphon to the biblical context or the event from which the text of the antiphon is drawn. *Tertia dies est* is reflected in the Cluny capital in *"Tertius impingit Christumque resurgere fingit"* ("The third mode encroaches; it depicts Christ rising again").

Such characterizations of the modes are examples in the field of music theory of that borrowing of images and ideas from pagan antiquity and infusing them with Christian meaning that is so common in medieval thought. They form a counterpart to the characterizations of the Greek *harmoniai* (modes) found in Plato, where some are said to be "dirge-like," and others to suggest "the utterances of a brave man ... who, when he has failed ... confronts fortune with steadfast endurance."[36] It is often tempting to attribute a mood to each of the ecclesiastical modes. But from the fact that in the chant repertory texts of very different characters are set to melodies of the same mode, and from the way in which a single text in different liturgical roles may have melodies in different modes, it is evident that this would not be valid.

What then are the illustrations in a tonary intended to depict? The only complete illustrated tonary is that of the Bibliothèque Nationale Manuscript lat. 1118, the subject of an excellent study published by Tilman Seebass in 1973.[37] The images there do not illustrate the modes one by one—how could they?[38] Some of them derive from the tradition of Psalter illustrations, a tradition in which the instruments of music referred to in the Psalms, especially Psalm 150, appear time and again, in forms that change according to the understanding of the Latin names: *"Laudate eum in sono tubae ... in psalterio et cithara ... in tympano et choro ... in chordis et organo ... in cymbalis benesonantibus ... in cymbalis iubilationis.*[39] The figure of King David appears at mode I. For modes II, III, V, and VII there are four other musicians, David's companions, who often appear with him in Psalters. But the pictures for modes IV and VIII show jongleurs, the popular entertainers of the Middle Ages. (See Figure 4.19 for the mode IV picture.) The Cluny capital for mode IV shows bells (*cymbala*; see Figure 4.20). Bells are also carried by the figure that stands at the beginning of

Figure 4.20. Cluny, capital depicting mode 4. *Photo Wim Swaan.*

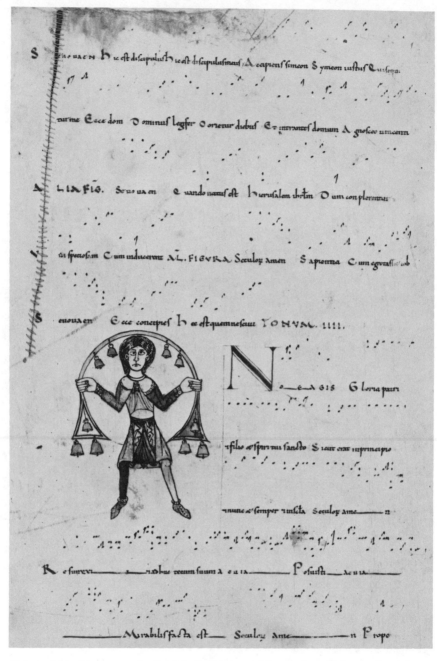

Figure 4.21. Tonary, end of mode-3 chants and beginning of those of mode 4. Harley 4951, fol. 299ᵛ. *British Library, London.*

mode IV in the only other tonary with illustrations of this kind, that from Toulouse (see Figure 4.21).

The representations of the modes on the Cluny capitals make up, as has often been said, a tonary in stone. All the parts of a tonary that can be represented in the medium are present, and the result is a monument both to the ecclesiastical chant of that abbey and to the scholarly analysis of it carried on there. The theory of music must have been studied at Cluny both for what it could help to clarify or correct in everyday musical practice and for its own sake. Indeed, a long tradition attributes unusual diligence in the cultivation of the art and the science of music to that monastery. Unfortunately, this is based, at least in part, on a mistake—the misattribution of a series of treatises about music to Odo of Cluny.[40] It seems now that Odo did not contribute directly to the development of medieval music theory. He did compose a series of chants for the feast of St. Martin, three hymns and twelve antiphons. But his main contributions to music seem to have been those of the enlightened patron—encouraging the effort of others, recognizing the importance of their work, providing a roof under which it could be carried out.[41] There is no questioning Odo's gifts and his achievements in other fields. He was the first great abbot of Cluny and saw in the life and work of St. Benedict a model for his own—"a man of venerable life, blessed in grace as in name." In a sermon about St. Benedict that was read at Cluny in the days following the feast, Odo wrote: *"Ubicunque sancta Ecclesia diffunditur, per tribus, per nationes, per linguas, laus Benedicti frequentatur."*[42] ("Wheresoever the holy Church is spread, by peoples, by nations, by languages, the praise of Benedict is repeated.") It might have been a motto for the monks of Cluny as they sang.

NOTES

1. The Latin text will be cited in this study as it is given in the edition by Umberto Moricca, *Gregorii Magni Dialogi* (Rome: Tip. del Senato, 1924), the English in the translation by Myra L. Uhlfelder *The Dialogues of Gregory the Great. Book Two: Saint Benedict* (Indianapolis: Bobbs-Merrill, 1967).

2. *Regula monachorum*, edited by D. Philibert Schmitz (Maredsous: Éditions de Maredsous, 1946), XLIII, 7.

3. The services given for the feasts of St. Benedict in six different medieval monastic sources are outlined by R.-J. Hesbert in *Corpus Antiphonalium Officii*, 6 vols. (Rome: Herder, 1963–79), 2: 210–15, 243–45, 493–95. The chant texts referred to by incipit there are edited in full in volumes 3 and 4 of the same work; these texts will be given in the present study as in that edition.

4. The lack of consistency in the division of the lessons from one source to another is striking, but no more so than the diversity in the chants themselves. In many breviaries the lessons are very short, only a few lines each; V. Leroquais points out many examples of this in *Les Bréviaires manuscrits des bibliothèques publiques de France*, 6 vols. (Macon: Protat Fréres, 1934). Some breviaries were made for use by monks who were traveling, who needed relatively small (portable) books from which they could carry out their observance of the Divine Office while they were away from the monastery. In such books some abbreviation of the lessons could be expected. But the Cluny breviary to be discussed below is not a small book; it measures 355 by 237 mm. It seems likely that it gives the lessons in the form in which they were read in the monastery itself.

5. To Mario Righetti, it seems that the responsories placed after each of the lessons of Matins may have either an esthetic role—that of providing articulation for the lessons, which if uninterrupted might become monotonous—or a dramatic one, enabling the congregation to express through prayer the emotions experienced during the reading, in *Manuale di storia liturgica*, 3rd ed., vol. 2 (Milan: Àncora, 1969), p. 769.

6. This variety is clearly demonstrated in the six monastic antiphonals surveyed by Hesbert. A study of the Matins services for feasts of St. Benedict has been undertaken by Linus Ellis, a graduate student in music at Catholic University. He has surveyed these offices as they appear in several dozen sources, working with Hesbert's book and with microfilms in the collection of medieval liturgical manuscripts containing musical notation in the School of Music at Catholic University. The choice of manuscripts to be considered here was made partly on the basis of some of his preliminary work; I thank him for sharing it with me.

7. Hesbert, *Corpus Antiphonalium Officii*, V: 13; Leroquais, II: 418–19. References after this one to manuscripts in the Bibliothèque Nationale, Paris, will omit the name of the library.

8. J. Hourlier, "Le Bréviaire de Saint-Taurin. Un livre liturgique clunisien à l'usage de l'échelle Saint-Aurin," *Études grégoriennes* 3 (1959): 163–73. Solange Corbin identifies this and the gradual lat. 1087 as the only early manuscripts from Cluny containing neumes; as she says, it is surprising that there are so few, yet the matter has been thoroughly studied. (*Die Neumen* [Köln: Arno Volk-Verlag, 1977], p. 130.) The origin of this manuscript had not been determined at the time that Léopold Délisle drew up his *Inventaire des manuscrits de la Bibliothèque nationale, Fonds de Cluny* (Paris: H. Champion, 1884), and thus it is not included there. Leroquais determined its place and date of origin (III, 226–28). Hourlier's first study of it was in "Remarques sur la notation clunisienne," *Revue grégorienne* 30 (1951): 231–40. The modifications in the manuscript, and the additions made after it left Cluny, are all relatively minor; in its 271 large folios it gives lessons, prayers, and chants for the second half of the liturgical year, beginning with Trinity. Except for a few places, detailed by Hourlier, "tout le bréviaire a été neumé par les moines de Cluny," "Le Bréviaire," p. 165.

9. Alexandre Vidier, *L'historiographie à Saint-Benoît sur Loire et les Miracles de Saint Benoît* (Ouvrage posthume revu et annoté par les soins des moines de l'Abbaye de Saint-Benoît de Fleury) (Paris: A. et J. Picard, 1965), 141–49, 153–57. The text is published in *Acta Sanctorum*, Mart. III, 3rd ed., 300–303. Concerning the accuracy of this account by Adrevald, the editors of the Vidier book comment, "Cette double question fort difficile des origines de Fleury et de l'authenticité de la translation est actuellement à l'étude. Elle est plus complexe que l'auteur ne le laisse entendre," p. 145, n. 21. See also P. Meyvaert, "Peter the Deacon and the Tomb of St. Benedict. A reexamination of the Cassinese Tradition," *Revue bénédictine* 65 (1955): 3–70. In his article on "Benedetto di Norcia" in *Bibliotheca sanctorum*, II (Rome: Istituto Giovanni XXIII della Pontificia Università Lateranense, 1962), Anselmo Lentini speaks of the narratives of the translation as "così favolosi che, se fossero venuti alla luce oggi,

nessun serio studioso li avrebbe accettati," p. 1151. Other recent thought on the subject is summarized by J. Laporte in his article on Fleury in the *Dictionnaire d'histoire et de géographie ecclésiastiques*, Vol. XVII (Paris, Letouzey et Ané, 1971), cols. 441–76.

10. My thanks to Professor Frank Mantello for his guidance in the interpretation of this text and several others.

11. Even though they tell only part of the story, the lessons here are quite long. Hourlier calls attention to the length of the lessons in this breviary, seeing in it a reminder of "les grandes dévotions clunisiennes," "Le Bréviaire," p. 165.

12. In lat. 12601, the sermon extends from fol. to 59v to 64v; it is edited in J. P. Migne, ed., *Patroligiae Cursus Completus, Series Latina*, 221 vols. (Paris: Migne, 1844–65), 133: cols. 721–29.

13. This is not to deny that there is a large letter *F* at the beginning of the notation of just this chant. Its role is unclear; but if it is in the original hand, and if it is intended as a clef, then it is an anomaly.

14. It would obviously be extremely interesting to find the Office manuscript with staff notation that gives melodies in forms most closely resembling those rendered in neumes in the Cluny breviary. Doing this would require making lengthy and detailed comparisons of the readings of many melodies, something that could not be accomplished within the time limit set for the completion of this study. But the decision to refer here to lat. 12044 was not entirely arbitrary. In volume II of *Corpus Antiphonalium Officii*, Hesbert explained his decision to survey the contents of an earlier antiphonal of St.-Maur-des-Fossés, lat. 12584, by saying that it could be taken to represent, "avec une précision suffisante, toute la famille clunisienne," p. vi. There is a list of antiphonals and breviaries of the Cluniac type in the same work, Vol. V, p. 411, but it is not complete since Hesbert has included there only books that contain services for the Sundays of Advent. Thus lat. 12601 is absent, as is the fragmentary Cluny breviary described in *Revue bénédictine* 57 (1947): 201–209. For a comparison of the two antiphonals of St. Maur-des-Fossés, see A. Renaudin, "Deux antiphonaires de Saint-Maur," *Etudes grégoriennes* 13 (1972): 53–150. Urbanus Bomm dates lat. 12584 in the 10th or 11th century; see *Archiv für Liturgiewissenschaft* 19 (1978): 286. Michel Huglo has observed, "The adoption of the usages of Cluny in a monastery did not always result in the complete disappearance of earlier liturgical practices, particularly in centers as powerful as Corbie, St.-Denis, or St. Martial: the comparison of the manuscripts of these abbeys with those of Cluny is quite instructive on that point. But it should be recognized that in Paris, St. Maur-des-Fossés, and especially St. Martin-des-Champs were much 'closer' to Cluny than the other abbeys mentioned here," *Les Tonaires: Inventaire, Analyse, Comparaison* (Paris: Heugel, 1971), p. 115.

15. W. H. Frere pointed out many such turns of phrase, of frequent recurrence among Office responsories; see the introduction to his *Antiphonale sarisburiense* (London: Plainsong and Medieval Music Society, 1901–24). Understanding of the compositional procedures that led to such similarities is probably not helped by the use of the term *centonization*, as Leo Treitler has pointed out; see his articles, "Homer and Gregory: The Transmission of Epic Poetry and Plainchant," *The Musical Quarterly* 60 (1974): 333–72, and "'Centonate' Chant: *Übles Flickwerk* or *E pluribus unus?*" *Journal of the American Musicological Society* 28 (1975): 1–23.

16. Uhlfelder, *Dialogues of Gregory*, pp. 45–46.

17. This is not to imply that every melisma that appears near the end of a Matins responsory has this role. Such melismas are a commonplace in a later chant style; in certain Matins services every responsory has a melisma. These add to the solemnity of the celebration in a general way, by adding musically to its richness; but they seem not to be intended to

enhance the expression of the individual words or phrases on which they are heard.

18. In his doctoral dissertation, "Responsory Tropes" (Harvard, 1973), and in two articles, "Melodic Elaboration in Responsory Melismas," *Journal of the American Musicological Society* 27 (1974): 461–74, and "New Music from Old: The Structuring of Responsory Prosas," *ibid.* 30 (1977): 366–90.

19. Helma Hofmann-Brandt surveys the whole subject in her dissertation, "Die Tropen zu den Responsorien des Officiums," 2 vols. (University of Erlangen, 1971). See also my articles, "Some Melismas for Office Responsories," *Journal of the American Musicological Society* 26 (1973): 108–31, and "The Gregorian Chant Melismas for Christmas Matins," *Essays on Music in Honor of Charles Warren Fox*, ed. J. Graue (Rochester, N.Y.: Eastman School of Music, 1979), 241–53.

20. Kathi Meyer, "The Eight Gregorian Modes on the Cluny Capitals," *Art Bulletin* 34 (1952): 75–94; Kenneth Conant, *Cluny. Les Eglises et la maison du chef d'ordre* (Macon: Protat Freres, 1968), 89–91.

21. The matter is admirably dealt with by David Hughes in a work intended to serve as a music history textbook for undergraduates, *A History of European Music* (New York: McGraw-Hill, 1974), pp. 8–19; see also his review of Paul Evans' *The Early Trope Repertory of St. Martial de Limoges*, in *Speculum* 48 (1973): 353–55.

22. The source is MS Rome, Biblioteca Casanatense 54. See B. Albers, "Le plus ancien coutumier de Cluny," *Revue bénédictine* 20 (1903): 174–84; *Consuetudines monasticae*, II (Monte Cassino, 1905); M. Huglo, *Les Tonaires*, p. 41.

23. There is one additional formula, called the *tonus peregrinus*, that is limited in use to a certain group of antiphons, and thus in a certain sense stands outside the system under discussion here. Concerning the treatment of it in some early sources, see Carlton Russell, "The Southern French Tonary in the Tenth and Eleventh Centuries" (Ph.D. dissertation, Princeton University, 1966), pp. 76–80.

24. Huglo discusses these in his first chapter, *Les Tonaires*, pp. 25–45.

25. J. Ponte, "Aureliani Reomensis *Musica Disciplina*" (Ph.D. dissertation, Brandeis University, 1961), Vol. III, pp. 42–49, goes over one area in which Byzantine modal practice seems to have influenced that of the West. See also the text on which this is a commentary, Vol. II, pp. 67–70.

26. Sister Mary Protase LeRoux, "The *'De Harmonica Institutione'* and *'Tonarius'* of Regino of Prüm" (Ph.D. dissertation, Catholic University, 1965), p. 23.

27. Huglo, *Les Tonaires*

28. On p. 29, Huglo introduces the notion of "a special category which we call 'tonaries for teaching' or didactic tonaries, in contrast to practical tonaries, intended for the use of singers, in which all antiphons of the repertory are classified."

29. Huglo, *Les Tonaires*, pp. 122–28.

30. U. Bomm, *Der Wechsel der Modalitätsbestimmung in der Tradition der Messgesänge im IX. bis XIII. Jahrhundert* (Einsiedeln: Benziger & C., 1929); D. Dealande, *Le Graduel des Prêcheurs* (Paris: Editions du Cerf, 1949); K. Fleming, "The Editing of Some Communion Melodies in Medieval Chant Manuscripts" (Ph.D. dissertation, Catholic University, 1979).

31. This is the dating of the illustrations in it given by Tilman Seebass in *Musikdarstellung und Psalterillustration im früheren Mittelalter: Studien ausgehend von einer Ikonologie der Handschrift Paris, Bibliothèque Nationale, fonds latin 1118* (Bern: Francke Verlag 1973), Textband, p. 84. That there were parallels between the illustrations for the modes on the Cluny capitals and those in this manuscript was pointed out long ago; see *Speculum* 7 (1932): 31, where K. Conant thanks Charles Niver for calling his attention to the

drawings in lat. 1118 and Harley 4951, and (opposite p. 33) gives a facsimile of one of the drawings in each manuscript.

32. G. Weiss, *Monumenta monodica medii aevi, III: Introitus-Tropen I* (Kassel: Baerenreiter-Verlag, 1970), supplementary vol., p. 22, gives this introit as it appears in lat. 909, where the melismatic tropes are similar, though not identical, to those of Harley 4951. See also Russell, "The Southern French Tonary," pp. 83, 88.

33. For these see Huglo, *Les Tonaires*, pp. 383–90.

34. "Statuta Petri Venerabilis," edited by G. Constable, *Corpus consuetudinarium monasticarum*, VI (Siegburg: Apud Franciscum Schmitt Success, 1975), 98.

35. See the works referred to in footnote 20. Even after thirty years, Kathi Meyer's catching these allusions still seems absolutely brilliant. See also Huglo, *Les Tonaires*, pp. 386–87.

36. O. Strunk, *Source Readings in Music History* (New York: Norton, 1950), pp. 4–5; from *The Republic*, I, 10.

37. See note 31. Seebass includes first-rate color reproductions of these illustrations.

38. In his review of Seebass' book, J. McKinnon observes, "As the earliest illustrated tonary, [lat. 1118] leaves us with no precedents to aid in its interpretation; even more basic, the illustrations, unlike most early medieval miniatures, do not function as illustrations in the narrow sense. Thus the first illustration has no specific relationship to the first church mode, in spite of the fact that the first eight illustrations are carefully aligned with the beginning of the eight sections of the tonary. ... Presumably, then, the illustrations relate to the tonary as a whole, perhaps to its general character as a liturgical music book; in this case, they might be borrowed from some well-established genre of medieval illustration having to do with liturgical music," *Journal of the American Musicological Society* 28 (1975): 362.

39. See the "vergleichende Tabelle" at the end of Seebass' Bildband, and Chapter V of the Textband, "Musik als Thema der bildenden Kunst im früheren Mittelalter," pp. 83–164.

40. Dom Pierre Thomas, "Saint Odon de Cluny et son oeuvre musicale," *A Cluny: Congrès scientifique; fêtes et cérémonies liturgiques ... 1949* (Dijon: Bernigaud & Privat, 1950), pp. 171–180. For Dom Thomas, "The hypothesis according to which works concerning the theory of music can be attributed to St. Odo has been proven false for all the treatises published under his name except for one—the tonary of the manuscript Monte Cassino 318—and even that is doubtful" (p. 179). Huglo, however, is able to demonstrate conclusively that of all the tonaries attributed to an Abbot Odo, not the smallest fragment can be ascribed to Odo of Cluny (*Les Tonaires*, p. 185).

41. Dom Thomas puts it as follows: "But the hymns and antiphons written by St. Odo are not his only reason for being remembered by friends of sacred music. If he himself composed verses and melodies, would he not also have encouraged, in the famous Aquitanian monasteries, the developing talents of younger composers and poets? ... The art of musical composition made significant progress beginning at the end of the tenth century; perhaps some credit for that should be given to St. Odo, to the extent that he, as the superior of so many in religious life, had the wisdom to help along those works of artistic creation and transcription that are so effective in combating spiritual sloth and, even more, in maintaining and refining that attraction to the beautiful that is one of the ways in which God reveals Himself to His creatures," *Saint Odon de Cluny*," p. 180.

42. J. P. Migne, *Patr. lat.* 133, col. 728 D; in lat. 12601, this passage appears on fol. 64ᵛ as part of the fourth lesson on the octave of the feast of the Translation of the Relics of St. Benedict.

The Cistercian Contribution

Otto von Simson

Professor Otto von Simson traces the roots of later medieval piety to the influence of the great Cistercian monastic theologian, St. Bernard of Clairvaux. He interprets the new sensibility evident in Gothic sculpture as a reflection of the affective spirituality of St. Bernard, with its mystical concentration on love. Von Simson stresses the effect of this new emotional atmosphere in monasteries on contemporary and later lay piety, seen especially in the appearance in art of devotional images that emphasize Christ's humanity. In the final section of this chapter, Professor von Simson explores the esthetic background of that style of church plan associated with St. Bernard, expanding and bringing up to date ideas originally presented in his monumental study of medieval architecture, *The Gothic Cathedral.*

Otto von Simson is Professor Emeritus of Art History of the Free University of Berlin, Federal Republic of West Germany.

CISTERCIAN THEOLOGY AND GOTHIC SCULPTURE

To speak of the contribution of Cistercian spirituality to monasticism and the visual arts is to speak of the renaissance of St. Benedict's *regula sancta* and of his concept of monastic life. The Cistercian reform is certainly part of that "renaissance of the twelfth century" often evoked by historians, and in many ways it is the most important part of that renaissance.

115

The founders of Cîteaux (and no one more than the greatest figure of the order, St. Bernard of Clairvaux) were determined to restore and to live St. Benedict's *Rule* in its pristine and pure form.[1] The impact of that reform, and, in particular, of St. Bernard's thought upon medieval art was profound and far reaching, so much so that medieval art after St. Bernard was never to be the same as it had been before him. The influence of the Abbot of Clairvaux and his mystical theology can be traced not only in Cistercian architecture but in much of the painting and sculpture of the High Middle Ages as well.

In the early twelfth century, St. Bernard launched an attack upon the worldliness of the great Benedictine monastery of Cluny, an attack that included a scathing criticism of Cluniac art and architecture.[2] That attack has so colored the view of historians regarding Bernard's opinions on Christian art that he has frequently been called a puritan.[3] In point of fact Bernard objected to two quite distinct aspects of Cluniac art, which have often been misunderstood by being confounded with one another. There was, first of all, the sumptuousness of Cluniac churches, their vastness and the spendor of their liturgical furniture. To St. Bernard both seemed incompatible with the ideal of monastic poverty and with the postulate of Christian charity towards the poor. On them, Bernard felt, rather than on expensive liturgical vessels were the monastery's resources to be lavished. On the other hand, Bernard's hostility towards what seemed to him the superfluous, grotesque, and distracting ornaments of Romanesque sculpture sprang from a very different source, one that had nothing whatever to do with his alleged puritanism. His quite extraordinary ability to describe these works of sculpture, rightly praised by Erwin Panofsky, points to an unusual esthetic sensibility. And it was this very sensibility that made the Abbot of Clairvaux fearful of the effect, not only of the imagery he inveighed against, but of all images excepting painted crucifixes upon his monks. He told his young novices to "leave the senses behind" upon entering the monastery, and his own attitude (which the superficial modern observer might interpret as absent-mindedness) was exemplary. His biographer tells us that St. Bernard was convinced that the church in which he spent many hours every day had but one window when in point of fact it had three.[4]

When considering St. Bernard's attitude towards religious art two things must be borne in mind. On the one hand, he was quite ready to admit that religious imagery was necessary to kindle the devotion of the *carnalis populus*, the people living in the world outside the cloister. His rejection of that imagery for the Cistercian monastery, on the other hand, sprang from his conception of monastic spirituality, a spirituality centered

in the vision of divine love that would eventually lead the monk to that ultimate aim of Christian meditation, the union of his soul with God. It was in the light of that contemplative ideal that Bernard perceived the Cistercian cloister—and especially the monastery church—as a *paradisus claustralis*, an enclosed paradise. Here, on the threshold of this spiritual vision, St. Bernard found all images wanting.[5]

These basic facts are to be borne in mind when we inquire into the Cistercian influence upon art. That this influence was not purely negative, that St. Bernard was not a puritan (notions that have long distorted historical evaluation), is evident in the grandeur of Cistercian architecture—a reminder that beauty is never absent from the Benedictine monastery. Many volumes have been devoted to Cistercian architecture and Bernard's influence upon it. My object here is to explore instead the possible impact of St. Bernard's thought upon both iconographic themes and their expression in High Medieval art.[6]

St. Bernard's mystical theology centers in the idea that "God is love" (1 John 4:8), an idea also essential to Benedict's *Rule*. In elucidating that theological truth, however, the Abbot of Clairvaux goes far beyond St. Benedict, who alludes to it but tersely. Benedict emphasized meditation on the Last Judgement: fear, and not only the fear of God but also of God's punishment, play a capital role in the apprenticeship of spiritual life as St. Benedict conceived it. It is of course important to note that at the end of this apprenticeship love takes the place of fear as the motivation for our acts (RB 7:68–69). But whereas St. Benedict does not explain *how* humility introduces love, this is the very question Bernard sought to answer. According to the *Rule* of Benedict, the monk reaches the vision and beholds the reality of God's love only after the gradual and arduous ascent of the Jacob's ladder of monastic asceticism (RB 7:5–9). St. Bernard explicitly connects this insight with what is said in the First Letter of St. John: "He that loveth not, knoweth not God, for God is love" and, further, "Herein is our love made perfect that we may have boldness in the Day of Judgement. There is no fear in love, but perfect love casteth out fear" (1 John 4:8 and 4:17–18). Indeed, in commenting on St. Benedict's "ladder" of asceticism, Bernard paraphrases St. John, saying, "*ad caritatem Dei perveniet illam quae perfecta foris mittit timorem* ("it [the ladder] reaches that love of God which perfectly casts out fear)".[7]

Thus the fearful vision of the Last Judgment and of God's wrath is replaced by a very different one of God as love, a vision from which fear has been expelled. I would suggest that this redirected emphasis of St. Bernard's may have been responsible for, or reflected in, a significant transformation of the iconography of the Last Judgment.

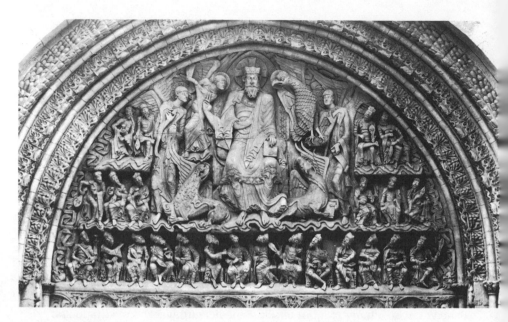

Figure 5.1. Tympanum, Abbey of Moissac. *Photographie Bulloz, Paris.*

The great tympana of the Benedictine abbey church of Moissac
and of the Royal Portal of Chartres Cathedral have often been compared
(Figs. 5.1 and 5.2). At Moissac the Divine Judge is a fearful God, a God of
wrath, perhaps the most monumental evocation of the dominant religious
attitude of what we call the Romanesque Age. The Christ in Majesty of
Chartres, while representing the same eschatological theme as the tym-
panum at Moissac, certainly does not evoke fear. He appears mild and even
benign, although the artist has magnificently succeeded in merging these
qualities with the majesty of the Judge in his vision of the Second Coming.
The tympana at Moissac and Chartres may hardly be more than two
decades apart: they are datable, respectively c. 1125–30 and c. 1145–55.
That is what renders so extraordinary the change of content to which the
new style of the Chartres west façade seems so admirably attuned. May we
discover here the influence of St. Bernard? All we can say is that the Christ
of Chartres seems as close to Bernard's mystical theology of God as love as
the Christ at Moissac appears alien to it. We may add that the bishop
under whom these sculptures of the west façade of Chartres Cathedral
(which mark a watershed in the history of medieval art) were executed,
Bishop Geoffrey of Lèves, was a close friend of St. Bernard's, so close that to

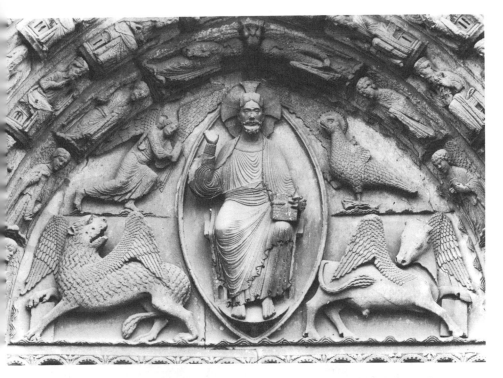

Figure 5.2. Tympanum, Royal Portal, Chartres Cathedral. *Bildarchiv Foto Marburg.*

contemporaries the two men appeared inseparable.[8] Geoffrey's admiration for the Abbot of Clairvaux was reciprocated by St. Bernard. So it seems quite likely that the vision of God's love, and of our confidence in God's love replacing fear, quintessential in St. Bernard's thought, should also have inspired the splendid composition over the Royal Portal at Chartres.

There are other interesting changes in the iconography of the Last Judgment that make the transition from what we call Romanesque to what we call Gothic. In the tympanum over the central entrance to the southern transept of Chartres Cathedral, executed nearly half a century after the west façade, there is depicted the Last Judgment according to St. Matthew (Fig. 5.3). One interesting aspect of this scene, that I should like to mention in passing, is that the central group no longer shows the so-called *Deësis*—Christ between the Virgin Mary and John the Baptist as intercessors; the Baptist's place has been taken by John the Evangelist, the disciple "whom Christ loved" and supposed author, not only of the fourth

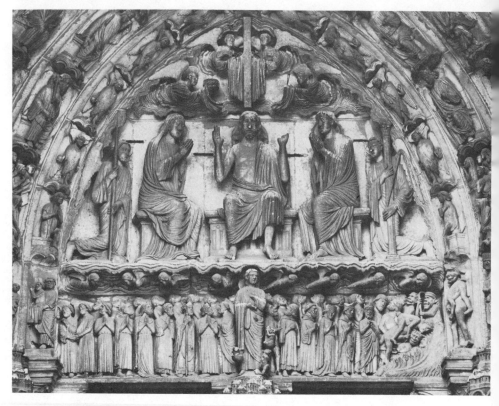

Figure 5.3. Tympanum, Central Portal of South Transept, Chartres Cathedral. *James Austin MA FIIP.*

Gospel and the Book of Revelation but of that epistle to which I have referred as central to St. Bernard's teaching. That John the Evangelist should be singled out here in the representation of the Last Judgment bears witness to the singular devotion he enjoyed along with the Virgin Mary since the twelfth century; his presence in this Judgment scene may also be a reminder of John's words, already quoted, "Herein is our love made perfect that we may have boldness in the Day of Judgment."

Bernardine influence upon the iconography of the Last Judgment seems evident elsewhere. The allegories of Church and Synagogue had long figured in this scene. Ecclesia appeared on Christ's right side crowned and triumphant, while Synagogue, personifying the Old Law of the Jews, was shown defeated and rejected: the crown and royal mantle taken from

her, she is blindfolded to suggest the blindness of the Jews who have failed
to recognize the Messiah, and her staff, the scepter of her power, has been
broken. In a beautiful miniature in Lambert of St. Omer's *Liber Floridus*
(c. 1120), this eschatological theme is represented in what may be called
Romanesque or pre-Bernardine iconography. Christ is shown repulsing
Synagogue while accepting Ecclesia as his spouse.[9]

The allegories of Church and Synagogue within the context of the
Last Judgment point to the exegesis of the biblical text that, next to the
Psalter, elicited during the twelfth century more commentaries than any
other book of either the New or the Old Testament: Solomon's Song of
Songs. This work is the source of the bridal mysticism of medieval theol-
ogy. St. Ambrose referred to it on innumerable occasions; St. Bernard's
close friend and biographer, William, Abbot of St. Thiery (who eventually
became a Cistercian himself), collected these passages in the work of St.
Ambrose in a single treatise. It was St. Ambrose who, in the Song of Songs,
had heard the voices of two brides of the heavenly bridegroom, identifying
one with the Church, and the other with the Synagogue. Since the eleventh
century this thought was taken up and further developed in commentaries
and paraphrases of the Song of Songs. What is noteworthy is the fact that
in these works the thought that one of the brides, the Synagogue, will be
rejected gives way to a different idea: that of reconciliation between the
two brides in their common love of the divine bridegroom, Solomon-
Christ.[10]

St. Bernard was by no means the only theologian to have
expounded this idea, but he was certainly the most eloquent and the most
influential one. To the Song of Songs he devoted more than eighty sermons
delivered before his monks in the cloister of Clairvaux and, although he
sternly admonished them not to take any notes, one of them fortunately
disobeyed him, thus putting posterity in his debt. In these remarkable
sermons, the bridal mysticism of the theology of love, and the vision of the
two brides reconciled in their common love of the divine spouse has found
its most profound exposition. Obviously, the iconography of Church and
Synagogue as given in the *Liber Floridus* is incompatible with St. Bernard's
thought. It is all the more remarkable that since the mid-twelfth century,
this iconography changes, and Ecclesia and Synagogue in a number of
important representations are differently interpreted.[11]

The most beautiful representation of Church and Synagogue in
medieval art is undoubtedly that on the southern transept façade of
Strasbourg Cathedral (Fig. 5.4). Unfortunately this group is no longer
complete. The central figure of Solomon-Christ on the trumeau (Fig. 5.5)
was destroyed in the French Revolution and has been replaced by a copy.

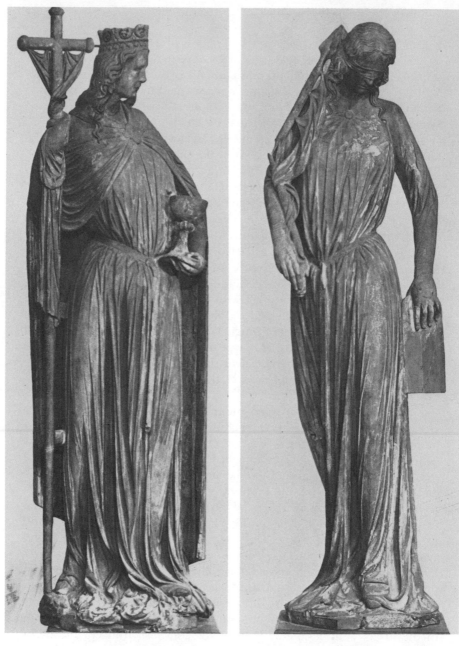

Figure 5.4. *Ecclesia and Synagoga*, South Portal, Strasbourg Cathedral. *Von Simson.*

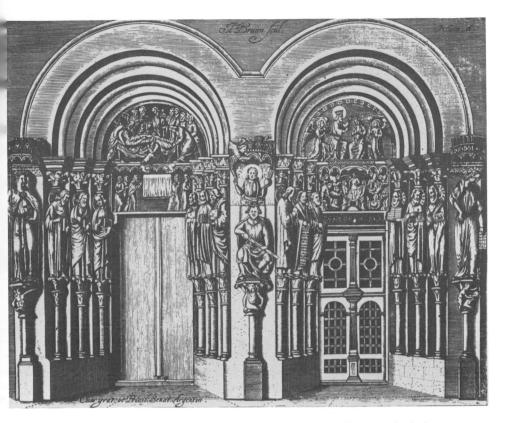

Figure 5.5. Pre-1789 engraving of the South Portal, Strasbourg Cathedral. *Von Simson.*

The two feminine allegories are oriented towards this figure. Contrary to a view that has long prevailed, the Church and Synagogue are not shown here in hostile confrontation; what we are witnessing is their impending reconciliation, the moment when the Synagogue is about to return to follow the exhortation of her sister the Church, here of course meant to suggest the eventual conversion of the Jews that was predicted to occur before the Last Judgment.[12] It is interesting to note in this context that the figure of the Synagogue is more beautiful, just as the passage of the Song of Songs (1:16; 4:1), "Behold, thou art beautiful my love," was in medieval exegesis occasionally applied to her rather than to the Church. Ecclesia, I believe, is shown awaiting the return of the Synagogue to their common bridegroom, an interpretation that is confirmed by literary parallels of the

time. It is the Church who in sisterly compassion calls on the Synagogue to return.

Further confirmation of this intepretation is found in the program of a church portal which, although demolished, is known to us by an eighteenth century drawing now in the *bibliothèque municipale* at Besançon. On either side of the portal of the Church of the Magdalene at Besançon there is represented Ecclesia in the midst of six apostles and opposite her Synagogue in the midst of six prophets. Synagogue carries the model of the Solomonic Temple. The composition, fragments of which have survived, is chronologically and stylistically close to the Strasbourg sculpture. What seems to me interesting is that at Besançon, Ecclesia and Synagogue were juxtaposed on a level of nearly equal dignity and with no trace of hostility of the one against the other.

The remarkable fact about the Strasbourg façade is that the theme is the traditional one of the Last Judgment. However, the figure of Solomon-Christ appears not only as judge but as bridegroom. And the bridal mysticism—possibly suggested by the prominent role which the Song of Songs played in the medieval liturgy of Strasbourg Cathedral— allows the vision of reconciliation to vanquish the fearsome evocation of retribution and punishment. I suggest that that vision would not have taken hold of the Christian imagination without St. Bernard's grandiose interpretation of the Song of Songs.

ST. BERNARD AND THE MAN OF SORROWS

I should like also to raise the question of the influence of Bernardine spirituality upon Christian iconography with regard to the Man of Sorrows, since about 1300 perhaps the most popular devotional image of the later Middle Ages. Its typological origin in the East seems beyond doubt. But what are the reasons that account for its popularity?

According to St. Bernard, the meditation over Christ's Passion is the center of Christian spirituality. God, he explains, knew the misery of the human estate but wanted to experience it.[13] Why did God desire this *experientia passionis?* Bernard's answer to this mystery is as simple as it is moving. He imagines, as it were, a divine monologue in which God poses to himself the question of how to save mankind. "Of course," God says, "I could compel him. But what good would that do? Man, though a noble creature, acting under such compulsion would be no better than a beast.

And shall I give the kingdom of Heaven to an ass?" Again, God says, "I could instill fear in him, but all the horrors of hell, its darkness and its fire, have not induced him to turn to me. Or, I could appeal to man's concupiscence, to his greed. But have I not promised him everything already? Eternal life, and in eternal life bliss which no eye has seen and no ear has heard. But even this promise has not been sufficient to lure man away from sin." It is at this point that God recalls the third force by which man is motivated, and that force, stronger than anything else, according to St. Bernard, is love. And so God decides to appeal to man's love. It is this sublime purpose that determines God to become man by sharing man's suffering, that God might reveal his charity, his *pietas*. It is at this point that there emerges before the mystical vision of St. Bernard the suffering Redeemer, the *imago pietatis*, the image of Christ as the "Man of Sorrows," as he calls him, following the Prophet Isaias.[14]

As a devotional image the Man of Sorrows became popular only much later, meeting the needs of the private and individualized devotion so characteristic of the fourteenth and fifteenth centuries. Yet it seems certain that the theme springs from that vision of Christ's Passion that for St. Bernard was the ultimate token of divine love. In this context I should like to call attention to yet another group of sculptures at Strasbourg, namely, the Pillar of Judgment inside the south transept of the Cathedral (Fig. 5.6). Here the Last Judgment is represented once more, but again in an entirely novel fashion. Omitting the usual groups of the blessed and the damned, the sculptor shows but a small group of human beings rising from their graves. Their faces are turned upwards, their gestures appealing to the mercy of Christ who is not majestically enthroned but almost awkwardly seated above them. This Christ has shed the last vestiges of the stern Judge; showing the wounds of his Passion, his facial expression meek and gentle, he appears, if not actually as an anticipation of the Man of Sorrows, at least as an extraordinary fusion of Christ in Judgment with the *imago pietatis*.[15]

The Pillar of Judgment, like the group of Church and Synagogue at Strasbourg to which it is closely related in style as well as spirit, was executed about eighty years after St. Bernard's death. I cannot prove that they were commissioned as evocations of St. Bernard's thought. My intention has been to demonstrate, firstly, the remarkable transformation of one of the great traditional themes of Christian art, the Last Judgment, and secondly, the emergence of what was eventually to become the most popular devotional image, the Man of Sorrows—both as it seems to me in intimate relation to the very core of St. Bernard's mystical theology of divine love. No other medieval theologian has evoked with comparable

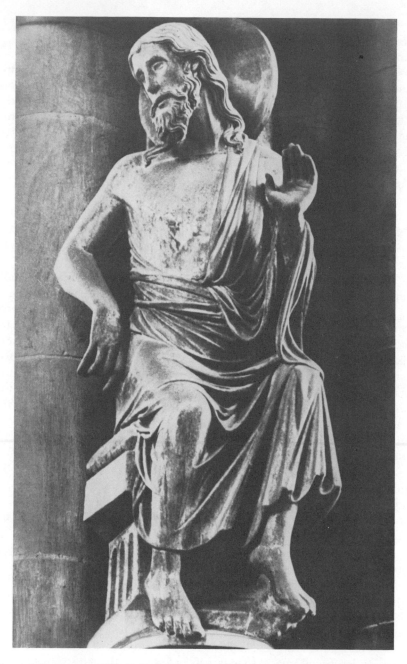

Figure 5.6. Christ on Pillar of Judgment, South Transept, Strasbourg Cathedral. *Von Simson.*

profundity or comparable eloquence the claim *Amor vincit timorem* or the *imago pietatis* as the revelation of the mystery of salvation. The great mystics and theologians of the thirteenth century, especially those of the Franciscan order, are all indebted to Bernard.[16] I believe the new interpretations and the new themes emerging in what we call Gothic art likewise have their roots in his thought. Bernard, I believe, was one of St. Benedict's greatest followers. The purpose of my remarks would be fulfilled if I have demonstrated the seminal role of Bernardine thought in the unfolding of Gothic imagery—for which he himself, within the walls of his *paradisus claustralis*, would have had no use.

THE CISTERCIAN CONTRIBUTION TO ARCHITECTURE

St. Bernard's primary concern was with spirituality, not with esthetics. For the medieval mind, however, beauty was itself a manifestation of truth—the *splendor veritatis*, as Thomas Aquinas was to call it in the thirteenth century—and thus part of the spiritual realm. Already in the twelfth century, Bernard's illustrious contemporary and friend, Hugh of St. Victor, taught that beauty reveals God's wisdom, and the Abbot of Clairvaux himself thought no differently.

There is no better proof of St. Bernard's view than Cistercian architecture. Anselme Dimier, the eminent Cistercian architectural historian, remarked many years ago that the structures built by the White Monks can be understood only within the context of Cistercian spirituality, and substantiated that proposition from the viewpoint of Benedictine and Cistercian asceticism.[17] I believe Dimier's statement can be extended in another direction. The earliest Cistercian churches—their execution and in all probability their plan—were so closely associated with the Abbot of Clairvaux that the term "Bernardine architecture" has recently become more and more accepted. To understand this architecture as an evocation of Cistercian spirituality, we must recall first of all what has become unfamiliar to us, although it was self-evident to the Middle Ages: I mean the intrinsic rapport between architecture and music.[18]

This affinity was expounded by St. Augustine of Hippo in his celebrated treatise, *De Musica*, and further elaborated by Boethius in the sixth century. The gist of this doctrine was that music is the science of good modulation, concerned with relating several musical units according to a module, a measure, in such a way that the relationship can be expressed in

simple mathematical ratios. The most perfect of these is the ratio of 1:1 or unison. Next in rank are the ratios 1:2, 2:3, and 3:4, which correspond to the musical consonances octave, fifth, and fourth, respectively. To St. Augustine, as to the Middle Ages, these were the "perfect" consonances: not because of their acoustic or esthetic qualities, but as audible echoes of metaphysical perfection. Centuries before Christianity, Pythagorean mysticism had already ascribed to number, especially the numbers 1, 2, 3, and 4 the same metaphysical dignity.[19]

Thus, since Augustine's principles of good modulation were mathematical principles, in his opinion and in that of his medieval followers they could be applied to the visual arts as well as to music. On the monochord the musical intervals are marked off by divisions on a string; the arithmetical ratios of the perfect consonances thus appear as the proportions between different parts of a line. And since Augustine deduced the musical value of his "perfect" consonances from the metaphysical dignity of the simple ratios on which they were based, it was only consistent for him to conclude that visual proportions based on the same ratios were equally perfect. In his treatise *De Ordine*, Augustine describes how Reason, in her quest for the blissful contemplation of divine order, turns first to music and then to what lies within the range of vision. Beholding earth and heaven, she realizes that only beauty can ever satisfy her, and in beauty only the figures which underlie beauty's structure, and in those figures only proportion, and finally in proportion, number.[20]

It is difficult for us to grasp the impact of this musical mysticism on medieval spirituality. Let me give you but one example. In his treatise on the Trinity, St. Augustine meditates on the mystery of redemption by which the death of Christ atoned for humanity's twofold death (of body and, through sin, of soul). As Augustine ponders what he calls this congruence, this correspondence, this consonance of one and two, musical experience gradually gains hold over his imagination until it suddenly dawns on him that *harmony* is the proper term for Christ's work of redemption. "This is not the place," Augustine writes, "to demonstrate the value of the octave that seems do deeply implanted in our human nature— by whom if not by Him who created us?—that even the musically and mathematically uneducated immediately respond to it." Augustine feels that the sound of the octave, that is, the musical expression of 1:2, conveys even to human ears the mystery of redemption.[21]

Let us turn from music to architecture, and from St. Augustine to St. Bernard. It is only consistent with Augustine's metaphysics of beauty, based on the metaphysics of number, that it should be hostile to images;

and it is equally consistent that he should have appreciated architecture. In fact, Augustine considered music and architecture as sisters, since both, if scientifically understood and scientifically applied, are children of number, of perfect ratios. They have equal dignity, inasmuch as architecture mirrors eternal harmony just as music echoes it. As to the esthetic perception of this affinity, Augustine's pupil Boethius observed that "the ear is affected by sound in quite the same way as the eye is by visual impression."[22]

As to St. Bernard, he may well be described as an Augustinian. He once wrote that, with Augustine, he wished to err as well as to know. He considered the Bishop of Hippo the greatest theological authority after the Apostles. And the library at Clairvaux (St. Bernard's creation, as Dom André Wilmart has pointed out) contained all the works of St. Augustine from which I have quoted.[23] At the same time, Bernard was intensely musical. Something of a composer himself—and even in this regard an Augustinian, as Father Luddy observed—he was once invited to compose an office for the feast of a saint. In his reply, Bernard stated his views of what ecclesiastical music ought to be. It ought to radiate the truth, *resplendeat veritate* (we are reminded of Aquinas' definition of beauty as *splendor veritatis*), and should be attuned to the ascetic and spiritual life of the community.[24]

That these values were to be reflected in ecclesiastical architecture as they were in music must have been obvious to St. Bernard, and fortunately there is evidence that this was the case. The oldest surviving Cistercian church in France is at Fontenay (Fig. 5.7). As John Bilson was the first to point out, this church was intimately connected with St. Bernard. Founded as a daughter community of Clairvaux, Fontenay's first abbot was Bernard's cousin Godfrey and its principal benefactor his maternal uncle. Begun in 1139, the church was solemnly consecrated in 1147 in the presence of Pope Eugenius III and St. Bernard. It may well have been designed by the Cistercian monk Achardus under Bernard's direction, *"jubente et mittente beato Bernardo"* ("St. Bernard ordering and sending [him]"), since Archardus is known to us as *"plurimorum coenobium initiator et extructor"* ("the one who began and built many monasteries").[25]

Now in Fontenay, Augustinian harmonies are very much in evidence. The octave ratio 1:2 determines the elevation as well as the ground plan. Moreover, the bays of the side aisles are of equal length and width, and exactly the same dimensions are marked off vertically by a stringcourse. We thus obtain what might be called a spatial cube, a fact recalling what Boethius calls "geometrical harmony," since in a cube the surfaces, angles, and edges—6, 8, and 12 in number, respectively—are related to one another as are the ratios of octave, fifth, and fourth.

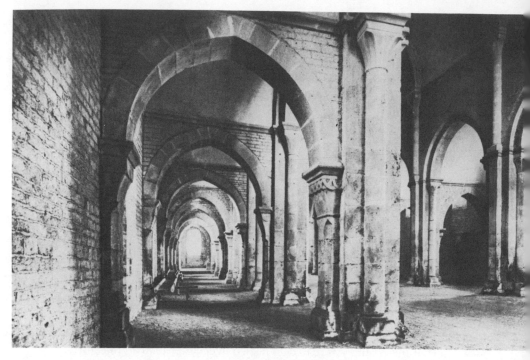

Figure 5.7. Aisle and Nave, Abbey of Fontenay. *Von Simson.*

This interpretation of Cistercian proportions finds confirmation elsewhere. In the famous model book by the Gothic architect Villard de Honnecourt, whose connections with the Cistercian order are well known, we find what is obviously meant as the ideal ground plan of a Cistercian church (Fig. 5.8).[26] The plan is drawn *ad quadratum*, i.e., the square bay of the side aisles is the basic unit or module which determines all the proportions of the ground plan. Needless to recall that the square, the sides of which are related 1:1, corresponds to unison in music—according to St. Augustine the most perfect of all ratios. Moreover, as Professor de Bruyne in his remarkable study of medieval esthetics has observed, all proportions of Villard's plan correspond to the ratios of the perfect consonances: the length of the church is related to the transept as 2:3 (the ratio of the musical fifth); the octave ratio determines the relation between nave and side aisles, and between length and width of the transept; the 3:4 ratio of the presbytery evokes the musical fourth, and the 4:5 ratio of nave and side aisles taken as a unit corresponds to the third. Finally the cross-

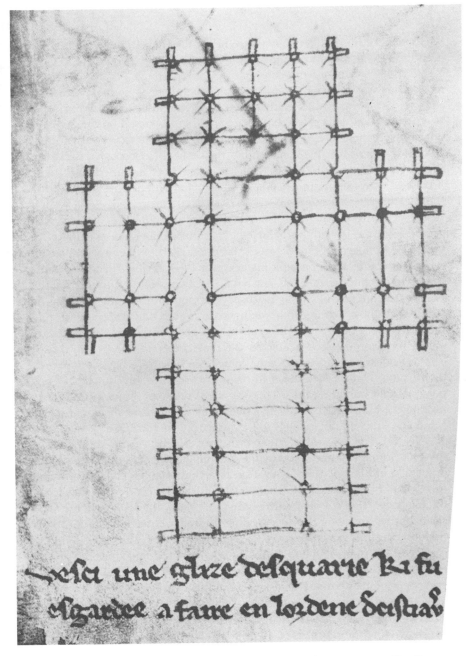

Figure 5.8. Plan of an ideal Cistercian church, Villard de Honnecourt. *Von Simson*.

ing, liturgically and esthetically the center of the church, is again designed according to the 1:1 ratio of unison.[27]

May we infer from this that application of St. Augustine's "perfect" ratios was general Cistercian practice? There is some evidence to suggest that it was. In his study of the Cistercian abbey at Eberbach, the late Hanno Hahn suggested that its ground plan is based on two squares which are related to one another according to the ratios of 1:2 and 3:4. Since Hahn was also able to show that the design of Eberbach dated from the mid-twelfth century (much earlier than had been assumed until then), it belongs with the pristine group of Cistercian churches designed during the life time of St. Bernard.[28]

Quite possibly the Cistercian contribution to the architectural geometry of the twelfth and thirteenth centuries does not end there. In Villard de Honnecourt's model book, mentioned above, he time and again relates different parts of a building according to a geometric device transmitted to the Middle Ages by Vitruvius (*Ten Books of Architecture*, 6,3; 9, Preface), who names Plato as its discoverer and praises him for what he calls one of those extraordinary achievements that had improved human life and therefore deserved the gratitude of posterity. To us this discovery seems simple enough. It occurs in the dialogue *Meno*, and Plato uses it only as evidence for his theory that knowledge is acquired by memory, not by learning. Plato asks a slave to draw two squares, the surface of one being exactly half the other. This the slave does by drawing lines connecting the middle of each of the two adjoining lines of the square. The result is a small square related to the larger one as 1:2.

Two centuries after Villard, at the very end of the Middle Ages, this very principle is employed by the German architect Mathes Roriczer in drawing a ground plan and elevation of a Gothic pinnacle. The drawing occurs in a little book by Roriczer setting forth the correct way of determining proportions by geometrical means.[29] From the architect's text, it is clear that he considers this way of determining architectural proportions by following the simple rule of a series of squares, each one half the surface of the preceding one, to be a basic law of architecture. Villard de Honnecourt seems to have thought likewise, and in view of Villard's Cistercian connections we may well ask whether this was not Cistercian practice also. There is some evidence to suggest that it was. Walther Tschescher, in a recent study of the geometry of Cistercian churches in eastern Germany, has shown that the churches of Altzella and Buch, both of which date from the twelfth century, employ in their ground plans the geometrical device used and taught in the thirteenth century by Villard.[30]

A still more recent finding may be of interest in this connection.

Professor Peter Fergusson has published an engraved design he discovered at Byland Abbey. It is a design for one of those clustered piers so frequent in English Cistercian architecture. The question raised by this graffito is by what geometrical means did the designing architect determine the relation between the segments of the larger circles to the diameters of the shafts? One possible answer, Fergusson suggests, is again Plato's method of halving the square, transmitted to the Middle Ages by Vitruvius and considered a sort of scientific law determining architectural proportions by Villard de Honnecourt and Roriczer.[31] If Fergusson is right, the incised drawing of Byland Abbey would be the earliest of its kind known, and thus be additional evidence for the Cistercian contribution to architectural geometry. But this relationship of squares is again an application of the octave ratio of 1:2, and thus a sort of confirmation of the conviction of Augustine and Boethius that "the ear is affected by sound in quite the same way as the eye is by visual impression."

Finally, the most significant contribution to the problem of Cistercian proportions may well prove to be a recent study by Professor Wolfgang Wiemer, "Die Geometrie des Ebracher Kirchenplans. Ergebnisse einer Computeranalyse."[32] Wiemer and his associates studied the geometry of groundplan and vaults of the great Cistercian abbey of Ebrach (1200–1285) by means of data analysis on an electronic computer. Wiemer found that the Ebrach groundplan, while not derived from a single geometrical figure, "confirmed the role, attested by medieval sources, of the square and the equilateral triangle" as well as of the pentagon, geometrical figures that are here combined in a single structure. The dimensions of the groundplan, moreover, seem to be determined by a sequence of "expanding" squares and triangles, corresponding to the "quadrangulation" used by Villard as well as Roriczer. In concluding his report, Wiemer remarks: "The Ebrach groundplan in all likelihood attests to the spirituality and esthetics of the Order at the beginning of the thirteenth century."[33] To this we only have to add the belief that the beauty of these geometrical proportions is ultimately based on the musical metaphysics of St. Augustine.

NOTES

1. See Philippe Guignard, ed., *Les monuments primitifs de l'Eglise Cistercienne* (Dijon: Rabutot, 1978), pp. 61–63.

2. See Bernard's *Apologia ad Guillelmum*, in J. P. Migne, ed., *Patrologiae Cursus Completus, series Latina*, 221 vols. (Paris: Migne, 1844–64), 182:914f. (hereafter referred to

simply as Migne, *Patrologia Latina*, with relevant volume and page numbers). An English version of the relevant portion of St. Bernard's letter is given in C. Davis-Weyer, ed., *Early Medieval Art, 300–1150*, Sources and Documents in the History of Art (Englewood Cliffs, N.J.: Prentice Hall, 1971), pp. 168–70. For a discussion of the letter, see Otto von Simson, *The Gothic Cathedral: Origins of Gothic Architecture and the Medieval Concept of Order*, 2nd. ed. rev., Bollingen Series no. 48 (1962; reprint ed. Princeton and London: Princeton University Press, 1974), pp. 43–44; see also Sister M. Killian Hufgard, O.S.U., "A Theory of Art Formulated from the Writings of St. Bernard of Clairvaux" (Ph.D. dissertation, Western Reserve University, 1957), p. 49f.

 3. Hufgard, "A Theory of Art," p. 2f., discusses that, to my mind, curiously distorted view, sustained by such an eminent scholar as Emile Male.

 4. See Guillelmus, *Vita Bernardi*, in Migne, *Patrologia Latina* 185:238–39.

 5. On the admissibility of visual art for non-monks, Bernard says: " ... Carnalis populi devotionem quia spiritualibus non possunt, corporalibus excitant ornamentis" ("They excite the devotion of carnal people by physical ornaments, since [such people] are not capable of spiritual things"), *Apologia*, in Migne, *Patrologia Latina* 182:914. See also his first sermon on the Song of Songs: "To you, brethren, one has to speak of different things, or at least in a different mode, than to those living in the world," Migne, *Patrologia Latina* 183:785. In speaking of a *paradisus claustralis*, St. Bernard quotes Gen. 28:17, "How dreadful is this place! This is no other but the house of God, and this is the gate of Heaven," which his audience knew from the dedication rite for a church to refer to the sanctuary. On the meaning of this term, see Etienne Gilson, *La théologie mystique de S. Bernard* (Paris: J. Vrin, 1934), p. 108.

 6. For a sampling of this bibliography, see Simson, *Gothic Cathedral*, pp. 47–48 and 56–58.

 7. See Gilson, *Théologie mystique*, p. 43, who quotes from St. Bernard's *De gradibus humilitatis*.

 8. See Simson, *Gothic Cathedral*, p. 146.

 9. See most recently V. G. Tuttle, "An Analysis of the Structure of the *Liber Floridus*" (Ph.D. dissertation, Ohio State University, 1979).

 10. On medieval interpretations of the Song of Songs, see Jean Leclercq, *The Love of Learning and the Desire for God* (New York: Fordham University Press and New American Library, Mentor Omega, 1962), pp. 90–93; see also Beryl Smalley, *The Study of the Bible in the Middle Ages* (Oxford: Clarendon Press, 1952).

 11. On St. Bernard's sermons on the Song of Songs, see Ray C. Petry, ed., *Late Medieval Mysticism*, Library of Christian Classics no. 13 (Philadelphia: Westminster Press, 1958), pp. 47–53, including bibliography.

 12. See Otto von Simson, "Le programme sculpturale du transept méridionale," *Bulletin de la Société des Amis de la Cathédrale de Strasbourg* 10 (1972): 33–50. W. Sauerlander, in the exhibition catalog *Die Zeit der Staufer*, 4 vols. (Stuttgart: Wurtembergisches Landesmuseum, 1977), 1:322, seeks to uphold the older interpretation, but fails to note the theological relationship between the sculptural program on the southern transept and the program of the two rose windows above, where not the "triumph" of Church over Synagogue but, on the contrary, "Vetus Testamentum cum Novo conjunctur" is allegorically depicted, as I have pointed out. As sisters, Church and Synagogue also appear in a miniature in a commentary to the Song of Songs in the *bibliothèque municipale* at Troyes. This commentary comes originally from Clairvaux.

 13. Bernard actually uses the word *experience*: "Sciebat quidem per naturam, non autem sciebat per experientiam" ("He knew [it] by virtue of his [Divine] nature, but not,

however, through experience"), *De gradibus humilitatis*, 3,6, in Migne, *Patrologia Latina* 182:945.

14. After the soliloquy paraphrased in the text, Bernard says: "Venit igitur in carne, et tam amabilem se exhibuit, ut illam nobis impenderet charitatem, quo majorem nemo habet, ut animam suam daret pro nobis, 'Quid debui facere tibi et non feci' (Isa. 5:4). Et vere in nullo sic commendat Deus charitatem suam, quomodo in mysterio Encarnationis eius et passionis ... " ("He came, therefore, in the flesh and showed himself to be so lovable so that he might teach us that charity, greater than which no man hath, that he give up his soul for us: 'What ought I have done for you, and did not do?' ... And truly, in nothing does God so show his love as in the mystery of his Incarnation and Passion") *Sermones de diversis*, 39, in Migne, *Patrologia Latina* 183:620. Bernard stresses time and again the significance of contemplating and re-living Christ's Passion; thus in his forty-third sermon on the Song of Songs he describes his own method, "ab ineunte mea conversione" ("beginning with my conversion"); as following step by step the Lord's ascent to Calvary. On the central importance of human compassion with Christ's sufferings, see sermon twenty on the Song of Songs: " ... is quidem qui Christo passo pie compatitu" ("he who therefore has piously suffered along with Christ who suffered"), in Migne, *Patrologia Latina* 183:870. The image of the Man of Sorrows (Isa. 53:3) is evoked frequently in this sermon. Similarly, Bernard's friend and disciple, William of St.-Thierry, says: "Exhibes me igitur bonum hominem despectum et novissimum virorum, vivum dolorem et scientem infirmitatem, ut zelet et imitetur in me humilitatem, per quam perveniat ad gloriam" ("Show me therefore a good man who is despised, the last of men, familiar with lively sorrow and infirmity, that he may strive for and imitate my humility, through which he will reach glory"), *Liber de Natura et Dignitate amoris*, in Migne, *Patrologia Latina* 184:401; see also Gilson, *Théologie mystique*, and more recently A. Schneider, ed., *Die Cistercienser. Geschichte, Geist, Kunst* (Cologne: Wienand, 1974), p. 121.

15. See Otto von Simson, *Das Hohe Mittelalter*, Propyläen-Kunstgeschichte no. 6 (Berlin: Propyläen-Verlag, 1972), p. 245.

16. See Petry, *Late Medieval Mysticism*, Introduction and p. 118. A later instance of St. Bernard's influence on Franciscan devotional practices is discussed in William Hood's chapter in this volume.

17. See A. Dimier, "Architecture et spiritualité cisterciennes," *Révue du moyen age latin* 3 (1947): 255–74; *idem, Recueil de plans d'eglises cisterciennes*, 2 vols. (Grignan, Drôme: Abbaye Notre Dame d'Aiguebelle, 1949), 1:27. More recently see W. Beckel, "Die Kunst der Cistercienser," in Schneider, *Die Cistercienser*, pp. 193–343; for a brief summary, see U. Schröder, "Architektur der Zisterzienser," in *Die Zisterzienser: Ordensleben zwischen Ideal und Wirklichkeit. Ausstellung des Landschaftsverbandes Rheinland* (Cologne and Bonn: Rheinland-Verlag and R. Habelt, 1980), pp. 311–44.

18. See Simson, *Gothic Cathedral*, pp. 21–58.

19. *Ibid.*, pp. 49, n. 70, and 50.

20. See Augustine, *De Ordine* 2, 39, in Migne, *Patrologia Latina* 32:1013.

21. Augustine, *De Trinitate* 4,2,4, in Migne, *Patrologia Latina* 42:889; for the wide distribution of this work in the Middle Ages, see Simson, *Gothic Cathedral*, p. 40, n. 47.

22. *De Musica*, 1,32, in Migne, *Patrologia Latina* 63:1194; cf. Simson, *Gothic Cathedral*, p. 33, n. 31.

23. A. Wilmart, "L'Ancienne bibliothèque de Clairvaux," *Mémoires de la Société Academique ... de l'Aûbe*, 55–56 (1916).

24. See Bernard's *Epistula ad Guidonem*, in Migne, *Patrologia Latina* 182:610.

25. J. Bilson, "The Architecture of the Cistercians," *Archaeological Journal* 66 (1909): 205; see also Simson, *Gothic Cathedral*, p. 47, n. 65.

26. Villard de Honnecourt, *Livre de Portraicture*, ed. H. Hahnloser (Vienna: Schroll, 1935).

27. See E. de Bruyne, *Etudes d'esthétique medievale*, 3 vols. (Bruges: De Tempel, 1946), 1:22.

28. See H. Hahn, *Die frühe Kirchenbaukunst der Zisterzienser* (Berlin: Mann, 1957), p. 75.

29. Mathes Roriczer's "Büchlein von der Fialen Gerechtigkeit" is now available, along with three related treatises, in an excellent translation with introduction by Lon R. Shelby, *Gothic Design Techniques: The Fifteenth-Century Design Booklets of Mathes Roriczer and Hans Schmuttermayer* (Carbondale: Southern Illinois University Press, 1977).

30. See W. Tscheschner, "Die Anwendung der Quadratur und der Triangulatur bei der Grundrissgestaltung der Zisterzienserkirchen östlich der Elbe," *Analecta S. Ordinis Cisterciensis* 22 (1966): 96ff.

31. See P. J. Fergusson, "Notes on Two Cistercian Engraved Designs," *Speculum* 54 (1979): 1–18; on the geometrical knowledge of medieval architects, see R. Branner, "Villard de Honnecourt, Reims, and the Origin of Gothic Architectural Drawing," *Gazette des Beaux Arts* 61 (1963): 129–46; and more recently, L. R. Shelby, "The Geometrical Knowledge of Medieval Master Masons," *Speculum* 47 (1972): 345–421 (with exhaustive bibliography). Shelby states in an earlier essay, "The Role of the Master Mason in Medieval English Building," *Speculum* 39 (1964): 387–402, that "the master masons were by no means illiterate, but there is little indication that literacy played a part in the acquisition of the technical knowledge necessary for designing and constructing a building." He goes even farther, saying "the education of the master mason was empirical and utilitarian." In my view, this may be true if a distinction is drawn between master mason and architect. Yet such does not seem to be the case. In his 1964 essay Shelby writes: "One of the primary functions of the master mason— and the one for which he received the most attention—was that of designing the building. Insofar as stone buildings are concerned, the master mason deserves above all other building officials the title of 'architect'" (p. 388). I find it difficult to believe that Gothic cathedrals were designed by professionals only some of whom, and only "from the thirteenth-century onwards ... learned to read and write." What about the nobleman Ailbert who had studied the quadrivium at the cathedral school at Tournai and subsequently became a renowned architect? See Simson, *Gothic Cathedral*, p. 31, n. 27. And what about the great clerics like Bishop Benno of Osnabrück, equally celebrated as architects in their own lifetime? This is not the place to restate what I have said elsewhere about the medieval architect, his education, his functions, and the relation between his architectural designs and the esthetic ideas and experiences of his time (see my *Gothic Cathedral, passim*). That same relation has been proved to exist in R. Wittkower's brilliant study *Architectural Principles in the Age of Humanism*, 3rd. rev. ed. (1962; reprint ed., New York: Norton, 1971), the only flaw in which is the author's failure to realize that the Platonic tradition to which the architects of the Renaissance were indebted was no innovation of theirs, but inherited from their medieval predecessors. The influence of Platonic, or rather Augustinian ideas cannot and need not be proved in the case of every medieval church. That it did exist in the case of Cistercian architecture is more than likely, to judge by the plans of the early churches of that order, for which the term "Bernardian" seems to have gained general acceptance.

32. I am much indebted to the author for sending me a typewritten copy of his paper, which is to be published shortly.

33. Wiemer shares my doubts as to the alleged well-nigh illiteracy of the medieval architect, especially as regards mathematics (see note 31 above, my critique of Shelby), and remarks: "Die Rolle dieser symbolischen Bezüge für die mittelalterliche Baugeometrie wird in

der Literatur verschieden eingeschätzt, an ihrer Existenz ist jedoch grundsätzlich nicht zu zweifeln. Es ist kaum vorstellbar, dass sie im vorliegenden Fall vom entwerfenden Archi-tekten oder vom Bauherrn weder bemerkt noch beabsichtigt wurden."

The *Rule* and the Book
Cistercian Book Illumination in Burgundy and Champagne

Walter Cahn

The purity and austerity of the architecture associated with the Cistercian reform reflected an "official" taste that may be found in other areas of monastic art as well. In this chapter, Professor Walter Cahn documents Cistercian legislation with regard to the production and decoration of books, pointing out significant discrepancies between stated ideals and the reality. He carefully traces the process by which the early Cistercian rejection of Cluniac ostentation—in book illumination as in the other arts and in liturgy—gradually gave way to a richer style, as the monks came into contact with wealthy lay patrons. Professor Cahn's chapter also suggests the place of books in the life of a medieval monastery, the size and composition of monastic libraries, and the methods of "publication" by which a given manuscript, with its illuminations, was recopied in multiple exemplars.

Walter Cahn is Professor of Art History at Yale University.

The attitude of the Cistercians to the *Rule* of St. Benedict is well known: they were, in the words of L. Lekai, "antiquarians," in that they wished to strip away what they regarded as later accretions or modifications and to reform monastic life by a return to the founder's original intentions. Although virtually nothing is known of the architectural schemes of the first Cistercian monasteries, by the fourth and fifth decades of the twelfth century a characteristic plan and type of structure (illustrated, for example, at Fontenay) had appeared.

139

The purity and austerity of this architecture and its conscious departure from contemporary practice, especially that followed by the Cluniacs, have often been described and analyzed.[1] In its stark volumes and avoidance of decoration, it reflects the spirit and policy enunciated by the founding fathers of the Order in such documents as the *Exordium parvum* and the *Carta caritatis*. Benedict's instructions on artistic matters are not very explicit, and it would not be possible to find in them a specific justification for the reforms of the Cistercians in this sphere. But the rejection of ostentation and the cultivation of austerity in food, dress, and the shaping of the physical environment seemed consistent with the ascetic temper of early monasticism as it was perceived not only through St. Benedict, but on the basis of pre-Benedictine ideals of Eastern origin.

While the Cistercians elaborated a distinctive architecture and a consistent position in regard to monumental forms of decoration, their views on the subject of book illumination are much less clear and their reforming efforts in this area achieved much more limited results. It is well known that a number of handsomely illuminated books were produced at Cîteaux during the abbacy of Stephen Harding in the early years of the twelfth century. Among these is the famous Bible of Cîteaux in four volumes, completed in 1109, and a copy of Pope Gregory's *Moralia in Job*, finished two years later by the same team of scribes and painters.[2] It is also true that the other major Cistercian houses in Burgundy and Champagne were quick to build substantial collections of books. Some 340 twelfth-century manuscripts from Clairvaux are still preserved in the municipal library at Troyes.[3] The library of Pontigny, a daughter of Cîteaux founded in the year 1114, has been dispersed and considerably decimated, but an inventory made around the year 1200 or in the early years of the thirteenth century lists some 185 volumes.[4] There are lesser, though still substantial remains in the Bibliothèque Nationale in Paris of the library of Fontenay, a foundation of Clairvaux established in 1119,[5] and of Vauclair in the Municipal Library at Laon;[6] books in somewhat lesser number survive from other important Cistercian houses of the region, among them Morimond, La Ferté, and Igny.[7]

The most explicit statement of Cistercian attitudes toward book illumination is found in the *Instituta*, the first body of Cistercian legislation. Several of its articles concern the subject. One enjoins uniformity in the production of liturgical books. Writing must be done in silence, and bindings made of precious materials are forbidden. Article 82 in the standard edition of the *Instituta* concerns both illumination and stained glass: "Letters should be made of one color and without illustration [*non depictae*]. Windows should be made of white [clear] glass, and without the

cross or other pictures."[8] The date of this article is disputed, some authors believing that it was introduced in 1134, others placing it as late as 1151.[9] The *Dialogus duorum monachorum*, or Dialogue between a Cluniac and a Cistercian, written by the monk Idung of Prüfening during the third quarter of the twelfth century, also touches on this subject, stigmatizing the use of gold in liturgical vessels and manuscripts. When the speaker for the Cluniac side makes the point that, far from avoiding manual labor as they were accused, the monks of Cluny did work with their hands, the advocate for the Cistercian position ridicules this assertion with the words: "What is grinding gold into dust and illuminating huge capital letters with gold dust, if it is not useless and idle work?"[10]

Since the Cistercian legislators professed fidelity to the *Rule*, it could be asked what sort of historical consciousness they possessed of the art of St. Benedict's time. With regard to *litterae pictae*, it would be right to say that elaborate historiated initials did not exist in early Christian times, becoming part of manuscript illumination only from the Carolingian period onward.[11] But three hundred years is a long time, and complaints that they represented a novel departure from custom would seem a little strained. Gold is another matter. It is not employed in the few illuminated manuscripts from the early Christian period which have come down to us. In the early Middle Ages, its use is particularly associated with the Byzantine tradition. In the West, it is found in some ninth-century manuscripts closely linked with the imperial court, and later, with much more prominence, in German art of the eleventh century.[12] For religious or esthetic reasons, or simply because of the scarcity of the material, it hardly appears at all in French illumination prior to the year 1100. Around that time, however, perhaps under German or Italo-Byzantine influence, it makes its presence felt in a fairly dramatic way. A copy of St. Ildefonsus' treatise *De Virginitate Beatae Mariae* is one of a group of manuscripts made at Cluny around this time that illustrate the phenomenon.[13] The Cistercian founding fathers would thus have had some grounds for the view that its use was a recent novelty, and this might explain their vigorous reaction against it.

When we turn from these stern principles to the material evidence which could be expected to illustrate their application, the situation before us is not so straightforward. Although the legislation certainly had an effect, it was not followed everywhere with the same degree of uniformity and rigor. In the place of illustration and zoomorphic ornament, illumination came on the whole to favor more sober designs limited to abstract penwork or foliate decoration. On the other hand, self-denial in the area of color (which, if we understand the pertinent statute correctly, would have

Figure 6.1. Initial, Cistercian Statutes from Fontaine-Jean. Yale University, Beinecke Rare Book and Manuscript Library, Ms. 349, fol. 1ᵛ. *Sotheby's London.*

permitted only strict monochrome) proved most difficult to achieve. In the Beinecke Rare Book and Manuscript Library at Yale University, there is a late twelfth-century copy of the Cistercian Statutes from Fontaine-Jean, a daughter of Pontigny founded in 1124 near Montargis in Gatinais, which may serve as an example of this differentiated pattern of responses.[14] The manuscript has calligraphic initials in red and blue throughout the volume, and indeed, on the very page on which Article 82 appears. There are also a few more elaborate painted initials, of fairly unassuming quality, executed in red, blue, and green hues (Fig. 6.1). If pictorial representation and grotesque subjects have been eliminated, or nearly so—an animal mask and beast heads sprouting foliage remind us of the continued attraction of this imagery—it is not easy to see how these initials can be called "of one color." Gold, however, is everywhere banished, and in its place, ochre and yellowish tones are used for the fillet outlining the letter and a few buds within the foliage.[15]

But there are also some spectacular exceptions to the pattern which must be reckoned with. The Bible of the Cistercian monastery of Heisterbach in the Rhineland is one of the most splendid examples of German book illumination of the thirteenth century.[16] It contains miniatures in bold and varied colors on gold grounds before most of the biblical books like the three scenes from the life of St. Paul in Figure 6.2. We cannot be sure that the manuscript was made at Heisterbach, and it may well be that it is the product of a nearby center of greater importance, such as Aachen or Cologne. All that is known with certainty is that it was at Heisterbach by the middle of the sixteenth century. Yet there is naturally an element of special pleading in the arguments of scholars who reason that it cannot have been there during the Middle Ages because it is so much at variance with Cistercian precepts. The same consideration applies to another work of great interest and beauty, the Psalter of the upper Rhenish region in the municipal library of Besançon. Executed shortly after the middle of the thirteenth century, it contains an extremely rich sequence of illustrations of two types—some, like the symbolic Crucifixion (Fig. 6.3), painted in opaque colors with gold for the backgrounds, others executed in a more economical technique of drawing enhanced with color washes. The text points without doubt to a Cistercian house. Bonmont in the diocese of Geneva was once favored, but Wettingen in Aargau is now preferred as the more likely provenience.[17] A third example, of Spanish origin, is the copy of the Commentary of Beatus on the Apocalypse from Las Huelgas, a Cistercian convent near Burgos founded in 1187 by Alphonsus VIII of Castile. According to the colophon, this manuscript was completed in 1220.[18] In this instance as well, the lavish decoration is not easy

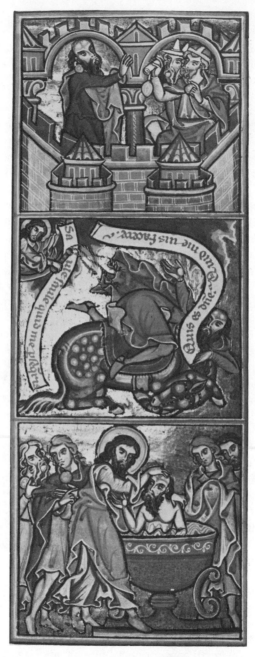

Figure 6.2. Scenes of the life of St. Paul, Bible of Heisterbach, Berlin, Staatsbibliothek. Ms. theol. lat. fol. 379, fol. 467. *Bildarchiv Foto Marburg.*

Figure 6.3. *Symbolic Crucifixion*, Psalter of Bonmont. Ms. 54, fol. 15ᵛ. *Bibliothèque municipale, Besançon.*

to square with the legislation of the Order. Gold and silver are modestly employed, but color and illustration have not been spared (Fig. 6.4). This last example, however, also makes a point of more general relevance for my topic. The Las Huelgas manuscript is, of course, not an original creation but one of the latest of some twenty surviving copies of the Beatus text. The illustrations were an integral component of the work from the start, and whatever scruples the thirteenth-century scribes might have felt were evidently overcome by this fact.

Figure 6.4. *Horsemen of the Apocalypse*, Beatus of Las Huelgas. Ms. 429, fol. 94. *The Pierpont Morgan Library, New York.*

In their efforts to procure the books which they required, the Cistercians faced a special problem. Unlike the old Benedictine houses, which might have libraries accumulated over a substantial length of time, they had to start from scratch. Before they could launch a production of their own, Cistercian monasteries thus had to buy or borrow books where they could find them. We know that the Las Huelgas manuscript of the Beatus Commentary was copied from a much older exemplar, the Beatus of Tavara dated 970: the scribe was conscientious to the point of copying the colophon of the model along with the text![19] The constraints which I have described did not, of course, affect the Cistercians alone. They were common to the other monastic and canonical communities founded in the eleventh and the twelfth century—Carthusians, Premonstratensians, Augustinians among others—all of which were faced with the need to obtain as expeditiously as possible the necessary books for the cult and for study. It may well be that this factor of increased demand had an effect on the organization of book production itself, accounting in some measure for the rise of a professional class of scribes beyond the confines of institutional scriptoria.

However this may be, old and new foundations were on an equal footing in respect to the books of new authors, *moderni* such as Peter Lombard, the Victorines, or the writings of Cistercians like Bernard of Clairvaux, Guerric of Igny, and Arnaud of Bonneval. Based on a study of manuscript proveniences, it is sometimes observed that the Cistercians were particularly receptive to this prescholastic literature. These writings—Biblical exegesis, theology, devotional or mystical tracts—were only rarely illustrated. But there are exceptions. The edifying tract for nuns known as the *Speculum Virginum*, written in the early decades of the twelfth century, is known through some twenty manuscripts of the twelfth and thirteenth centuries, of which nearly half come from Cistercian houses.[20] Among this Cistercian group is the earliest copy of the work, the Arundel manuscript of the British Library, believed to have come from the Rhenish monastery of Eberbach.[21] Its illustrations are pen drawings using inks of several colors and occasional touches of solid hue. Figure 6.5 depicts the Awakening of the Dead and, in the middle register, the Wise and the Foolish Virgins. There is a much more refined version of the same subject, using color throughout and some touches of gold, in a miniature of the Rheinisches Landesmuseum in Bonn, which belongs to a manuscript of a venerable Benedictine house, the monastery of St. Matthias in Trier (Fig. 6.6).[22] A third version of the composition from a Clairvaux manuscript of the early years of the thirteenth century makes the greatest show of austerity, executed as it is entirely in line (Fig. 6.7).[23] Here, it

Figure 6.5. *Awakening of the Dead* and *Parable of the Wise and Foolish Virgins, Speculum Virginum.* Arundel Ms. 44, fol. *British Library, London.*

Figure 6.6. *Awakening of the Dead* and *Parable of the Wise and Foolish Virgins*,
Speculum Virginum fragment. No. 15327. *Rheinisches Landesmuseum, Bonn.*

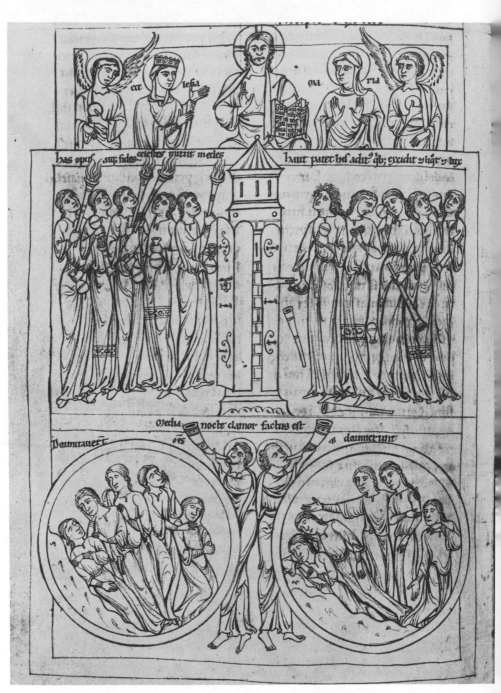

Figure 6.7. *Awakening of the Dead* and *Parable of the Wise and Foolish Virgins, Speculum Virginum.* Ms. 252, fol. 58ᵛ. *Bibliothèque municipale, Troyes.*

would seem, we have at last some tangible evidence for the impact of Cistercian reforms.

Before any definite conclusion is drawn, however, it may be useful to compare a set of illustrations from another text, of which there are also multiple copies, some from Cistercian houses and some from other religious communities. I have in mind Richard of Saint-Victor's commentary of the last section of Ezekiel, embodying the prophet's vision of the Temple on the mountain. Eleven manuscripts of this work are known to me, all of them datable within the period from the third quarter of the twelfth century to the early years of the thirteenth.[24] In this instance, a Saint-Victor manuscript, representing the original version or copy obviously derived from it, is known. It was Richard's own ambition to offer a literal interpretation of Ezekiel's often obscure text, and the images were intended to assist in this process of clarification. The illustration here shown is that of the structure which stood on the northern slope of Ezekiel's temple complex: *aedificium versus ad aquilonem* (Ezekiel 42:1ff). Richard imagines it to be a building of two stories, rising above a succession of chambers and having a kind of solarium with a gazebo-like outer gallery at the top. In the Saint-Victor manuscript, this design is rendered in a forthright if not overly refined manner with the help of thin applications of flat color (Fig. 6.8). An English copy from Exeter cathedral (Fig. 6.9) offers a somewhat more precise and sparingly colored version of the structure.[25] My Cistercian witness, on the other hand, once again a manuscript from Clairvaux, presents a linear reduction of greater sobriety (Fig. 6.10).[26] The Cistercians, to be sure, had no monopoly on self-denial, and several copies of Richard's commentary have illustrations that are even sparer. One, with drawings in red outline, is not even monastic in origin, but comes from the cathedral of Cambrai.[27] Beyond the question of economy in esthetic or in material terms, drawing seems particularly suited to the requirements of technical and scientific demonstration, and this diagrammatic tradition was no doubt more appropriate to Richard's didactic purposes than a full-fledged painterly rendering.

But even within this sphere, there are distinctions that are not completely explicable in terms of religious ideals or ingrained artistic practice. This point can be illustrated with the help of another Clairvaux manuscript in Troyes, a copy of the concordance of the Gospels devised by Zachary of Besançon.[28] As is customary, Zachary's text is preceded by a sequence of Canon Tables representing the author's attempt to improve upon the system introduced in the fourth century by Eusebius and thereafter the norm. Some of these arches are in a Romanesque or even vaguely "Mozarabic" style, with round arches surmounted by an architectural

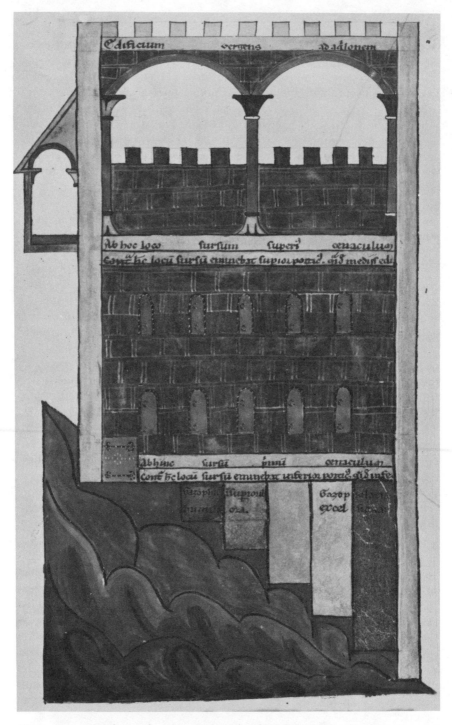

Figure 6.8. *Temple on the Mountain*, Richard of Saint-Victor, Commentary on Ezekiel. Ms. lat. 14.515, fol. 248. *Bibliothèque nationale, Paris.*

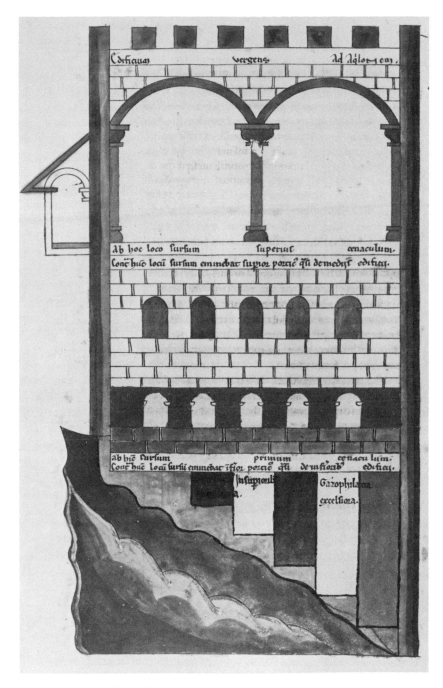

Figure 6.9. *Temple on the Mountain*, Richard of Saint-Victor, Commentary on Ezekiel. Bodley Ms. 494, fol. 162ᵛ. *Bodleian Library, Oxford.*

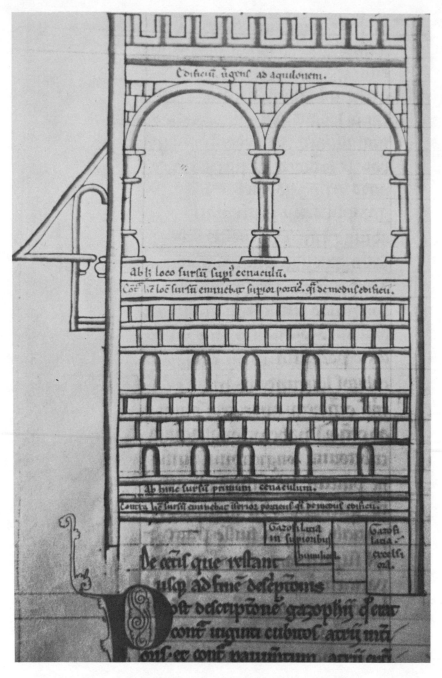

Figure 6.10. *Temple on the Mountain*, Richard of Saint-Victor, Commentary on Ezekiel. Ms. 544, fol. 23. *Bibliothèque municipale, Troyes.*

prospect. Others have pointed arches and are distinctly Gothic in character (Figs. 6.11 and 6.12). The mansucript can scarcely have been executed much after 1170, and it is especially valuable since this rendering of Gothic structure would seem to be one of the earliest reflections of the new style in book illumination. The contrast between the Romanesque and Gothic designs is further underscored by the difference in technique. The Romanesque arches are rendered in solid, opaque colors, bringing out in an effective way the sturdy and massive character of the form. The Gothic arcades, on the other hand, are drawn with multicolored lines. They appear lighter, and this choice of technique enabled the draftsman to define with as much clarity as possible the multiplicity of parallel moldings along the profile of the arch. Linearity is thus a function of architectural self-definition. Still, after exceptions and complicating factors have been enumerated, I think that one can conclude that Cistercian ideals, all things being equal, favored drawing, first as an appropriate substitute for painted images, and eventually as a means of artistic expression in its own right.

This is speculation and we are on safer ground with a group of manuscripts which students of Cistercian art, following the late Jean Porcher, have cited as the clearest illustration of the effect of the reforms legislated by the statutes of the Order. The number of these manuscripts is small. The core of the group is constituted of three Bibles—one from Clairvaux, another probably from Morimond, and a third of unknown origin. All of them are large books, designed for the choir and refectory readings, with a particular five-volume format.[29] We are in all likelihood dealing with a specially designed edition, in line with the stipulation of uniformity in the use of books for the cult. The Clairvaux Bible exemplifies the decoration found in these manuscripts (Fig. 6.13). It consists of initials like those of other Romanesque Bibles in their large scale and painterly elaboration, yet which have a marked character of their own. The formal vocabulary is restricted to abstract and foliate components, and the execution is entirely in shades of one color, fortified by black outlines with highlights in white. Major Cistercian books of the same period show reductive liner designs of the same kind but wholly carried out in monochrome.

Thus we have both evidence of reforming zeal and some quite striking signs to the contrary. There is no ready explanation for this confusing state of affairs and for the Cistercians' apparent failure to put their precepts into practice in a consistent way. One deviation from these precepts does seem to have gained eventual acceptance. This came about in the Order's dealings with the outside world, and especially in connection with gifts received from powerful lay and ecclesiastical patrons. On a

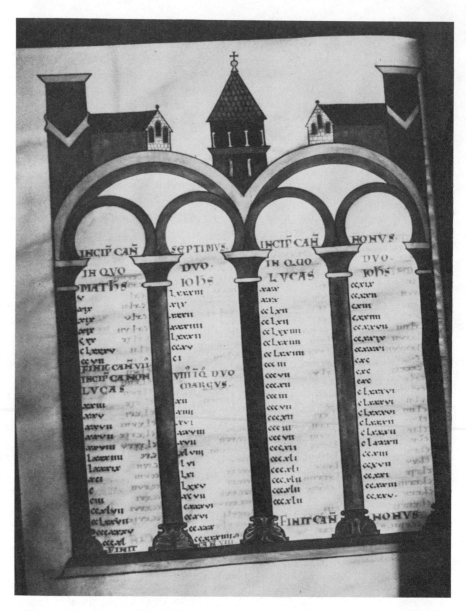

Figure 6.11. Canon Table, Zachary of Besançon, *Concordantiae Canonum*. Ms. 84, fol. 8. *Bibliothèque municipale, Troyes.*

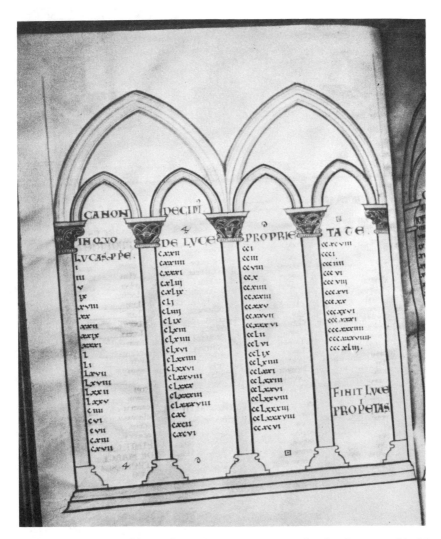

Figure 6.12. Canon Table, Zachary of Besançon, *Concordantiae Canonum*. Ms. 84, fol. 15ᵛ. *Bibliothèque municipale, Troyes*.

number of occasions, the General Chapter stigmatized the donation of paintings and other ornaments as contrary to the statutes of the Order.[30] This was evidently a continuing problem. Although burial of members of the secular clergy and laity within the walls of the monastery was initially forbidden, this rule was modified by the middle of the twelfth century to

Figure 6.13. Daniel initial, Bible of Clairvaux. Ms. 27, vol. IV, fol. 181ᵛ. *Bibliothèque municipale, Troyes.*

permit the interment of the four der of the house.[31] Later, such burial privileges were extended to royal† and other high-born personages, with, as a consequence, the introduction of monumental tombs with effigies and elaborate canopies within the church. Illuminated manuscripts of great luxury, whose presence in a Cistercian library would otherwise be surprising, reached their destination in the same manner. The monastery of Zwettl in Lower Austria possesses a handsome Psalter with illuminated initials and full page paintings on gold backgrounds. It was given to the monastery by a noble lady, Jutta Tursina of Lichtenfels, who is shown in one of the miniatures kneeling before Mary Magdalene, her patron saint (Fig. 6.14). Her name is recorded in a marginal inscription which also forbids the monks to sell the manuscript or to excise the paintings from it, since it was given for the salvation of her soul and in order that the memory of her name be kept alive.[32]

Clairvaux also received a number of illuminated manuscripts in this way. A group of such books, mainly Biblical commentaries, came from Prince Henry, a son of Louis VI, who entered the monastery as a monk in 1145. Such texts of Biblical exegesis did not as a rule receive much decoration. Henry's manuscripts, as befits the status of the owner, belong to the more attractive productions of the genre. They are introduced by handsome initials on gold grounds, constructed of foliate and zoomorphic elements.[33] Alanus of Auxerre, a disciple of St. Bernard who had been a monk of Clairvaux, abbot of Larivour and, from 1152 to 1167, bishop of Auxerre, gave to Clairvaux a copy of Gratian's *Decretum*. The manuscript was seen by Martène at the beginning of the eighteenth century, but it is presently unaccounted for.[34] I mention it just the same because it calls attention to the precocious and fairly assiduous interest of the major Cistercian houses in Burgundy and Champagne in Gratian's work. The *Decretum* is thought to have been compiled shortly after 1139 and, initially at least, it must have reached northern Europe through the medium of copies from northern Italy and especially from Bologna. In the Walters Art Gallery in Baltimore there is a volume of this work, considered to be of north Italian or Spanish origin, which in the thirteenth century was at Cîteaux.[35] Among the Clairvaux manuscripts of the *Decretum*, the earliest of the series is definitely north Italian.[36] Now the *Decretum*, like the Spanish series of Beatus manuscripts, had a recognizable artistic profile. It was generally provided with a large Tree of Consanguinity and, as in the case of the volume from Cîteaux, a diagrammatic illustration showing the degrees of kinship according to affinity. Historiated initials, like the design at the beginning of the text in the Clairvaux manuscript, illustrated the division and harmonious interplay of the two powers which is the subject of Grat-

Figure 6.14. Donor portrait, Psalter of Jutta Tursina of Lichtenfels, Zwettl, Stiftsbibl. Cod. 204, fol. 128ᵛ. *Institut für Kunstgeschichte der Universität Wien.*

ian's opening words. Several years ago, I published a reconstruction of yet another *Decretum* from Pontigny, of which there are fragments in Auxerre, London, Cleveland, and elsewhere.[37] It is one of the earliest of the series of northern French copies of this work, and its image of the Tree of Consanguinity displayed by a regal standing figure must have been inspired by a model of the same Italian ancestry.[38]

The case that I will consider next might well have a similar explanation. It concerns a most paradoxical work, the Clairvaux manuscript known as the Bible of St. Bernard.[39] St. Bernard's ownership of this two-volume work is recorded in a number of marginal inscriptions, the earliest datable toward the end of the twelfth century. Bernard died in 1153, and the later-recorded association with him of the manuscript cannot be verified beyond doubt. Nevertheless, the script and decoration of the work do not contradict the assumption that this tradition might be correct. This decoration consists of painted initials in which gold is undeniably present as are fantastic and grotesque animals, albeit not prominently so. All this is hard to reconcile with Bernard's severe stance on this subject. André Wilmart, who wrote a thorough study of the Clairvaux library published nearly fifty years ago, sought to resolve the difficulty with the suggestion that Bernard had received the Bible as a present.[40] One is tempted to feel that for purposes of the issue involved, it does not really matter by what means Bernard obtained the manuscript. Yet purely on the level of fact, Wilmart's supposition has much to commend it. It can be shown, I think, that Bernard's Bible was written and illuminated in the workshop responsible for the production of another manuscript of the Scriptures, the Bible from Saint-Étienne in Troyes, a house of Canons founded and endowed by the Count of Champagne, Henri le Libéral, in 1157.[41] Without pursuing the matter in the greatest detail, one may note that the two manuscripts share a number of fairly rare subjects. Among these are the murder of Antiochus from 2 Maccabees and a sequence of scenes from the life of St. Paul drawn from the Acts of the Apostles and the Pauline Epistles. Here are illustrations, quite exceptional in French Bibles of the time, of Paul saved from shipwreck off the coast of the Island of Malta, and his salvation from the viper's bite (Acts 28:1–7; Figs. 6.15 and 6.16). There is every chance that the workshop in which the two Bibles were made was located in Troyes, a city whose artistic importance in the twelfth and thirteenth centuries has perhaps not yet been sufficiently appreciated. There are, as we shall see, other connections between that brilliant courtly center and Clairvaux, situated some forty miles to the east of the city.

From the category of luxury gifts, accepted with whatever degree of reluctance, I pass now to another, more speculative category of acquisitions. I would like to propose, with all due regard for the tentative nature of my evidence, that the Cistercians acquired some illuminated manuscripts by purchase. There are several considerations which can be adduced in support of this hypothesis. The number of manuscripts from Cistercian houses of Burgundy and Champagne whose elaborate decoration would seem to violate the letter and spirit of the *Rule* is too large to be

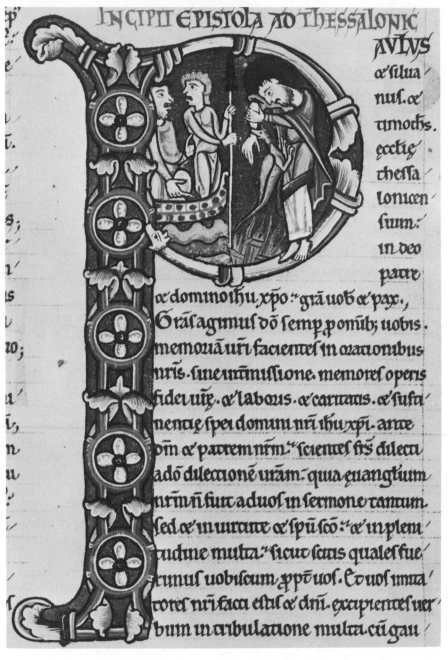

INCIPIT EPISTOLA AD THESSALONIC
AVLVS
& silua
nus. &
timoths.
ecctie
thessa
lonicen
sium:
in deo patre

& domino ihu xpo ·: grā uob & pax.,
Grãs agimus dō semp p omib; uobis.
memouā uri facientes in ozationibus
uris. sine intmissione. memores operis
fidei uie. & labous. & cantatis. & susti
nentie spei domini nri ihu xpi. ante
dm & parrem nrm." scientes frs dilecti
ad dilecione urām. quia euangtium
nrm ñ fuit ad uos in sermone tantum.
sed & in uirtute & spū sco ": & in pleni
tudine multa." sicut scitis quales fue
rimus uobiscum xpt uos. Et uos imita
tores nri facti estis & dni. excipientes uer
bum in tribulatione multa cū gau

Figure 6.15. *St. Paul Saved from Shipwreck and Casting the Viper into the Fire*, Bible of Saint-Etienne de Troyes. Ms. 2931, fol. 223ᵛ. *Bibliothèque municipale, Troyes.*

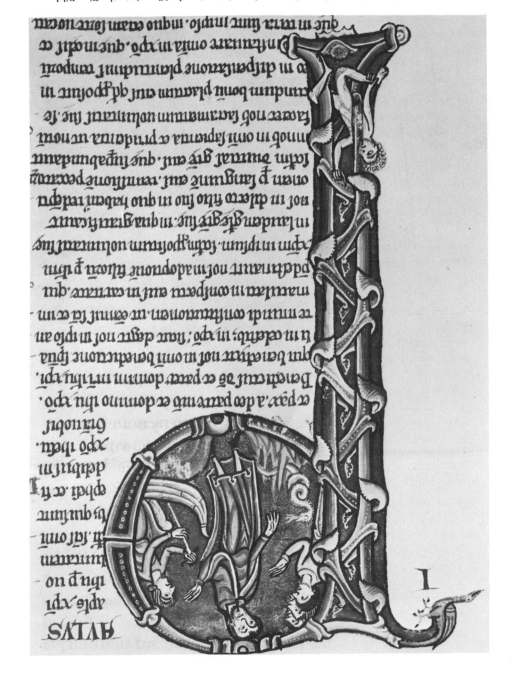

Figure 6.16. *St. Paul Saved from Shipwreck and Casting the Viper into the Fire*, Bible of St. Bernard. Ms. 458, Vol. II, fol. 211v. Bibliothèque municipale, Troyes.

explained as occasional works in an established genre or as donations from princely or ecclesiastical patrons. Figure 6.17 shows a fragment, recently discovered, of Augustine's commentary on the psalms from Pontigny, with a superb initial and incipit elaborated into a full-fledged title page.[42] The better known Pontigny Bible fragment in the Bibliothèque Nationale from the 1170s or '80s is another example.[43] In a manuscript at Troyes, there is also a note which lists a series of books written for Peter of Virey, abbot of Clairvaux in the fifteenth century. Peter had these books written by a monastic scribe. For the illumination, however, he turned to a lay professional active in Troyes.[44] It was evidently accepted at this time that the production of illuminated books was one thing and that mere ownership was something else. The date of this transaction is surely too late to serve my argument, and, in the final analysis, the most telling evidence that can be marshalled in its favor derives from the manuscripts themselves. It is a fact that among the manuscripts of Clairvaux, there are several which were decorated by painters whose hand can be recognized in books from other places. This indicates, I think, that the Cistercians were willing, when necessary, to turn to suppliers outside their houses. The case of the Bible of Bernard of Clairvaux has already been mentioned. The fine copy from Clairvaux of Peter Lombard's commentary on the psalms is another example.[45] Its initials are clearly the work of one of the painters who took part in the execution of the great Bible of the Capucins in the Bibliothèque Nationale. His manner has also been recognized in the oldest surviving windows of the cathedral of Troyes, and it is, again, that city which is likely to have been the principal seat of his activity.[46]

It thus seems that the reality of Cistercian practice in the sphere of book illumination was rather different from what the stern pronouncements of the Statutes would lead us to believe. It is striking that while the annual decisions of the General Chapter contain repeated condemnations concerning infractions of certain abbeys with respect to vestments, overly showy pavements, stained glass windows, and paintings within the church, I have found not a single instance, in the enormous collection of these pronouncements to have come down to us, in which painting in manuscripts is mentioned and castigated. Perhaps, as one author has supposed, the visitors on their regular rounds did not find it practical to leaf through every manuscript to satisfy themselves that everything was in order. Perhaps a certain distinction came to be made, in practice if not in principle, between the context of public display and the more private, introspective character of painting hidden in books. A note of compromise along still different lines is found in the treatise *Pictor in Carmine*, attributed to an English Cistercian writer of the later twelfth century. As

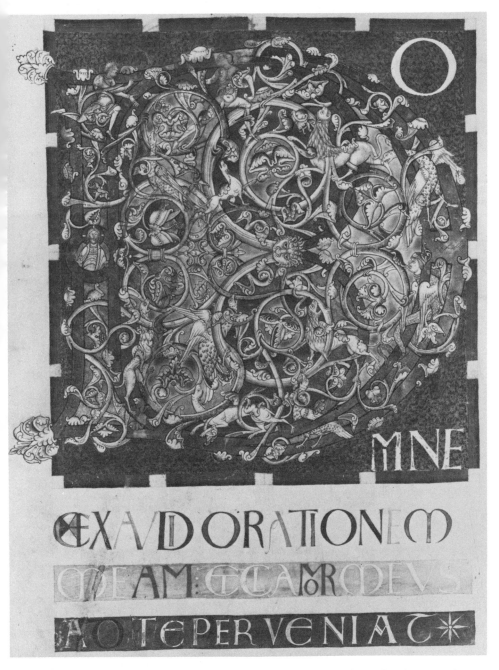

Figure 6.17. Initial of Psalm 101, Augustine, *Commentary on the Psalms* (fragment), Clamecy, Musée Municipal. *Photographie Bulloz, Paris.*

this author ruefully notes, the vain display of ornament is easier to denounce than to remove altogether. But if we must accept the inevitable, at least in cathedrals and parish churches where the public gathers, let us make the best of it. If pictures there must be, let them not be meaningless and foolish fantasies, but the stories of the Old and the New Testament. For the rest, let them who supervise such things "look to it themselves as the fancy takes each, or as he abounds in his own sense, provided only that they seek Christ's glory, not their own: and so not only may He draw praise from the mouths of babes and sucklings, but even if these hold their peace, the stones may cry out and a painted wall declare the wonderful works of God after a fashion."[47]

Appendix: Donors of Books to Clairvaux in the Twelfth and Thirteenth Centuries

1. Henry of France

Troyes Mss. 511 (Glossed Psalter); 512 (Glossed Pauline Epistles); 871 (Glossed Mark); 872 (Jerome, Epistles); 1023bis (Glossed John); 1083 (Glossed Luke); 1620 (Glossed Catholic Epistles). Montpellier, Bibliothèque de l'Ecole de Médicine, Mss. 155 (Glossed Matthew); 231 (Ivo of Chartres, Epistles).

Henry was a brother of Louis VII. He became a monk of Clairvaux in 1140, Bishop of Beauvais in 1149, and Archbishop of Reims in 1162. His anniversary was commemorated at Clairvaux on November 13 (Ch. Lalore, *Le trésor de Clairvaux du XIIe au XVIIIe siècle*, Troyes: J. Brunard, 1875, 174–83).

2. Alan of Auxerre

Gratian, *Decretum* (lost).

Alan, a monk of Clairvaux, became Abbot of Larivour (1140) and Bishop of Auxerre (1152–67). He died at Clairvaux in 1185. See note 34 above, and on his career, C. B. Bouchard, *Spirituality and Administration. The Role of the Bishop in Twelfth-Century Auxerre* (Cambridge, Mass.: Harvard University Press 1979) pp. 69ff.

3. Garnerius of Rochefort

Troyes Mss. 32 and 392 *(Liber Angelus)*; 577 (Bible).

Garnerius, Abbot of Auberive (1186), became Abbot of Clairvaux in 1192, then Bishop of Langres in 1193. He resigned this office five years later, retiring to Clairvaux. He was still alive in 1216. See J.-Ch. Didier, ""Garnier de Rochefort, sa vie et son oeuvre. Etat de questions," *Collectanea ordinis sacris Cisterciensis*, 17 (1955):145–58, and A. Dimier, *Dictionnaire des auteurs cisterciens* (Rochefort: Abbaye Notre-Dame de St. Remy, 1975) 1:272–73.

4. Cardinal Peter of Bar

Troyes Mss. 58 (Glossed Psalter); 65 (Glossed Genesis and Exodus); 106 (Glossed

Joshua, Judith, Esdras, etc.); 110 (Glossed Leviticus, Numbers, Deuteronomy); 111 (Glossed Pauline Epistles); 395 (Comestor, *Historia Scholastica*).

Peter of Bar was a monk and later Prior of Clairvaux. He became Abbot of Mores in 1238, of Igny in 1239, and Cardinal of St. Marcel in 1241. He died in 1252. See J.-M. Canivez, *Dictionnaire d'histoire et de géographie ecclésiastique*, 18 vols. (Paris: Letouzey et Ané, 1932) 6:546, and on his manuscripts, R. Branner, *Manuscript Painting in Paris during the Reign of Saint Louis* (Berkeley, Los Angeles and London: University of California Press, 1977) p. 70.

5. *Master Frederick, Canon of Langres*

Troyes Mss. 83 (Glossed Job, Acts, Catholic Epistles and Apocalypse); 113 (Glossed Joshua, Judges, Ruth and Esdras); 157 (Glossed Luke and John); 220 (Glossed Matthew and Mark).

Frederick "quondam canonici Lingonensis" is memorialized by an anniversary on the Obituary of Clairvaux on March 1 (Lalore, *Trésor de Clairvaux*, 174–83).

6. *Cardinal James of Preneste*

Troyes Ms. 79 (Glossed Pauline Epistles).

Jacobus Pecorari, archdeacon of Ravenna, was a monk of Clairvaux and later of Trois-Fontaines. He became Cardinal of Preneste in 1231, died in 1244, and was buried at Clairvaux near the tomb of St. Malachy. His anniversary figures in the Obituary of Clairvaux on May 28 (Lalore, *loc. cit.*)

7. *Johannes Pisanus, Canon of Lausanne*

Troyes Mss. 217 (Lombard on the Psalms); 238 (Glossed Pauline Epistles); 922 (Glossed Ezekiel and Lamentations); 1378 (Glossed Proverbs, Ecclesiastes and Songs).

8. *Frater Nicolas Parisiensis*

Troyes Ms. 475 (Glossed Luke and John)

Two men of that name are recorded by P. Glorieux, *La faculté des arts et ses maîtres au XIII^e siècle*, Etudes de philosophie médiévale, 59 (Paris, J. Vrin, 1971):262–63, No. 320, and 401, No. 472.

9. *Bartholomeus Guidonis Agricolae filius*

Troyes Mss. 449 (Glossed Luke and John); Ms. 479 (Lombard on the Psalms); 517 (Glossed Leviticus); 649 (Glossed Acts and Catholic Epistles); 1024 (Comestor, *Postillae* on the Gospels).

10. *Magister Bovo Medicus*

Troyes Mss. 78 (Chronicles, Tobit, Judith, Esther, Esdras, I–II Maccabees); 139 (Glossed Chronicles and Maccabees); 233 (Glossed Pauline Epistles); 467 (Job and Minor Prophets); 568 (Glossed Leviticus, Numbers and Deuteronomy).

11. *Bernardus monachus Clarevallis*

Troyes Ms. 176 (Lombard on the Psalms).

12. Dominus Johannes Bouvin

Troyes Ms. 243 (Glossed Proverbs, Ecclesiastes, Song of Songs, Wisdom and Ecclesiasticus).

13. Frater Johannes Canturiensis

Toyes Ms. 1294 (Origen on Leviticus).

NOTES

 1. M. Aubert and M. de Maillé, *L'architecture cistercienne en France*, 2 vols. (Paris: Editions d'art et d'histoire, 1957). H. Hahn, *Die frühe Kirchenbaukunst der Zisterzienser. Untersuchungen zur Baugeschichte von Kloster Eberbach im Rheingau und ihren Analogien im 12. Jahrhundert* (Frankfurter Forschungen zur Architekturgeschichte, I) (Berlin: Gebr Mann, 1957), pp. 97ff.

 2. Dijon, Bibl. Mun. Mss. 12–15 and 168–170, 173. C. Oursel, *La miniature du XII^e siècle à l'abbaye de Cîteaux* (Dijon: L. Venot, 1926), pp. 14ff. The problems of Cistercian book illumination are discussed by J. Porcher, *L'art cistercien*, Collection Zodiaque, 1962, pp. 320–29; A. Schneider, A. Wienand, W. Bickel, and E. Coester, *Die Cistercienser. Geschichte, Geist, Kunst*, (Cologne: Wienand, 1974), pp. 429ff., and G. Plotzek-Wederhake, "Buchmalerei in Zisterziensklostern," *Die Zisterzienser. Ordensleben zwischen Ideal und Wirklichkeit*, Exh. Catal. (Aachen: Rheinland-Verlag, 1980), pp. 357–78.

 3. A. Wilmart, "L'ancienne bibliothèque de Clairvaux," *Mémoires de la Société académique de l'Aube* 53 (1917): 127-90; F. Bibolet, "Les manuscrits de Clairvaux au XII^e siècle," *Congres archéologique de France* 113 (1955): 174–79; *idem*, "Les manuscrits de Clairvaux," *Les dossiers de l'archéologie* No. 14 (Jan.–Feb. 1976): 86–92; A. Vernet, *Catalogue des manuscrits de l'abbaye de Clairvaux*, (Paris: Centre National de la Recherche Scientifique, 1980).

 4. C. H. Talbot, "Notes on the Library of Pontigny," *Analecta Cisterciensia* 10 (1954): 106–68.

 5. A list of Fontenay manuscripts, which are in the Bibliothèque Nationale, is given in L. Delisle, *Le Cabinet des manuscrits de la Bibliothèque imperiale* (Paris: Imprimerie Nationale, 1868–81), I: 465 and II: 366–67.

 6. The Vauclair manuscripts are inventoried in the *Catalogue général des manuscrits des Bibliothèques des Departements* (Quarto Series) ed. F. Ravaisson, 1 (Paris: Imprimerie Nationale, 1849), and a certain number figure in the publication of E. Fleury, *Les manuscrits à miniatures de la Bibliothèque de Laon* (Laon: 1863). See also on these books, S. Martinet, "Les manuscrits de Vauclair," *Archeologia* 14 (Jan.–Feb. 1967): 45–47.

 7. For Morimond, see the inventory of the Municipal Library of Chaumont by J. Gauthier in *Catalogue général des manuscrits des Bibliothèques publiques des Départements* 21, (Paris: Librairie Plon, 1893), and M. Henriot, "Dans quelle mesure la Bibliothèque de Chaumont a-t'elle sauvée le fonds de l'abbaye de Morimond," *Cahiers Haut-Marnais* 112 (1973): 1–13. A number of other manuscripts are in the Bibliothèque Nationale (Delisle, *Cabinet des manuscrits* 2: 386).

 The manuscripts of La Ferté-sur-Grosne are in the Municipal Library at Chalon-sur-Saone. See the catalogue of S. Bougenot in *Catalogue général*, 6, 1887. Those of Igny are

now scattered. A fine *Speculum Virginum* from the abbey is in Berlin (Staatsbibl. lat. 73), a Seneca in the Beinecke Library at Yale University (Marston Collection, Ms. 45), and two books given to the conventual library by Archbishop Samson of Reims are in Troyes (Bibl. Mun., Ms. 72) and the Bibliothèque Nationale (Lat. 6160).

8. The date 1134 given by J. Canivez, *Statuta capitulorum generalium ordinis Cisterciensis ab anno 1166 ad annum 1786* ... (Louvain, 1933), 1, 31, is seriously challenged by F. Kovàcs, "A propos de la date de la rédaction des 'Instituta generalis capituli apud cistercium,'" *Analecta Sacri Ordinis Cisterciensis* 7(1951): 85–90, and J. Lefèvre, "Pour une nouvelle datation des 'Instituta generalis capituli apud Cistercium,'" *Collectanea Ordinis Cisterciensium Reformatorium*, 16 (1954): 241–66. The possibility that the article concerning illumination and stained glass introduced, or more likely reaffirmed, at a later date, around 1182, is envisaged by J. Leclercq, "Les peintures de la Bible de Morimondo," *Scriptorium* 10 (1956): 22 n. 2. See on this point also the same author's article "Epîtres d'Alexandre III sur les cisterciens," *Revue bénédictine* 64 (1954): 77–78.

9. Canivez, *Statuta*, 31, and J. Turk, "Cistercii statuta antiquissimi," *Analecta Sacri Ordinis Cisterciensis* 4 (1948): 27–28, no. 82. De litteris vel vitreis. Litttera unius coloris fiant, et non depictae. Vitreae albae fiant, et sine crucibus et picturis.

10. The Latin text is found in R. B. C. Huygens, "Le moine Idung et ses deux ouvrages: 'Argumentum super quatuor questionibus' et 'Dialogus duorum monachorum,'" *Studi medievali*, 3ᵉ ser., 13, 1 (Spoleto, 1972) pp. 375–470. An English translation has been published under the title *Cistercians and Cluniacs: The Case for Cîteaux. A Dialogue between Two Monks* ... , Cistercian Fathers Series, No. 33 (Kalamazoo: Western Michigan University, 1977).

11. J. Gutbrod, *Die Initiale in Handschriften des achten bis dreizehnten Jahrhundert* (Stuttgart: W. Kohlhammer, 1965), and J. J. G. Alexander, *The Decorated Letter* (New York: Braziller 1978) pp. 11ff.

12. A general study of this question is as yet lacking.

13. M. Schapiro, *The Parma Ildefonsus: A Romanesque Illuminated Manuscript from Cluny and Related Works*, Monographs on Archaeology and Fine Arts sponsored by the Archaeological Institute of America and the College Art Association of America no. 11 (New York: College Art Association, 1964).

14. Yale University, Beinecke Library of Rare Books and Manuscripts, Ms. 349. On the monastery, see E. Jarossay, "Histoire de l'abbaye de Fontaine-Jean de l'ordre de Cîteaux, 1124–1790," *Annales de la Société historique et archéologique du Gatinais* 9 (1891): 21–94, 126–354; 10: 97–184; 166–289.

15. There are other examples of the substitution of earth colors for gold. See, for example, the manuscript from Altzelle illustrated in R. M. Libor, *Ars cisterciensis. Buchmalereien aus mittel- und ostdeutschen Klosterbibliotheken* (Würzburg: Holzner 1967) p. 21. It is instructive to compare the effects of the Cistercian legislation on book illumination with those observable in the domain of stained glass, governed by the second part of Article 82 of the *Instituta*. See on this subject H. J. Zakin, *French Cistercian Grisaille Glass*, Outstanding Dissertations in the Fine Arts (New York and London: Garland Press, 1979).

16. Berlin, Staatsbibl. Preuss. Kulturbesitz, Theol. lat. 379. On this manuscript, see the exhibition catalogues *Zimelien. Abendlandische Handschriften des Mittelalters aus der Sammlungen der Stiftung Preussischer Kulturbesitz* (Berlin, 1975–75), 67, No. 45, and *Die Zeit der Staufer* (Stuttgart, 1977) I: 582–83, No. 753.

17. Besançon, Bibl. Mun. Ms. 54. V. Leroquais, *Les psautiers manuscrits latins des Bibliothèques publiques de France* (Mâcon: Protat Frères, 1940–41), I: 81–86, and *Zeit der Staufer*, 543–45, No. 723.

18. New York, Pierpont Morgan Library, Ms. 429. W. Neuss, *Die Apokalypse des Hl. Johannes in der altspanischen und altchristlichen Bibelillustration* (Münster, 1931), pp. 54–55, No. 21.

19. Neuss, *loc cit.* and No. 19 for the transcription of the colophon on folio 182.

20. For the list of manuscripts, see M. Bernards, *Speculum Virginum. Geistigkeit und Seelenleben der Frau im Hochmittelalter*, (Forschungen zur Volkskunde, 36–38 (Cologne and Graz: Böhlau, 1955), pp. 7–9. For the illustrations, A. Watson, "The Speculum Virginum with Special Reference to the Tree of Jesse," *Speculum* 3 (1928): 445–69; *idem*, "A Manuscript of the Speculum Virginum in the Walters Art Gallery," *Journal of the Walters Art Gallery* 10 (1947): 61–74; E. Simmons Greenhill, *Die geistigen Voraussetzungen der Bilderreihe des Speculum Virginum. Versuch einer Deutung* (Beiträge zur Geschichte der Philosophie und Theologie des Mittelalters. Texte und Untersuchungen, 39), Münster in W., 1962.

21. London, British Library, Arundel Ms. 44. E. Simmons Greenhill, "Die Stellung der Handschrift British Museum Arundel 44 un der Überlieferung des Speculum Virginum," *Mitteilungen des Grabmann-Instituts der Universität München*, Heft 10, 1966.

22. Bonn, Rheinisches Landesmuseum, No. 15326–28. These leaves are from the manuscript in the Trier Dombibliothek, Ms. 132. See Bernards, *Speculum Virginum*, p. 7.

23. Troyes, Bibl. Mun. Ms. 252. L. Morel-Payen, *Les plus beaux manuscrits et les plus belles reliures de la Bibliothèque de Troyes*, (Troyes: J.-L. Paton, 1935), 109–110.

24. For the manuscripts, see W. Cahn, "Architectural Draftsmanship in Twelfth-Century Paris: The Illustrations of Richard of Saint-Victor's Commentary on Ezekiel's Temple Vision," *Gesta* 15, 1–2 (Essays in Honor of Sumner McKnight Crosby), p. 254, note 11. Since this list was compiled, I have come across another copy of this work, found in Bibl. Nat. lat. 16.702, from the Sorbonne.

25. Oxford, Bodleian Library, Ms. Bodley 494. See C. M. Kauffmann, *Romanesque Manuscripts, 1066–1190*, A Survey of Illuminated Manuscripts in the British Isles, III (London: Harvey Miller, 1975): 113–14, No. 88.

26. Troyes, Bibl. Mun. Ms. 544.

27. Cambrai, Bibl. Mun. 305. One might examine, in the same spirit, the Cistercian and non-Cistercian copies of another popular text of this period, the bestiary of Hugh of Fouilloy. The most complete list of manuscripts of this text is found in N Häring, "Notes on the 'Liber avium' of Hugues of Fouilloy (ca. 1100–ca. 1174)," *Recherches de théologie ancienne et médiévale* 46 (1979): 53–83.

28. Troyes, Bibl. Mun. Ms. 84. Morel-Payen, *Les plus beaux manuscrits*, pp. 75–76, and W. Cahn in *Art Quarterly* 33 (1970): 299.

29. Troyes, Bibl. Mun. 27; Chaumont, Bibl. Mun. 1–5; Paris, Bibl. de l'Arsenal, Ms. 578–79, completed by Leningrad, Public Library, Ms. f.v.I.24. See Porcher *Art cistercien*, 324–29. The Pontigny inventory contained in Montpellier, Bibl. de l'Ecole de Medicine, Ms. 12 also lists a Bible in five volumes.

30. Aubert and De Maillé, *Architecture cistercienne* I: 144.

31. *Idem*, 329ff.

32. Zwettl, Stiftsbibliothek, Ms. 204. See P. Buberl, *Die Kunstdenkmäler des Zisterzienserkloster Zwettl* (Baden: R. M. Rohrer, 1940), pp. 203–5.

33. On the volumes of Prince Henry, see W. Cahn, "A Twelfth-Century Decretum Fragment from Pontigny," *Bulletin of the Cleveland Museum of Art*, Feb. 1975, p. 53.

34. B. Jacqueline, "Le Décret de Gratien à l'abbaye de Clairvaux," *Collectanea Cisterciensia* 14 (1952): 259–64. E. Martène and U. Durand, *Voyage littéraire de deux religieux bénédictins de la Congrégation de Saint-Maur* (Paris: 1717), I: 103: "Nous y trouvames aussi un fort beau *Decret de Gratien* qui a été donné autrefois par Alain, disciple de Saint Bernard

et ensuite évêque d'Auxerre sur lequel sont écrits ces mots 'Ego Alanus quondam Autissiodorensis episcopus haec Decreta Gratiani dedi monasterio Clarevallis ...'" Thibaut, bishop of Chalon (d. 1264) gave to La Ferté his Bible and a volume of his own sermons (Bougenot, *Catalogue général*, 6: 359), and Archbishop Samson of Reims gave books to Igny (see above, note 7).

35. Baltimore, Walters Art Gallery, Ms. 777. See D. Minor, "Since De Ricci—Western Illuminated Manuscripts Acquired since 1934, II," *Journal of the Walters Art Gallery* 31–32 (1968–69): 48ff.

36. Troyes, Bibl. Mun. Ms. 60. See Morel-Payen, *Les plus beaux manuscrits*, 58–60, and W. Cahn, "The Tympanum of the Portal of Saint-Anne at Notre-Dame de Paris and the Iconography of the Division of the Powers in the Early Middle Ages," *Journal of the Warburg and Courtauld Institutes* 32 (1969) p. 70.

37. Cahn, "A Twelfth-Century Decretum Fragment." Since the publication of this article, another leaf from this manuscript has come to light in a volume of cuttings in the National Library of Wales, Aberystwyth, Ms. 4874 E, No. 2. I must thank Mr. Daniel Huws, Assistant Keeper of Manuscripts and Records, for bringing this fragment to my attention.

38. For the illustrations of the *Decretum*, see A. Melnikas, *The Corpus of the Miniatures in the Manuscripts of the Decretum Gratiani*, Studia Gratiana 16–18 (Rome: Studia Gratiana, 1975), and the important review of this publication by Carl Nordenfalk, *Zeitschrift für Kunstgeschichte* 43 (1980): pp. 318ff.

39. Troyes, Bibl. Mun. Ms. 458. Morel-Payen, *Les plus beaux manuscrits*, 65–70; W. Cahn, *Romanesque Bible Illumination* (Ithaca: Cornell University Press, 1982), 282, no. 113.

40. Wilmart, *Ancienne bibliothèque de Clairvaux*, 134–35. On Bernard's attitudes in the sphere of esthetics, see H. B. de Warren, "Bernard et les premiers cisterciens face au problème de l'art," *Bernard de Clairvaux*, Commission d'histoire de l'Ordre de Cîteaux, III (Paris, 1953): 487–534; R. Assunta, "Sulle idee estetiche di Bernardo di Chiaravalle," *Rivista Estetica* (1953): 240–68; J. Leclercq, "Essais sur l'esthétique de Saint Bernard," *Studi medievali* 9 (1968): 688–728; *idem*, "'Ioculator et saltator.' St. Bernard et l'image du jongleur dans les manuscrits," *Translatio Studii. Manuscript and Library Studies Honoring Oliver L. Kapsner, O.S.B.* (Collegeville, Minn.: St. John's University, 1973), 124–48; E. Simi Varanelli, "'Nigra sum sed formosa.' La problematica della luce e della forma nell'estetica bernardina. Esiti e sviluppi," *Rivista dell'Istituto Nazionale d'archeologia e Storia dell'arte* (1979): 119–67.

41. Troyes, Bibl. Mun. 2931. Morel-Payen, *Les plus beaux manuscrits*, 71–75; Cahn, *Romanesque Bible Illumination*, 282, no. 114.

42. There is a brief note on this work by G. Guillot-Chêne, "Deux enluminures romanes provenant de Pontigny au Musée de Clamecy." *Mémoires de la Société académique du Nivernais* 40 (1977): 21–24.

43. Paris, Bibl. Nat. lat. 8823. Cahn, "A Twelfth-Century Decretum Fragment," pp. 47 and 57, note 4; Cahn, *Romanesque Bible Illumination*, 277, no. 91.

44. The note concerning this transaction is found in Troyes, Bibl. Mun. Ms. 2299, and cited by H. Arbois de Jubainville, *Etudes sur l'état intérieur des abbayes cisterciennes et principalement Clairvaux aux XIIe et XIIIe siècles* (Paris: A. Durand, 1958), p. 62. Other references to the purchase of books by Cistercian houses are given by C. R. Cheney, "English Cistercian Libraries: the First Century," *Medieval Texts and Studies* (Oxford University Press, 1973), 330 (a slightly revised version of a paper earlier published in the *Mélanges Saint Bernard* (XXIVe Congrès de l'Association Bourguignonne des Sociétés Savantes), Dijon, 1953, 372–82.

45. Troyes, Bibl. Mun. Ms. 92. Morel-Payen, *Les plus beaux manuscrits*, p. 104.

46. L. Grodecki, "Problèmes de la peinture en Champagne pendant la seconde

moitié du XIIe siècle," *Romanesque and Gothic Art: Acts of the Twentieth Congress of the History of Art* I (Princeton, 1963): 129–41. A study of Troyes as a center of manuscript production in the second half of the twelfth century would be a most useful undertaking.

47. M. R. James, "Pictor in Carmine," *Archaeolgia* 94 (1951): 141–66.

Lay Patronage and Monastic Architecture
The Norman Abbey of Savigny

Bennett Hill

The interdependence of monasticism and its art and lay patronage, which Walter Cahn introduced in regard to book illumination in the preceding chapter is the central theme of Bennett Hill's study. Hill analyzes the motives that prompted wealthy lay people to foster the growth and embellishment of monasteries, illustrating his conclusions with a specific example, the little-studied Cistercian Abbey of Savigny. Hill too sees evidence for supposing that monastic art was affected by the patrons' tastes: in this case, in the gigantic scale of the abbey church structure. Equally important, however, is the author's demonstration of the extent to which the lay patrons themselves were drawn into the spiritual orbit of a monastic community with which they became associated.

Bennett Hill was Professor of History at the University of Illinois at Champaign-Urbana; while this volume was in preparation he joined the monastic community of St. Anselm's Abbey, Washington, D.C.

The highest aspirations of the Christian faith are hidden with Christ in God. Throughout all of Western history, however, ideals have been expressed in material objects. The sacred has rarely been separated from the secular or the secular viewed in complete isolation from the religious. Nowhere is this more obvious than in medieval church building. In the Middle Ages, a church was looked upon as a visible image of God's earthly kingdom, as "the symbol of the kingdom of God on earth."[1] The spirit of faith was so united with the physical that the mystical presence of God was visible and apparent even to the reluctantly receptive and the minimally sensitive. It is my conten-

tion that lay patronage of splendid monastic buildings reflects this union between the sacred and the secular—indeed, that it reflects specific aspirations of lay faith and a practical interdependence of monasticism and secular society in the Middle Ages. My discussion will move from a general consideration of lay patronage to the analysis of a conspicuous instance, the Norman abbey of Savigny.

Today, monks exercise a marginal or liminal role in society as symbols of Christian ideals—of values antithetical to a consumer, competitive, and materialistic culture. In the Middle Ages, however, monks were considered to have a central part in the life and work of European society. Asser, the ninth-century biographer of King Alfred, divided the Christian community into those who pray, those who work, and those who fight, implying that the services of monks were as socially utilitarian as those of the warriors who defended society with the sword, or those of peasants who gave bread through toil. Monks were the natural intercessors for humans with God. The late twelfth-century Cistercian author Adam of Perseigny put it succinctly: "What does receiving the offerings of the faithful imply but the obligation to obtain their pardon by prayer?"[2]

The monk, *miles Christi*, prayed wherever he happened to be and in whatever he happened to be doing. But it was above all in the choir of his monastery church that monastic prayer, the *opus Dei*, was executed: in that place which St. Bernard, describing Cistercian life, called the *paradisus claustralis*.[3] The particular style of monastic prayer—its relative splendor or simplicity—depended on a given community's interpretation of the *Rule* of St. Benedict. And that style would in turn be reflected in architecture most often paid for by lay patrons who shared the spiritual vision of the monks.

In composing his *Rule*, St. Benedict passed over the question as to how monasteries were to acquire the land, materials, and money with which to institutionalize the spiritual ideals he set forth. He apparently expected generous laypersons as a matter of course to assist the monks,[4] and this in fact happened. Throughout the early and high Middle Ages, the most common form of gift was land, and not infrequently it was wasteland—swamp or forest or perhaps land exhausted by centuries of exploitation. Other sources of monastic income derived from fairs and markets, from tolls on bridges or roads (or exemptions from those tolls), and from tithes. The dowries often required in the twelfth and thirteenth centuries as conditions for entrance into the religious life were also significant sources of monastic revenue. After 1100, monastic houses sometimes possessed the usufruct of crusaders' estates while they were away in the

Holy Land. And, after 1200, some religious houses, such as the Norman abbey of Savigny, acquired income by serving as houses of credit, that is, by lending money at interest.[5]

It is difficult for the modern student to calculate the value of gifts to monasteries. Most gifts were in the form of land, and, while contemporaries may have understood the dimensions and value of a piece of property, the charters of endowment ae extremely vague. Such phrases as "all my wordly goods in ... " or "all my lands in ... " permit only a rough estimate of the gift's value, dependent upon the agricultural productivity of the area as reflected in the payment of taxes of various kinds. Then again, even when a charter does give a precise monetary figure, we face the considerable difficulty of translating medieval sums into modern monetary equivalents.[6]

It is one thing to arrive at a reasonable estimate of the sources of an abbey's income and an informed guess at its revenues based on the costs of living and the salaries of workers in a given year. It is another matter to relate that revenue to specific building programs. The evidence of Abbot Suger of St. Denis and his application of specific agricultural incomes for the reconstruction of his abbey church survives as a very exceptional record.[7] But the royal abbey of France, with its close connections with the Capetians, cannot be taken as typical. Likewise the vast charitable, educational, and medical responsibilities undertaken by many large establishments and not a few small ones would seem to have reduced the money available for building programs. Also, construction costs were enormous. Jean Gimpel, who has compared the energy and environmental crises of the Middle Ages with those of the 1970s, and who maintains that stone mining in the Middle Ages is industrially comparable to the drilling for oil in the twentieth century, calculates that the costs of transporting stone over land for a distance of twelve miles was roughly equivalent to the cost of the stone itself.[8] Yet, by Wolfgang Braunfels' count, some 40,000 monasteries rose in western Europe in the period between the fifth and eighteenth centuries. Thus, it is reasonable to assume that a high percentage of a monastery's income went into building.[9]

What, we must ask, were the motives of lay patrons of medieval religious houses? One traditional explanation is that wealthy patrons gave lands and cash out of a sense of remorse for crimes of violence. Accordingly, feelings of guilt for arson, rape, murder, and other deeds of destruction provoked thousands of gifts as a means of penance and purification.[10] Great lords looked upon the monks as "knights of Christ," who performed through prayer a valuable social service. Monks, they reasoned, should not have to be preoccupied about material things.

The literature on medieval patronage, charity, and almsgiving has

grown considerably in recent years, giving nuance and depth to these ideas. At least three basic interpretations may be distinguished. One school of thought, which emanates from Professor Michel Mollat's seminar at the Sorbonne, discusses almsgiving in terms of voluntary and involuntary poverty, to which it ascribes most medieval religious and social change. Jacqueline Caille's heavily documented *Hôpitaux et charité publique à Narbonne* is a typical example of this position; Caille holds that broad public consciousness of and response to the poor brought about significant urban change.[11] A somewhat similar interpretation appears in Lester Little's book, *Religious Poverty and the Profit Economy in Medieval Europe*. For Little, the monks alone were the *pauperes Christi*, Christ's poor; they believed themselves to be, and society looked upon them as, the poor (weak) in spirit. The monks, often recruited from the warrior classes, had laid down their weapons and made themselves voluntarily weak in order to perform the most important function for Christian society: prayer. Moreover, in return for the gifts they received, the monks performed all sorts of political, diplomatic, and social services for members of the nobility, who were frequently their relatives.[12]

Another explanation for almsgiving comes from the students of the annals school who, with their concern for "total history," stress that religious attitudes and acts cannot properly be distinguished from social structures and economic practices. Noble men and women endowed and supported religious houses because doing so was a function of their social status. Gift-giving had cultural roots which went deep into ancient Germanic folk practices, and by the twelfth century largesse was a mark of prosperity, prestige, and power. The greater the person, the more lavish and generous he or she was expected to be.[13]

A third interpretation, primarily that of such Catholic scholars as Father Marie Dominique Chenu and of Vicaire, describes almsgiving as an expression of lay spirituality. According to Vicaire in his recent book, *Assistance et charité*, charity was "religious" in the sense that the fundamental motive for gifts to benefit the unfortunate seems to have been love of God (seen incarnate in the poor) and fear of God's judgment. Charity was "religious" in that the duty to give alms was an aspect of the new twelfth-century emphasis on service to one's neighbor in imitation of Christ.[14] Just as in the ancient world the participation in religious ceremonies had a definite political significance, so in the Middle Ages charity was "religious" in the sense that it involved the social relations between one Christian and another.

This last interpretation is suggestive of the work of Ernest Troeltsch, the German student of the sociology of religion. More than sixty

years ago, Troeltsch pointed out that the Church idealized poverty as one means by which the Christian came to the knowledge of God. The relief of suffering and distress represented an awakening of the spirit of love and, by means of this love, the believer helped overcome social distress. The aim however was not the healing of social wrongs, which was beyond the limited resources of medieval society; in the medieval view, the world remained the realm of Satan and of sin, the place of pilgrimage and preparation, and there was no need to be anxious about its positive improvement. Troeltsch stressed that charity was never the equivalent of social reform; in fact, it had nothing to do with it. Almsgiving was a fundamental Christian duty, and a responsibility incumbent upon all who accepted the name of Christian. Assistance to the poor and needy was an aspect of the virtue of charity, as emphasized by all the theologians from Ambrose through Augustine to Thomas Aquinas. The giver shared vicariously in the poverty and need of the recipient, who in his or her poverty represented Christ. The wealthier the individual Christian, the greater his or her social status, so much the heavier was the duty to contribute to the needs of the poor.[15]

Philanthropic acts, of course, are not exclusively expressions of medieval piety, however much they may be justified in patristic and scholastic writings. Almsgiving as an aspect of moral uprightness, and the range of motives which inspire it have deep roots in Judeo-Christian culture. In the Old Testament, for example, the Book of Job expresses the worldly view that piety and charity are part of a bargain, a quid pro quo for benefits which can be anticipated from God. When God calls the devil's attention to Job's goodness, Satan replies, "Yes, but Job is not God-fearing for nothing, is he? Have you not put a wall around him and his house and all his domains? You have blessed all that he undertakes, and his flocks throng the countryside. But stretch out your hand and lay a finger on his possessions, and, I warrant you, he will curse you to your face" (Job 1:8–12, *The Jerusalem Bible*). Satan argues that people are pious because it pays them to be so; if people are charitable, it is in order to get something in return.

In the New Testament, Christ promises a reward for those who give alms, characterizing right and wrong ways of giving:

> Be careful not to parade your good deeds before men to attract their notice; by doing this you will lose all reward from your Father in heaven. So when you give alms, do not have it trumpeted before you; that is what the hypocrites do in the synogogues and in the streets to win men's admiration. I tell you solemnly that they have their rewards. But when

you give alms, your left hand must not know what your right is doing;
your alms giving must be in secret, and your Father who sees all that is
done in secret will reward you.

(Matthew 6:1–4)

Most twelfth- and thirteenth-century patrons of monasteries were
not willing to wait for God's reward. Monks might represent Christ's poor,
but noble patrons were socially as well as economically incapable of com-
pletely disinterested almsgiving and commonly expected concrete material
returns on their gifts of property and cash. The men and women who
founded and endowed the Cistercian abbeys in Yorkshire and Lincolnshire
in England often required a specific return in the form of cash or goods or
the reclamation of the land in return for their gifts, and on the semibar-
barous fringes of Normandy and Brittany French lords expected monastic
comunities to serve as a politically stabilizing force and to bring the land
under cultivation.[16]

Finally, an astute observer like St. Bernard of Clairvaux could see
yet subtler shades of motivation both in those who received and in those
who gave alms. Speaking of monastic art, he wrote that

eye-catching adornments are to attract gifts … It is possible to spend
money in such a way that it increases; it is an investment which grows,
and pouring it out only brings in more. The very sight of such sumptuous
and exquisite baubles is sufficient to inspire men to make offerings,
though not to say their prayers. In this way riches attract riches, and
money produces more money … the richer a place appears, the more
freely do offerings pour in. Gold-cased relics catch the gaze and often
purses. … This is the reason the churches are decked out. … Do you think
such appurtenances are meant to stir penitents to compunction, or
rather to make sight-seers agog? Oh, vanity of vanities, whose vanity is
rivalled only by insanity.[17]

St. Bernard's diatribe was directed, of course, at the abbey of Cluny. Not
long after his death in 1153, however, the same criticisms could have been
leveled at some of Bernard's own Cistercian abbeys.

It is true that monastic chroniclers and compilers of cartularies
explained the gifts of lay patrons in an entirely different way. But charters
of foundation were usually written down long after the event, and the
cartularies were written much later still. Consequently, as Galbraith,
Knowles, and others have pointed out, many kinds of anachronisms
entered into them. Scribes used the cartularies and foundation histories to

serve the judicial needs of their monasteries. Foundation histories became "spiritual swords" written in defense of the monastery's property rights and legal interests. Monastic chroniclers frequently used histories of their houses as propaganda devices to promote the spiritual and political reputation of their houses as well.[18] (This is perhaps a reflection of that self-conscious awareness of monastic identity which Dom Jean Leclercq recently discussed in a provocative article.[19]) For example, although most Benedictine and Cistercian abbeys founded in the late eleventh and twelfth centuries began in economically poor, politically unstable, and geographically isolated circumstances, one would never realize this from reading the chroniclers. The fame and prestige which many houses acquired later in the Middle Ages were projected backwards to the abbey's beginnings. Similarly chroniclers were aware that a public reputation for fidelity to the *Rule* of St. Benedict, for care and exactness in the execution of the liturgy and ceremonial, and for the piety and devotion of abbot and monks enhanced a monastery's prestige. A distinguished reputation tended to stimulate the flow of visitors and of gifts.

The construction of the church of the Norman abbey of Savigny serves as a prime illustration of the general observations offered above. Given its wealth and vast buildings, it is somewhat surprising that Savigny has attracted so little scholarly attention in the twentieth century. Several nineteenth-century historians and antiquarians, however, did comment upon the preeminence of this house. In 1825, in a sketch of the religious houses of the Department of La Manche, de Gerville maintained that "among the abbeys of Normandy, I have found none whose claims to first rank should be more evident than those of Savigny ... The revenues of Cérisy may have been slightly larger. As a fortress, as a pilgrimage site, and as a repository of manuscripts, Mont-Saint-Michel has particular importance. But in the monastic hierarchy of the times, the first place incontestably went to Savigny."[20] Twenty-five years later (1850) the Abbé Desroches, a member of the Society of Antiquarians of Normandy, wrote: "Of all the abbeys of France, Savigny was the most illustrious. In the Middle Ages she gave birth to a prodigious number of celebrated monasteries, which were not only oratories but centers of learning. ... The monks of these houses were not simple men, but for the most part distinguished knights, who, weary of roaming the world, chose to end their lives in the cloister."[21]

The history of Savigny may be reconstructed as follows: In 1105 Ralph de Fourgères, a vassal of the Count of Mortain, granted land to the hermit Vital for the establishment of a monastery. The land was in the forest of Savigny, on the Mortain fief in the southwestern corner of Nor-

mandy on the borders with Brittany. A close and mutually beneficial relationship between the Fourgères family, the Counts of Mortain, and the abbey of Savigny continued throughout the twelfth century. Because of the prestige of St. Bernard of Clairvaux, in 1148 the abbey and congregation of Savigny opted for union with the Cistercian Order.[22]

In 1112 Vital began the construction of conventual buildings. The location of the monastery in the middle of a forest and Vital's eremetical proclivities led him to build in wood. The work begun by Vital was finished by his successor, Abbot Geoffrey (1122–39), but, because of the remarkable growth in the number of monks, the abbey church soon proved too narrow and constricted for the conduct of a dignified liturgy.[23] Land rich but cash poor, Savigny made a number of foundations in a relatively short period of time. The lack of cash delayed the constuction of a permanent abbey church.

In the third and fourth quarters of the twelfth century, however, a large and steady stream of gifts—tithes, rents, parish churches, buildings, and lands—flowed to Savigny. The chroniclers stress that lay faith and material support made the erection of the new church possible. As Dom Claude Auvry, the historian of Savigny, stated: "The generosity of many lords, particularly those of Fougères, encouraged the abbot Joscelin (ninth abbot of Savigny, 1164–79) ... to undertake the building of another, larger and more spacious church."[24] Among others, the lords of Gorron, Saint Hilaire-du-Harcourt, and of Vitre gave rents to help in financing the church.[25] Lay patrons frequently requested as a condition of their gifts that when they died they be buried before the high altar of the church or in one of the chapels which would radiate around it. These men wished to be associated with the prayers and choral office of the monks; they wanted to rest eternally in the *paradisus claustralis*. Thus Robert, Count of Vitre, gave lands in the neighborhood of Rennes in Brittany specifying that the rents and other revenues were to be used for the construction of the new church, and stipulating that, when he died, his body was to be buried in a chapel dedicated to St. Catherine.[26] Without the financial support of such laypersons, the monastic church of Savigny could not have been built. It was the tangible product of their faith as well as of their money, of their desire to be remembered in and associated with the continual round of monastic prayer. The church, when completed, would truly incarnate the interdependence of monasticism and lay society.

In 1173, Joscelin was able to cut the sod for the new church. When ground was broken, adequate funds existed or were reasonably antici-pated, for the years 1172–74 witnessed the accumulation of the necessary money with which to begin. The church was to conform to strict Cister-

cian architectural principles, and in fact it was modeled upon the recently completed (second) abbey church of Clairvaux. Not only did the statutes of the General Chapters of 1132, 1157, and 1182 prescribe what was permissible in the Order's buildings,[27] and not only was the relationship between Savigny and Clairvaux close since the affiliation of 1148, but in the years 1187–1200, the abbots of the two houses had been in frequent contact. They faithfully attended the general Chapters at Cîteaux, and several times during those years they were assigned together to conduct visitations of other houses and to handle various kinds of business for the Order. The possibility certainly exists that the abbot of Savigny had attended in 1174 the dedication of Clairvaux's new church.[28]

Who was the master mason, that is, the architect, and who did the actual work of construction at Savigny? Marcel Aubert, researching for many years at the École des Chartres, could discover only one lay architect working on a French monastery in the entire twelfth century, although he lists many monk-architects.[29] The recent studies of Lon Shelby at Southern Illinois University and those of the late Robert Branner at Columbia have not disproved Aubert.[30] The architect of Savigny was probably a monk, conceivably a monk trained by St. Bernard's architect–confrère, Garard (Achardus; see Chapter 5), and certainly a person familiar with the architectural structure of Clairvaux.[31] Conant's belief that all houses of the Cistercian affiliation were designed by the monks themselves lends support to this theory. But since most of the monks of Savigny were of the knightly class, Conant's assertion that the monks built the church themselves should be qualified: when he speaks of monk builders, he must be referring to the lay brothers, since choir monks, being aristocrats, did not work with their hands.[32] It is difficult to identify the architect of Savigny because, as Shelby has pointed out, the technical skill and knowledge of cathedral building were acquired by learning the traditions and techniques of the craft and passed on orally from one generation to another. Only in the thirteenth century did master masons begin to commit their designs to paper.[33]

Between July of 1789 and the winter of 1793, during the massive destruction of ecclesiastical property which accompanied the French Revolution, the monastery and church of Savigny were so totally razed that scarcely was stone left on stone; the archives and records were so scattered that Auguste Laveille has said that "to attempt to write the history of Savigny is like trying to move the stone from the sepulchre."[34] Several attempts have, nevertheless, been made. In 1835, an English archeologist, Gally-Knight, visited Savigny and recorded his observations in the *Voyages Archéologiques*.[35] In 1895, a French lawyer, Hippolyte Sauvage, interested

in the local history of Mortain, produced a deeply pious and semipopular study of St. Vital and Savigny. Sauvage had the advantage of a late eighteenth-century drawing of the structure of Savigny then preserved at the Bibliothèque National.[36] In 1935 Mademoiselle Jacqueline Buhot attempted a full archeological reconstruction. She excavated the site of the church, measured it, and drew up a plan.[37] In 1953 a French architectural student, Durand de Saint-Front, attempted a sketch of the history of the monastery and its architecture from its beginnings to 1789. Saint-Front's short article relies on the four notebooks which the Abbé Lemesle, curé of Mortain, wrote in 1751.[38] Drawing on this evidence, the following conclusions may be posited.

The church of Savigny was built on the basic plan of Clairvaux. Its proportions were not only cathedral-like, but absolutely gigantic. The church measured two hundred forty-seven feet in length, and the transept from the north to the south wall was one hundred and fifty feet. By way of comparison, the nave of the great church of Mont Saint-Michel was only sixty-eight feet, the nave of the abbey church of St. Etienne of Caen, built by William the Conqueror with all his great resources and often described as "immense," was less than eighty-four feet. Among the cathedrals of the region, the nave of Bayeux was only ninety-two feet, that of Coutances eighty-eight feet, and the cathedral of Le Mans ninety-six feet. The abbey church of Savigny was easily the largest church building in Normandy, probably in all of western France.

As for architectural style, Savigny's cannot be easily pinpointed. Writing in 1835, Gally-Knight observed that "it is hardly possible, in the middle of this mutilated debris, to obtain a clear idea of the architecture of the edifice. However, one recognizes in it a marked characteristic of transition, and it seems to resemble more the circular than the pointed style."[39] Strongly infuenced by Clairvaux, which embodied what Conant calls St. Bernard's preference for the Burgundian "half-Gothic,"[40] Savigny had a mixed style. The columns in the nave supported capitals of a definitely late Romanesque style. Yet the arches in the vaulting over the nave seem to have been pointed. The church was under construction from 1173 to 1220. Professor von Simson has identified the spread of the Gothic with the expansion of the political power of the Capetians; the conquest of Normandy by Philip Augustus in 1204 led to the introduction into the province of the style called "French."[41] Thus, at Savigny the large west window was divided into three panels with a trefoil at the top, as were the large circular windows in the north and the south walls above the transept. The major sculptural parts of the church were Romanesque, while some parts show primitive Gothic.

The choir and some of the altars of the apse were completed at the turn of the century and consecrated on the feast of the Assumption (August 15) in 1200. The entire church was finished in the relatively short span of forty-six years, which suggests that funds were available to the monks in an uninterrupted flow. This is remarkable when we remember that at the same period Christ Church, Canterbury—one of the richest abbeys in western Europe—had to delay reconstruction after the fire of 1174 for lack of funds. Abbot Ralph of Savigny (1208–22) had the satisfaction of summoning Robert Pullen, Archbishop of Rouen, all the bishops, and many of the abbots of Normandy to participate in the formal consecration of the finished church. The great event occurred on May 9, and the bishops proclaimed an indulgence to all those who made a pilgrimage to the new church within eight days of the dedication.[42] This indulgence may well have been another soure of revenue for the abbey's building fund.

Thus the great abbey church of Savigny symbolized both the close and strong financial support of the laity and the prudent management of the monks. The costs of construction must have been prodigious by any reckoning, and to embark upon and complete such a structure in so short a time demonstrates the wealth of the house and the sure patronage of the nobility of the region. The unusual size of the church may reflect the taste of its lay patrons, although to some extent the increasing demands of the liturgy and the steadily growing size of the community at Savigny would have favored a church of large proportions. The White Monks deeply appreciated the significance of the liturgy. In a letter to Guy, abbot of Montieramey, St. Bernard says that the chant should be "quite solemn,"[43] and he intended the word *solemn* to carry the original, literal sense of ceremonious, stately, and formal. It was in this spirit that the church of Savigny was built, for in Gothic architecture size contributed to a sense of dignity and solemnity. Magnificent in scale and decoration, the vast interior of Savigny was the setting for a rich liturgy, that "work of God" to which St. Benedict had insisted nothing be preferred. For its lay patrons as well as for the monastic community that used it, the abby church at Savigny embodied the principle that monks were above all men of prayer.

NOTES

I am happy to acknowledge the support granted for part of the research for this paper by the Research Board of the University of Illinois at Champaign-Urbana. I am also grateful to Walter L. Arnstein for his kind advice and good counsel.

1. Cited in Otto von Simson, *The Gothic Cathedral: Origins of Gothic Architecture and the Medieval Concept of Order* Bollingen Series (Princeton: Princeton University Press, 1974), p. xvi. The phrase apparently was coined by St. Jerome. See the fascinating discussion of this symbolism in Paul Frankl, *The Gothic: Literary Sources and Interpretations through Eight Centuries* (Princeton: Princeton University Press, 1960), pp. 757–58.

2. *The Letters of Adam of Perseigny*, translated by Grace Perigo, Introduction by Thomas Merton. Cistercian Fathers Series #21. (Kalamazoo: Cisterian Publications, 1976), pp. 185–86.

3. Migne, *P.L.*, CLXXXIII, col. 663. Etienne Gilson, *The Mystical Theology of Saint Bernard* (New York: Sheed & Ward, 1955), pp. 85 *et seq.*, interprets St. Bernard's meaning to be "The cloister, the school where charity is taught, is truly the antechamber of paradise." Von Simson, *The Gothic Cathedral*, pp. 43–44, interprets *paradisus claustralis* as "an image and forestaste of heaven." See also Henry-Bernard de Warren, "Bernard et les premiers Cisterciens face au probleme de l'Art," in *Bernard de Clairvaux*, Preface by Thomas Merton (Paris: Commission d'Histoire de l'Ordre de Citeaux; Editions Alsatia, 1953), pp. 487–534.

4. This is the clear implication of Chapters 31 (The Cellarer of the Monastery), 48 (The Daily Manual Labor), and 59 (The Offering of the Sons of the Rich and the Poor): see Justin McCann, trans., *The Rule of St. Benedict* (Westminister, Maryland: The Newman Press, 1952). Just as the *Rule* does, the various commentaries on it pass over the matter of the sources of monastic property. Among the more recent, see, for example, Claude Peifer, *Monastic Spirituality* (New York: Sheed & Ward, 1966), which concentrates on the theory of monastic life and spirituality; it is not strong on practice or reality. The wish expressed in Hubert van Zeller's *The Holy Rule: Notes on St. Benedict's Legislation for Monks* (New York: Sheed & Ward, 1958), that it "escape the scrutiny of scholarship" (p. vii) should be respected. Although the older Paul Delatte, *Commentary on the Holy Rule of St. Benedict*, translated by Dom Justin McCann (London: Burns & Oates, 1959), concentrates on the qualities necessary in the personality and character of the cellarer, there is some brief treatment of monastic property. Delatte assumes that it will come from "benefactors."

5. The historical literature on these subjects is vast. To begin, see S. F. Hockey, *Quarr Abbey and Its Lands, 1132–1631* (Leicester: Leicester University Press, 1970), esp. ch. 5 (a rich, important study, but inadequately appreciated, at least in North America); and the same author's *Beaulieu: King John's Abbey* (Old Working, Surrey: Pioneer Publications, 1976). For the advantages to lay benefactors of giving lands, see Bennett D. Hill, *English Cistercian Monasteries and Their Patrons in the Twelfth Century* (Urbana: University of Illinois Press, 1968), and for the late Middle Ages see Joel T. Rosenthal, *The Purchase of Paradise: The Social Function of Aristocratic Benevolence, 1307–1485* (London: Routledge and Kegan Paul, 1972). For tithes, the indispensable work is Giles Constable, *Monastic Tithes, From Their Origins to the Twelfth Century*, (Cambridge: At the University Press, 1964); Joseph Lynch, *Simonical Entry into the Religious Life: A Social, Economic, and Legal Study* (Columbus: Ohio State University Press, 1976), provides valuable material on the economic and canonical implications of monastic dowries. Scores of crusaders mortgaged their lands to religious houses to secure funds for the journey to the Holy Land. In the early twelfth century, Roger de Mowbray borrowed from the Savigniac abbey of Furness in Lancashire: see John Brownbill, ed., *The Coucher Book of Furness Abbey*, vol. II, Part II (Manchester: Chetham Society, 1916), pp. 290 and 342; in 1199 William fitz Alexander of Northamptonshire borrowed from Samson of Bury St. Edmunds': see in *Feet of Fines of the Tenth Year of Reign of King Richard I* (London: Pipe Roll Society, 1900), p. 235. The most extreme example may have occurred when Duke Robert of Normandy mortgaged the entire duchy to Gerento, abbot of St. Benigne of Dijon for 10,000 marks of silver. See Kenneth M. Setton, *A History of the Crusades*, I (Philadelphia, 1958), p.

276. The monasteries, of course, profited from these loans, usually by the acquisition of lands. On religious houses lending money at interest, the pioneering work of R. Genestal, *Rôle des monastères comme établissements de crédit* (Paris, 1901), is provocative, but the entire problem requires further study.

 6. B. D. Hill, *English Cistercian Monasteries*, pp. 66–72; see also Henry Kraus, *Gold Was the Mortar: The Economics of Cathedral Building* (London: Routledge and Kegan Paul, 1979).

 7. Erwin Panofsky, ed. and trans., *Abbot Suger: On the Abbey Church of St. Denis and Its Art Treasures* (Princeton, 1956), *passim*, but especially pp. 123 *et seq.*

 8. Jean Gimpel, *The Medieval Machine: The Industrial Revolution of the Middle Ages* (New York: Holt, Rinehart and Winston 1976), pp. 59–61. A. Burford, "Heavy Transport in Classical Antiquity," in *Economic History Review*, 2d series 13, no. 1 (1960): 1–18, provides interesting comparable material on transportation in the ancient world.

 9. Wolfgang Braunfels, *Monasteries of Western Europe: The Architecture of the Orders* (Princeton: Princeton University Press, 1972), p. 7. Georges Duby, *The Early Growth of the European Economy: Warriors and Peasants from the Seventh to the Twelfth Century* (Ithaca, New York: Cornell University Press, 1978) states: "The best uses to which the heads of monasteries and cathedral churches could think of putting their wealth were dutifully to embellish, rebuild and decorate the place of prayer, and to accumulate round the altar and saints' relics the most glittering splendour. Assured of resources that the generosity of the faithful kept on increasing, they had but one economic attitude: to spend for the glory of God" (p. 166). However, the enormous sums that monasteries spent to assist the poor and the sick, which Duby acknowledges, tend to qualify his too sweeping generalization.

 10. See Georges Duby, *Early Growth of the European Economy*; Bennett D. Hill, *English Cistercian Monasteries*, pp. 53–55; and Marc Bloch, *Feudal Society*, trans. L. A. Manyon (London, 1961), pp. 346–47.

 11. Jacqueline Caille, *Hôpitaux et charité publique à Narbonne au moyen âge* (Toulouse: Société Francaise d'Histoire des Hôpitaux, 1978).

 12. Lester K. Little, *Religious Poverty and the Profit Economy in Medieval Europe* (Ithaca : Cornell University Press, 1978), esp. p. 68. Little gives greater weight to the activities of the mendicants as agents of social change. (He considers himself more a student of Père Marie Dominique Chenu than of Mollat.)

 13. See, for example, Georges Duby, *Early Growth of the European Economy*, esp. pp. 48–57, 165-166; Pierre Riche, *Daily Life in the World of Charlemagne*, translated by Jo Ann McNamara (Philadelphia: University of Pennsylvania Press, 1978), p. 73.

 14. This point is discussed in the important review of *Assistance et charité* by Caroline Walker Bynum in *Speculum* 55, no. 1 (January 1980): 92–94, on whom I am leaning here.

 15. Ernst Troeltsch, *The Social Teaching of the Christian Churches*, trans. Olive Wyon (New York: Harper Torchbooks, 1960), pp. 115–20, and 303. Troeltsch's statement, "All the frequent exhortations (of the Church Fathers) to regard property as nothing, and all the talk about community of possessions which are gifts of God like light and air, were equally only a challenge to energetic *charitable* activity" (p. 115—emphasis added), suggests that Troeltsch either did not know or chose to ignore some of St. Ambrose's important writings on the subject of property. In his *De officiis ministrorum*, I, XXVIII, 132, for example, he wrote, "for nature has poured forth all things to be held in common by all. For God commanded all things to be produced so that sustenance should be common to all, and that the earth should be a sort of common possession of all men. Nature therefore created a common right (to these things), usurpation created private right." Of all the patristic fathers, as Arthur Lovejoy

has pointed out, St. Ambrose should most be identified with the ideal of an equalitarian and communistic form of Christian society: "He was zealous to bring about a better distribution of this world's goods; and his invectives against the rich were based less upon the ground that they lacked Christian charity than upon the ground that a social order marked by so great inequalities of economic condition was contrary to natural justice and an aberration from the normal order established at the beginning of human history." See Arthur O. Lovejoy, "The Communism of St. Ambrose," in *Essays in the History of Ideas* (New York: Capricorn Books, 1960), pp. 297 and 303.

16. See Bennett D. Hill, "The Beginnings of the First French Foundations of the Norman Abbey of Savigny," in *The American Benedictine Review* 31, no. 1 (March 1980): 130–52.

17. "Cistercians and Cluniacs: St. Bernard's *Apologia* to Abbot William," Intro. by Jean Leclercq OSB, trans. Michael Casey OCSO in *The Works of St. Bernard of Clairvaux*, vol. 1, Treatises I, Cistercian Fathers Series: #1, (Spencer, Massachusetts: Cistercian Publications, 1970), p. 65.

18. On this problem, see the recent study of Jörg Kastner, *Historiae fundationum monasterium: Frühformen monasticher Institutionsgeschichtesschreibung im Mittelalter.* Münchener Beiträge zur Medievästik und Renaissance-Forschung 18 (Munich, 1974), Part II; and the older studies of V. H. Galbraith, "Monastic Foundation Charters of the Eleventh and Twelfth Centuries," *Cambridge Historical Journal* 4, no. 3 (1933); R. W. Southern, "The Place of England in the Twelfth Century Renaissance," in his *Medieval Humanism and Other Studies* (Oxford: The Clarendon Press, 1970), esp. pp. 160–62; and the useful information on monastic charters in David Knowles, C. N. L. Brooke, and Vera London, eds., *The Heads of Religious Houses—England and Wales, 940–1216* (Cambidge: At the University Press, 1972), pp. 5–12, esp. p. 10.

19. Jean Leclercq, "Consciousness of Identification in Twelfth-Century Monasticism," in *Cistercian Studies* 14, no. 3 (1979): 219–31.

20. M. de Gerville, "Recherches sur les Abbayes du departement de la Manche," in *Mémoires de la Société des Antiquaires de Normandie*, t. II, (Caen, 1825), p. 25.

21. M. l'Abbé Desroches, *Analyse des titres et chartres inedits de l'Abbaye de Savigny.* Mémoires de la Société des Antiquaires de la Normandie. 2d. ser., vol. 20 (Caen, 1853), p. 32.

22. *Etienne de Fougères, Vie de Saint Vital, Premier Abbé de Savigny*, trans. Hippolyte Sauvage, (Mortain: Leroy, 1896), pp. 29–30, 49–57; Hippolyte Sauvage, *Saint Vital et L'Abbaye de Savigny*, (Mortain: Leroy, 1895); *Histoire de la Congregation de Savigny par Dom Claude Auvry*, ed. Auguste Laveille, 3 vols. (Rouen and Paris: A. Lestringant 1896–98) (hereafter *HCS*) I: 146–200; and II: 375–83; and Bennett D. Hill, "The Counts of Mortain and the Origins of the Congregation of Savigny," in *Order and Innovation in the Middle Ages: Essays in Honor of Joseph R. Strayer*, William Jordan, et al., eds., (Princeton: Princeton University Press, 1976), pp. 237–53.

23. *HCS* III: 194–95.

24. *HCS* III: 195.

25. *HCS* III: 198–99. The chronicle dwells at length on the unusual number of gifts to Savigny in the years 1172–74. See pp. 196–208.

26. *HCS* III: 200.

27. D. Josephus-M. Canivez, ed., *Statuta Capitulorum Generalium Ordinis Cisterciensis*, t. I, (Louvain: Bureaux de la Revue, 1933). Legislation dealing with architecture was approved in 1134 (pp. 13–33), 1157 (pp. 61–69), and 1182 (pp. 89–91). A few of these statutes have been translated by Braunfels, *Monasteries of Western Europe*, p. 234. For the broad

problem of monastic architecture and the necessity that it conform to theological principles, see the brilliant essay by Paul Frankl, "Architectural Theory and Aesthetics in the Middle Ages," in his *The Gothic* (Princeton: Princeton University Press, 1960), pp. 86–110. The older study of Emile Mâle, *The Gothic Image: Religious Art in France in the Thirteenth Century* (New York: Harper Torchbooks, 1958) Introduction, is somewhat sentimental, but still useful.

28. Canivez, *Statuta*, pp. 111, 149, and 194; Migne, *P.L.* 185: 1248.

29. Marcel Aubert, *L'Architecture Cistercienne en France*, t. I, (Paris, 1947), pp. 96–98.

30. See Lon R. Shelby, "The Education of Medieval Master Masons," in *Medieval Studies* 32 (1970), pp. 1–26, and his "The Geometrical Knowledge of Medieval Master Masons," in *Speculum* 47 (July 1972): 395–421; Robert Branner, "Three Problems from the Villard de Honnecourt Manuscript," in *Art Bulletin* 39 (1957), pp. 61–69, and "Villard de Honnecourt, Reims and the Origin of Gothic Architectural Drawing," in *Gazette des Beaux-Arts*, ser. 6 61 (1963): 129–46.

31. This is a reasonable deduction. See Aubert, p. 216, *L'Architecture Cistercienne*, who says that the architectural plan of Savigny was "inspired" by that of Clairvaux. Abbot Joscelin of Savigny probably attended the consecration of the second abbey church of Clairvaux in 1174, or, in the same year the solemn canonization of St. Bernard. See Migne, *P.L.* 185, cols. 1247–1251.

32. Kenneth John Conant, *Carolingian and Romanesque Architecture 800–1200*, 2nd ed. (New York: Penguin Books, 1966), ch. 11, "The Cistercians and Their Architecture," pp. 223–237, esp. pp. 224–25.

33. Lon R. Shelby, "The Geometrical Knowledge of Mediaeval Master Masons," *Speculum* 47 (July 1972): 398.

34. Laveille, *HCS*, pp. vii–viii.

35. G. de Caumont, ed., *Voyage Archéologique par Gally-Knight* (Caen, 1838).

36. Hippolyte Sauvage, *Saint Vital et L'Abbaye de Savigny* (Mortain, 1895).

37. Jacqueline Buhot, "L'Abbaye normande de Savigny, chef d'Ordre et fille de Cîteaux," in *Le Moyen Age*, vols. 45–46 (1935–36). Aubert's work, *L'Architecture Cistercienne*, pp. 216–17 relies on Buhot.

38. J. Durand de Saint-Front, "Bréve Histoire de L'Abbaye de Savigny," in *Memoires de la Société Archèologique et d'Histoire de Fougères*, vol. 3 (1959), pp. 11–33.

39. Cited in Hippolyte Sauvage, *Saint Vital*, p. 66.

40. Conant, *Carolingian and Romanesque Architecture*, p. 225.

41. Von Simson, *Gothic Cathedral*, pp. 62–64. One basic feature of Norman ecclesiastical architecture, the twin towers, Savigny apparently did not have.

42. *Chronicon abbatiae Savigniacense* in Baluze-Mansi, eds., *Miscellanea Nova Ordine Digesta* (Lucca: Junctinium 1761), p. 328; Laveille, *HCS*, III: 305, 321–22.

43. The letter is translated by Chrysogonus Waddell, O.C.S.O., in *The Works of Bernard of Clairvaux, Treatises I*. Cistercian Fathers Series: Number One (Spencer, Mass.: Cistercian Publications, 1970), p. 181.

Chapter 8

Abbot Suger's Program for His New Abbey Church

Sumner McK. Crosby

Among the most conspicuous examples of lay patronage in the whole Middle Ages was the Benedictine monastery of St.-Denis, outside Paris: the *"Abbaye Royale"* that was school for France's princes and, for a thousand years, the burial place for her kings. In this chapter, Professor Sumner Crosby shows how the Abbey's twelfth-century rebuilder, the famous Abbot Suger—monk, statesman, and connoisseur—incorporated into his plan for the new church elements of design which would visually link the Abbey not only with the Crown, but with the other great symbolic institution of medieval society, the Papacy. Crosby's citations from Suger's written account of his project bring to vivid life the love of splendor in ecclesiastical art and ritual that distinguished the older Benedictine branch of the monastic family from their more austere Cistercian brothers.

Sumner Crosby, whose scholarly publication on the Royal Abbey of St.-Denis spans four decades, was Professor Emeritus of Art History at Yale University; he died while this volume was in preparation.

When Abbot Suger began his new abbey church at Saint-Denis in the mid-1130s, he was fulfilling a boyhood dream.[1] Some forty years had passed since he had entered the gates of the monastery as an *oblatus*,[2] only ten years old, and his ideas, expressed in the different parts of the new building, continued to develop as the construction advanced. Although he died in 1151, as the nave and transept were just beginning to rise above the

ground, his vision of this new house of God was so apparent that we can comment on the entire structure. The building proceeded in three successive campaigns. Each major part of the church was intended to signify different fundamental beliefs about the Christian universe and its successful existence. Order in the temporal realm dominates the first campaign: the western façade and entrance bays, dedicated on June 9, 1140.[3] The celestial hierarchy, the realm of light, and the verities of sacred literature were given material exisence in the second campaign, the new eastern choir, dedicated on June 11, 1144.[4] Although destined to remain unfinished during Suger's lifetime, the nave, or central body of the church, was to join the two ends and invoke the authority of the Papacy by a direct reference to Saint Peter's basilica in Rome. Before examining the details that justify the recognition of such an elaborate program, a brief summary of the early buildings, dedicated to Saint Denis—patron and protector of the French monarchy[5]—will strengthen the proposal that symbolic intent was present in Suger's new building.

Toward the end of the fifth century, when northern France was all but deserted,[6] Saint Genevieve (who became the patron saint of Paris because she had insisted that Attila the Hun would not reach the city) was disturbed that the tomb of Denis, the city's first bishop, was in such a fearful place.[7] She persuaded the priests of Paris to solicit enough funds to build a chapel over the burial place of the bishop in the cemetery of the village of Catulliacum, now St. Denis, about four Roman miles directly north of the city. The chapel immediately became one of the *praecipua loca sanctorum* of Gaul, and throughout the sixth century nobles of high rank at the Merovingian court chose to be buried in or near the simple rectangular building whose dimensions—approximately thirty–five by seventy meters—made it one of the more important masonry structures in the area. About 570 Queen Arnegunde, wife of Clotaire (the grandson of Clovis) and mother of Chilperic, was buried just outside the western entrance, the first in the long series of royal burials at Saint-Denis.[8] After Dagobert I and his son, Clovis II (ca. 645), the monastery was fully established and royally endowed to such an extent that when the Carolingian dynasty replaced the Merovingian, Pepin the Short, the father of Charlemagne, was anointed in the abbey church by Pope Stephen II.[9] Even earlier Charles Martel, Pepin's father, had sent his sons to be educated at Saint-Denis, apparently in the hope that association with so many former kings and queens would give them the aura of royalty. He also chose Saint-Denis as his own burial place.[10] Although Charlemagne was buried at Aix-la-Chapelle in his own palace chapel, after the death of Hugh Capet in 987 only three French kings—Phillip I, Louis VII, and Louis XI—were not

buried at Saint-Denis. The abbey church had indeed become the *nécropole dynastique*, where the regalia and the royal standard, the oriflamme, were protected.[11] Saint Denis, the patron saint, was not only recognized as the first bishop of Paris, as the patron and protector of the French monarchy, but also as the Areopagite, author of mystical treatises destined to become an integral segment of medieval philosophy. Nurtured in such an environment, it is not surprising that Suger, when he became abbot of Saint-Denis in 1122, envisaged the building of a great new church. What is surprising is that he succeeded in introducing so many new ideas, in perfecting so many technical advances, and that his masons introduced a new style, the Gothic, which dominated Western Europe for the next three centuries.

Let us turn to an examination of the details of the three successive campaigns of building. Normally the construction of medieval churches began at the eastern end, so that services could be conducted undisturbed as soon as possible in the new environment. Why, then, did Abbot Suger begin at the western end? Although Suger does not record the fact, there was evidently considerable opposition to any proposal to replace the old building with a new one. A legend had developed that the old church had been built by Dagobert I and that the building had been miraculously consecrated by Christ himself, accompanied by Saint-Denis, his companions, and a host of shining angels. Yet the legend ignored the fact that Dagobert's embellishments at Saint-Denis were completely replaced by Fulrad's new church, dedicated in 775 in the presence of Charlemagne and his court. The account of the miraculous consecration does not appear in writing until the late eleventh century, but apparently popular opinion accepted it so enthusiastically that every stone of the church standing in Suger's day was venerated as though it were a relic, and passions were so fervid at that time that they could not be ignored. Suger, who had spent hours as a student in the abbey's archives, recalled that the western end of the old church was said to be an addition built by Charlemagne, so that it did not actually belong to Dagobert's venerable shrine and could, consequently, be torn down with impunity. Such clever reasoning, however, hardly justified the need for such a monumental new entrance, elaborately decorated with sculpture and surmounted by high and noble towers. Obviously Suger knew that such towers would dominate the plains north of Paris and that they would constantly call attention to the abbey (Fig. 8.1).

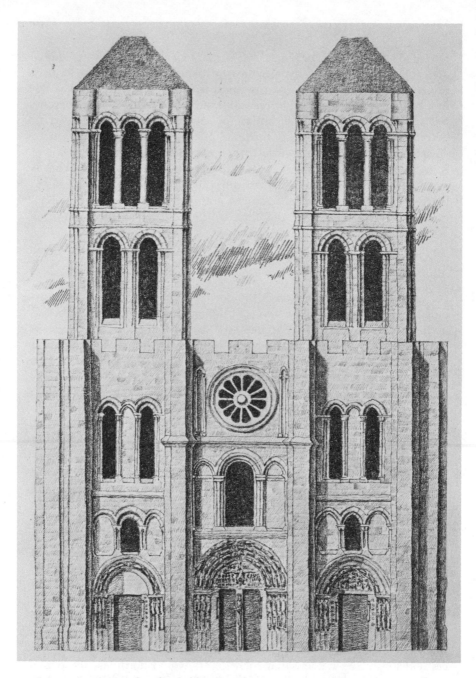

Figure 8.1. Western façade of Abbot Suger's Saint-Denis, reconstructed and restored by Sumner Crosby, drawn by Robeson.

Scholars have commented on these twin towers and noted similar towers above the façade of William the Conqueror's great abbey church of Saint-Etienne at Caen, in Normandy. Originally that church stood outside the town walls, providing an impressive entrance to the ducal capital. Suger may well have seen it during his early years, when he first served as prior of the small church of Berneval, near Fécamp in Normandy. But before Suger began his own new church, he had made many other trips for his abbot and his king. Three times he went to Rome, even to Bitonto at the southern tip of Italy. He traveled to Bordeaux in southwestern France to be present at Louis VII's wedding to Eleanor of Aquitaine. In 1124, he was present at the Reichstag in Mainz to represent the claims of Saint-Denis.[12] He must have visited most of the important monasteries and growing communities of the early twelfth century in western Europe, with the exception of England, and he evidently traveled with attentive eyes and a retentive memory. When he summoned artists from many lands to build and decorate his new church, he remembered the most active and interesting workshops he had visited. Masons, sculptors, and artists expert in other techniques came to Saint-Denis with different backgrounds and training. Suger must have encouraged them to assist him in formulating the details of the new programs. The west façade and the western bays illustrate how successfully these different ideas could be incorporated into a single program.

The façade at Saint-Denis, for example, is not just an exterior embellishment. The twin Norman towers are not flush with the plane of the façade but are set back on the mass of the entrance bays so that they become an integral part of the whole western structure. These western bays have two stories with upper chapels which function independently of the rest of the building. Such a western mass, or *westwerke*, was introduced into ecclesiastical architecture in Carolingian times and further developed in the Othonian imperial basilicas of the tenth and eleventh centuries in the Rhine valley. The *westwerke* were symbols of secular, royal authority distinct from the authority of the Church, which was presided over by the clergy at the eastern end of the building. Suger does not tell us that he had this in mind, but the forms certainly suggest such an intention and his contemporaries would not have misunderstood the references.

An unusual feature at Saint-Denis is the presence of crenellations crowning the top of the façade. The ones we see today are restorations, rebuilt in the fourteenth and nineteenth centuries. Proof that they were part of the original design is Suger's mention of *superiora frontis propugneula* "both for the beauty of the church and, should circumstances require it, for practical purposes."[13] Similar crenellations over gateways

can be traced back to early antiquity and are present in early images of the Temple of solomon. At Saint-Denis they remind us that the patron saint was protector of the monarchy, and that the church guarded the regalia and the oriflamme.

Directly below the crenellations is a rose window, the first, to our knowledge, to appear as an integral part of the design of a western façade. Erwin Panofsky described the rose as "superimposing a magnificent *Non* upon the *Sic* of the big window beneath it" and added that "the very concept of an isolated circular unit conflicted with the ideals of Gothic taste in general." Others however, such as Jurgis Baltrusaitis, have noted the frequency with which circular patterns (like the wheel-scheme as a cosmic metaphor) came to be used in the High and Later Middle Ages as a formal means of organizing ideas.[14] At Saint-Denis the rose opened into the central upper chapel, where it could also be seen from the eastern choir. Such a circular, solar disc was added to the wall of the western apse at Worms, another of the Rhenish imperial basilicas. There it framed the emperor when he sat in his throne at the western end of the nave. Unfortunately Suger does not record any purpose or meaning for the rose window at Saint-Denis. In fact, he does not even mention it. If such an "isolated circular unit conficted with the ideals of Gothic taste in general," the presence of rose windows in almost all Gothic façades is a peculiar phenomenon in the history of taste.

Any discussion of the west façade at Saint-Denis must include some comment about the triple portals which gave access to the interior. One of the many new features of the portals at Saint-Denis is that there are three arched openings immediately adjacent to each other. The image of three arches with the central one larger than the side ones recalls the famous Roman triumphal arches of Constantine or the one at Orange, in the Rhone Valley, both of which Suger must have seen.[15] Roman writers have described the triumphant emperor with his legions as he passed through the arch as an act of purification and cleansing on his way to be received as a divinity in his heavenly city. This concept of the emperor's filial relation to the deity was reiterated by the Othonian emperors of the tenth and eleventh centuries, and the idea of purification as one entered the Church of God would be appropriate for western portals. Suger, however, refers to them in quite different terms. His account of the dedication on June 9, 1140, describes "one glorious procession of three men" which left the church through a single door. The three bishops, acting as one, proceeded to perform the dedication of the three doors in a single act and re-entered the church through a single door.[16] The reiteration of the numbers one and three certainly implies a trinitarian symbolism, an implication confirmed by the carved imagery of the central portal. There,

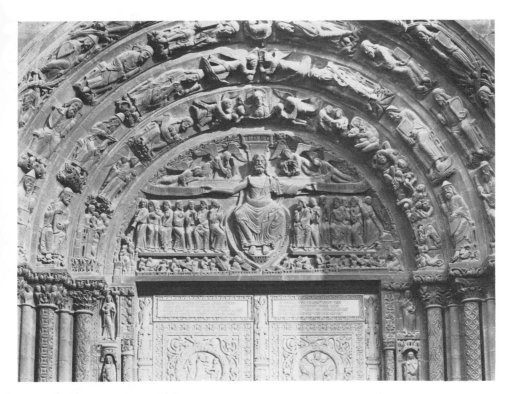

Figure 8.2. West façade of Saint-Denis, central portal, detail. *J. Feuillie*, © *CNMHS, Photo Paris/SPADEM.*

at the top of the two outer archivolts on the central axis of the portal and of the whole church is a dove attended by angels with, immediately below, the bust of God the Father holding a disc which contains the Paschal Lamb—the symbolic representation of the Trinity. The Trinity was a vital theological question in the second quarter of the twelfth century, so the orthodox statement at Saint-Denis is in clear support of papal authority. The Trinity also represented the beginning of the Christian universe and of Christian time. Such multiple references complicate the possible interpretation of the exact meaning of the iconography at Saint-Denis, but they also demonstrate the interrelation of the major themes of the Old and New Testaments.

The dominant theme at Saint-Denis is the Last Judgment, depicted in the tympanum, the archivolts, the decorated jambs, and the original bronze doors of the central portal (Fig. 8.2). In contrast to the

almost literal representation of St. John's magnificent apocalyptic vision on the tympanum at Moissac, carved only some fifteen years before Saint-Denis, the Last Judgment on Suger's portal is depicted by various references. Christ the Judge, dominating everything, reveals his two natures as Son of God and Son of Man. As judge, Christ summons the dead to appear from the grave, shown in the lintel below his feet. He is also shown at the moment of the crucifixion with outstretched arms and his right side bared and pierced by the spear of Longinus. These specific images are supplemented by the trumpeting angels awakening the dead, by scenes of heaven and hell awaiting the blessed and the damned, and by less traditional ones, such as the apostles seated *in collegio*, representing the Last Judgment.[17] The apostles converse with each other *in disputatione*—a scholastic reference to their role as teachers of the people. Even more unusual are the Wise and Foolish Virgins holding both upright and overturned lamps on the jambs of the portal. In the lower extremities of the tympanum one maiden prepares to enter heaven while the other, on Christ's left, kneels before a barred door. This parable from Matthew (25:1–12) refers both to the blessed and the damned at the time of judgment and to the apocalyptic Second Coming of Christ. Reference to the Second Coming is completed by the images of the twenty-four elders of John's apocalypse, seated on thrones and holding viols and musical instruments, in the archivolts surrounding the tympanum. The elders, or patriarchs, with the symbol of the Trinity in their midst, symbolize the celestial Jerusalem. On the outer archivolt the elders are shown framed by an intertwining garland or vine, a favorite motif for the ancestors of Christ in representations of the Tree of Jesse, seen in the stained-glass window added a few years later when Suger's new choir was finished at the other end of the church. The possible association of the patriarchs with the ancestors of Christ leads us to one of the most original and influential innovations in the sculpture of the western portals—the statue-columns that originally decorated the embrasures of all three portals.[18]

No statue-columns exist today on the western portals, but a few fragments in scattered museums and a series of eighteenth-century drawings prove that such statues did exist. Although Suger made no mention of them, scholars today accept the idea that these important figures were part of the original program for the western portals, and agree that they must have been the earliest ensemble in the long series of statue-columns that became an integral feature in Gothic portal design. Removed from Saint-Denis in 1771, probably because of their damaged condition, only heads of four statues are known to exist today: three in this country (two in the Walters Art Gallery in Baltimore, one in the Fogg Museum), and one

in a private collection in Paris.[19] The drawings of twenty-four statue-columns done in 1718 or 1719 by Antoine Benoit for Bernard de Montfaucon's *Les Monuments de la Monarchie Française*, published in 1729, are now in the Cabinet des Estampes in the Bibliothèque Nationale in Paris. Although there has been some question about the accuracy of the details in the drawings, a comparison of the existing heads and of a surviving statue from the Saint-Denis cloisters, now in the Metropolitan Museum in New York, prove the drawings to be quite faithful. In the Montfaucon plates the figures are shown in the order they presumably appeared on the portals, but this is not certain, so that any association of a given statue with an iconographic theme is open to question. The drawings show that there were four women, only one of them crowned, eight crowned men, five of them with sceptres, ten men wearing bonnets, some decorated, and others associated with prophets. Two lacked heads. One figure may be identified with certainty: the figure of Saint Denis, wearing a mitre, on the trumeau of the central portal. The figure holding tablets is probably Moses, and the woman with long braids may have represented the Queen of Sheba. The earliest descriptions called the statues "kings and queens and other benefactors." Montfaucon named them after the kings and queens of the first dynasty, the Merovingians. In 1751 the Abbé Lebeuf said that they were Old Testament figures showing the royal ancestry of Christ and the concordance between the Old and New Testaments, and also that they referred to *regnum et sacerdotium*—secular and spiritual authority, identifications still agreed with today.[20] The presence of royalty, prominently displayed on the entrance portals, was certainly appropriate to the royal abbey, and the emphasis on *regnum et sacerdotium* was a basic premise of Suger's philosophy.

The carved jambs of the lateral portals as they exist today show the works of the months on the south portal and the signs of the zodiac on the north. The latter scenes, in rectangular frames which alternate with purely decorative panels, have been rearranged or altered, so that three of the signs—Leo, Cancer, and Virgo—are missing, but enough remains of the other signs to make identification positive. On the south portal, all of the works of the months in circular garlands are shown in order, so that when considered with the signs of the zodiac on the north portal they add another dimension to the Alpha and Omega of the central portal: namely, the concept of the cosmic and the terrestrial worlds.

Suger wrote that he had a mosaic affixed to the tympanum of the north portal, but there is no description to tell us whether it was a decorative design or some scene. The unusual mosaic was removed in 1771, at the same time as the statue-columns. A carved tympanum showing Saint

Denis and his two companions being taken from prison to be decapitated replaced the mosaic, but, since it was considered to be ugly, it too was replaced, in 1837, by the sculpture in place today showing an equally unattractive variant of the same scene.[21] Only the outer of the two archivolts on the north side was carved in the twelfth century. Although heavily restored, there are enough fragments remaining to suggest that the bust of Christ with outstretched arms in the center reached to give, or receive, a sceptre on his left and a book or tablet on his right. Christ's right hand is veiled and the figure below it has bare feet, while his left hand is uncovered and the figure below it wears shoes. It is quite possible that this archivolt was intended to refer to *regnum et sacerdotium*, symbolized by the sceptre and shod feet and the book and bare feet, so that one of Suger's major preoccupations was given further emphasis.

If important details are lacking for a complete understanding of the significance of the north portal, the details of the south portals are much clearer. Suspect in terms of their authenticity, the tympanum and, in this case, the inner archivolt have now been proven to be of the same stone as the central portal and, although the details have all been cleaned or recut, the scenes and figures as a whole are considered original, as claimed by Wilhelm Voge in 1894 and again by Emile Mâle in 1922. The tympanum depicts the miraculous last communion offered by Christ and a host of angels to Saint Denis and his companions while these were still in prison awaiting execution. Christ and angels in wavy clouds occupy the upper part of the tympanum. In the lower portion, the Prefect Fescenius, who condemned Saint Denis, is seated at the right on his throne, while the prison with the saints and an altar occupy the center. The blessed Larcia, who was converted to Christianity by Saint Denis, waits outside as two executioners enter the prison from the left. The elongated figures on the inner archivolt are easily recognizable as an angel holding a martyr's crown in the center, Saint Denis holding his Bishop's mitre on the left, and his two companions, Rusticus and Eleutherius, on the right. At the bottom of the archivolt are two pairs of executioners with their swords and axes. The choice of this particular episode in the passion of the patron saint has been explained as an emphasis of the intimate relationship between Christ and Saint Denis and of the saint's special function as a martyred bishop to lead the initiated to salvation. *The Golden Legend* recounts that the three saints' heads were cut off as they confessed the Trinity, a detail supplying another possible meaning for the triple portals.[22]

One additional major part of the symbolism of the western portals remains to be examined. These are the bronze doorways, melted down in 1794 during the French Revolution, which Suger says he installed in each

of the three portals. Since the bronze reliefs have completely disappeared and little is known about the side doorways—Suger says that the north ones were old—I simply mention in passing the text which Suger had inscribed on the central doors. Scenes of Christ's passion, resurrection, and ascension were depicted in low relief on the eight medallions of the two panels, which, since they were originally gilded, shone brightly, at least during Suger's lifetime. Panofsky saw the verses as a condensed version of the whole theory of "anagogical illumination" expounded by Dionysius the Pseudo-Areopagite, which complete the symbolism of the first campaign and express a fundamental concept underlying the building of the entire new church:

> Whoever thou art, if thou seekest to extol the
> glory of these doors,
> Marvel not at the gold and the expense but
> at the craftsmanship of the work.
> Bright is the noble work; but, being nobly bright,
> the work
> Should brighten the minds, so that they may
> travel, through the true lights,
> To the True light where Christ is the true door.
> In what manner it be inherent in this world
> the golden door defines:
> The dull mind rises to truth through that
> which is material
> And, in seeing this light, is resurrected
> from its former submersion.[23]

In this detailed summary of the multiple interpretations of so many details in the construction and decoration of the western façade and entrance bays, I have tried to be impartial. The reader is invited to select his or her own major theme for emphasis as the underlying symbol that Suger wished to convey. My own vision extends from the "high and noble" towers above the mass of the western bays down past the crenellations, the rose window, and the triple arcades to the three portals, bound into a single unit by the horizontal band of the statue columns and by the statue of Saint Denis in the center. With kings, queens, patriarchs of the Old Testament, and saints, the theme of the balance of authority between *regnum et sacerdotium* remains dominant. The emphasis is on the Christian Church in this world and on the human personalities who embodied Christian truth to Abbot Suger and his advisors. In conclusion I shall

summarize the dominant symbols I perceive in the new east end and the nave that was intended to join the two ends.

The difference between the symbolism of the western bays and that of the eastern choir is the difference between literal exposition and intuitive response. At the western end, the actual forms of the architecture—crenellations, circular window, arched doorways with images carved in stone—all invite specific, often multiple interpretations. By contrast, in the eastern portion, where the monks' liturgy took place, the environment created by an emotional reaction to colored light and to bright, shining surfaces evokes abstract, metaphysical responses (see, for example, figure 12a in Chapter 9). The difference is that between the material world of our cognitive experience and the immaterial universe of celestial hierarchies. Abbot Suger reflects this difference in his description of the laying of the foundations for the crypt. For the procession to perform the dedication of the eastern end, the prelates arranged themselves in ecclesiastical order reflecting the hierarchies of celestial order, and walked round and round the choir "so piously that the king and attending nobility believed themselves to behold a chorus celestial rather than human." After the simultaneous consecration of twenty altars, all these dignitaries performed a solemn celebration of Masses, both in the upper choir and in the crypt, "so festively, so solemnly, so differently and yet so concordantly, so close to one another and so joyfully, that their song by its consonance and unified harmony was deemed a chorus angelic rather than human."[24] We have no evidence that such a simultaneous celebration of Masses was a regular occurrence, but the "circular string of chapels," the nine contiguous, radiating chapels around the ambulatory are a perfect solution for such a program (Fig. 8.3). Suger's master mason proved his genius by his construction of this "crown of light," these adjacent chapels open to one another, illuminated by large stained glass windows so that the "whole church would shine with the wonderful and uninterrupted light of luminous windows pervading the interior beauty"[25](Fig. 8.4).

The striking contrast at Saint-Denis between the crypt and the choir above it demonstrates vividly the difference between Romanesque and Gothic construction. Both levels have exactly the same plan. Indeed, the crypt functions as foundation for the choir; but the structure contrasts the solidity of mural construction, groin vaulting, enclosed volumes, and reflected light with the diaphanous construction of minimal support, articulated skeletal rib vaults, and the maximal introduction of refracted

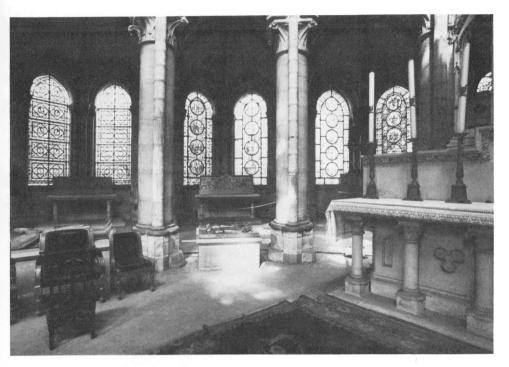

Figure 8.3. Saint-Denis, ambulatory and radiating chapels of Abbot Suger's new choir. *Photo William Crosby*

colored light (see Chapter 9, figures 12a and 12b). Once again historians of architecture know of no prototype for Suger's choir. Suger tells us that his masons "cunningly provided that ... the central nave of the old church should be equalized, by means of geometrical and arithmetical instruments, with the central nave of the new addition; and, likewise, that the dimensions of the old side-aisles should be equalized with the new side aisles, except for that elegant and praiseworthy extension in [the form of] a circular string of chapels ... "[26] This seems a very simple, straightforward statement. Unfortunately, this passage cannot be interpreted literally. The new choir is not exactly the width of the old nave nor are the new side aisles (the ambulatory around the choir) the same dimensions as the old side aisles. The masons' *instrumentis* may have been some application of Hugo of St. Victor's "practical geometry." The recent photogrammetric plans and elevations of the crypt and choir prove how accurate their construction is. The levels of the abaci of the capitals over the ambulatory

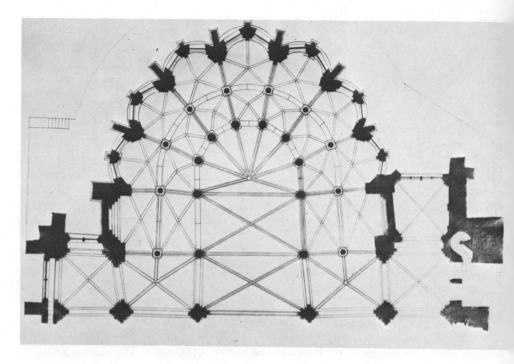

Figure 8.4. Plan of Suger's chevet at Saint-Denis, redrawn and remeasured by Sumner Crosby.

columns on the north side vary, for instance, only ten centimeters from those on the south side, and the segmental arcs of the rib vaults all have the same radii. These discoveries demonstrate an unexpected mastery of the construction of the wooden scaffolding on which the stone armature was built and how carefully conceived was the entire fabric of this "circular string of chapels."

For Suger and his contemporaries this architectural beauty was enhanced by the costly vessels and other decorations made for the new choir. A basic tenet of Suger's philosophy was that "every costlier or costliest thing should serve, first and foremost, for the administration of the Holy Eucharist."[27] His own peasant background may have accounted for his admiration for glittering things as well as a lack of restraint that may have resulted in rather garish combinations. The few liturgical vessels that survived the melting pots of the Revolution bear witness to this taste, as well as to Suger's respect for Roman antiquities such as cameos or por-

phyry and crystal vases, which his artisans embellished with new mount-
ings. Only his written descriptions and a Flemish painting survive to give
us some idea of his golden altars or of the great golden crucifix, more than
six meters high, with its enamel plaques and complicated iconography.
Suger's well-known passage from his *De Administratione* shows how per-
fectly these lavish ornaments could be explained in terms of the basic
Neoplatonic philosophy of Dionysius the Pseudo-Areopagite, whom he
believed to be his patron saint, the blessed Saint Denis:

> "Thus when the loveliness of the many colored gems has called me away
> from external cares and worthy meditation has induced me to reflect,
> transferring that which is material to that which is immaterial, on the
> diversity of the sacred virtues: then it seems to me that I see myself
> dwelling, as it were, in some strange region of the universe which neither
> exists entirely in the slime of the earth nor entirely in the purity of heaven;
> and that, by the grace of God, I can be transported from this inferior to a
> higher world in an anagogical manner."[28]

Clearly Suger intended the same for his new choir. With its luminous
windows and gem-encrusted ornaments, it seemed to be neither of the
slime of this earth nor entirely of the purity of heaven—a material celestial
Jerusalem, an earthly abode of God.

Suger certainly planned to complete his new church and probably
hoped that the new transept and nave would signify the successful joining
of the terrestrial to the celestial realms.

> "Eager to press on my success, since I wished nothing more under heaven
> than to seek the honor of my mother Church which with maternal affec-
> tion had suckled me as a child, had held me upright as a stumbling
> youth, had mightily strengthened me as a mature man and had solemnly
> set me among the princes of the Church and the realm, we devoted
> ourselves to the completion of the work and strove to raise and to enlarge
> the transept wings of the church [so as to correspond] to the form of the
> earlier and later work that had to be joined [by them]."[29]

His apprehension that this would not be accomplished, however, proved
justified. Our excavations in the transepts and nave show that work was
started on both the north and the south sides, as a sort of envelope around
the old eighth-century building, but neither side progressed very far, so
that the old nave remained standing until it was replaced in the thirteenth
century.[30] Enough remains to prove that the new nave was to be two

meters wider on both sides than the old one but that the old bay width—
four meters from center to center—would be maintained, as would the
width of the central nave, even though work on the interior of the new
nave was never begun. The proportions of the side aisles as well as the
presence of the ambulatory and radiating chapels in the choir are ade-
quate proof that double side aisles on each side of the nave were planned
by Suger's master mason. The fact that worked stopped, probably shortly
after Suger's death in January 1151, meant that there was no consecration
and therefore no inscriptions or dedication that might provide a clue
about Suger's intentions, although the verses he recorded in his *De Admin-
istratione* as the inscription for the new choir refer to the nave:

> Once the new rear part is joined to the part in front,
> The church shines with its middle part brightened.
> For bright is that which is brightly coupled with the
> bright,
> And bright is the noble edifice which is pervaded by
> the new light
> Which stands enlarged in our time,
> I, who was Suger, being the leader while it was
> being accomplished."

The recent discovery of bases—carved for the new nave, but used only to
shore up the foundations of the thirteenth-century crossing—prove that
columns, not piers, would have been the supports. Now, a colonnaded
nave with double side aisles was a distinguishing feature of Old Saint
Peter's in Rome. Although we cannot prove that Suger had such a reference
in mind, it is true that the great third church at Cluny had double aisles, as
did Saint-Sernin at Toulouse, and that in both instances allegiance to Rome
was a major element in their existence. It may not be too much of an
exaggeration to suggest that Suger's new nave was to have been an explicit
reference to the papacy as a juncture between the terrestrial *regnum* of the
western bays and the celestial *sacerdotium* of the choir.

By the middle of the seventh century, therefore, Saint-Denis was one of the
important monasteries of northern France. It was also closely allied to the
ruling dynasty and an active center for the arts. Destined to remain a royal
abbey over the centuries, its church was successively: one of the earliest, if
not the first of the great Carolingian basilicas; the first Gothic structure;

and, after the completion of new transepts and nave in the thirteenth century, one of the first examples of the *rayonnant*, or refined Gothic style. Indeed, Suger's twelfth-century building was one of the last important monastic churches, for the focus of medieval culture was to shift to the growing urban centers and to the secular cathedral. Saint-Denis bears witness to the vitality of the monastic environment as a creative milieu in the new style of the twelfth century.

NOTES

1. Erwin Panofsky, *Abbot Suger on the Abbey Church of St-Denis and its Art Treasures*, 2nd ed. (Princeton: Princeton University Press, 1979), pp. 42–43.

2. Panofsky, pp. 60–61. For a recent article on the *oblatus* see: Ilene H. Forsyth, "*The Ganymede Capital at Vézelay,*" Gesta 15:241–46.

3. The date, 1140, was recorded in the verses engraved on the bronze doors: Panofsky, pp. 98–99; the day, 9 June, the fifth day before the Ides of June: Panofsky, *Abbot Suger*, pp. 102–103.

4. Panofsky, *Abbot Suger*, pp. 112–13.

5. The first surviving original French royal charter, written in 625 on papyrus, now preserved in the Archives Nationales, Paris, K1, N.F., mentions *sancti domini Dionensis peculiares patroni nostri*, as the special patron of Clothaire II. This same formula, often abbreviated as *pec. pat. nos.*, appears in twenty-two other royal charters before the crowning of Pepin the Short in 751. From Pepin's accession to the throne until the thirteenth century almost every French royal charter relating to Saint-Denis used this identical phrase.

6. Among others see Ernest Lavisse, *Histoire de France*, 12 vols. (Paris: Librairie Hachette, 1903) 2: 94–95; C. W. Previté-Orton, *The Shorter Cambridge Medieval History*, 2 vols., (Cambridge: At the University Press, 1952) 1: 150–51.

7. The anonymous sixth-century author of the *Life of St. Genevieve* describes St. Denis' tomb as being "in a terrifying and fearful place." For a list of published editions of the *Vita Genovefae*, and a discussion of the thorny textual problems attaching to this work, see F. Cabrol and H. Leclercq, *Dictionnaire de l'Archéologie chrétienne et de Liturgie*, 15 vols. (Paris: Letouzey and Ané, 1924–53), 6: columns 960–90.

8. On St.-Denis as a royal necropolis, see the final chapter of my *Abbaye Royale* (Paris: P. Hartmann, 1953); see also, for some of the later tombs and for bibliography, Timothy Verdon, *The Art of Guido Mazzoni* (New York: Garland Publishing, 1978), pp. 123–24.

9. For details of these events see S. Crosby, *The Abbey of St. Denis, 475–1122* (New Haven: Yale University Press, 1942), 53–73.

10. For a concise summary of this confusing historical moment see C. W. Previté-Orton, *The Shorter Cambridge Medieval History*, 1:150–160.

11. Relations between Saint-Denis and the monarchy, including the custody of such royal insignia as the *regalia* and the oriflamme, were summarized in my first volume, cited above note 9. Recent scholarship on the subject will be reviewed in my forthcoming volumes, *The Abbey Church at Saint-Denis, 475–1151* (New Haven: Yale University Press).

12. The doctoral dissertation by Otto Cartellieri, "Abt Suger von Saint-Denis, 1081–1151," includes a meticulous chronological register of Suger's activities.

13. Panofsky, Abbot Suger, pp. 46–47.

14. Ibid., pp. 70-71; see also J. Baltrusaitis, Réveils et Prodiges: le gothique fantastique (Paris: Colin, 1960), pp. 236–64.

15. Although Suger does not mention them, he must have seen the arch at Orange on his way to Italy, as well as the arches in Rome and such Roman city gates as those at Autun and Trier.

16. Panofsky, Abbot Suger, pp. 44–47.

17. See Crosby, The Apostle Bas-relief at Saint Denis (New Haven: Yale University Press, 1972), pp. 63–65.

18. See S. Crosby and Pamela Z. Blum, "Le Portail Central de la façade occidentale de Saint-Denis," Bulletin Monumental 131 (1973): 257.

19. The only publication with photographs of all four heads is The Royal Abbey of Saint-Denis in the time of Abbot Suger (1122–1151) (New York: The Metropolitan Museum of Art, 1981), figs. 13–16, pp. 40–43.

20. Abbé Lebeuf, "Conjectures sur la reine Pedauque," Mémoires de l'Academie des Inscriptions et Belles-Lettres 31:227.

21. S. Crosby, "A Relief from Saint-Denis in a Paris Apartment" Gesta 8 (1969): 45–46.

22. Jacopus da Voragine, The Golden Legend, tr. G. Ryan and H. Ripperger (New York: Arno Press, 1969; repr. ed. Longmans, Green, 1941), pp. 620–21.

23. Panofsky, Abbot Suger, pp. 46–47; cf. pp. 21–24.

24. Ibid., pp. 118–21.

25. Ibid., pp. 100–101.

26. Ibid.

27. Ibid., pp. 64-65.

28. Ibid., pp. 62–65.

29. Ibid., pp. 50–57.

30. The summary account of this last campaign in the transepts and nave in my Abbaye Royale (Paris: Hartmann, 1953), pp. 49–53, will be expanded in my forthcoming volumes.

31. Panofsky, Abbot Suger, pp. 50–51.

Chapter 9

Monastic Stained Glass: Patronage and Style

Meredith Parsons Lillich

This chapter too deals with the Royal Abbey of St.-Denis, and specifically with the stained glass windows to which Abbot Suger's new architecture was designed to give such prominence. Professor Lillich contrasts the uncolored windows favored by Cistercian monasteries with the vibrant color of the glass at St.-Denis, analyzing both from the point of view of their meaning for the monk-patrons. She closely relates the color and iconography of the St.-Denis windows to the influence of the school of mystical theology that had its center at the Royal Abbey, and distinguishes the character of monastic imagery from that of less specialized glass programs in non-monastic churches. She also sketches the extent of the influence exerted by monastic glass styles on cathedral and parish church windows. Three Appendices offer a wealth of information from original sources on aspects of Professor Lillich's subject, enabling the student to test her innovative conclusions against the known documents.

Meredith Lillich teaches the history of art at Syracuse University.

This study begins with the premise that the arts of the medieval monastery are different from others—different not only from the arts of the palace and the bourgeois home, but from those in the service of the cathedral and the parish church. The uses and purposes of art in monasteries are different in kind, and the demands made upon the arts by monks are more severe and more pervasive. Monastic patronage of the arts leaves an indelible, identifiable mark upon the artistic product.

207

This mark should be particularly noticeable in an art form such as medieval stained glass, which is identified in the popular imagination as the "cathedral art." There is no question that stained glass plays a major role in the Gothic esthetic[1] and that stained glass windows, especially rose windows, became a hallmark of Cathedral Gothic. There is, moreover, little question that the same craftsmen glazed both cathedrals and abbeys, not to mention palace chapels and even rural parish churches.[2] And those artists were for the most part laymen. It is monastic patronage, not monastic workmen, that seems to make the difference.

Very early in the Gothic era, we encounter the idea of a difference between cathedral arts and arts of the monastery. I refer to Saint Bernard and his dramatic attack upon artistic luxury entitled the *Apologia*,[3] which states that what was appropriate and fitting in a cathedral ("excusable" to the saint) was not the same by any means as what was suitable for the monk's cloister or his house of prayer.[4]

The mark of monastic patronage should be most easily discerned in iconography: the subjects chosen and the particular forms of those subjects. A work of art in a monastery may, like the arts elsewhere, be handsome or decorative or even present narrative stories, but its subjects do not function primarily for instruction. The monastic audience is already well instructed. Madeline Caviness, in studying the subjects of the windows at Canterbury, came to the conclusion that "the essential differences between the glazing program of Chartres and that of Canterbury arise from the fact that Canterbury was a monastic foundation."[5] The windows of Chartres Cathedral, she says, are like a collection of the legends of popular saints—some repeated several times according to the wishes of various donors. The stained glass of Trinity Chapel, Canterbury, is much more bookish. The ensemble resembles a *libellus*, one of those sumptuously decorated manuscripts which established the official version of the miracles of the patron saint venerated by a monastery. Such books were kept in the abbey's treasury, not its library; Wormald has called them "manifestations of the pride and grandeur of the monastic houses."[6] So too were the windows of Trinity Chapel: extravagantly rich in decoration, bookish and esoteric in their detailed exposition of Becket's miracles. As in a *libellus*, the word and the image at Canterbury are closely interrelated; the word is made concrete. Text inscriptions therefore assume great importance.

No *libellus* remains of Becket's life. Where such monastic books have survived, however, we can see that they established the official iconography. They therefore served as models for windows, often many generations later, as for example at the convent of Sainte-Radegonde in Poitiers

(Figures 9.1a and 9.1b). The *libellus* of ca. 1100 now in the municipal library of Poitiers (ms. 250) was the basic source for the window made for the north nave in the late thirteenth century.[7] the designer of the lancet of Saint Denis, made for the Benedictine abbey of Saint-Père de Chartres at the beginning of the fourteenth century, made use of two manuscripts of the life of the saint which he could only have consulted together in the scriptorium of Saint-Denis itself.[8]

The essential difference of monastic iconography is more basic, however, than a difference in models. It can ultimately be traced to the two foundations of western monasticism, the *Rule* of Saint Benedict and the Psalter. As Wolfgang Braunfels says, the Benedictine *Rule* sets out the why and where of monastic life and the Psalter the what and how.[9] Together they are the taproot not only of monastic thought but also, in his view, of monastic architecture. One can easily extend his remarks to include the subject matter of monastic art[10] as well.

The pervasive structure and discipline of monastic life according to the *Rule* find expression in the elaborate and extended iconographic schema of monastic windows. Such glass programs are often tightly organized and extensive in scale, and they are as idiosyncratically tailored to their monastic communities as were the abbeys' customaries. Such programs were often tenaciously pursued to their completion over many generations, as at Canterbury[11] or at the Benedictine abbey of Saint-Père in Chartres.[12] At Saint-Ouen de Rouen[13] the program was established and the choir glazing begun in 1318 by Abbot Marc d'Argent. The final windows at the nave façade, ending with Adam and Eve—in effect the beginning of the subject program—were finally put in place over two centuries later, about 1550.[14]

The emphasis on the Psalter in the daily office encourages a habit of mind accustomed to typological subtlety and richness. The psalms are religious poetry, but poetry composed by a very different culture from the monks' own. In Christian use they require constantly refreshed interpretation; they encourage thinking in symbolic analogies and simultaneously at several levels of meaning; and they imply a continuum of Old and New Testaments. Of course typology as a mode of thought is by no means strictly monastic. It is a basic method of Saint Paul, and Emile Mâle[15] has eloquently discussed the pervasiveness of typology in medieval religious art of all kinds. Though not limited to monasteries, typology was nurtured and exercised in them.[16] The monastic office was the never-ending fountain of fresh and personal inspiration. The verses which Abbot Suger composed for two of his windows at Saint-Denis (Figure 9.2) include the familiar interpretation of Moses raising the brazen serpent:

EVOCETVR ME
MORIE

A quod tacitu poene preterit
nderedus agens eiusdem bea-
tissime cu sibi filii nascern-
tur quos ut uideret mox p
deret cogitabat sepelire
Sed et mater tristis aliquando
du pareret exanimem in

fantulum lacrimosi simul pa-
rentes iactant in sce caliciu
ut ut salubrima uestem mox
attigit adofficium uitale
redit infans de funere
Et rubens leuat de pallio pal
lor uicinus adtumulum

Figure 9.1a. *Libellus* of Sainte Radegonde: *Resurrection of the Newborn of Anderedus*. Ms. 250, fol. 38ᵛ. Ca. 1100 (after Société française de reproductions de manuscrits à peintures, 1914). *Bibliothèque municipale, Poitiers.*

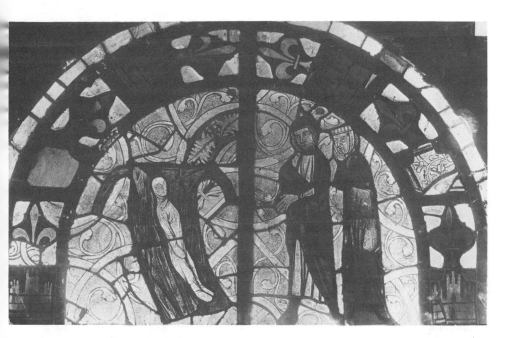

Figure 9.1b. Sainte Radegonde window: *Resurrection of the Newborn of Anderedus.* Poitiers, Sainte-Radegonde, north nave bay. Ca. 1270. *Photo © ARCH. PHOT./ SPADEM/VAGA, New York 1983.*

> Just as the brazen serpent slays all serpents,
> So Christ, raised on the Cross, slays His enemies.[17]

Suger plays with more sophistication and ingenuity upon other established themes. For example:

> What Moses veils the doctrine of Christ unveils.
> They who bare Moses despoil the Law;[18]

and

> What Baptism does to the good, that [drowning] does to
> the soldiery of Pharaoh:
> A like form but an unlike cause.[19]

Figure 9.2. *"Just as the brazen serpent slays all serpents*
 So Christ, raised on the cross, slays His enemies."
Medallion of the Abbot Suger, Saint-Denis ambulatory. Ca. 1140 (after Cahier-
Martin ca. 1845).

Panofsky pointed out the peculiar emphasis in these couplets. Grodecki
emphasized not only their uniqueness and divergence from the expected
iconographic sources (Mosan theology), but their surprising lack of impact
as well.[20] Von Simson[21] and Grodecki remind us that the abbot draws
heavily upon the teachings of Saint Paul—whose disciple the Areopagite
was, in Suger's view: the evangelist to Gaul and the patron saint of his own
monastery. Suger's Pauline lessons are tailored for the monks of Saint-
Denis.

A heavy emphasis on the Old Testament frequently marks monastic arts as well. The poetry of the psalms themselves does not easily lend itself to visualization; the historical books and the prophets were the richer mines for images. Montague Rhodes James remarks on the monastic proclivity for obscure typologies: "The reader cannot, I think, fail to be impressed by the ingenuity with which the most unpromising incidents in the Old Testament story are pressed into service, and perhaps he may feel, as I do, that this ingenuity often testifies to a really poetic imagination, exercised by generations of men determined to find Christ everywhere."[22]

In sum, as products of the Benedictine *Rule* and the Psalter, monastic thinking and therefore monastic iconographic programs are likely to be highly structured—their subjects many-layered in reference, as well as complex and sophisticated in actual arrangement. Their function is not to instruct but to provide stimulus for introspection and encouragement for the meditations of the monks who spend so many hours in their company. This contemplative function imparts a distinctive character to the images. Long before the Franciscans had introduced the "you-are-there" method of prayer to the laity, monastic spirituality stressed the telescoping of time and encouraged mystical participation in divine events (see Chapter 12). The Cistercian Abbot Aelred of Rievaulx gives the following instructions for meditation upon the Annunciation: "First enter the room of the blessed Mary and with her read the books which prophesy the virginal birth and the coming of Christ. Wait there for the arrival of the angel, so that you may see him as he comes in, hear him as he utters his greeting, and so, filled with amazement and rapt out of yourself, greet your most sweet lady together with the angel." Abbot Aelred continues with his instruction on the Visitation: "Run and take part in such joy, prostrate yourself at the feet of both. ... "[23]

It is therefore no surprise to find the abbots of medieval communities, fathers of their flocks, physically present in gospel scenes: Abbot Suger prostrates himself at the Virgin's feet in the Annunciation panel at Saint-Denis (Figure 9.3a);[24] the abbot at Saint-Père de Chartres has crept into the room and quietly occupied the spot where the Virgin's vacated chair is normally found (Figure 9.3b).[25] In a comparable telescoping Saint Benedict, from his clerestory lancet, waves his *Rule* and admonishes his monks far beneath him in their choir stalls at La Trinité, Vendôme.[26] In the church of Sées, Saint Augustine instructs a cluster of monks (Figure 9.4) who could almost be portraits from the Augustinian community.

The telescoping of events and individuals can produce very complicated images indeed. An example is the window of the donor at Vendôme (Figure 9.5). The stained glass of the new church was donated by

Figure 9.3a. *Abbot Suger at the Annunciation*, Saint-Denis ambulatory. Ca. 1140 (after de Lasteyrie ca. 1855).

one of the French princes—the unlucky Pierre d'Alençon—who appears kneeling, clad in his heraldic surcoat, no chance of mistaking his identity.[27] He is, however, performing an action which in fact never happened: he is presenting to the abbot and monks the famous relic which was kept in this very church in a great stone chamber constructed between two piers of the choir. The relic in question made this abbey a famous center of pilgrimage. I refer to the Holy Tear, the *Sainte Larme*, the tear which Christ shed upon the death of Lazarus. Of course the French prince, a son of Saint Louis who lived and died in the latter thirteenth century, never gave this famous relic to the abbey of La Trinité. They had owned it for centuries; in fact, the abbey had been founded to house it. The original donor and founder had been a local petty warlord, as a matter of fact a distant ancestor of the English Plantagenet kings.[28] The foundation of the Benedictine community of Vendôme, the relic which gave it identity, and the new donor who had just provided windows for the new Gothic sanctuary, are all compacted and telescoped into one potent image.

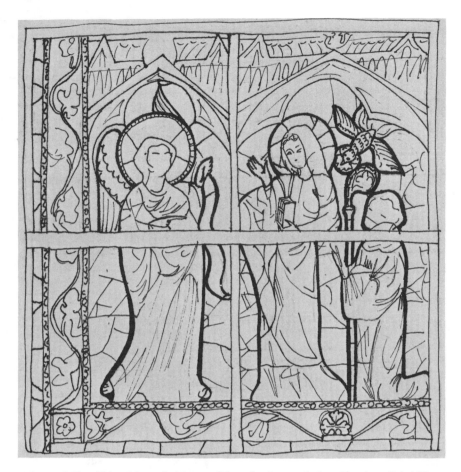

Figure 9.3b. *Abbot Jehan de Mantes (?) at the Annunciation.* Chartres, Saint-Père, south nave, Bay 19. Ca. 1305–10. *Drawing by Victoria Lillich.*

A comparison of monastic and non-monastic stained glass indicates that the requirements of meditation often dictated style and form, as well as iconography.[29] I would therefore like to propose three revisions of art history based upon that premise. My first revision concerns Cistercian grisaille (monochrome) windows, defined so aptly in the phrase of Emile Mâle: *"Il est impossible d'être pauvre avec plus de noblesse"* ("One cannot be poor with greater nobility").[30] The second revision concerns another twelfth-century achievement of great renown: the diaphanous blues of the windows of Abbot Suger, in his own words *"magni constant mirifico opere*

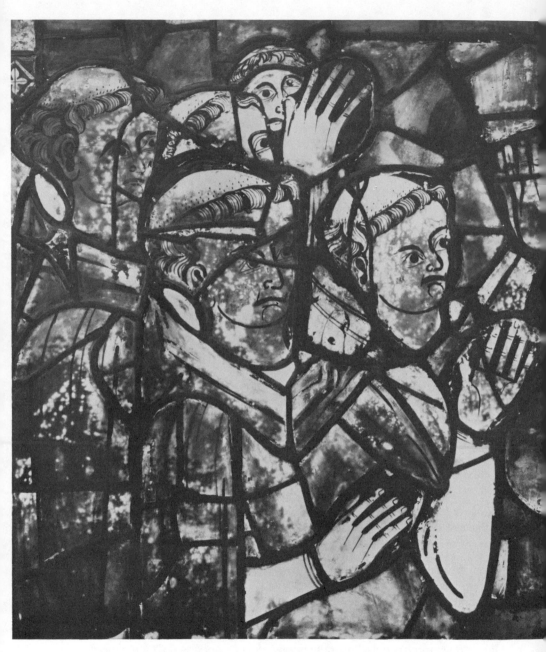

Figure 9.4. *The monks of Sées*. Sées Cathedral (Orne), south choir chapel. Ca. 1270–84. *Photo New York, Metropolitan Museum, reproduced by permission of Glencairn Museum, Academy of the New Church, Bryn Athyn, Pennsylvania.*

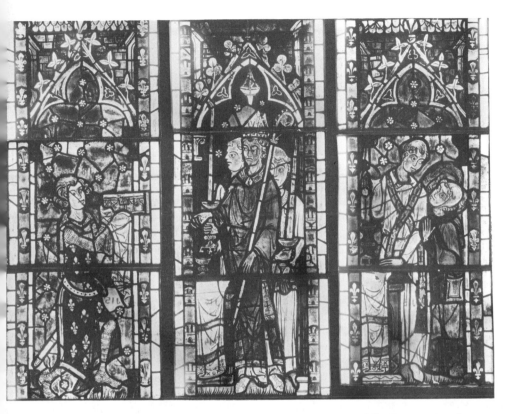

Figure 9.5. *Prince Pierre d'Alençon Presenting the Sainte Larme to the Community of La Trinité. The Faithful Kneel before It.* Vendôme, La Trinité, south hemicycle bay. Ca. 1280. *Photo © ARCH PHOT./SPADEM/VAGA, New York 1983.*

sumptuque profuso vitri vestiti et saphirorum materia" ("are very valuable on account of their wonderful execution and the profuse expenditure of painted and sapphire glass").[31] And my third revision will address the problem of the watershed in Gothic taste which occurred from roughly 1240–70, again epigrammatized by Mâle: *"Rien ne ressemble moins à un vitrail du XIII^e siècle qu'un vitrail du XIV"* ("nothing looks less like a 13th-century window than one of the 14th century").[32] It should not surprise the reader that I detect the concerns of monastic spirituality and involvement in these three phenomena in the history of medieval stained glass.

CISTERCIAN GRISAILLE

Consider Cistercian grisaille windows, which are a very distinctive type but of very limited influence on non-monastic design. The Cistercian reform forbade color, as well as figures or images.[33] The elimination of images clearly reflects the teaching of Saint Bernard: "There is here (in contemplation), as I think, no need or use for material, sense-transmitted images of Christ's Flesh or cross, or any other representations which belong to the weakness of His mortality."[34] In the prohibitions against color, moreover, there is no hint from the Statutes that it was more expensive.[35] Indeed, the production of so-called colorless glass in the Middle Ages may have involved a complicated step, the addition of manganese (known as "glassmaker's soap") to counteract by its pink color the common greenish tinge of iron impurities.[36] Just as the Cistercian imageless patterns free the mind from what Bernard regarded as obstacles and impediments to contemplation, so does the colorless medium eliminate any obstacle to the eye's perception of sunlight, that Light which is God.[37] The patterns of Cistercian grisailles (Figures 9.6, 9.7, 9.8) are far too ornate to be simply a denial, an avoidance of the distraction of narrative as well as of the sensuous appeal of color. They are not simply so much decorative, repetitive wallpaper. The designs are of an elaborate intricacy, often complicated to excess. Even the simple patterns are fascinating: one could look at them for hours. This intricacy is usually explained by the premise that "art will out." Deny an artist color and image, so this theory goes, and the creative instinct will overflow elsewhere. However, I would like to suggest that Cistercian grisailles are hypnotic to a purpose. They are *Andachtsbilde;* they are mandalas, if you like; they provided emblems and abstract forms for the monks' meditations.

Cistercian grisaille motifs fall into two categories: stylized flowers and vegetation, and geometric patterns. Helen Zakin[38] has connected the floral group with Saint Bernard's references to Christ, truth, light, the Resurrection, the line of Jesse and, by extension, the Virgin. Two examples (compare Figure 9.6):

> Truth however is a beautiful lily, remarkable in its brightness ... and its brightness is of eternal light, its splendor and form is the essence of God.[39]

> For there is nothing incongruous in different things representing Christ under different aspects. Thus the rod (*virga,* stalk) reminds us of His power; the flower of the good odour of His fame; the fruit of His sweetness; the leaves of His ever-watchful providence ... [40]

Figure 9.6. Cistercian grisaille, vegetal design. From Pontigny. *Reconstruction by Helen Zakin.*

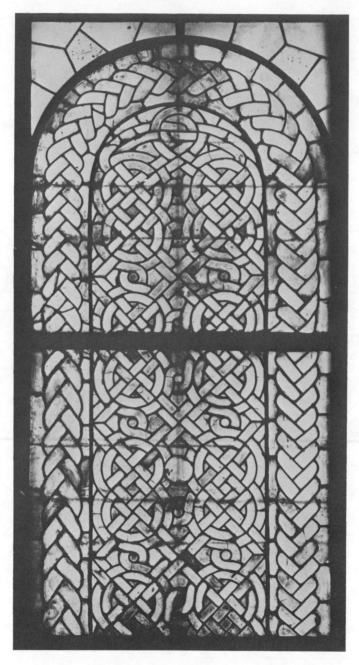

Figure 9.7. Cistercian grisaille, geometric interlace design. From Eberbach, now in the Wiesbaden Museum. *Photo Wiesbaden (Hesse) Museum, Sammlung Nassauischer Altertümer.*

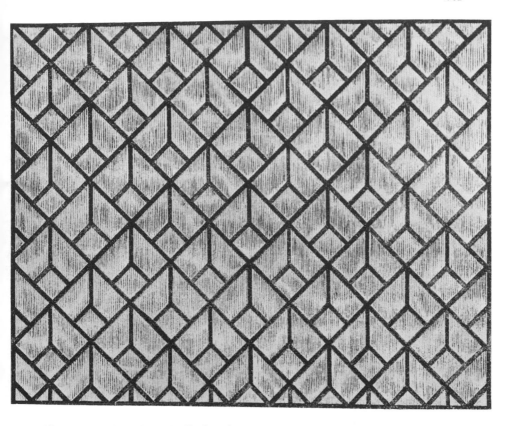

Figure 9.8. Cistercian grisaille, box design. La Bénissons-Dieu (after Amé ca. 1850).

The second group of Cistercian grisailles, the geometric motifs (Figure 9.7), reflect Bernard's conviction about the divine order of creation.[41] The saint dwells on themes of order, regularity, system, and structured existence and speaks of the divine in these terms:

> The beautiful order established by divine providence will produce an inexpressible delight in [you]. ...

> Under the light of uncreated Truth, you shall clearly and perfectly behold everything arranged in the most admirable order, his own place assigned to everyone, or rather everyone assigned to his own place. ...[42]

> From the beginning, my brethren, God has shown his predilec-
> tion for order, and nothing out of order has ever been acceptable to him
> whose very essence is order.[43]

Cistercian interlace, unlike many other kinds known to the history of art, is symmetrical and orderly. Moreover it is complete—finite and self-contained, without loose ends. And its forms, no matter how complicated, are based upon simple geometric schema.[44] Von Simson has established for us the foundation of Bernardine architectural proportions in the concept of divine order in mathematical relationships, and it is my belief that a similar metaphysical significance for number and ratio lies behind Cistercian geometric patterns. The perfect circle, the one-to-one ratio of the square, the unending interlace, echo God's unity and eternity; the triplet lancets and the braided borders[45] recall God's trinitarian nature; the interlocking forms express the continuum and the ordered complexity of all creation.

Even the simplest Cistercian patterns yield up such nutritious food for thought. The "box design" of La Bénissons-Dieu (Figure 9.8) and Pontigny[46] hypnotically repeats a motif composed of the tripartite division of a square. The three are unequal—only one member of the Trinity was incarnate.[47] The four sides of the enveloping lozenge suggest Bernard's four ways in which God can be comprehended: length, breadth, height, and depth.[48] In sum, Cistercian grisailles are constructions of great meditative import; their apparently inexplicable intricacy and complexity are in fact their *raison d'être*.[49]

ABBOT SUGER'S BLUE

Saint Bernard's mysticism focused on the Word made flesh and was based very strongly on Augustine.[50] Another pervasive force in monastic mysticism was the thought of Dionysius the Pseudo-Areopagite, available to the Gothic West in translations made at the Benedictine abbey of Saint-Denis. Saint-Denis is also the place where the first Gothic stained glass appears in the early twelfth century, the same beautiful windows of Abbot Suger which have already figured large in my argument here.

What is it about Suger's windows which separates them from other twelfth-century glass, at least as far as we can tell from the scanty evidence which remains to us? Among other things it is their deep color

saturation.[51] Windows made previously at Saint-Denis (and elsewhere for a while yet to come) placed figures against white backgrounds. The craftsman Theophilus instructs us specifically to do so in his twelfth-century manual on the making of stained glass windows.[52] The prophets of Augsburg have clear grounds, as do other isolated survivors.[53] Still other types of twelfth-century glass have a warm rainbow coloration—they are like spring bouquets, which much red and yellow.[54] But Suger's windows are deeply colored—chiefly with blue.[55] The reasons which have been advanced for their blueness have ranged from remarks about the prevalence of blue in enamelwork (once considered a possible source for Suger's designs)[56] to observations on the lack of weathering crusts on medieval blue glasses.[57] The fact remains that blue is the binding color of these windows,[58] for the first time as far as we know.[59] Why is that?

I come now to my second revision of art history, which concerns Suger's blue. The medieval color scale was strictly linear, each color taking a specified position between the extremes of white and black. No matter where the other colors occur—and they do jockey for position in various medieval color systems—the color next to black was always blue.[60] Blue therefore is the color to make a window if it is intended to be gloomy, obscure, almost black. Why would Suger wish his new Gothic choir to be gloomy?

Suger had been reading the mystical texts of Dionysius the Pseudo-Areopagite, as we know from Otto von Simson, Erwin Panofsky, Paul Frankl, and others. The doctrine of the Pseudo-Areopagite identifies the Godhead with light and radiance: "Every creature, visible or invisible, is a light brought into being by the Father of lights. ... "[61] But Dionysius presses the implications of his conception of God as a Super-Light to the point of declaring a "negative theology."[62] He eventually defines the Super-essential One not as light and knowledge, as we can ever hope to know them, but as eternal darkness and eternal ignorance.

Panofsky dismisses this "negative theology," saying that Suger also dismissed it.[63] This is precisely the point at which I disagree. Suger's blue is a perfect expression of this "negative theology" of the divine darkness, of that doctrine of Dionysius which has been rendered in flatfooted English as the concept of God as the "Divine Gloom." The second chapter of Dionysius' *Mystical Theology* begins: "We desire to abide in this most luminous darkness, and without sight or knowledge, to see that which is above sight or knowledge, by means of that very fact that we see not and know not."[64] Dionysius explains himself—more or less—in the letter to Dorotheus the Deacon: "The divine darkness is the inaccessible light in which God is said to dwell."[65]

Suger was probably not the first admirer of the Pseudo-Areopagite to attempt to translate this concept into art. There is some evidence that Greek artists much closer to Dionysius' own time attempted to show God's place as black and blue:[66] at Saint Catherine's on Mount Sinai, as well as at San Vitale in Ravenna,[67] both around the mid-sixth century (see Chapter 1). Suger did introduce the concept into Western Gothic stained glass,[68] however. For a hundred years to come, glazing in the Ile-de-France attempted to recreate the Divine Gloom.[69]

The texts of the Pseudo-Areopagite had been known in the West long before Suger. A Greek manuscrpt (now in the Bibliothèque Nationale) had been given to the abbey of Saint-Denis by Louis the Debonaire about the year 830[70] and was quickly translated. But there was a difference between the versions of Dionysius that Suger had before him and those generally available to his contemporaries. Suger had two Latin translations of the Greek text, both of the ninth century. The first had been produced at Saint-Denis under the Abbot Hilduin ca. 832–35. It was a tortured piece of work, done by a team of Greek-speakers working orally.[71] The first collaborator attempted to make sense of the old Greek uncial letters, run together without word separation or accents, and he read aloud; the second listened to this and translated it aloud into Latin, while a scribe wrote it down. The Hilduin translation was nearly unintelligible in parts— not surprisingly—and it remained in the library of Saint-Denis, largely unknown until the twentieth century.[72] The second translation was a correction of it made around 860 by the famous Carolingian scholar, John Scotus Erigena.[73] Erigena's version and his extensive commentary were the avenue by which Westerners knew and studied the Pseudo-Areopagite.[74]

Suger, however, had the two versions at hand in his abbey's library, and he seems to have pored over both. The Greek word *kúanos* is used only once by Dionysius, in the *Celestial Hierarchy*, where he establishes a color symbol for "hidden light."[75] In the ancient Greek of Sophocles, this word was still in transition and could mean either black or blue.[76] Erigena and later academics translated it by the meaning it retained in poetic usage, namely, *black*.[77] But the Greek-speakers working for Abbot Hilduin rendered its meaning as it had evolved into everyday street language—as *blue*.[78]

The Pseudo-Dionysius remained popular long after Suger. Aquinas and Bonaventure eventually commented on his texts, and they were copied and studied up to the beginning of modern times. The story of their translation, however, was by no means finished. After the death of Suger, in the fast-moving intellectual climate of the late twelfth century—when Arabic texts on optics were first appearing in Paris[79]—even the Erigena

translation of the Pseudo-Dionysius was found unsatisfactory. A third translation was made at Saint-Denis ca. 1165 by a monk named John Sarrazin, a friend of the theologian John of Salisbury.[80] With a few other additions, Sarrazin's translation[81] became the core text which was used by most of the famous scholastic theologians of the thirteenth century.[82] This Dionysian corpus available to the Sorbonne scholars[83] had developed not only by accretion[84] but also by deletion, as it were. The commentary of Erigena—in Suger's time the only useful text—had fallen under a cloud,[85] partly because the Albigensian heretics found in Erigena support for their resistance to organized Catholicism.[86] In 1225 the Pope supported a censure of one of Erigena's tracts,[87] a censure which the papacy repeated several times in the 1230s. These condemnations culminated in the Ten Propositions forbidden in 1241 and 1244.[88] The power struggle in Paris was, on the theological level (as Chenu puts it), "Augustine versus Dionysius"; on the sociological level it was the established Benedictine communities versus the friars. For purposes of art history, it is enough to summarize its effects: the mid-thirteenth century[89] leaves out the Divine Gloom, and light is light.

THE THIRTEENTH-CENTURY GLASS OF SAINT-DENIS ABBEY

What does the reinterpretation of the Pseudo-Areopagite have to do with Gothic stained glass? The question produces the third revisionist hypothesis of this study. Art historians have recognized for a long time that between 1240 and 1260, the Gothic esthetic underwent a sea-change— from tenebrous, color–saturated interiors to cages of light glazed with much grisaille.[90] By 1270 these grisailles are normally band windows, horizontal rows of colored glass sandwiched between areas of grisaille, above and below.[91]

Jean Lafond believed that Paris dictated these changes in fashion.[92] Jean-Jacques Gruber identified three reasons for the new increase in grisaille: economy, a desire to light the elegant surfaces of the new rayonnant architecture, and the eternal desire of artists for change.[93] I would add to Gruber's reasons the one that I now consider to be more basic: the shift in the theological underpinnings of the Gothic esthetic. Lafond is surely correct that the fashion changed first in Paris. I would go further.

Several Parisian churches can be pinpointed where new construction at this time required glazing, and probably received grisaille in

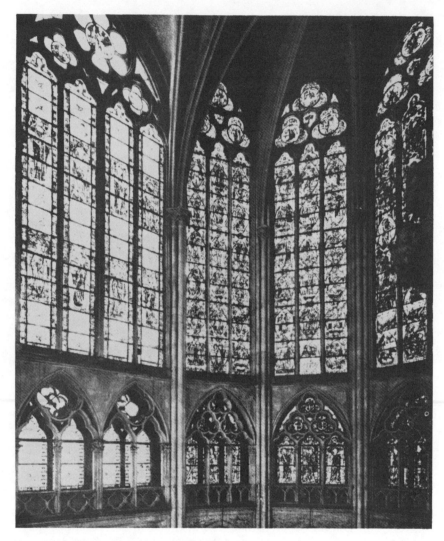

Figure 9.9. Tours Cathedral. North choir. *Photo Robert Branner.*

various experimental combinations with color. These ensembles are now lost. Among them were small chapels and cloister structures for the abbeys of Saint Germain-des-Prés, Saint-Victor, Saint-Martin-des-Champs, the Carthusians, the Templars, the college of Cluny, and so on.[94] Chief among them—by virtue of sheer size and importance, if nothing else— was unquestionably the abbey of Saint-Denis.

One hundred years had passed since Suger had built his beautiful sanctuary. Beginning in 1231[95] the monastic community of Saint-Denis finally reconstructed and glazed a vast new church between Suger's old ambulatory and his narthex. Although the thirteenth-century windows have been totally destroyed since the Revolution,[96] scholars have assumed that they were deeply colored:

> The new windows of the church were glazed in the style of 1240–60, very dark and deeply colored; they no longer exist but writers of the 17th and 18th centuries praised their rich color and noted the darkness of the interior, 'though there are more windows than building.' Their effect can be imagined by looking at the clerestories of a monument which is not only contemporary with Saint-Denis but related to it in elevation design, the choir at Troyes Cathedral.[97]

Neither Troyes nor another cathedral glazed with color during the 1240–60 period, Le Mans, has strong Parisian connections, however. Better to seek a reflection of these prestigious lost windows in a work of Parisian imprint: for example, the cathedral of Tours (Figure 9.9), where (as Grodecki indicates) the typical France/Castille borders which Lebeuf noted at Saint-Denis still remain.[98] Another Benedictine abbey in the Ile-de-France which imitated Saint-Denis in razing its twelfth-century choir down to the vaults of the ambulatory and erecting atop them a rayonnant cage was Saint-Père de Chartres (Figure 9.10).[99] It is my belief that the famous thirteenth-century glazing of Saint-Denis included some grisailles, as do the choirs of both Tours and Saint-Père. I will base my reconstruction on more critical examination of the pre-Revolution descriptions and depictions of the abbey, as well as on evidence of glazing styles before, during, and after 1240–60 which can be considered Parisian or Paris-related. My conclusion is not only that the glazing included some grisailles (as at Tours and Saint-Père, Figures 9 and 10, in the pierced triforium on the flanks of the choir), but that among the clerestories of this renowned ensemble were probably the first band windows—a fountainhead from which sprang a new Gothic fashion.

There is tantalizing evidence about the lost windows of Saint-Denis, both verbal and pictorial. The descriptions of the eighteenth century refer to the glass as dark because of its thickness and painting.[100] The abbey church bore the nickname of "The Lantern" in the previous century, however,[101] and it is difficult to imagine that term, in the era of Louis XIV, referring to a totally color-saturated interior.[102] Henry IV (1589–1610), for example, had called St. Martin-aux-Bois—which is almost entirely glazed in grisaille—"*la plus belle lanterne de mon royaume.*" Moreover, the "thick-

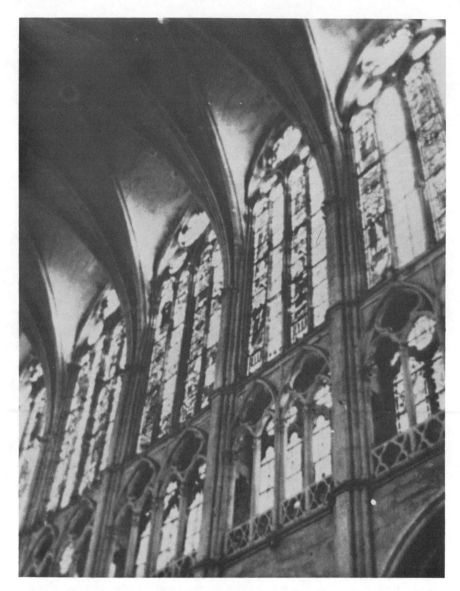

Figure 9.10. Chartres, Saint-Père. South choir.

ness of the glass and its heavy painting" make more sense in the context of grisailles, many of which were removed wholesale in the seventeenth and eighteenth centuries because they had weathered to the point of opacity.[103] Some of those which remain are now in this condition (Figure 9.11)[104]

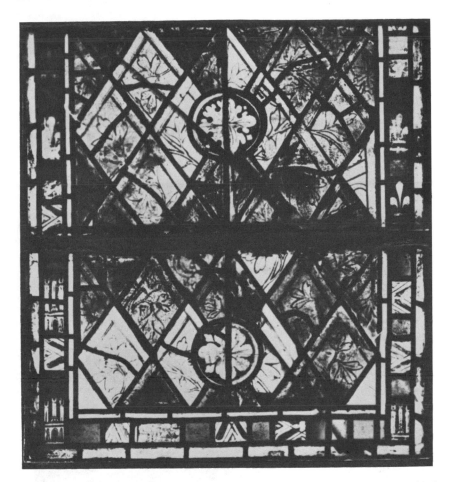

Figure 9.11. Grisaille darkening and turning opaque. Vendôme, La Trinité. Band window, north choir. Ca.1290. *Photo © ARCH PHOT./SPADEM/VAGA, New York 1983.*

To this argument can be added the pictorial evidence for the lost thirteenth-century windows of Saint-Denis (Figure 9.12a). There are two images. One is a drawing made by Percier about 1795, showing giant (elephantine) standing saints in the transept clerestory, one figure to each lancet (Figure 9.12b).[105] This drawing was the basis for the present nine-teenth-century restorations, and their awfulness derives in part from that mistake. It is not likely that Percier's drawing depicts the windows he saw exactly; such monster saints would be grotesque, as the nineteenth-century versions in fact are. Either Percier saw several rows of figures (as at Le Mans where there are two rows, or at Troyes which has three) and reduced

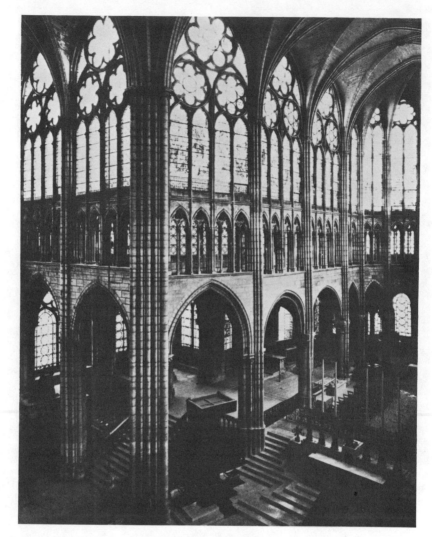

Figure 9.12a. Interior of Saint-Denis. *Photo Robert Branner.*

them to one, or, more likely, he was looking at band windows, with figures sandwiched between grisaille above and below.[106] And, as usual, he omitted the grisaille. There is not a single baroque drawing known to me which correctly depicts grisaille, in those cases where we know that it existed in the window in front of the artist;[107] it is more usual to find the

Figure 9.12b. Interior of Saint-Denis. Drawing by Percier, 1795. Compiègne, Musée Vivenel, fol. 43. *Photo © ARCH PHOT./SPADEM/VAGA, New York 1983.*

Figure 9.13. Master of St. Giles, *The Mass of St. Giles*, detail showing the interior of Saint-Denis ca. 1500. *Reproduced by courtesy of the trustees, the National Gallery, London.*

windows shown blank, no matter what was in them. Grisaille was uniformly ignored, and frequently still is. Very little of it was removed to safekeeping during World War II.[108]

The second piece of pictorial evidence is more exciting. It is a painting of about 1500, which shows the interior of Saint-Denis with the great golden altar-fittings (now melted down) and the tomb of Dagobert: "The Mass of Saint Giles" in the National Gallery of London.[109] The clerestories do not show completely in the painting, alas! but the glazed triforium does, in the upper left corner (Figure 9.13). And both are glazed in grisaille.

What might the glass in Saint-Denis have looked like? It is possible to suggest it from these various types of evidence. It is possible that the hemicycle clerestories were totally colored—that was traditional,[110] and retained at Saint-Père de Chartres—and the transept roses[111] certainly were (Figure 9.14). And of course Suger's dark windows remained in the choir ambulatory. The triforium glazing included grisaille, according to the painting of 1500 (Figure 9.13). Perhaps it resembled the triforium of Tours, a cathedral in the Paris style, dated 1255.[112] The triforium of Tours (Figure 9.9) has grisailles along the sides of the choir, flanking a colored hemicycle.[113] Such a colored hemicycle would accommodate the figure (of Pepin the Short?) which Lenoir reportedly saw in the choir triforium of Saint-Denis.[114] This glazing pattern had appeared in Paris at the Benedictine abbey of Saint Germain-des-Prés, in their Lady Chapel begun in 1245, in which grisailles flanked a colored hemicycle.[115] Other grisaille trforia can be seen at the Abbey of Saint-Père de Chartres (Figure 10), at Sées (Figure 16), and at La Trinité de Vendôme.[116]

What did the Saint-Denis clerestories look like? Here, Percier's distorted drawing (Figure 12b) and our good sense must guide us. The Saint-Denis bays (Figure 12a) are transitional windows, already immense but still squat in proportion, since they are as yet divided into only four lancets, their traceries filling nearly the entire upper half.[117] Comparably proportioned bays in cathedrals of the mid-century were glazed with several rows of figures: examples are in the cathedrals of Troyes (three rows) and Le Mans (two rows), buildings of no particular Parisian connections.

Experimentation in the Paris region in combining grisaille with colored figures probably predated Saint-Denis. Such early combinations can be seen at such Paris-related monuments as the country churches of Linas, [118] Brie-Comte-Robert,[119] and Villers-St.-Paul (Figure 9.15),[120] and ultimately at Auxerre Cathedral.[121] The final evolution of the grisaille-figure combination can be seen after Saint-Denis at the Victorine cathedral of Sées,[122] where the developed band windows[123] have the exaggerated vertical proportions of a later decade (Figure 9.16). Saint-Denis fits nicely between these two extremes. Percier's row of single figures across a bay of four lancets could be a reflection for us of the first band windows in Gothic stained glass.

This chapter has thus investigated the impact of monastic patronage on Gothic glass. The idea that monastic ensembles have distinctive subject programs[124] is reasonable and has already gained some accep-

Figure 9.14. North rose window of Saint-Denis. Drawing by Percier, 1796. Compiène, Musée Vivenel, fol. 45. *Photo © ARCH PHOT./SPADEM/VAGA, New York 1983.*

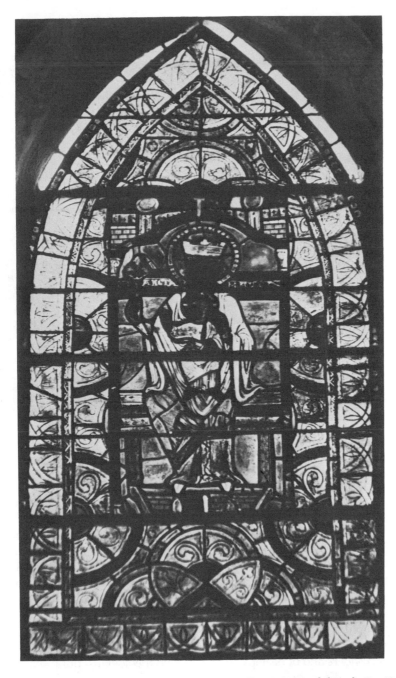

Figure 9.15. Grisaille and color combination. Villers-Saint-Paul (Oise). Ca. 1240.
Photo Michael Cothren.

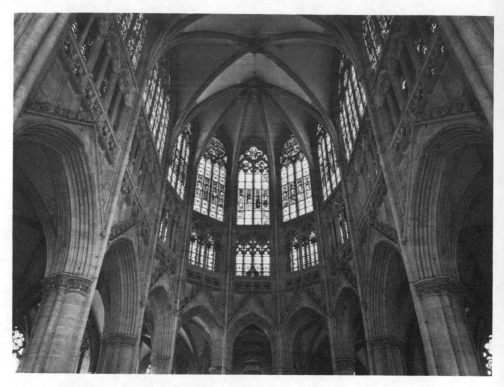

Figure 9.16. Sées Cathedral. Choir. *Photo Piel.*

tance. On the other hand, the notion is a new one that monastic needs
made a contribution to basic stylistic decisions such as color harmony,
pattern, and the choice, arrangement, and combination of forms. The
inquiry began by looking into the sources of, and the rationale for, several
recognizable stylistic types of Gothic window: the distinctive Cistercian
grisaille; the dark, color-saturated medallion of the early and the classic
high Gothic; and the light, bright band window of the later rayonnant
period. The patterns of monastic life and discipline, the fruits of monastic
thought, and the dictates of monastic mysticism appear everywhere. The
impact of the monks' patronage is not only identifiable and measurable, it
is pervasive and often profound. The Gothic style was the creation of kings
and crusaders and of bishops and scholastic theologians, but monks were
also among the tastemakers.

APPENDICES

The appendices reprint seventeenth- and eighteenth-century descriptions of the lost thirteenth-century glass of the Benedictine abbeys of Saint-Denis and Saint-Germain-des-Prés. The goal is twofold: to provide accurate, accessible versions of these texts, and to establish how descriptions of that period should be interpreted. In the case of Saint-Denis, chronology of texts is also important: the church is nicknamed "The Lantern" in the early seventeenth-century texts only; by the eighteenth century, writers speak of the surprising gloom in the interior considering the number of windows. A change in taste, or a gradual darkening and opacity of grisailles?

In texts of this period grisaille glass is often called "thick," while colored glass never is. Also, grisaille was thought to have been "painted" with a whitish gray wash and is therefore often described by such terms: *épais*, *peint*.

Colored glass of the late twelfth and the thirteenth centuries is always described only as *vitraux rouges*. Other colors are hardly ever specified.[125] Evidence and a control for my statements here are provided in Appendix A, in the many references to thirteenth-century grisaille and/or colored ("red") glass by the Abbé Lebeuf and by Pierre Le Vieil.

APPENDIX A: THE VOCABULARY OF LEBEUF AND LE VIEIL

Abbé Jean Lebeuf, *Histoire de la ville et de tout le diocèse de Paris* 6 vols. (Paris: Féchoz et Letouzey, 1883). I have relied on the index of the 1883 edition and have checked all references to twelfth- and thirteenth-century glass therein; volume and page references below are therefore to the 1883 edition. The most unequivocal and instructive references are:

> Bessaucourt (volume 2, page 74):
>
>> "Une autre observation que j'ai faite dans la même Eglise, et qui fait voir par un autre endroit sa rélation avec l'Ordre de Cîteaux, regarde les vitrages du sanctuaire qui sont de verre très-épais, chargés de quelques couches de peinture grise ainsi que les statuts de cet Ordre vouloient qu'on en mît dans les Eglises des Monastéres."

> Abbaye d'Herivaux (2:216):
>
>> "L'Eglise de cette Abbaye ... paroît être de la fin du XII siecle ou plutôt du commencement du suivant, ce qui se connoît plus visiblement à la mitre des Evêques figurés dans les vitrages, lesquels vitrages sont ou d'un rouge foncé de ces temps-là, ou d'un blanc sur lequel on a jetté une couleur pâle comme dans les Eglises de l'Ordre de Cîteaux d'environ l'an 1200, et que l'on qualifie de grisailles."

Brie-Comte-Robert (5:257):

> "Le fond [*of the church*] n'est pas à rond-point, mais se termine en quarré; il est orné d'un grand vitrage rond en couleur rouge comme ceux de la Sainte-Chapelle de Paris, et supporté par deux autres fenêtres oblongues également de même couleur."

References to colored ("red") glass by volume and page:

Chevilly—4:33
La Queue—4:484
Ponteaux—4:469
St. Germain de Corbeil—5:80 (some of this glass still exists)
Fourches—5:136–7
Coubert—5:150
Varennes—5:172

References to grisaille and color combinations:

St. Martin de Louveciennes—3:112–3
Linas—4:119 (some still exists)
Sainte-Geneviéve-des-Bois—4:380
Noisy-le-Grand—4:622
Limoges—5:134
Gercy—5:169 (some exists, now in the Cluny Museum, Paris)

Pierre Le Vieil, *L'Art de la peinture sur verre et de la vitrerie* (Paris: Institute de France, 1774).

> "Enfin, on trouve encore dans un grand nombre d'Eglises de notre France, qui datent du 12e. siecle, des vitreaux en verre de couleur, qui ne sont qu'un tissu de différents compartiments de ce verre, dont le fond est le plus ordinairement rouge; verre si commun dans ce temps, & maintenant si rare, que ce n'est à proprement parler que par le défaut où nous sommes de ce beau verre rouge, qu'on pourroit regarder la Peinture sur verre, comme un secret perdu pour notre siecle" (p. 25).
>
> "L'amour de la simplicité & de la pauvreté qui régnoit dans les premiers Monasteres de l'Ordre de Cîteaux, avoit occasionné dans cette Religion des défenses portées par les statuts & réglements des Chapitres généraux, d'employer d'autres vitres que des vitres blanches: *Vitrea alba tantùm fiant*. Or ces vitres blanches ne doivent pas s'entendre à la lettre d'un verre nud sans teinture ni couverte; car ce dernier usage n'a pris naissance que vers le commencement du 14e. siecle. La plupart des vitres qu'on appelle ici *vitres blanches*, étoient teintes ou couvertes d'un blanc un peu opaque; telles que celles qui éclairent encore actuellement beaucoup d'Eglises des Monasteres de Bernardins, lesquelles sont ornées de compartiments" (p. 27).
>
> "Ces vitres sont ordinairement connues sous le nom de *grisailles;* les lacis qui en forment les compartiments, tout gothiques qu'ils sont, les fleurons de verre rouge ou bleu autour desquels ils serpentent & se croisent, présentent à la vue un aspect séduisant qui frappe & éblouit en quelque façon, & ressemble, sur-tout dans les fleurons de verre rouge, à un grand feu, au milieu du gris, du jaune & du noir qui les entourent.

"Dans d'autres, ces mêmes lacis serpentent autour d'autres pieces d'un fond blanc, sur lequel paroissent comme brodés en or toutes sortes d'ornements au simple trait, peints en jaune, comme des fleurs, des fruits & des animaux. L'exacte circulation de ces lacis est marquée d'un côté par un trait noir, & recuit sur le verre qu'ils bordent, de l'autre par le plomb qui joint ensemble les pieces de verre.

"Ces ouvrages d'un grand détail exigeoient de la part du Peintre Vitrier un soin des mieux entendus & des plus exacts pour en marier & détacher alternativement les couleurs & les ornements, avec d'autant plus de délicatesse & de patience, que l'Artiste cherchoit à rendre ces lacis plus spirituels & plus gracieux" (p. 27).

Appendix B: Saint-Germain-des-Prés

Dom Jacques Bouillart, *Histoire de l'abbaye royale de Saint Germain des Prez* (Paris: G. Depuis, 1724):

"Une des choses les plus considerables que l'abbé Simon ait entrepris pour son abbaye, est la construction du réfectoire, l'un des plus beaux qui se puisse voir en ce genre. ... Les vitreaux aussi anciens que le réfectoire, sont d'un verre épais & peint d'une maniere particuliere & agréable. L'un d'entre eux représente les armes de Castille plusieurs fois répetées en l'honneur de la Reine Blanche, qui fut pendant long-tems régente du Royaume" (p. 123).

"[*The chapterhouse*] subsiste encore aujourd'hui, & il peut-être consideré comme un des beaux monumens de ce tems-lá. ... Le parterre est à la mosaïque, orné de divers compartimens composez d'une infinité de petits pavez de terre cuite, qui forment dans des quarrez des desseins différens, & vernis de diverses couleurs; ce qui ne s'est pû faire qu'avec un travail incroyable. La peine & la même varieté éclatent dans les vitres qui éclairent ce chapitre. Quantité d'entrelas & lavis de plusieurs couleurs en font la beauté & marquent le goût du tems. La sale qui est à côté, que l'on nomme parloir, est voûtée & pavée de la même maniere que le chapitre" (p. 137).

Henri Sauval, *Histoire et recherches des antiquitez de la ville de Paris* (Paris: Chés C. Moette, 1724).

"Ce bâtiment [*the chapterhouse*] sans doute est fort ancien ... ; le parterre est à la mosaïque, enrichi de quantité de compartimens, faits de petites pierres de couleur, & de maniere differentes. Ce sont toutes pieces de raport, à la verité dont le travail est gothique, aussi-bien que la disposition, mais qui ne s'est pu faire sans beaucoup de tems, & une peine incroyable. La même peine, & la même diversité éclatent dans les vitres qui l'éclairent; quantité d'entrelas & lacis blancs, noirs, & rouges y sont admirés, étant tous beaux, plaisants differents, & fort spirituels" (p. 340).

"La grande Chapelle de la Vierge qu'on croit avoir été commencée en 1245. ... De côté & d'autre elle est éclairée de vitres de clair-obscur, dont les lacis sont fort beaux à la verité, fort gothiques, & d'une gentillesse extraordinaire; mais surtout les vitres du fond du choeur sont universellement admirées, tant pour cette diver-

sité & vivacité du coloris, que parce qu'en y entrant, le rouge éclatant de celles du milieu, frape & éblouit en quelque façon, & se détachent si bien des autres vitres, qu'elles ne ressemblent pas mal à grand feu au milieu du gris, du blanc, du bleu, du noir, & de toutes sortes de couleurs. Le coloris des uns & des autres est si fort & si vif, qu'ils semblent partir tout fraîchement des mains de l'Ouvrier. Ce sont des couleurs qui depuis tant de siecles ne sont point encore mortes, & qu'on ne verra point mourir" (p. 341).

Pierre Le Vieil, *L'Art de la peinture sur verre et de la vitrerie* (Paris: Institut de France, 1774):

"On avoit vu des exemples de ces vitres blanches dès le siecle précédent [*i.e., the 12th*]: telles étoient celles qui subsistoient encore en 1741, dans les grandes parties circulaires des hauts vitreaux du choeur au midi de l'Eglise cathédrale de Paris.

"D'autres fondateurs moins détachés ou plus magnifiques dans la décoration des temples dédiés au culte de l'Etre suprême, introduisirent dans l'assemblange de ces vitres blanches des fleurons de verre de couleurs. La grande Chapelle de la Sainte Vierge sous le cloître de l'Abbaye de S. Germain-des-prés à Paris, & l'Eglise du College de Cluni en la même ville, en sont ornées: on voit de semblables vitres qui se sont bien conservées dans la Cathédrale aux fenêtres de quelques Chapelles au nord & au levant, dans l'enceinte du choeur; on en voit aussi dans un grand nombre d'Eglises de notre France, dont la construction date du 13e. siecle" (p. 27).

Appendix C: Saint-Denis

Jacques Doublet, *Histoire de l'abbaye de S. Denys en France* (Paris: I. de Hevqueville, 1625):

"Le corps de l'Eglise & voultes sont soustenuës par 60. pilliers à deux rangs, & tout le circuit entourné de belles galleries fort claires & spacieuses, les parois & arboutans qui portent tant le dedans que le dehors, & tout ce qui y est contenu, le tout est autant delicatement eslabouré, & autant artistement travaillé qui se puisse voir.

"Les vitres sont les plus riches, les plus magnifiques, & les plus exquises qui soient en l'Europe, tant pour la matiere, que pour les vives couleurs dont elles sont composees. En voicy le tesmoignage que rend le venerable Abbé de S. Denys Suggere, qui les a fait faire, tiré de son livre, intitulé, *Gesta Suggerii Abbatis: Unde quia magni constant mirifico opere sumptuque profuso, vitri vestiti, & saphirorum materia, tuitioni & refectioni earum ministerialem magistrum, sicut etiam ornamentis aureis & argenteis, peritum aurifabrum constituimus*. Et en un autre endroit: *Qui enim inter alia maiora, etiam admirandarum vitrearum operarios, & materiem saphirorum locupletem administrabit*.

"Lesquelles vitres sont en telle quantité, qu'elles surpassent le surplus de l'edifice, c'est pourquoy l'on nomme l'Eglise Lucerna, Lanterne, tout ne plus ny moins que l'on dit des Eglises de nostre Dame de Paris, de Rheims, de Beauvais, d'Amiens, & de Chartres, Tours de nostre Dame, Portail de Rheims, Choeur de Beauvais, Nef d'Amiens, & Clocher de Chartres: aussi l'Eglise de S. Denys est denommee Lanterne S. Denys, à cause qu'il y a plus de vitres & d'ouverture que de

bastiment, en quoy elle excelle, comme lesdites Eglises excellent en ces choses"
(pp. 285–86).

Germain Millet, *Le tresor sacré; ou inventaire des sainctes reliques et autres precieux joyoux qui se voyent en l'eglise & au thresor de l'abbaye royale de S. Denys en France* (Paris: Iean Billaine, 1636):

"Je ne doute pas qu'il ny ait en France & ailleurs des Eglises plus longues, peut estre aussi de plus hautes que celles de Sainct Denis, mais d'en trouver qui soient aussi delicatement basties, aussi bien croisées, aussi bien vitrées, c'est chose bien difficile, pour ne pas dire impossible.

"Quant à la delicatesse du bastiment, elle se recognoist en toutes le parties d'iceluy, tant par le dedans que par le dehors, & specialement en ces beaux pilliers, qui soustiennent ces grandes & larges voutes, si deliez & menus, qu'il semble presque impossible, qu'ils puissent porter un si pesant fardeau. ... Et de là il resulte une autre chose grandement considerable, qui est, que, ces pilliers estant si deliez, & les vitres qui sont entre deux, si hautes & si larges, toute l'Eglise depuis la grande gallerie, qui va tout à l'entour iusques au feste, semble estre de vitre, (ce qui est tres agreable à voir.) C'est la cause pourquoy on appelle ceste Eglise lanterne de S. Denis, parce qu'elle est presque tout à jour ainsi qu'une lanterne.

"Quant à la croisée, elle est si belle & large, & si bien proportionnée, qu'il ne se peut rien dire de plus. Sur tout sont admirables ces deux belles roses, qui sont aux deux bouts d'icelle, si grandes & si larges, qu'elles ont plus de trente six pieds de diametre, si delicatement taillées, que c'est merveille, que des pierres si minces estenduës en si grande largeur ayent peu si long temps durer & supporter tant de siecles, les injures du temps sans estre aucunement offensées. Si on ioint à cela les vives & diverses couleurs des vitres, dont elles sont composées, on pourra dire sans scrupule, que ce sont en matiere de vitres deux des plus belles pieces, qui soient en l'Europe.

"Pour le regard des autres vitres, qui sont tout autour de ce grand vaisseau, elles ne sont pas moins belles, que celles des deux roses. Il y en a trente sept grandes par le haut, sur lesquelles sont representez plusieurs personnages & belles histoires, mais avec des couleurs si vives & si luysantes, qu'il semble qu'elles viennent de sortir du fourneau, quoy qu'il y ait cinq cens ans qu'elles soient faites & exposées à la pluye, au vent & aux tempestes. Et ie pense qu'en cela l'Eglise de Sainct Denis surpasse toutes les autres belles Eglises du Royaume & d'ailleurs.

"Outre ces trente sept grandes vitres il y a bon nombre d'autres en diverses Chappelles, specialement en celles du Chevet, lesquelles, quoy que differentes en grandeur, sont toutefois égales en la vivacité des couleurs, laquelle vivacité ne provient pas de la peinture, comme celles des vitres communes, ains des pierres precieuses, qui furent fonduës en grande quantité avec le verre, comme l'Abbé Suger, qui les a fait faire, l'asseure au livre de ses gestes. C'est pourquoy il ne faut pas s'esbahir, si elles sont si excellentes" (pp. 27–29).

Dom Michel Félibien, *Histoire de l'abbaye royale de Saint-Denys-en-France* (Paris: F. Leonard, 1706):

"Toute l'église est ... éclairée par trois rangs de fenestres, l'un sur l'autre. Les plus grandes au nombre de trente-sept qui sont au dessus des galeries ont environ quarante pieds de hauteur, & se touchent de si prés qu'il n'y a pas plus de trois

pieds d'épaisseur de pillier entre chacune. Quoique l'église soit percée de tous costez avec une hardiesse surprenante, la peinture & l'épaisseur du verre temperent le grand jour de telle sorte, qu'on y trouve toûjours un certain sombre qui semble inviter au recueillement si convenable au lieu saint" (p. 529).

Abbé Jean Lebeuf, *Histoire de la ville et de tout le diocese de Paris*, 6 vols. (Paris: Féchoz and Letouzey, 1883):

> "Il y a dans cette Eglise des vitrages qui représentent quelques actions de S. Louis. On y en voit aussi qui peuvent être plus anciens, et avoir été réservés de l'edifice précédent; vers le fond est représenté S. Paul tournant la meule d'un moulin, et les Prophetes qui apportent leurs sacs de bled, avec quatre vers, dont le premier est *Tollis agendo molam de furfure, Paule, farinam.*
>
> "L'épaisseur et la couleur du verre ne contribuent pas peu à rendre cette Eglise un peu obscure, malgré la grande étendu des vitrages, qui a fait dire à quelques-uns qu'il y avoit plus de vitres que de bâtimens" (vol. 1, p. 497).

Pierre Le Vieil, *L'Art de la peinture sur verre et de la vitrerie* (Paris: Institut de France, 1774):

> "[*Stained glass windows of the 13th century*] étoient quant à la partie historique, appliqués sur un fond de vitres composées de pieces de rapport de toutes couleurs, ... & par le mélange heureux & bien entendu de ces couleurs brillantes, formoient une mosaïque transparente très-gracieuse à la vue. ...
>
> "Telles sont entr'autres la plupart des vitres de l'Eglise de l'Abbaye de S. Denys en France, postérieures à celles que l'Abbé Suger y fit faire; celles des deux roses laterales de l'Eglise de Paris, celles de la Chapelle de l'infirmerie de l'Abbaye de S. Victor de cette Ville, & surtout les vitres toujours admirables de la Sainte Chapelle à Paris" (p. 26).

NOTES

The reader is referred to the following article, which appeared after the present chapter was in press: John Gage, "Gothic Glass: Two Aspects of a Dionysian Aesthetic," *Art History* 5, no. 1 (March 1982): 36–58. Gage's conclusions concerning "Suger's blue" are evidently an extension of his research on color published in 1978, which I cite in note 67. It is gratifying to find them so close to my own, though he does not suggest Suger's familiarity with his abbey's Hilduin translation of the Pseudo-Areopagite, which seems to me the crucial point. Gage's remarks about the changed Dionysian esthetic in thirteenth-century stained glass, while less closely related to my own, bring to the question a vast display of useful evidence from the history of medieval gems and gem literature. The heretical cloud over Erigena in thirteenth-century Paris seems to me more pertinent.

1. Among many references two of seminal importance can be cited: Louis Grodecki's introductory essay in *Vitraux des églises de France* (Paris: Les Editions du Chêne, 1947); Otto von Simson, *The Gothic Cathedral: Origins of Gothic Architecture and the Medieval Concept of Order* (New York: Pantheon Books, 1956).

2. Jean Lafond, "Le Vitrail en Normandie de 1250 à 1300," *Bulletin monumental* 111 (1953): 320–21.

3. A discussion of this famous treatise by Dom Jean Leclerq and a recent translation with very good notes by Michael Casey, O.C.S.O., may be found in *The Works of Bernard of Clairvaux: Treatises I* (Spencer, Mass.: Cistercian Fathers, 1970), pp. 3–69.

4. A Cistercian treatise of c. 1200 which repeats the distinction between what is acceptable in the cathedral and parish church and in the monastery is Montague Rhodes James, "Pictor in Carmine," *Archaeologia* n.s. 94 (1951): 141.

5. Madeline Caviness, *The Early Stained Glass of Canterbury Cathedral, Circa 1175–1220* (Princeton: Princeton University Press, 1977), p. 102. Caviness' work is a breakthrough in our understanding of this basic difference in stained glass programs.

6. *Ibid.*, p. 142, citing Francis Wormald, "Some Illustrated Manuscripts of the Lives of the Saints," *Bulletin of the John Rylands Library, Manchester* 35: 262.

7. Emile Ginot, "Le manuscrit de Sainte Radegonde de Poitiers et ses peintures du XIᵉ siècle," *Bulletin de la Société française de reproductions de manuscrits à peintures, Années 1914–20* (Paris: 1920): 56–58. The eighteenth-century Maurists reported a tradition that the nave window was based on this treasured manuscript.

8. Although *libelli* were not a phenomenon of the high Gothic era (Wormald places their floriation between Cluny and the friars), the peculiar political responsibilities of the Abbey of Saint-Denis required intermittent revisions in the "official" life of the patron saint of France and thus new manuscripts, of which the most famous is that made for Philippe le Bel by the monk Yves. On this manuscript see Charlotte Lacaze, *The "Vie de St. Denis" Manuscript (Paris, Bibliothèque Nationale, Ms.fr. 2090–2092)* (New York: Garland Publishing, 1979). On the intermittent need for a new version of the saint's life, the basic study is Charles J. Liebman, Jr., *Etude sur la vie en prose de Saint Denis* (Geneva, N.Y.: The W. F. Humphrey Press, 1942). On the use of the manuscripts at Saint-Denis to design the Saint-Père nave window, see Meredith Parsons Lillich, *The Stained Glass of Saint-Père de Chartres* (Middletown, Conn.: Wesleyan University Press, 1978), pp. 138–42, 176, and notes 53 and 54.

9. Wolfgang Braunfels, *Monasteries of Western Europe, the Architecture of the Orders*, translated by Alistair Laing (Princeton: Princeton University Press, 1972), p. 12.

10. The monastic imprint on Romanesque sculpture was considered in a limited way by Emile Mâle, *Religious Art in France: The Twelfth Century*, edited by Harry Bober (Princeton: Princeton University Press, 1978), pp. 364–76.

11. Caviness, *Early Stained Glass*, p. 103 and passim.

12. Lillich, *Stained Glass of Saint-Père*, p. 190 f.

13. Jean LaFond, *Les Vitraux de l'église Saint-Ouen de Rouen I (Corpus Vitrearum Medii Aevi France* IV 2/1) (Paris: Caisse *Nationale des Monuments Historiques*, 1970), pp. 14–18.

14. Those cathedrals with tight subject programs, such as Bourges or Tours, were glazed in a comparatively brief period of time.

15. The valuable pioneer works of Emile Mâle are available to English-speaking students in the following editions: *Religious Art in France; The Twelfth Century* (1978) and *The Gothic Image: Religious Art in France of the Thirteenth Century*, translated by Dora Nussey, 1913 (New York: Harper Torchbooks, 1958).

16. Caviness, *Early Stained Glass*, p. 116–17, makes this point very well.

17. This typology is absolutely standard. See Erwin Panofsky and Gerda Panofsky-Soergel, *Abbot Suger on the Abbey Church of St. Denis and its Art Treasures*, 2nd ed. (Princeton: Princeton University Press, 1979), pp. 76–77, 215; Louis Grodecki, "Les Vitraux allegoriques de Saint-Denis," *Art de France* 1 (1961): esp. 37–38, n. 191.

18. Exodus 34: 33–35; II Cor. 3: 12–18. See Panofsky, *Suger*, pp. 74–75, for Suger's couplet; pp. 211–12 for a discussion of the sources and peculiarities of Suger's exegesis, with references to studies by von Simson, Grodecki, and Konrad Hoffmann.

19. Exodus 14: 23; I Cor. 10: 1f. Panofsky, *Suger*, pp. 74–75; pp. 214–15 with bibliography, emphasizing the differences between Suger's analogies and the *Bible moralisée* and *Speculum Humanae Salvationis*. I would like to thank Professor George Scheper for references to this typology in the Fathers, specifically Hugh Riley, *Christian Initiation* (Washington D.C.: Catholic University of America Press, 1974), pp. 43–51; Peter Lucas, ed., *Exodus* (London: Methuen, 1977), pp. 65, 117, and copious bibliography.

20. Grodecki, "Les Vitraux ... ," *Art de France* 1 (1961): esp. 41.

21. *Ibid.*, p. 35; von Simson, The Gothic Cathedral, p. 121 and notes.

22. James, "Pictor in Carmine," *Archaeologia* n. s. 94 (1951): esp. 141, 151. The extra-Biblical authorities which he noted in the *Pictor in Carmine* (a work of ca. 1200 by the Cistercian abbot Adam of Dore) are limited and significant: Augustine, Dionysius the Areopagite, Jerome, and Gregory (p. 147).

23. *The Works of Aelred of Rievaulx I: Treatises*, introduction by Dom David Knowles (Spencer, Mass.: Cistercian Fathers, 1971), p. 80, 81.

24. Louis Grodecki, *Les Vitraux de Saint-Denis* I (*Corpus Vitrearum Medii Aevi France, Études* I) (Paris: Centre Nationale de la Recherche Scientifique, 1976), Pl. 1; 69–75. Cited hereafter as CVMA-St.-Denis.

25. Bay 19, bottom row. Lillich, *Stained Glass of Saint-Père*, p. 113 and pl. 53.

26. Meredith Lillich, "The Choir Clerestory Windows of La Trinité at Vendôme: Dating and Patronage," *Journal of the Society of Architectural Historians* 34 (1975): fig. 5 and p. 243.

27. *Ibid.*, fig. 4. There would have been no chance of mistake by Pierre's contemporaries: my article spells out his identification for the less heraldically literate modern viewer.

28. See *ibid.* for bibliography on the history of La Trinité, Vendôme, and the *Sainte Larme*.

29. It may explain, on the negative side, why monastic churches often have no elaborate sculpted portals or western rose windows. The monks do not enter from those façades and do not at any rate spend very much time in the nave. The monks' choir is the nucleus of their activity.

30. Emile Mâle, "La Peinture sur verre en France," in André Michel, *Histoire de l'art*, 8 vols., (Paris: A. Colin, 1906), 2: pt. I., p. 384.

31. Panofsky, *Suger*, pp. 52–3, 76–77, 171.

32. Mâle in Michel, *Histoire*, p 392.

33. For the texts of the statutes see Helen Jackson Zakin, *French Cistercian Grisaille Glass* (New York: Garland Publishing, 1979), p. 5.

34. Sermon 45 on the Song of Songs, Sect. IV, para. 6; *S. Bernardi opera*, 2 vols., ed. Jean Leclercq (Rome: Editiones Cistercienses, 1957–72), 2: 53. Translation: *St. Bernard's Sermons on the Canticle of Canticles*, 2 vols. (Dublin: Browne and Nolan, 1920) 2: 17.

35. The modern view of art historians that colored glass was more expensive probably can be traced to early English records, where— since it was imported into England while colorless glass was produced there locally—colored glass definitely was more costly. The case is not so airtight in France.

36. The addition of manganese, known in first-fifth century Roman glassmaking, is mentioned in the treatise of Biringuccio (1540). Its absence from the treatise of Theophilus—which is unclear and imperfect at this point—is probably not as significant as the Third Book of Eraclius, thought to be a twelfth- or thirteenth-century French addition to the

text. The latter describes both a colorless glass made from fern ash and a flesh-colored glass from beech ash. For the texts see Mary P. Merrifield, *Original Treatises on the Arts of Painting* (1849, reprint New York: Dover Publications, 1967), pp. 212–14. The correct operation of "glass maker's soap" requires control of an oxidizing atmosphere, which Theophilus does not appear to have had. Professor Donald Royce-Roll's experiments with reproducing medieval glass colors indicate that some control of reducing and oxidizing atmospheres in a wood-fired kiln was probably achieved by the Gothic period. On Biringuccio, see *The Pirotechnia of Vannoccio Biringuccio*, edited and translated by Cyril S. Smith and M. T. Gnudi (New York: The American Institute of Mining and Metallurgical Engineers, 1942). On Theophilus and the question of a controlled oxidizing atmosphere, see the long and confused note in *On Divers Arts, the Treatise of Theophilus*, edited by Hawthorne and Smith (Chicago: University of Chicago Press, 1963) pp. 55–56. On Eraclius see John Chatterton Richards, ""A New Manuscript of Heraclius," *Speculum* 15 (1940): 255–71. On the unreliability of manganese decolorizing without an oxidizing atmosphere see Samuel R. Scholes, *Modern Glass Practice*, edited by Greene (Boston: Cahners Books, 1975), pp. 305–10, passim. I would like to thank Dr. Robert Brill and the librarian, Norma Jenkins, Corning Glass Center, for their help.

37. The theme, Johannine and Augustinian, is common in the writings of Bernard. Passages of Saint Bernard's light imagery are collected by Zakin, *Cistercian Glass*, pp. 144–49, 153; Elisabeth Melczer and Eileen Soldwedel in *Studies in Cistercian Art and Architecture* I (Kalamazoo: Cistercian Publications, 1982), p. 31–44. On Bernard's Johannine sources see Denis Farkasfalvy, O. Cist., "Use and Interpretation of St. John's Prologue in the Writings of St. Bernard," *Analecta Cisterciensia* 35 (1979): 205–26. I would like to thank Father Louis Lekai, O. Cist., for referring me to this study. For a discussion of Bernard's sunlight imagery in a broader context, see the still useful pioneer study by Millard Meiss, "Light as Form and Symbol in some Fifteenth-Century Paintings," *Art Bulletin* 27 (1945): esp. 176–77.

38. My discussion draws heavily on Zakin, *Cistercian Glass*, ch. 4.

39. Sermon 70 on the Song of Songs, sect. II, para. 5; *S. Bernardi opera* II, p. 210. Translation Zakin, *Cistercian Glass*, p. 157.

40. Second Sermon on the Virgin Mother. Translation: *S. Bernard's Sermons for the Seasons and Principal Festivals of the Year*, 2 vols., (Dublin: Browne and Nolan, 1921), 1: 74. For this and other references to the Tree of Jesse theme, see Sister M. Kilian Hufgard, O.S.U., "A Theory of Art Formulated from the Writings of Saint Bernard of Clairvaux," Ph.D. dissertation, Western Reserve University, 1957, pp. 291–320 passim.

41. Again the basis is Augustinian. See von Simson, *The Gothic Cathedral*, ch. 2; Zakin, *Cistercian Glass*, pp. 167–68. Elisabeth Melczer has traced references to Saint Bernard's concept of divine order in: Melczer and Soldwedel, "Monastic Goals," *Studies in Cistercian Art and Architecture*. The quotations which I use in this paragraph are from her examples.

42. Eighth Sermon on Psalm 90. *Sermons for the Seasons*, p. 206.

43. Second Sermon for the Feast of Circumcision. *Sermons for the Seasons*, p. 430.

44. Zakin, *Cistercian Glass*, pp. 162–63.

45. Professor Neils Rasmussen, O.P., has pointed out to me the resemblance of this continuous braid—for example the border of a grisaille from Eberbach (Figure 7), now in the Wiesbaden Museum—to the *perichoresis* and to Suger's consecration procession of 1140, deliberately arranged to imply a Trinitarian symbolism. See Panofsky, *Suger*, pp. 44–45, 154. I would like to thank Father Robert Ayers for help on this point.

46. Zakin, *Cistercian Glass*, pls. 16, 44.

47. "Unequal trios" are commonly recognized among the rich imagery of fifteenth-century Flemish paintings, but they are no less typical of the fenestration of Cistercian buildings, which regularly play combinations of oculi and triplets.

48. On Consideration, Book V, ch. 13. *The Works of Bernard of Clairvaux* XIII: *Five*

Books on Consideration; Advice to a Pope, translated by John D. and Elizabeth Kennan (Kalamazoo: Cistercian Publications, 1976), p. 173f. Bernard uses other quaternities as well. I am grateful to Professor Helen Zakin for sharing with me her unpublished collection.

49. On the contrary the grisailles inserted into Chartres Cathedral in the mid-thirteenth century have not caught onto this profundity; they are "white" medallion windows. And by the time Cistercian-type designs reach the clerestories of the cathedral of Beauvais they certainly have not retained their heavy payload of symbolism. They are just light-passers.

50. While Bernard's Augustinianism has been established beyond doubt, the question of his use (or non-use) of Dionysius the Pseudo-Areopagite is of some importance here. If my premises are correct concerning Cistercian colorless grisaille and Suger's blue, it follows that Bernard was not involved in Dionysian mysticism, and I am satisfied that scholars of his writings have now come to that conclusion. See particularly Edmond Boissard, O.S.B., "Saint Bernard et le Pseudo-Aréopagite," *Recherches de théologie ancienne et médiévale* 26 (1959): 214–63. Farkasfalvy "Use and Interpretation of St. John's Prologue ... ," *Analecta Cisterciensia* 35 (1979), sums up: "Our findings ... confirm [that] ... the influence of Pseudo-Dionysius on his thought cannot be proven" (p. 23). The question has been argued recently because of the strong affirmative position taken in the influential *Dictionnaire de spiritualité* 3 (Paris: Beauchesne et Fils, 1957): "Denys l'Aréopagite (Le Pseudo-) 3. Les Cisterciens," pp. 330–34. Boissard rebuts this article point by point. I am grateful to my friend Father Louis Lekai for many references and for hearing me out.

51. This may be the place to mention that this obscurity is noteworthy not only in Suger's figural glass discussed below, but in his ornamental windows as well (the famous "*verrières aux griffons*"). The latter are not grisailles by any commonly agreed-upon definition of the term. See Grodecki, *CVMA St-Denis* pp. 122–26, pls. 183–92.

52. *On Divers Arts*, Book 2, ch. 21, p. 64.

53. See, for example, Louis Grodecki, *Le Vitrail roman* (Fribourg: *Office du Livre*, 1977), pls. 36–39, 158, 160.

54. The twelfth-century windows of the Angevin school are notable for balanced primaries red-blue-yellow. See *ibid.*, pls. 46, 52, 54, 58, 62, 69, 162. See also his German examples.

55. The blues have been remarked for a long time. See Grodecki in Aubert et al. *Le Vitrail français* (Paris: *Editions des deux mondes*, 1958), p. 106; also Louis Grodecki, "Les Vitraux de Saint-Denis, L'Enfance du Christ," *De Artibus Opuscula XL, Essays in Honor of Erwin Panofsky*, edited by Millard Meiss (New York: New York Univ. Press, 1961), (hereafter referred to as *Opuscula*), p. 171, n. 10, quoting Pierre Le Vieil, 1774.

56. Grodecki has established on iconographic grounds that a source in Mosan enamelwork is unlikely; while emphasizing the difficulties of isolating stylistic sources, he has suggested the sculpture of Suger's portals in his *Vitraux de France*, exhib. cat. (Paris: Caisse Nationale des Monuments Historiques, 1953), pp. 38–39, and more recently manuscripts and metalwork. See Grodecki, *Opuscula*, pp. 184–85; "Les Vitraux ... ," *Art de France* 1 (1961): 19.

57. This generally observed phenomenon has been widely discussed since the cleaning of the Chartres west windows in 1975 (see for example *Time* magazine, January 31, 1977, p. 55). Research now suggests that the glass of the twelfth-century blues are of a different chemical composition than the other colors, one higher in soda. This sugests that they were not made in western Europe. As an import blue glass certainly would have been more expensive.

58. The Jesse at Chartres, generally considered a copy of Suger's Jesse window, is 40 percent blue: "La Restauration des vitraux anciens," *Revue de l'art* 31, (1976): 7.

59. Grodecki has emphasized that Suger's windows are the earliest remaining from the Ile-de-France (*Art de France* 1961, p. 19). A tantalizing description of the tenth-century Saint-Martin of Tours mentions wall paintings and blue windows, "*vitreiis sapphiro*": "*Sermo de combustione basilicae beati Martini*," attributed to Odo of Cluny, *Bibliotheca Cluniacensis* (Paris: R. Foüet, 1614 (facsimile edition, edited by Martin Marrier, Brussels: G. van Oest, 1915), col. 145. Carl K. Hersey, "The Church of Saint-Martin at Tours (903–1150)," *Art Bulletin* 25 (1943): 20f. I am indebted to Dr. Linda Papanicolaou, who told me of the existence of this sermon.

60. Samuel Y. Edgerton, Jr., "Alberti's Colour Theory: A Medieval Bottle without Renaissance Wine," *Journal of the Warburg and Courtauld Institutes* 32 (1969): 116–18 and n. 17. I would like to thank Professor Helen Zakin for this reference, which is a superb overview of medieval color theory.

61. Panofsky, *Suger*, p. 20. Panofsky is here quoting Erigena's commentary on Dionysius and provides the citations in "Notes on a Controversial Passage in Suger's *De Consecratione Ecclesiae Sancti Dionysii*," *Gazette des Beaux-Arts* 6th series 26 (1944): 111–12.

62. See, for example, Henri-Charles Puech, "La ténèbre mystique chez le Pseudo-Denys l'Aréopagite et dans la tradition patristique," *Etudes Carmelitaines* 23, pt. 2 (1938): 33–53; Otto Semmelroth, S.J., "Gottes ausstrahlendes Licht, zur Schöpfungs- und Offenbarungslehre des Ps.-Dionysius Areopagita," *Scholastik* 28 (1953): 481–503. For a discussion of Dionysius as part of a general tradition, see Rudolf Bultmann, "Zur Geschichte der Lichtsymbolik im Altertum," *Philologus* 97, no. 1 (1948): 1–36, esp. p. 35. I am grateful to Elisabeth Melczer for the German references. For others see John Gage, "Colour in History: Relative and Absolute," *Art History* 1, no. 1 (1978): n. 42, 43. Professor Frederick Hartt has pointed out to me the awareness of Dionysius' negative theology in Henry Vaughan (1622–95), *Silex Scintillans, The Night*, final stanza: "There is in God (some say)/ A deep, but dazzling darkness." This is confirmed by E. C. Pettet, *Of Paradise and Light, A Study of Vaughan's "Silex Scintillans"* (Cambridge: At the University Press, 1960), p. 152 and n. 1.

63. Panofsky, *Suger*, p. 19. For an unsuccessful attempt, based on Panofsky, to find a relationship between Dionysius' "metaphysics of darkness" and medieval art—specifically the stained glass of Chartres Cathedral—see Laurence Joseph James, "The Spread of the Effect of the Aesthetics of Dionysius the Areopagite," Ph.D. dissertation, Ohio State University, 1976. While I have not examined the dissertation itself, the abstract states that, working from Panofsky's writing and searching the literature on the cathedral and on the School of Chartres, it was impossible to establish "an intentional expression of the metaphysics of darkness via the color ensemble [of the Chartres windows]." *Dissertation Abstracts International A*, v. 37 no. 11 (1977), pp. 6812-A/6813-A. I would like to thank Professor Helen Zakin for bringing this abstract to my attention. The author was looking for his evidence in the theology of the School of Chartres—for which see von Simson, *The Gothic Cathedral*, ch. 2—whereas I believe that it is to be found in the Dionysian theology of Suger's Paris, specifically the victorines. See my n. 68 below.

64. A. B. Sharpe, *Mysticism: Its True Nature and Value, with a Translation of the "Mystical Theology" of Dionysius, and of the Letters to Caius and Dorotheus (1, 2 and 5)* (London: Sands and Co., 1910) pp. 213–14. I have used this translation because it is smoother than most.

65. Letter V. Sharpe, *Mysticism*, p. 228.

66. Patrik Reuterswärd, "What Color is Divine Light?" (*Light*, ed. Hess and Ashberry), *Art News Annual* 35 (1969): 122, notes that the Greek church used blue particularly for the Transfiguration. Kurt Badt, *The Art of Cezanne*, translated by Sheila A. Ogilvie (London: Faber and Faber, 1965), pp. 63–64, pinpoints the elevation of blue to a symbol of divinity to the end of the sixth century, without being able to give a satisfactory reason. See

also n. 67 below, and Chapter 1 of this volume by Prof. William Loerke.

 67. I owe much to the rich and provocative study by John Gage, "Colour in History: Relative and Absolute," *Art History* 1 no. 1 (1978): 104–30. Gage traces the use of blue in Greek Transfigurations to the apse of St. Catherine's Mount Sinai (dated after 548), and probably to the lost image of the Holy Apostles, Constantinople (pp. 110–12). He suggests a relationship between St. Catherine's and the Pseudo-Dionysius, whose writings first appear c. 520. For color plates of St. Catherine's apse, see G. H. Forsyth and K. Weitzmann, *The Monastery of St. Catherine at Mount Sinai, The Church and Fortress of Justinian* (Ann Arbor: University of Michigan Press, 1965), plates vol., pls. CIII, CIV, CXXIIA. A readily accessible color plate of the apse mosaic of San Vitale, Ravenna, is in *Gardner's Art through the Ages*, revised by H. de la Croix and R. Tansey, 7th ed. (New York: Harcourt Brace Jovanovich, 1980), p. 238. I have not been able to locate a color reproduction of the mosaics of the arch, which include a medallion of Christ at the keystone.

 68. The unknown in my equation remains Saint-Victor in Paris, a nest of Dionysian theology no doubt well-known to Suger; see the important observations of von Simson, *The Gothic Cathedral*, p. 105, 120–21, 131; and Grover A. Zinn, "Suger, Theology, and the Pseudo-Dionysian Tradition", to appear in the Proceedings of *Abbot Suger and Saint-Denis: An International Symposium* (New York, April 10–12, 1981).

 For an introduction to victorine thought, see Etienne Gilson, *History of Christian Philosophy in the Middle Ages* (New York: Random House, 1955), pp. 169–71, and the bibliography in notes pp. 633–35; an introduction to victorine esthetics can be found in Wladyslaw Tatarkiewicz, *History of Aesthetics II: Medieval Aesthetics* (The Hague, Paris: Mouton, 1970), pp. 190–203. The proof that victorine thought lies behind Suger's windows—the missing link—is of course the stained glass of Saint-Victor, a church contemporary with Suger's Saint-Denis. Snows of yesteryear: the abbey, largely rebuilt from 1518 on, was totally demolished 1811–13. We have the word of E. H. Langlois, writing in 1832, that twelfth-century stained glass still existed there at the Revolution. It was no doubt in the original choir, which was retained by the sixteenth-century architect as a crypt chapel, significantly dedicated to Saint Denis; Thiéry in 1788 described the glass of this chapel as *"ornés de peintures charmantes."* On Saint-Victor see Jacques Hillairet, *Dictionnaire historique des rues de Paris*, vol. 1 (Paris: Les Editions de Minuit, 1963), p. 695–96; E. H. Langlois, *Essai historique et descriptif sur la peinture sur verre* ... (Rouen: E. Frère, 1832), p. 155; the descriptions of Piganiol (1742) and Thiéry (1788) are most recently available in Paul and Marie-Louise Biver, *Abbayes, monastères, et couvents de Paris, des origines à la fin du XVIIIᵉ siècle* (Paris: Editions d'histoire et d'art, 1970), pp. 154–55. I would like to thank Margot Fassler for the last reference.

 69. Grodecki's fundamental study establishing that Gothic glass gets darker as the window openings are enlarged, until ca. 1240–50, is completely accepted by scholars. Louis Grodecki, "Le Vitrail et l'architecture au XIIᵉ et au XIIIᵉ siècle," *Gazette des Beaux-Arts* 6th series 36 (1949): 5–24.

 70. Paris, Bibliothèque nationale MS grec 437. My work relies heavily on the important study of H. F. Dondaine, O.P., *Le Corpus dionysien de l'université de Paris au XIIIᵉ siècle* (Rome: Edizioni di Storia e Letteratura, 1953). On MS grec 437 see his summary and notes, pp. 23–25. The text of the manuscript, which the ambassadors of Michel le Bègue presented to Louis the Debonaire, is published as the first (Greek) text line in: *Dionysiaca*, edited by Dom Philippe Chevallier, 2 vols. (Paris-Bruges, Desclée, de Brouwer & co., 1937 and 1949).

 71. Dondaine, *Le Corpus dionysien*, p. 25–26. The Hilduin translation was rediscovered in 1925 and edited in fundamental studies by Gabriel Théry, O.P., *Etudes diony-*

siennes, I: Hilduin, traducteur de Denys (Paris: J. Vrin, 1932). *Etudes dionysiennes, II: Hilduin, traducteur de Denys. Edition de sa traduction* (Paris: J. Vrin, 1937). This manuscript, Paris Bibl. nat. latin 15645, is published as line H in *Dionysiaca.*

72. The Hilduin manuscript was not copied and apparently not studied; Dondaine, *Le Corpus dionysien,* p. 26, n. 11; p. 111, and n. 108. But see Théry, *Etudes dionysiennes,* I pp. 141, 143f., and 166 n.l.

73. Dondaine *Le Corpus dionysien,* pp. 27–28, 35. Erigena's translation is line E in *Dionysiaca,* based on a text of 1556. Over a hundred manuscripts remain. The vast differences between the Hilduin and Erigena translations are summarized by Théry, *Etudes dionysiennes,* II: 420–21 and Edgar de Bruyne, *Etudes d'esthétique médiévale,* v. I (1946; reprint Geneva: Slatkine Reprints, 1975) pp. 358–60. Hilduin stresses moral terms *(benignum, bonum)* where Erigena introduces an esthetic cast *(pulchrum).*

74. The importance of Erigena's commentaries to Suger is stressed by Panofsky, "Notes," *Gazette des Beaux-arts* 1944, pp. 111–13. Hugh of Saint-Victor wrote his own commentary on the *Celestial Hierarchy,* based on the Erigena translation and commentary. He did not know enough Greek to make his own translation: Gabriel Théry, O.P., "Jean Sarrazin, 'traducteur' de Scot Erigène," *Studia mediaevalia in honorem admodum Reverendi Patris Raymundi Josephi Martin ...* (Bruges: De Tempel, 1948) pp. 365, 377–81. Hugh no doubt would have been able to address the Hilduin translation, but there is no evidence that he did so. Dondaine, *Le Corpus dionysien,* limits Hugh's sources to Erigena (pp. 29, n. 18; 46; 47, n. 34; 64, etc.).

75. Celestial Hierarchy ch. 15; Chevallier, *Dionysiaca* II: 1028; Maurice de Gandillac, ed., *Denys l'Aréopagite, La Hiérarchie Céleste* (Paris: Editions du Cerf, 1958) pp. 186–87 and notes.

76. Eleanor Irwin, *Colour Terms in Greek Poetry* (Toronto: Hakkert, 1974), pp. 28–30, 109–10.

77. Chevallier, *Dionysiaca* II: 1028: *"niger"* is used in the translations of Erigena, John Sarrazin, Grosseteste.

78. Chevallier, *Dionysiaca* II: 1028: *"caeruleus."* Interestingly this term was again picked up in sixteenth- and seventeenth-century translations.

79. On Arabic philosophy and particularly the influence of Alhazen's science of light see: Edgar de Bruyne, *The Esthetics of the Middle Ages* (New York: Ungar, 1969), pp. 18, 56; Tatarkiewicz, *History of Aesthetics,* p. 263–67.

80. On Sarrazin, who should be distinguished from the thirteenth-century chronicler of the same name, see: Dondaine, *Le Corpus dionysien,* pp. 28–30; Martin Grabmann, *Mittelalterliches Geistesleben* v. I (Munich: 1926) pp. 454–60. The Sarrazin translation is line S of *Dionysiaca.*

81. Sarrazin, probably an Englishman, worked from the Erigena translation, as well as from a corrected Greek text in cursive script. See, among Théry's many studies; "Recherches pour une édition grecque historique du Pseudo-Denys," in *Studia mediaevalia,* and his *The New Scholasticism* III (1929): 416–25. *Histoire littéraire de la France,* 38 volumes (Paris: Imprimeries nationales, 1733–1944) 14: 192, embalms a tradition that Guillaume de Gap, fellow monk and later abbot of Saint-Denis, had been sent by Suger's successor, Abbot Odo, to Constantinople to obtain these Greek manuscripts.

82. For example, Albertus Magnus, Aquinas, Bonaventure. Ananda K. Coomaraswamy, "Medieval Aesthetic I. Dionysius the Pseudo-Areopagite, and Ulrich Engelberti of Strassburg," *Art Bulletin* 17 (1935): 37–47; Tatarkiewicz, *History of Aesthetics,* pp. 214, 240–57 passim; Panofsky, *Gazette des Beaux-arts* 1944, pp. 111–13. The differences between Sarrazin's graceful translation and the ninth-century ones which preceded it has

been summed up by de Bruyne, *Etudes d'esthétique médiévale* I: "Il saute aux yeux qu'entre la traduction d'Hilduin et celle de Sarrasin il y a un monde" (p. 359); "On peut se demander ce que les maîtres du XIIIᵉ siècle auraient fait, si au lieu de disposer de Sarrasin, ils n'avaient possedé que le texte d'Hilduin ... " (p. 360). For additional comparative selections see: Théry's *Etudes Dionysiennes* I and "Sarrazin 'traducteur,'" and of course Chevallier, *Dionysiaca*.

83. My paragraph is a précis of the great study of Dondaine on the development and changing makeup of the Dionysian corpus. See particularly his conclusion, *Le Corpus dionysien*, pp. 122–28.

84. The most important accretion was the paraphrase of 1238 by the victorine Thomas Gallus, Abbot of Vercelli; Dondaine, *Le corpus dionysien*, passim, p. 31 provides Théry's many references; Grabmann, *Mittelalterliches Geistesleben* pp. 460–61. See for example a handsome manuscript of Dionysius' *Celestial Hierarchy* from the abbey of Saint-Denis c. 1240–50 (now Lambeth Palace MS 382). It is set up in three parallel columns: VETUS (Erigena), NOVA (Sarrazin), EXTRAC (Thomas Gallus). Robert Branner, *Manuscript Painting in Paris during the Reign of Saint Louis* (Berkeley: University of California Press, 1977) pp. 89, 226; Montague Rhodes James, *A Descriptive Catalogue of the Manuscripts in the Library of Lambeth Palace: The Medieval Manuscripts* (Cambridge, England: Cambridge University Press, 1932) pp. 526–69.

85. The "*âge d'or de l'érigénisme*" was the second half of the twelfth century: see Chenu article cited in n. 88 below. The first storm on the horizon was the condemnation in 1210 of the erigenist teaching of Amaury de Bène, professor at Paris. Erigena's "pantheism" had been condemned even in his own lifetime: Gilson, *History of Christian Philosophy* pp. 609–13. I would like to thank Father Robert Ayers for advice on this issue.

86. Gilson, *History of Christian Philosophy*, pp. 240–41, points up the Cathar danger, quoting the Cistercian Alberic of Trois-Fontaines; see also Carl Joseph Hefele, *Histoire des conciles*, ed. Leclercq, v. V pt. 2 (1913; reprint Hildesheim: Georg Olms Verlag, 1975), p. 1443. I would like to thank Professor James Powell for help and bibliography.

87. Pietro Pressutti, *Regesta Honorii Papae III*, v. 2 (Rome: ex typographia Vaticana, 1895) #5278; Hefele, *Histoire* p. 1443; Gilson, *History of Christian Philosophy*, p. 613, 773.

88. See the impressive study by Marie-Dominique Chenu, O.P., which is the basis of much of my argument here: "Le dernier avatar de la théologie orientale en Occident au XIIIᵉ siècle," *Mélanges Auguste Pelzer* (Louvain: Bibliothèque de l'Université, Bureaux de "Recueil", 1947) pp. 159–81. On the dates, see in the same volume (pp. 183–93) the study of Victorin Doucet, O.F.M., "La date des condamnations parisiennes dites de 1241. Faut-il corriger le Cartulaire de l'Université?" Dondaine, *Le Corpus dionysien*, traces the stigma increasingly attached to Erigena's name, and would push the shift back from 1241 to 1225. See his important note 43, p. 84. He in fact establishes a chronology for the development of the Dionysian corpus by the increasing circumspection with which references to Erigena were veiled, that is, ascribed to "Commentator" or to Maximus ("Pseudo-Maximus"): pp. 12–13; 70; 89, n. 67; 99; 118–19.

89. It is noteworthy that Gilson sees a new direction in Parisian light metaphysics from 1230 (*History of Christian Philosophy*, p. 260), and that de Bruyne already notes statements connecting the amount of light with the amount of beauty in the work of William of Auvergne, bishop of Paris (d. 1249) (de Bruyne, *Esthetics of the Middle Ages*, p. 61). The *lux* of Bonaventure and the *color clarus et nitidus* of Aquinas (both d. 1274) clearly chart a new world, and when Ulrich of Strassburg (d. 1287) can remark in a passage on Dionysius that "The less light each form has ... the more ugly it is, and the more light ... the more beautiful it is," we have arrived in the rayonnant Gothic era. For quotes see Tatarkiewicz, *History of*

Aesthetics, pp. 237, 244, 252, 261. See n. 90 below for Grodecki's date of 1240 for the first changes in glass.

90. Grodecki, *Gazette des Beaux-arts* 1949, pp. 18, 20.

91. Meredith Lillich, "The Band Window: A Theory of Origin and Development," *Gesta* 9, no. 1 (1970): 26–33.

92. Lafond, ""Normandie" pp. 356–57; and "The Stained Glass of Lincoln Cathedral," *The Archaeological Journal* 103 (1946): 153. See also Grodecki, "Stained Glass Windows of St. Germain-des-Prés," *Connoisseur* 160 (Aug. 1957): 33.

93. Jean-Jacques Gruber, "Quelques aspects de l'art et de la technique du vitrail en France (Dernier tiers du XIIIᵉ siècle, premier tiers du XIVᵉ)," in: *Travaux des étudiants du Groups d'Histoire de l'art* (Paris: Institut d'Art et d'archeologie de l'Université de Paris, 1927–28) esp. pp. 72,79.

94. Robert Branner, *St. Louis and the Court Style in Gothic Architecture* (London: A. Zwemmer, 1965), chs. 2 (1220s), 3 (1230s), 4 (1240s), 5 (mid-1250s–60s).

95. Branner, *St. Louis,* pp. 46–47 and his Appendix C, date the lost glazing of the choir and transept during a hiatus in architectural construction 1241–58; see also Sumner Crosby, *L'Abbaye royale de Saint-Denis* (Paris: P. Hartmann, 1953), pp. 58–60. Professor Caroline Bruzelius is now studying the thirteenth-century architecture of Saint-Denis.

96. Grodecki, *CVMA St-Denis,* pp. 39–43. Windows of the twelfth-century narthex were enlarged in the thirteenth century; Jules Formigé, *L'Abbaye royale de Saint-Denis* (Paris: Presses universitaires de France, 1960) pp. 73–74, 120. My notes indicate that the grisailles now in them—four windows with heraldic borders of France/Castille—would be perfectly dated to a campaign 1241–58 (see n. 95 above). These grisailles were in their present locations in 1844, and in my opinion it is more than likely that they had originated there. But see: Grodecki, pp. 31, 148.

97. Grodecki, *CVMA St-Denis,* p. 30, my translation. The relationship of Troyes to Saint-Denis goes the other way round, according to Branner; that is, the architect whom he calls "The St Denis Master" *began* his career in Burgundy/Champagne (*St. Louis,* ch. 3).

98. In addition to Lebeuf, whom Grodecki quotes (*CVMA St-Denis,* p. 30), Félibien also mentions that arms of France and Castille appear *"presque par tout dans le choeur & dans la croisée ... "* (Dom Michel Félibien, *Histoire de l'Abbaye royale de Saint-Denys-en-France* (1706; reprint Paris: Editions du Palais Royal, 1973), p. 227. On Parisian influence in the architecture of Tours see Branner, *St. Louis,* pp. 8, 37–39, 65–67; on Parisian relationships in the stained glass of Tours see Linda Papanicolaou, "Thirteenth Century Stained Glass from the Abbey Church of Saint-Julien at Tours and its Parisian Sources," *Gesta* 17, no. 1 (1978): 75–76. On the Parisian sources of Tours window types—grisailles, band windows, medallions—see my text at notes 112, 113 below.

99. As at Saint-Denis, Saint-Père retains the twelfth-century ambulatory and chapels at the east and an ancient tower-porch to the west. The architect of the rayonnant choir—a specialist in such church "remodeling" who also worked at Meaux, Evreux and Sens—has recently been identified as Gautier de Varinfroy. See Peter Kurmann and Dethard von Winterfeld, "Gautier de Varnifroy, ein 'Denkmalpfleger' im 13. Jahrhundert," *Festschrift für Otto von Simson zum 65. Geburtstag* (Berlin: Propyläen, 1977), pp. 101–59. On Saint-Père see: Lillich, *Stained Glass of Saint-Père,* pp. 6–8, p. 18 n. 6; ch. 2 (thirteenth-century choir construction and glass); also Paul Popesco, "Les Panneaux de vitrail du XIIᵉ siècle de l'église Saint-Pierre de Chartres, ancienne abbatiale," *Revue de l'art* 10 (1970): 47–56 (remnants of twelfth-century glazing of ambulatory chapels).

100. Félibien, *Saint-Denys-en-France* p. 529; see my Appendix C. After an examination of many descriptions of Gothic glass by seventeenth- and eighteenth-century authors,

it is my conviction that the terms *épais et peint* were used *only* to designate grisaille, which they assumed to be painted with a white/gray wash. See Lebeuf in Appendix A. Note that the terms *épais & peint* are also used in 1724 to describe the grisailles of the 1239 refectory of St.-German-des-Prés (which like Saint-Denis included arms of Castille) by Jacques Bouillart: see Appendix B. (On the St-Germain refectory see: Grodecki, *Connoisseur* 1957 p. 34; Branner, *St. Louis*, p. 68.) On the *'épais'* grisailles of Notre-Dame cathedral, see n. 103 below.

101. There is thus a difference between reports of the early 1600s and of the 1700s; see my introductory remarks to the Appendices. For the nickname "The Lantern" see Doublet (1625) and Millet (1636) texts in Appendix C. Millet uses the word *luysantes* (bright, shining, brilliant) to describe the clerestories, but *not* the roses (which were totally colored) or Suger's chevet windows.

102. Note that Pierre Le Vieil's discussion of colored glass of the thirteenth century specifies in the case of Saint-Denis, 'la *plupart* des vitres.' Appendix C.

103. This darkened condition—which sometimes makes the grisaille look rusty or brownish before it becomes totally opaque—is described occasionally by Lebeuf (*Histoire de la ville*, 1754): "des vitrages d'un blanc foncé [dark] du XIII siècle" (IV: 622); "une espèce de vitrage blanc chargé ou bronzé tel qu'on l'employait dans[13th] siècle ... " (5: 134). A painting by Petrus Christus of 1452 (Berlin, The Annunciation) shows a few darkened lozenges among those glazing the window above the angel's head, at a date when such lozenges could not have been more than a century and a half old at the most. On the removal of grisailles from Saint-Père in the baroque era, see Lillich, *Stained Glass of Saint-Père* p. 13, 41 n.11. Le Vieil removed grisailles from Notre Dame cathedral in the mid-eighteenth century, which he describes as "d'un verre fort épais, recouvert d'une grossiere grisaille dont les lacis au simple trait étoient rehausses de jaune." (Pierre Le Vieil, *L'Art de la peinture*, pp. 25, 27) The *jaune* was silver-strain, indicating that these grisailles dated after the introduction of the technique at the beginning of the fourteenth century; his term *une grossiere grisaille* refers to the second meaning of "grisaille," namely, the glassmaker's paint. On the two meanings of 'grisaille' see Lillich, *Band Window*, p. 30 n. 2.

104. For example Coutances, Vendôme, Sées; many blackened grisailles were replaced in nineteenth-century restorations. For example, see Lillich, "Three Essays on French Thirteenth Century Grisaille Glass," *Journal of Glass Studies* 15 (1973): 71, 77 (Bourges, St.-Urbain de Troyes). The light passed by eroded grisaille and by various Gothic blues has been measured in foot-candles on Weston and Metrastar light meters by Robert Sowers, "On the Blues in Chartres," *Art Bulletin* 48 (1966): 221:

	Weston	Metrastar
heavily eroded 15th-c. white	3.0	3.2
intense dark ultramarine	6.0	11.0
bleu de ciel	19.0	21.0

105. Grodecki, *CVMA St-Denis*, pp. 30, 154. Percier's drawing is Bibliothèque de Compiène, fol. 43.

106. As at Sées (Figure 9.16), St-Urbain de Troyes, Beauvais, Vendôme, Clermont-Ferrand.

107. Even the remarkable late seventeenth-century drawing of Saint-Père provides an approximation only (Lillich, *Stained Glass of Saint-Père* 1978 pl. 1). A drawing of the Sées band windows published as late as 1845 renders them very inaccurately: Leon de la Sicotière and Auguste Poulet-Malassis, *Le Département de l'Orne archéologique et pittoresque* (Laigle, J.-F. Beuzelin, 1845), after p. 8.

108. Among the sad stories is that of the north rose of Rouen cathedral; Lafond, "Normandie," p. 354.

109. The London panel is one of four showing Paris monuments or views; full references to previous studies are found in the article by William Hinkle, "The Iconography of the Four Panels by the Master of Saint Giles," *Journal of the Warburg and Courtauld Institutes* 28 (1965): 110–44. The accuracy of the views has been thoroughly discussed; there is an additional "negative" control on the accuracy of the panel showing Saint-Denis. By 1500 colored glass was out of style, and painters in the Flemish idiom avoided it. In another panel by the Master of St. Giles from the same retable (Washington D.C., National Gallery, the so-called Baptism of Clovis, which Hinkle has discussed), the interior of the Sainte-Chapelle is shown. The artist has avoided showing the heavily colored stained glass by giving a view out the door, only including the masonry up to the base of the windows. In his panel of Saint-Denis he did not have to duck the issue and includes the grisailles of the triforium and lower section of the clerestory in his view. He may have "rearranged" it, since the bays he painted are narrow hemicycle lights, the most likely location in the choir to have included some colored glazing (see text discussion below). If his view *is* accurate, the choir of Saint-Denis would most likely have resembled the choir of Sées. The accuracy which Flemish painters were capable of is demonstrated by the remarkable grisailles of the Master of Flémalle (Prado, Betrothal of the Virgin, ca. 1420): see the masterful study by Eva Frodl-Kraft, "Der Tempel von Jerusalem in der 'Vermählung Mariae' des Meisters von Flemalle," *Etudes d'art médiéval offertes à Louis Grodecki* (Paris: Editions Ophrys, 1981), pp. 293–316.

110. Lafond, "Normandie," pp. 320, 322.

111. There is a drawing by Percier, Bibl. Compiègne fol. 45. Millet (Appendix C) praises their color and "*matière*." On the significance of the term *matière* see n. 125 below.

112. On the date of the Tours triforium see Lillich, "The Triforium Windows of Tours," *Gesta* 19 (1980): 29–35.

113. Some, but not much, of the grisaille is old. H. Boissonnot, *Les Verrières de la cathédrale de Tours* (Paris: Imprimerie Frazier-Soye, 1932) p. 46. Linda Papanicolaou, "Stained Glass Windows of the Choir of the Cathedral of Tours," Ph.D. dissertation, New York University (1979), p. 31.

114. Formigé, *L'Abbaye royale* p. 120.

115. The description by Sauval (see Appendix B) of the St. Germain Lady Chapel is clear on this point, in spite of the argument of Philippe Verdier, "The Window of Saint Vincent from the Refectory of the Abbey of Saint-Germain-des-prés (1239–1244)," *Journal of the Walters Art Gallery* 25–26 (1962–63): 38–99.

116. Saint-Père retains much old grisaille, in terrible condition; see Lillich, *Stained Glass of Saint-Père*, pl. 43. The original glazing of the hemicycle triforium has been obliterated by later restorations. Both Sées and Vendôme retain only small amounts of old glass in their triforia, often in the small, irregularly shaped tracery lights where it is more difficult to remove. This is true at Dol as well.

117. For illustrations see Branner, *St. Louis*, plates 43, 44; pl. 47 shows the nave clerestory, where the design was streamlined in the later campaign under Abbot Mathieu de Vendôme, correcting this squat proportion.

118. Linas, Eglise Saint-Merry (Essonne, near Montlhéry). The grisaille is mentioned in: Grodecki, et al., *Les Vitraux de Paris, de la région parisienne ... (Corpus Vitrearum Medii Aevi, France, Recensement* I) (Paris: Editions du Centre National de la Recherche Scientifique, 1978), p. 82; Marcel Aubert, et al., *Vitrail français*, p. 168; Lafond, "Normandie," p. 357 n. 3; Baron Guilhermy (notes of 1838–50), Paris, Bibl. nat., nouv. acq. fr. 6114, v. XXI, fol. 70, 72; Abbé Lebeuf, *Histoire de la Ville*, IV: 119.

119. Seine-et-Marne. Branner, *St. Louis*, (pl. 9) provides an illustration and dates the architecture to the decade after 1225 (pp. 18–19, 34). The grisailles, now quite fragmentary, are mentioned in: *CVMA France Recensement* I, p. 89; Aubert, et al., *Vitrail français* p. 168; Baron Guilhermy, Paris, Bibl. nat., nouv. acq. fr. 6112, fol. 172.

120. Oise. See Branner, *St. Louis*, p. 17; *CVMA France Recensement* I, p. 212. Professor Michael Cothren would date this window c. 1245.

121. Virginia Raguin, "Thirteenth-Century Choir Glass of Auxerre Cathedral," Ph.D. dissertation, Yale University (1974) ascribes the grisaille/color combinations of the axial chapel and of the clerestory to the fifth atelier, dated 1235–45. Although this is not the forum for a lengthy discussion, it is my conviction that the windows I list in this sentence reflect the lost glazing of Notre-Dame cathedral, the glass inserted in the clerestory enlarged ca. 1225 (Branner, *St. Louis*, p. 16). We should take another look at Le Vieil's description of the cathedral's "grandes figures colossales, . . . leurs draperies de verre coloré *en blanc*" (p. 25). That Notre-Dame was filled with grisailles is amply apparent from his remarks on the clerestory rosaces of the south choir and the north and east choir chapels (p. 27); all the old documentation is reviewed by Lafond in *Les Vitraux de Notre-Dame et de la Sainte-Chapelle de Paris (Corpus Vitrearum Medii Aevi France* I) (Paris: Caisse Nationale des Monuments Historiques, 1959) pp. 14–19. Cited hereafter as CVMA-Notre Dame.

122. Sées Cathedral was an Augustinian community reformed by Saint-Victor in Paris. The choir ensemble of c. 1280 has grisaille in the triforium and band windows throughout the clerestory and the lower chapels. See: Jean Lafond, "Les Vitraux de la cathédrale de Sées," *Congrès archéologique*, 111th session (1953), pp. 59–83; Lillich, "A Stained Glass Apostle from Sées Cathedral (Normandy) in the Victoria and Albert Museum," *Burlington Magazine* 119 (1977): 498–99. On the Victorine reform of Sées, see: John C. Dickinson, *The Origins of the Austin Canons and their Introduction into England* (London: S.P.C.K., 1950), p. 29; Frank Barlow, The Letters *of Arnulf of Lisieux* (London: Offices of the Royal Historical Society, 1939), pp. xvii, xxxv, 55f.

123. Another abbey glazed in band windows at this time, La Trinité de Vendôme, also had close connections to Paris, specifically to the king's family—donors of their windows (see Figure 9.5)—and to Saint-Denis, whose abbot 1258–86 was Mathieu de Vendôme. Though Mathieu was no doubt born in Vendôme, nothing is known of his origins, education, or entry in religion (Félibien, *Saint-Denys-en-France*, p. 242). He served several kings as counselor and finished construction of the nave of Saint-Denis, and his influence is the likely impetus for the glazing of Vendôme. On Vendôme see: Lillich, "La Trinité at Vendôme", pp. 238–50.

124. The impact of monastic iconographic forms on those of cathedrals has also been mentioned in passing. On Suger's Jesse, and the influence of Saint-Denis on Chartres in general, see Grodecki, *Opuscula*, p. 182. Grodecki has also suggested that the *Signum Tau* panel from Saint-Denis may have been part of an ensemble which provided the prototype of the Nouvelle Alliance window at Bourges as well as at many other cathedrals: "Les Vitraux . . . ," *Art de France* 1 (1961): 41. The iconographic program of the Benedictine abbey of Saint-Remi in Reims is the suggested source of those of the Strasbourg nave (beginning thirteenth century) and of Reims Cathedral after 1230: Aubert, et al., *Vitrail français*, p. 108.

125. On the other hand Suger's windows are praised for their *"matière"* (sapphires) and the blue is mentioned by Doublet and Le Vieil. Grodecki, *CVMA St-Denis*, p. 36 n. 47; p. 38 n. 81. The window supposedly given by Suger to the cathedral is also noted for its blue by Le Vieil (Lafond in *CVMA Notre-Dame*, p. 15).

"By Gradual Scale Sublimed"
Dante's Benedict and Contemplative Ascent

Peter S. Hawkins

Dante's treatment of St. Benedict in the *Divine Comedy* illustrates the hold which monastic ideals continued to exert upon the popular imagination in the fourteenth century. The symbolic role of monasticism within late medieval society becomes clear both from Dante's lofty characterization of the Patriarch of Monks and from his harsh condemnation of Benedict's "sons," the monks of the poet's own day, for failing to fulfill the obligations of their way of life. Peter Hawkins also makes clear the extent to which a lay public was assumed to be conversant with the ideology and practices of the cloister.

> Peter S. Hawkins is a member of the faculty of the Yale Divinity School.

> So from the root
> Springs lighter the green stalk, from thence the leaves
> More airy, last the bright consummate flower
> Spirits odorous breathes: flowers and their fruit
> Man's nourishment, by gradual scale sublimed.
>
> —*Paradise Lost* 5

In a poem where almost nothing seems to have been left to chance, it is surely remarkable that from beginning to end Dante's *Paradiso* unfolds within the context of monasticism. At the outset the first of the blessed whom the pilgrim meets is Piccarda Donati (cantos 3–4), whose breaking of her cloistral vow under family pressure

255

does not prevent her from initiating Dante into the rule of the heavenly kingdom: *"E'n la sua voluntade è nostra pace"* (3: 85),[1] in His will is our peace. At the conclusion of the journey he joins up with St. Bernard (cantos 31–33), whose great abbey at Clairvaux was at best but a shadowy preface of the divine community which the saint now enables Dante to enter and, through his intercession to the Virgin, to worship among. Despite the earthly differences between failed nun and illustrious abbot, both of these monastic personages share with the pilgrim the great legacy of organized religious life and the fulfillment of its gift to the larger Church on earth: they teach him to know God. It should come as no surprise, therefore, that two cantos of this final portion of the *Commedia* are specifically devoted to exploring the fruits of the contemplative life, or that at the heart of this exploration the pilgrim should come upon the founder of Western monasticism himself, St. Benedict of Nursia.

In canto 22 of the *Paradiso*, Dante meets St. Benedict within the sphere of Saturn, the seventh heaven of the Ptolomeic universe, where those of the blessed who practiced monastic contemplation in their lifetimes share with him a measure of their far greater vision. To be sure, these spirits do not live out their beatitude within the dimensions of time and space; they appear in a specific place only as an extraordinary condescension to the pilgrim's mortality, a condescension *"per far segno/ della celestial"* (Par. 4: 38–39)—as a sign of the heavenly reality which lies entirely beyond signification. The different "identity" of each sphere is significant, however, for from the beginning of the *Paradiso* it is precisely through these fictive or metaphorical appearances that we begin to understand the different ways and degrees by which the blessed "feel more and less the divine breath" (*"sentir più e men l'etterno spiro,"* Par. 4: 36). Thus, those who in cantos 21 and 22 momentarily take their place "in" Saturn have prepared for their eternal experience of God in the Empyrean by following the influence of the "cold planet" while still on earth—an influence which led them not to melancholia, but to contemplation, that is (to quote the Postillatore Cassinese), "by giving themselves to the contemplative life in hermitage and in religious solitude ... living in silence and in chastity."[2] Dante's high esteem for this, the vocation of Rachel, is suggested not only by the inevitable association of Saturn with a paradisiacal Golden Age, but by its celestial position above the six lower spheres and the versions of the active life which they have been shown to represent in the preceding cantos.

In his valuation of the contemplative life over the active, Dante is, of course, at one with the medieval predilection. It is underscored, moreover, by a striking disruption of the poem's narrative procedure. From the

first canto of *Paradiso* onward, the pilgrim has moved from one planetary sphere to another, from one power of vision to another which sees yet deeper into the heart of things. He makes these transitions by looking into the face of Beatrice, finding her eyes or smile even more beautiful than he has seen them before. In that discovery he finds himself translated, as it were, *a claritate in claritatem*, from glory to glory (2 Cor. 3:18), into new light and sound.[3] At the entrance to the sphere of Saturn in canto 21, however, this pattern is suddenly broken: Beatrice does not smile and the *"dolce sinfonia di paradiso"* (Par. 21:59) is silent. What this absence betokens is a presence so full that were Dante actually to be shown its "face" in Beatrice's smile, he would become, she says, like Semele when she beheld Jove in his divinity and was immediately thereby turned to ash (verses 4–12). The degree to which the contemplatives know God is, therefore, not only magnitudes beyond the capacity of the blessed encountered in the spheres below, it is also a reality which the pilgrim can learn to experience for himself only gradually. To this end Beatrice urges him in a marvellous image to make mirrors of his eyes and in the act of "speculation" to practice the discipline of the contemplative life (vv. 16–18).[4] What he comes to reflect, and hence to reflect upon, is the central image of Saturn:

> di color d'oro in che raggio traluce
> vid'io uno scaleo eretto in suso
> tanto, che nol seguiva a mia luce.
> Vidi anche per li gradi scender giuso
> tanti splendor, ch'io pensai ch'ogne lume
> che par nel ciel, quindi fosse diffuso.
> E come, per lo natural costume,
> le pole insieme, al cominciar del giorno,
> si movono a scaldar le fredde piume;
> poi altre vanno via sanza ritorno,
> altre rivolgon sé onde son mosse,
> e altre roteando fan soggiorno;
> tal modo parve me che quivi fosse
> in quello sfavillar che 'nsieme venne,
> sì come in certo grado si percosse.
>
> (Par. 21:28–42)

I saw, of the color of gold on which a sunbeam is shining, a ladder rising up so high that my sight might not follow it. I saw, moreover, so many splendors descending along the steps, that I thought every light which appears in heaven had been poured down from it. And, as by their

natural custom, the daws move about together, at the beginning of the day, to warm their cold feathers, then some fly away not to return, some wheel round to whence they had started, while others wheeling make a stay; such movements, it seemed to me, were in that sparkling, which came in a throng, as soon as it smote upon a certain step.

The golden *scaleo* which we find here is an ancient and venerable one. It originates in Jacob's spectacular dream at Bethel of God standing at the top of the ladder and angels ascending and descending below Him.[5] Elsewhere in Scripture what Jacob finds at the apex is Wisdom, who "showed him the kingdom of God and gave to him knowledge of the holy ones" (Wisdom 10:10).[6] For this reason it is no surprise that Boethius' Lady Philosophy should be adorned with the same emblem, showing as it does the *"gradus ab inferiore ad superius"* which Wisdom prompts us to climb.[7] Nor is Dante's appropriation of the image for the sphere of Saturn in any way unusual. The ladder's association with the contemplative life is a medieval commonplace and one which all the poet's contemporary commentators had no trouble recognizing, even to the point of seeing in the varied flight of the daws an allegory of the contemplative's existence.[8] Nonetheless, if a specific gloss is required, the most likely one is offered by St. Benedict himself in the seventh chapter of the *Rule*, where the Abbot tells his monks that the true road to heavenly exaltation—what Beatrice speaks of at the opening of canto 21 as *"le scale/ de l'etterno palazzo"* (vv. 7–8)—is none other than a life of humility.

> Wherefore brethren … then must we set up a ladder by our ascending actions like unto that which Jacob saw in his vision, whereon angels appeared to him, descending and ascending. By that descent and ascent we must surely understand nothing else than this, that we descend by self-exaltation and ascend by humility. And the ladder erected is our work in this world, which for the humble heart is raised up by the Lord unto heaven.[9]

The blessed who appear to the pilgrim as "so many splendors descending along the steps" (vv. 31–32) have already been, to quote St. Benedict, "lifted up by the Lord to heaven." Their descent here, however, is no less an act of humility for being accomplished in glory; it is, in fact, an interruption of their beatific vision, offered on behalf of one who cannot yet see that "Supreme Essence," *"la somma essenza"* (v. 87), who is the end of all heavenly contemplation. It is a reaching down to the pilgrim in order that he, with them, might ascend.

The first of the spirits to "condescend" is not St. Benedict but rather a Benedictine who followed him by some six centuries: St. Peter Damian, a member of the Camaldolese monastery of Fonte Avellana (an extremely austere community reformed by St. Romualdus early in the eleventh century, which included within the framework of the *Rule* the eremitical life which Benedict himself esteemed, but which he nonetheless rejected). It is interesting to note that in his short work, *Dominus vobiscum*, Peter Damian praises the hermit's life as a Jacob's ladder and "golden way" *("via aurea")*, by which men travel back to their true home in heaven.[10] His prominent inclusion in the sphere of Saturn, however, has less to do with any gloss he may provide on the central image of these cantos than it does with what Dante would have best known and valued him for: the extreme rigor of his vocation and the vehemence of his anger against all those, no matter now highly placed, who abused the sanctity and responsibility of their office. Dante first presents him as one who is "content in thoughts contemplative"—*"contento ne' pensier contemplativi"* (v. 117)—a phrase which suggests by its syntax and alliteration the full enclosure of the monastic life. And yet it is precisely this soul, given over to worship and the "spiritual harvest" of the cloister, who is compelled by the present degeneracy of the Church to break the silence of this heaven, even as he was thus compelled to speak out while on earth:

> Venne Cefàs e venne il gran vasello
> de lo Spirito Santo, magri e scalzi,
> prendendo il cibo da qualunque ostello.
> Or voglion quinci e quindi chi rincalzi
> li moderni pastori e chi li meni,
> tanto son gravi, e chi di rietro li alzi.
> Cuopron d'i manti loro i palafreni,
> sì che due bestie van sott' una pelle:
> oh pazienza che tanto sostieni!
>
> (Par. 21:127–35)

Cephas came, and the great vessel of the Holy Spirit came, lean and barefoot, taking their food at whatsoever inn. Now the modern pastors require one to prop them up on this side and one on that, and one to lead them, so heavy are they, and one to hold up their train behind. They cover their palfreys with their mantles, so that two beasts go under one hide. O patience that do endure so much!

This invective shatters the silence of the sphere with what the poet identifies as "a cry of such deep sound that nothing here could be likened

to it" (*"un grido di sì alto suono,/ che non potrebbe qui assomigliarsi,"* vv. 140–41). The pilgrim is utterly overwhelmed at the end of canto 21, a condition in which he remains through the opening of canto 22, even as Beatrice interprets the *"alto suono"* as a righteous call for what she refers to darkly as *"la vendetta"*: an unspecified act of divine vengeance. It is against this tumultuous background that Beatrice turns the pilgrim's attention to the "hundred little spheres of light" (vv. 28–29) on the ladder, and in particular to the one which shines most brightly. The pilgrim "was standing as one who within himself represses the urge of desire, who does not make bold to ask, he so fears to go too far" (vv. 25–27). The situation recalls the sixth chapter of the *Rule*, *"De taciturnitate,"* where Benedict says that "it becomes the master to speak and teach, but it is fitting for the disciple to be silent and to listen"[11]—an association which might seem merely fanciful except for the fact that the *magister* who breaks through Dante's reserve is none other than the author of the *Rule!* What this most splendid of the contemplative fires then goes on to do is answer the question which the pilgrim hesitated to ask: the question of the spirit's individual, historical identity.

> Quel monte a cui Cassino è ne la costa
> fu frequentato già in su la cima
> da la gente ingannata e mal disposta;
> e quel son io che sù vi portai prima

> lo nome di colui che 'n terra addusse
> la verità che tanto ci soblima;
> e tanta grazia sopra me relusse,
> ch'io ritrassi le ville circunstanti
> da l'empio cólto che 'l mondo sedusse.
> Questi altri fuochi tutti contemplanti
> uomini fuoro, accesi di quel caldo
> che fa nascere i fiori e ' frutti santi.
> Qui è Maccario, qui è Romoaldo,
> qui son li frati miei che dentro ai chiostri
> fermar li piedi e tennero il cor saldo.

(Par. 22: 37–51)

That mountain on whose slope Cassino lies was of old frequented on its summit by the folk deceived and perverse, and I am he that bore up there His name who brought to earth that truth which so uplifts us; and such

grace shone upon me that I drew away the surrounding towns from the impious worship that seduced the world. These other fires were all contemplative men, kindled by that warmth which gives birth to holy flowers and fruits. Here is Macarius, here is Romualdus, here are my brethren who stayed their feet within the cloisters and kept a steadfast heart.

The biographical details in this passage come from Gregory's second *Dialogue:* Benedict's foundation of a community on the summit of Monte Cassino, his supplanting of local paganism, his gradual winning over the hearts of the country people round about.[12] The speech also ends with a characteristic invocation of the *votum stabilitatis* in the mention of the brothers who "stayed their feet within the cloisters." But what is perhaps more interesting and more subtle is Dante's incorporation of images and metaphors from the earlier canto, the effect of which is to generate a common lexicon for the sphere of Saturn. We notice this first of all in the submerged figure of the ladder: Benedict speaks of himself as the one who first brought *up* to Monte Cassino the name of Him who brought *down* to earth the truth that so *uplifts* us" (vv. 40–42). There is also the continued play on the opposition of cold and hot. The sphere of Saturn, the "cold planet," with its presumably icy austerities, is nonetheless populated with souls described as fires "kindled by that warmth which gives birth to holy flowers and fruits" *"accessi di quel caldo/ che fa nascere i fiori e 'frutti santi,"* vv. 47–48)—a complex of imagery that recalls Peter Damian's assertion in canto 21 that the cloister's heats and frosts yield a spiritual harvest *"fertilemente"* (v. 119).

It is precisely the "ardor" (v. 54) of Benedict's self-disclosure that causes Dante to expand in confidence "as the sun does the rose when it opens to its fullest bloom" (vv. 56–57)—or, to translate more literally than Singleton, "Thus I dilated my confidence as the sun does the rose when, fully open, it gives over whatever power it has." This extraordinary simile can be seen to grow imagistically from the "warmth that gives birth to holy flowers and fruits" cited just a few lines before. Its point, however, is to prepare us for what follows: not the pilgrim's wordless desire to know who Benedict *was*—the unspoken question that launched their dialogue—but the clear request to know *who he is now.* "May I behold you, not veiled by light, but directly": *"ch'io/ ti veggia con imagine scoverta"* (vv. 59–60).

This request to see one of the blessed, as Benvenuto da Imola puts it, *in pura essentia* ("in pure being"),[13] is unique in the whole of the *Paradiso*—an anomaly that all but forces us to ask why the sphere of Saturn should be its occasion or St. Benedict the one singled out. The

answer lies, I think, in Dante's understanding of the contemplative life as a formal, regularized preparation for nothing less than the beatific vision: for the sight of God *facie ad faciem*, face to face. Thus far in the *Commedia*—indeed, from the time of the *Vita nuova*—Dante's yearning for such vision has been focused on Beatrice and mediated in terms of her. It is in her unveiled face that he first sees the "splendor of the living light eternal" (*Purgatorio* 31: 139) and through her, as we have said, that he is enabled to rise through the heavens to the Empyrean. She represents in this regard the Lady transfigured, revealing how *eros* can be redeemed—can become, in fact, a means of ascent to God. On the other hand Benedict, the father of Western monasticism, would seem to represent a radically different route to the same destination, one in which *eros*, rather than becoming transcendent, is transcended altogether. And yet, in the pilgrim's longing to see Benedict *"con imagine scoverta,"* even as he has longed thus to see Beatrice unveiled, do we not find a juxtaposition of the two ways—the affirmation and the negation of a beloved one—a juxtaposition which may suggest the ultimate convergence of both? In any event, Francesco da Buti's 14th century commentary on this moment in the canto is especially apt: "[The] contemplatives ponder the high things of God, contemplating the creature and thereby ascending to contemplate the Creator; and because the human soul is made in God's likeness, therefore the contemplatives have the desire to see the essence of the human soul more than that of any other created thing. Thus the poet has it that such thoughts come to him in this place."[14] One thinks as well of St. Augustine's conjecture at the close of the *City of God* that the blessed will see God *facie ad faciem* precisely by looking into the faces of one another.[15]

When Benedict turns in answer to the pilgrim, it is to acknowledge both the profundity of what he has asked and its impossibility at this turning of the stair.

> Ond' elli: "Frate, il tuo alto disio
> s'adempierà in su l'ultima spera,
> ove s'adempion tutti li altri e 'l mio.
> Ivi è perfetta, matura e intera
> ciascuna disïanza; in quella sola
> è ogne parte là ove sempr' era,
> perché non è in loco e non s'impola;
> e nostra scala infino ad essa varca,
> onde così dal viso ti s'invola.
> Infin là sù la vide li patriarca
> Iacobbe porger la superna parte,
> quando li apparve d'angeli sì carca."
>
> (Par. 22: 61–72)

Whereon he, "Brother, your high desire shall be fulfilled up in the last sphere, where are fulfilled all others and my own. There every desire is perfect, mature, and whole. In that alone is every part there where it always was, for it is not in space, nor has it poles; and our ladder reaches up to it, wherefore it steals itself from your sight. All the way thither the patriarch Jacob saw it stretch its upper part, when it appeared to him so laden with Angels."

The reply is straightforward enough. Saturn, the mediation of all heavenly metaphors, the ladder of vision itself—all these must be transcended before Dante is able to see Benedict's *imagine scoverta*. It is a sight reserved for those who are in the presence of God, in the last and ineffable sphere—*l'Emperio*—whose name is hidden here within the verbs of fulfillment: *"s'adempierà"* (v. 62), *"s'adempion"* (v. 63). It is there, in fact, that canto 32:35 will show Benedict to us, seated in that cloister of which Christ Himself is the Abbot (*Purgatorio* 26:129), having assumed his glorified body and his "place" between St. Francis and St. Augustine. While the language of the passage encourages us to imagine the vision of the Empyrean primarily as something to climb up toward, it also presents the satisfaction of the "high desire" as something to grow into. Thus Benedict speaks here of a completion, or ripening, of a growth process—*"perfetta, matura, e intera"*—and for this reason we may begin to understand that fulfillment for which the imagery of cantos 21–22 has been a kind of promise. For what are the flowers born in the monastery and full-blown in Dante's desire to see but intimations of that eternal rose into whose "odor of praise," offered up to the sun, Beatrice leads him in canto 30? Likewise, how else can we finally understand the pilgrim's request to see the *imagine scoverta* of Benedict but as the shadowy forecast of the sight to which he will wholly give himself at the very end of the poem: the three circles of the Blessed Trinity and there, incarnate at their center, *"la nostra effige,"* (Par. 33: 131), our human image?

It is not, however, with the top of the stairway, nor with the fruition of "high desire," that Benedict leaves us. Rather, he shifts abruptly from the supernal heights of Jacob's ladder, "laden with angels," to the earthly neglect of even its bottommost rung.

> Ma, per salirla, mo nessun diparte
> da terra i piedi, e la regola mia
> rimasa è per danno de le carte.
> Le mura che solieno esser badia
> fatte sono spelonche, e le cocolle
> sacca son piene di farina ria.

Ma grave usura tanto non si tolle
 contra 'l piacer di Dio, quanto quel frutto
 che fa il cor de'monaci sì folle;
ché quantunque la Chiesa guarda, tutto
 è de la gente che per Dio dimanda;
 non di parenti né d'altro più brutto.
La carne d'i mortali è tanto blanda,
 che giù non basta buon cominciamento
 dal nascer de la quercia al far la ghianda.
Pier cominciò sanz' oro e sanz' argento,
 e io con orazione e con digiuno,
 e Francesco umilmente il suo convento;
e se guardi 'l principio di ciascuno,
 poscia riguardi là dov' è trascorso,
 tu vederai del bianco fatto bruno.
Veramente Iordan vòlto retrorso
 più fu, e 'l mar fuggir, quando Dio volse,
mirabile a veder che qui 'l soccorso.'

 (Par. 22: 73–96)

But no one now lifts his foot from earth to ascend it, and my Rule
remains for waste of paper. The walls, which used to be an abbey, have
become dens, and the cowls are sacks full of rotten meal. But heavy usury
is not exacted so counter to God's pleasure as that fruit which makes the
hearts of monks so mad; for whatsoever the Church has in keeping is for
the folk that ask it in God's name, not for kindred, or for other filthier
thing. The flesh of mortals is so soft that on earth a good beginning does
not last from the springing of the oak to the bearing of the acorn. Peter
began his fellowship without gold or silver, and I mine with prayer and
fasting, and Francis his with humility; and if you look at the beginning of
each, and then look again whither it has strayed, you will see the white
changed to dark. Nevertheless, Jordan driven back, and the sea fleeing
when God willed, were sights more wondrous than the succor here.

 Benedict's final words bring us back to the *vendetta* with which
this canto opened—the call for a miracle of Biblical proportions, a *soc-
corso* that will destroy, deliver, and cleanse. Yet there is more here that is
familiar than the repetition of a prophecy. There is the basic structure of
the speech itself: the contrast between then and now, between apostolate
and apostasy. It is a contrast we have seen most immediately in canto 21,
in Peter Damian's bitter comparison of St. Peter and St. Paul with *"li
moderni pastori"* (v. 131). But it is also writ large in the sphere of the Sun,
where praise for Francis and Dominic changes suddenly into denunciation

of those who presently bear their names. Its most dramatic instance, moreover, is still to come in canto 27, where the rapturous joy of the blessed turns to bitter mourning, as St. Peter cries out against the pollution of his office by the current pope, Boniface VIII.

> Quelli ch'usurpa in terra il luogo mio,
> il luogo mio, il luogo mio che vaca
> ne la presenza del Figliuol di Dio,
> fatt' ha del cimitero mio cloaca
> del sangue e de la puzza; onde 'l perverso
> che cadde di qua sù, là giù si placa.'

<div align="right">(Par. 27: 22–27)</div>

> He that usurps on earth my place, my place, my place, which in the sight of the Son of God is empty, has made of my tomb a sewer of blood and filth, so that the apostate who fell from here above takes comfort there below.'

What is noteworthy in Benedict's particular appropriation of this recurring rhetorical form is his use of exactly those images employed earlier in the canto to evoke the glory of the contemplative life. Once again the most obvious of these is the ladder, now become functionless from sheer disuse. More pervasive, however, is that cluster of metaphors suggesting growth and maturation. Here we are told that the spiritual "granary" of the abbey has become the den of thieves; the harvest has spoiled and the fruit of monastic life become a mad lust for money or power "*ne d'altro più brutto*" (v. 84), "or for other filthier thing." Before our eyes Benedict transforms the full-blown hope of contemplation from a white rose, opened to the sun, to one which has already darkened with corruption: "*del bianco fatto bruno*" (v. 93).

Nonetheless, despite the anger of these lines and the very dim view of the visible Church which they express, Benedict's parting word is not one of negation or despair; rather, it is one of hope, of *soccorso*. Once having left the pilgrim with that, he is able to leave him (and the sphere of Saturn) altogether. "Thus he spoke, then drew back to his company, and the company closed together; then like a whirlwind all were gathered upwards" (vv. 97–99). The word which Singleton twice translates here as "company"—*collegio*—can refer to any group bound together by a common function or identity. But Dante's use of it earlier in the *Commedia* has a more specific and monastic connotation. In *Inferno* 23, for instance, the pilgrim is welcomed by one of the Jovial Friars of the sixth *bolgia* "*al*

collegio/ de l'ipocriti tristi" (vv. 91–92), "to the assembly of the sad hypo-
crites." Then in *Purgatorio* 26, Guido Guinizelli will speak of paradise
itself as *"[il] chiostro/ nel quale è Cristo abate del collegio"* (vv. 128–29), "the
cloister in which Christ is abbot of the brotherhood." From all that we
have learned in the sphere of Saturn, both of these eternal dimensions of
collegio—the infernal and the heavenly—are possibilities afforded by the
monastic life on earth. But it is here, in the gathering of the contemplatives
around Benedict and in their whirlwind ascension of the ladder, that we
are reminded of the true nature and destiny of the vocation—what the
Prologue to the *Rule* describes as an "expanded heart" *("dilatato corde"),*
one which "runs with the unspeakable sweetness of love in the way of
God's commandments" *("via mandatorum Dei"),* "so that, by never aban-
doning his rule, but persevering in his teaching in the monastery until
death ... we may deserve to be partakers of his kingdom."[16]

It is into the heart of that kingdom—to the Empyrean which is,
so to speak, at the "top" of the ladder—that Benedict vanishes from
Dante's sight. All that remains, therefore, is the ladder itself. The situation
in which the pilgrim finds himself recalls most immediately that of the
prophet Elisha, who watches Elijah ascend to heaven in a whirlwind, *"per
turbinem in caelum"* (2 Kings 2: 11; cf. *"come turbo,"* v. 99).[17] But this
prophetic reference, with its provocative suggestion of a prophetic identity
for the pilgrim, may not be the only text that Dante would have us bring to
our reading. There is as well an incident which Gregory describes at the
end of his second *Dialogue:*

> [The day Benedict died] two monks, one of them at the monastery, the
> other some distance away received the very same revelation. They both
> saw a magnificent road covered with rich carpeting and glittering with
> thousands of lights. From this monastery it stretched eastward in a
> straight line until it reached up into heaven. And there in the brightness
> stood a man of majestic appearance, who asked them, "Do you know
> who passed this way?" "No," they replied. "This," he told them, "is the
> road taken by blessed Benedict, the Lord's beloved, when he went to
> heaven."[18]

In canto 22 the "majestic one" who appears in brightness at the
departure of Benedict is, of course, none other than Beatrice, she whom
the poet addresses here, without any sense of incongruity, as *"la dolce
donna"* (v. 100), "my sweet lady." Nor does this novice mistress waste any
words, but rather,

> mi spinse
> con un sol cenno su per quella scala,
> sì sua virtù la mia natura vinse;
> né mai qua giù dove si monta e cala
> naturalmente, fu sì ratto moto
> ch' agguagliar si potesse a la mia ala.
> S'io torni mai, lettore, a quel divoto
> triunfo per lo quale io piango spesso
> le mie peccata e 'l petto mi percuoto,

(Par. 22: 100–108)

with only a sign she thrust me up after them by that ladder, so did her power overcome my nature; nor ever here below, where we mount and descend by nature's law, was motion so swift as might match my flight. So may I return, reader, to that devout triumph for the sake of which I often bewail my sins and beat my breast.

Thus the episode ends. The pilgrim follows rapidly in the wake of the contemplatives, not yet to the Empyrean itself, but to the next rung of the celestial ladder, to the heaven of the fixed stars. It is from that vantage point that he will look down through the spheres and see our world, a small paltry thing. Thus Gregory says Benedict saw it, gathered into a single ray of light.[19] What is ultimately most poignant in the closure of the episode, however, is the poet's address to the reader, the effect of which is to place Benedict's ladder and all that it represents outside the sphere of the fiction; to place it, that is, in the world in which the *lettore* reads this poem—the world in which we live. "So may I return, reader, to the devout triumph for the sake of which I often bewail my sins and beat my breast." The poet's words, of course, are explicitly about himself, about his hope to return after death to the reality of which this poem can be but the dark glass of a similitude. But as we have known from the very first line of *Inferno*—"*Nel mezzo del cammin di nostra vita*"—the fiction of his experience is an invitation for us to discover the truth of our own. Or, to put it in the vocabulary of *Paradiso*, 21–22, Dante has given the reader a ladder to climb, a ladder whose canto-by-canto intention is, to quote his letter to Can Grande, "to remove those living in a state of misery, and to bring them to a state of happiness;"[20] to bring them, that is, from the frozen sign of Satan to the ineffable vision of Father, Son, and Holy Spirit. For what is the poem in the end but a rule that blossoms with observance?

NOTES

 1. All citations of the *Commedia* are from the Charles S. Singleton text and translation, Bollingen Series 80 (Princeton: Princeton University Press, 1970–75). For an excellent discussion of Benedict's place in Dante's thought and works, see "Benedetto, santo," *Enciclopedia Dantesca* (Roma: Istituto della Enciclopedia Italiana, 1970), which also includes a concise bibliography. I have also consulted the standard contemporary commentaries of Hermann Gmelin, André Pézard, Natalino Sapegno, John D. Sinclair, and Charles Singleton, as well as the studies of *Par.* 21 and 22 by Marco Pecoraro and Giorgio Varanini respectively, in *Lectura Dantis Scaligera* (Firenze: Felice Le Monnier, 1968).

 2. "Sub infusione Saturni due species hominum cadunt; una quarum grossa est et inculta: puta illorum qui grosse, nigre et inculte capillature sunt dicentes, vestes spernentes; alia est qui in heremis et in solitudine religiose ad contemplativam vitam se dant, monastice et hermitice abominantes omnia singularia, ac in silentio et castitate viventes ... " *Il codice cassinese della "Divina Commedia" per la prima volta letteralmente messo a stampa per cura dei monaci benedettini della Badia di Monte Cassino* (Tipographia di Monte Cassino, 1865), p. 493. Cited by Pecoraro, *Lectura Dantis Scaligera*, pp. 737–38.

 3. The first and most extensive of these transitions is found in *Par.* 1: 64–99.

 4. Ficca di retro a li occhi tuoi la mente,

 e fa di quelli specchi a la figura

 che 'n questo specchio ti sarà parvente.

 (Par. 21: 16–18)

 Fix your mind after your eyes, and make of them mirrors

 to the figure which in this mirror shall be shown to you.

 5. "Viditque in somnis scalam stantem super terram, et cacumen illius tangens caelum: angelos quoque Dei ascendentes et descendentes per eam, et Dominum innixum scalae." Genesis 28: 12–13. All citations of the Vulgate are from Biblia Sacra (Milwaukee: Bruce, 1955); the English text is the Revised Standard Version.

 6. "Haec profugum irae fratris iustum deduxit per vias rectas, Et ostendit illi regnum Dei, Et dedit illi scientiam sanctorum." Sapientia 10:10.

 7. *De Consolatio Philosophiae*, I Prosa Prima. *PL.* 63, 588 89.

 8. Benvenuto da Imola, *Commentum super Dantis Aligherii Comoediam* (Firenze: Barbera, 1887), 5: 278, says that the poet figures the contemplatives as birds because they flee from evil and soar above the flesh ("quia omnes animae separatae ubique figurantur in avibus volantibus propter earum levitatem et velocitatem; et inter caeteras animas animae contemplativorum sunt veloces, leves et expeditae, non gravatae a carne, non impeditae ab occupaminibus mundi"). He describes them as daws *(pole)* in particular, "quia polae amant solitudinem, similiter et contemplativi." Francesco da Buti, *Commento di Francesco da Buti sopra la Divina Commedia di Dante Alighieri*, edited by Crescentino Giannini (Pisa: Nistri, 1862), 3: 590, interprets the simile as an allegory of different contemplative vocations, some constant and lifelong, others going into active life only later to return to the first calling. ("E questa fizione non à fatto l'autore senza cagione; ma sotto senso allegorico dimostra come a la fantasia sua si rappresentarno alquanti beati spiriti che sempre erano stati contemplativi, e questi che sono quelli che ritornorno unde erano venuti: imperò tali beati animi sempre da Dio tornano a Dio, alquanti vanno altro'; e questi sono quelli che lasciato ànno la contemplazione e sono iti di rieto a le virtù attive poi, et altri sono che roteano e girano quine; e questi sono quelli che, usciti de la contemplazione, girano per certi atti virtuosi; ma pur ritornano a la contemplazione.")

 9. "Unde fratres ... actibus nostris ascendentibus scala illa erigenda est quae in

somnio Jacob apparuit, per quam ei descendentes et ascendentes angeli monstrabantur. Non aliud sine dubio descensus ille et ascensus a nobis intelligitur, nisi exaltatione descendere et humilitate ascendere. Scala vero ipsa erecta nostra est vita in saeculo, quae humilitato corde a Domino erigatur ad caelum." Latin text and English translation of *The Rule of Saint Benedict*, prepared by Abbot Justin McCann (Westminster, Maryland: Newman Press, 1952), pp. 38–39.

10. "Tu scala illa Jacob, quae homines vehis ad coelum, et angelos ad humanum deponis auxilium. Tu via aurea, quae homines reducis ad patriam." Migne, *PL.*, 145: 248, cited by Pecoraro, *Lectura Dantis Scaligera*, p. 742.

11. "Nam loqui et docere magistrum condecet: tacere et audire discipulum convenit." *The Rule*, pp. 36–37.

12. *Vita S. Benedicti, ex libro II Dialogorum S. Gregorii Magni excerpta*, ch. 8. Migne, *PL.*, 66: 152.

13. Benevenuto da Imola, *Commentum*, p. 299.

14. "[Li] contemplativi pensano tutte l'alte cose d'Iddio, contemplando la creatura s'inalzano a contemplare lo creatore: e perche l'anima umana e fatta a similitudine sua, pero anno desiderio li contemplativi di vedere l'essenzia dell'anima umana piu che di niuna altra cosa creata; e pero finse l'autore che tale pensieri li venisse in questo luogo." Francesco da Buti, *Commento ... sopra la Divina Commedia*, p. 611.

15. "Ita Deus nobis erit notus atque conspicuus, ut videatur spiritu a singulis nobis in singulis nobis, videatur ab altero in altero, videatur in se ipso. ... " *The City of God Against the Pagans*, text and translation prepared by William M. Green (Cambridge: Harvard University Press, 1972), 7: 370.

16. "Processu vero conversationis et fidei, dilatato corde, inenarrabili dilectionis dulcedine curritur via mandatorum Dei; ut ab ipsius numquam magisterio discendentes, in ejus doctrina usque ad mortem in monasterio perseverantes, passionibus Christi per patientiam participemur, ut et regni ejus mereamur esse consortes." *The Rule*, pp. 12–13.

17. "Cumque pergerent, et incedentes sermocinarentur, ecce currus igneus, et equi ignei diviserunt utrumque: et ascendit Elias per turbinem in caelum." *Liber Regum Quartus* 2:11.

18. "Qua scilicet die duobus de eo fratribus, uni in cella commoranti, alteri autem longius posito, revelatio unius atque indissimilis visionis apparuit. Viderunt namque quia strata palliis atque innumeris corusca lampadibus via recto orientis tramite ab ejus cella in coelum usque tendebatur. Cui venerando habitu vir desuper clarus assistens, cujus esset via quam cernerent, inquisivit. Illi autem se nescire professi sunt. Quibus ipse ait: Haec est via qua dilectus Domino coelum Benedictus ascendit." Migne, *PL.*, 66:202. English translation by Odo John Zimmerman, *St. Gregory the Great, Dialogues*, Fathers of the Church 39 (New York: Fathers of the Church, 1959), p. 108.

19. "Mira autem res valde in hac speculatione secuta est: quia, sicut post ipse narravit, omnis etiam mundus velut sub uno solis radio collectus, ante oculos ejus adductus est." Migne, *PL.*, 66:198. Gregory then goes on to explain this phenomenon as an interior flooding of light which caused the exterior universe to be seen in miniature. "In illa ergo luce quae exterioribus oculis fulsit, lux interior in mente fuit, quae videntis animum cum ad superiora rapuit, ei quam angusta essent omnia inferiora monstravit." Migne, *PL.*, 66: 200. Cf Par. 22: 151 and Par. 27: 85–87.

20. "Sed omissa subtili investigatione, dicendum est breviter quod finis totius et partis est, removere viventes in hac vita de statu miseriae et perducere ad statum felicitatis." *Epistola* 10: 15, *Dantis Alagherii Epistolae*, text and translation prepared by Paget Toynbee, 2d ed. (Oxford: Clarendon Press, 1920; 1966), p. 178.

Some Monastic and Liturgical Allusions in an Early Work of Lorenzo Monaco

Marvin Eisenberg

This chapter treats a work by the Florentine "Lawrence Monk," an early-fifteenth-century Camaldolite monk who also had an active career as a painter. Professor Eisenberg interprets the iconography and style of a major altarpiece by the monk-artist on the basis of monastic liturgical practice. Moreover, dealing with a work commissioned by a lay donor for an urban monastery chapel that also served as a parish church, Eisenberg's short study makes a fitting transition to the next chapter of this collection, concerned precisely with the influence of monastic spirituality upon lay Christians.

Marvin Eisenberg is Professor of Art History at the University of Michigan, Ann Arbor.

A mong the signs of recovery from the onslaught of the Black Death in mid-fourteenth-century Florence was the flowering of the major urban house of the Camaldolese Order, Santa Maria degli Angeli. The original nucleus of the monastery, which had been built around 1300, was expanded in the third quarter of the Trecento into a grand complex of three cloisters, made even more impressive by the adjacent and dependent churches of Santa Maria Nuova and Sant'Egidio (Figure 11.1).[1] This Florentine hub of Camaldolese life became in the later fourteenth century one of the strongholds of the pietistic Observance Movement and at the same time a center of theological scholarship and the production of art in the service of liturgy. From the earliest years of Camaldolese history, scholarly and artistic traditions had

Figure 11.1 *Santa Maria degli Angeli and Saint Benedict*, Codex Rustichi, fol. 17ᵛ. Florence, Biblioteca del Seminario Maggiore del Cestello. *Gab. Fotografico, Soprintendenza Beni Artistici e Storici di Firenze.*

flourished within the Order, exemplified most notably by Gratian, the father of Canon Law, and by Guido of Arezzo, who helped formulate the modern system of musical notation and syllabic equivalents.[2]

The prosperous and conservative world of Santa Maria degli Angeli nurtured the most important monastic workshop of book and panel painters of the Florentine Trecento.[3] There still survives a rich inheritance of choir books wherein the monk-painters and secular assistants exercised the craft of illumination and miniature painting. The artistic ascendancy of the Camaldolese lasted well into the second quarter of the fifteenth century, at which time the Dominicans at San Marco came to the fore, with Fra Angelico as guiding genius. A generation earlier than Angelico, a comparable position as the principal Camaldolese painter of both manuscripts and panels was held by Don Lorenzo di Giovanni, more frequently called Lorenzo Monaco.

Don Lorenzo's life is recorded only meagerly, as is true of most early Italian artists, and his being a monk without civil ties further diminishes the biography. His birth date remains uncertain, and his death occurred either in 1423 or 1424.[4] Early in the 1390s, at some point in his mid-teens, he entered the monastery of the Angeli with the secular name of Piero di Giovanni. The passage from the novitiate to minor and major orders occurred between 1390 and 1392. In 1396 he was ordained deacon, apparently the highest clerical level he reached. It seemed certain that by the last years of the Trecento, Don Lorenzo had taken up residence outside the monastery, probably to allow the expansion of what had become a large and prolific shop of both monastic and secular assistants, all under his supervision. For the rest of his life the painter dwelled outside the walls of the monastery, but never abandoned his calling as a monk.[5]

In 1414, at the summit of his career, Lorenzo Monaco and a corps of assistants created the vast *Coronation of the Virgin* altarpiece, now in the Uffizi, but originally on the high altar of the church within the monastic precinct of the Angeli (Figure 11.2). His receiving this focal commission leaves no doubt that Don Lorenzo's ties with the monastery had not diminished. As if to confirm the bond, the inscription on the lower frame of the main panel records the collaboration of the master and his monk assistants, a testament to monastic humility and fraternalism.[6] Don Lorenzo reveals here a literal obedience to Chapter 57 of the *Rule* of Saint Benedict: "If there are craftsmen in the monastery, let them practise their crafts with all humility, provided the abbot give permission. But if one of them be puffed up because of his skill in his craft, supposing that he is conferring a benefit on the monastery, let him be removed from his work and not return to it, unless he have humbled himself and the abbot entrust it to him again."[7]

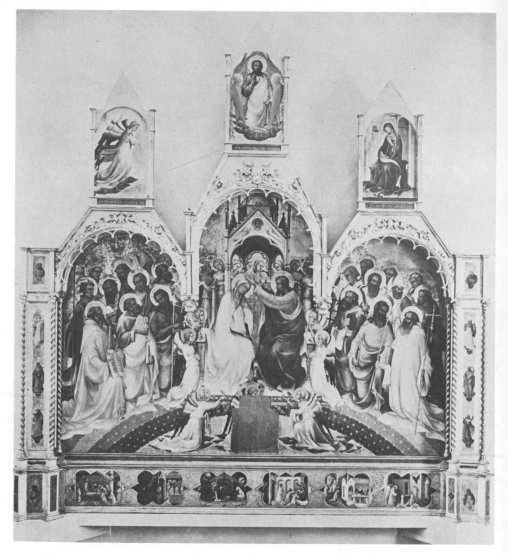

Figure 11.2. Lorenzo Monaco, *Coronation of the Virgin*. Florence, Galleria degli Uffizi. *Gab. Fotografico, Soprintendenza Beni Artistici e Storici di Firenze.*

As is the case with most of his works, Lorenzo Monaco rendered the *Coronation of the Virgin* in a traditional iconography. Camaldolese authority and patronage are immediately recognized in the white-clad Saint Benedict to the left and Saint Romuald to the right, bracketing the

choir of saints, and by the stories of Saint Benedict in four panels of the predella. The wreath of angels cordoning off the throne at the center of the main panel underscores the fact that the altarpiece was made for the monastery of the Angeli. While Lorenzo has been caught up in the rhythmic pulse of the International Style, the sobriety of his Florentine and monastic taste is conveyed by the absence of ornamentation, the eschewal of the embellished surface so beloved of his contemporaries working in the last decorative phase of Gothic complexity. The monastic allusion in the *Coronation* altarpiece could be stretched to the extent of proposing that the contrast between the panorama of the main panel and the intimacy of the scenes of the predella is a visual analogy to the cenobitic and hermitic existences of a monk. More to the point, however, is the role the *Coronation of the Virgin* played not only in the monastic community but also for a larger, public congregation which converged at Santa Maria degli Angeli. For the worshipper in a church which was both monastic and parochial, this vast image stood as a kind of pictorial witness to the link between a central mystery of Christianity and Benedictine history.

My emphasis in this brief essay will be on an early work by Lorenzo Monaco, executed nearly two decades before the *Coronation of the Virgin*, which I believe allows a more concrete demonstration of the painted image serving as visual parallel to an internal monastic world of liturgy and devotions. This is the *Agony in the Garden* (Figure 11.3), now in the Accademia in Florence, the only work other than the *Coronation* assuredly made by Don Lorenzo for Santa Maria degli Angeli.[8] He painted the *Agony in the Garden* and its accompanying predella somewhere between 1395 and 1400, just before establishing his independent shop. It is, in my view, the first major surviving work on panel from the painter's hand.[9]

In the main panel there unfolds the drama of Christ's Agony in Gethsemane, in the valley between Jerusalem and the Mount of Olives across the brook Cedron. An unidentifiable secular donor who kneels at the lower left of the scene seems to conjure up the image in his act of veneration and prayer. Long, sloping diagonals of severely stylized rock formations provide the caves of space which contain the principles in this tableau; in the upper left are the praying Christ and the approaching angel, and in the lower right the sleeping disciples, Peter, James, and John. The rhythms of drapery, still modest in contrast to the rich flux of line in Lorenzo's mature works, bind the disciples in their sleep and form a sympathetic response between the cloud-borne angel and the kneeling Christ. His cascading mantle is echoed by the rushing stream. The angel with the bitter cup, hovering at the summit of the panel, implies a source of light that reaches fullest intensity along the spine of the picture, a path

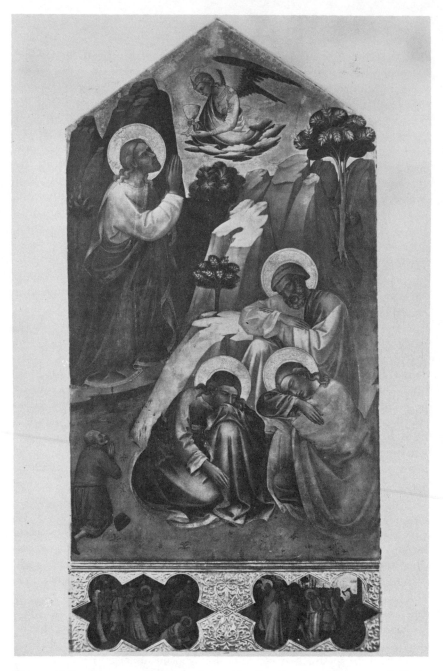

Figure 11.3. Lorenzo Monaco, *Agony in the Garden*. Florence, Galleria dell'Accademia. *Gab. Fotografico, Soprintendenza Beni Artistici e Storici di Firenze.*

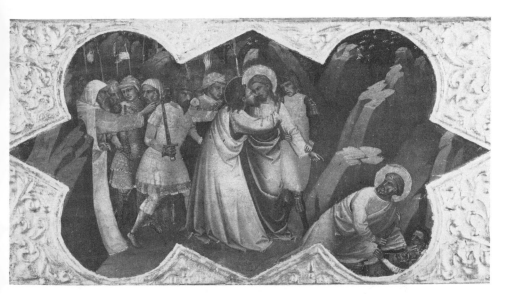

Figure 11.4. Lorenzo Monaco, *Betrayal of Christ* (detail of Figure 11.3)

leading down the rocky declivities to the triad of sleeping figures. Christ endures his travail in a darker, more private zone; his somber blue mantle and light rose tunic stand in dramatic contrast to the resonant chromaticism of the disciples' robes. Within that vivid game of interlocked silhouettes the important note of violet in James's tunic is the least familiar hue in the palette of later Trecento Florentine painting.

The effects of color and light of the *Agony* are extended with purposeful repetition and contrast into the two scenes of the predella. The *Betrayal of Christ* (Figure 11.4), in the left half, is enacted in a shadowy world mirroring Christ's darkling enclave above. Now Judas' mantle assumes the violet of James's tunic, while the golden yellow and vermilion of Peter's robes are repeated exactly from the main scene above. In contrast to the suggestion of night in the *Betrayal*, in the *Stripping of Christ* (Figure 11.5) daylight is implied by the open area of unadorned gold silhouetting Calvary and the staff of the cross. Christ's rose garment repeats the hue in the mantle of the sleeping Saint John immediately above this panel of the predella. At the farthest reach of the scene, framed by the lobe of the quatrefoil, the Virgin gazes upon her son, a tragic figure who foreshadows the intensely pathetic women in Lorenzo's later art.[10]

This impressive narrative icon, some seven feet in height, seems

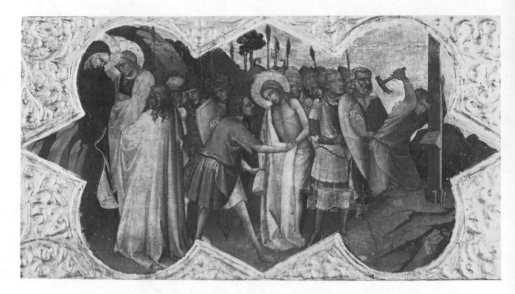

Figure 11.5. Lorenzo Monaco, *Stripping of Christ* (detail of Figure 11.3).

as much a work of mural as of panel painting. It is understandable that both Burckhardt and Ruskin considered the picture to be a work by Giotto, analogous to his frescoes.[11] The depiction of the *Agony in the Garden* as the main theme of an ensemble of panel pictures is unknown in early Italian art before this version by Lorenzo Monaco, whereas the subject had notable interpretations in narrative Passion cycles, particularly in fresco programs.[12] In his panel, Don Lorenzo reduced the drama to its iconic core: the active confrontation of Christ and the angel, and the passive cluster of three sleeping disciples.

 The use of a narrative scene, or of an image other than the madonna and child, as the main theme of an altarpiece was especially frequent among the works installed at Santa Maria degli Angeli in the later Trecento. For example, the *Presentation of Christ in the Temple with Saints John the Baptist and Benedict*, a work by Giovanni del Biondo of 1364, once stood on an altar at the monastery, as did the *Trinity with Saints Romuald and Andrew* (Figure 11.6), of 1365, from the circle of Nardo di Cione.[13] The Camaldolese had inherited the Benedictine predilection for ritualistic drama in the service of the liturgy. The stylistic modes that prevailed in these narrative altarpieces at Santa Maria degli Angeli were the closely linked ones of Orcagnesque and Cionesque painting, styles that had first

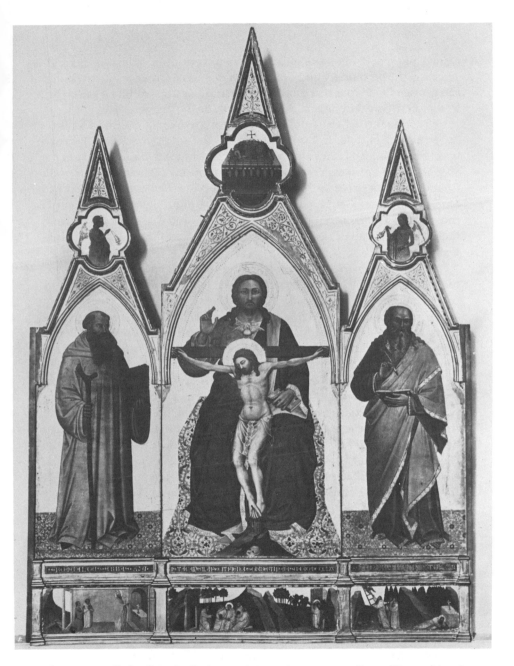

Figure 11.6. Circle of Nardo di Cione, *Trinity with Saints Benedict and Romuald and Scenes from the Life of Saint Benedict*. Florence, Galleria dell'Accademia. *Gab. Fotografico, Soprintendenza Beni Artistici e Storici di Firenze*.

gained favor with the Dominicans in the fervent atmosphere of the mid-Trecento.[14] The sobriety and didacticism of severe Orcagnesque style and the gentler Cionesque counterpart found another appropriate sponsorship in the pietistic environment of Santa Maria degli Angeli.

One further source of a distinctive ingredient of Lorenzo Monaco's art is worthy of note. In his use of light as an expressive device, Lorenzo was heir to Taddeo Gaddi's luminous effects, as in the *Annunciation to the Shepherds*, an episode in his fresco program of the 1330s in the Baroncelli Chapel at Santa Croce in Florence.[15] With less insistent contrasts, Lorenzo Monaco cast over Gethsemane the cloak of a night aglow with supernal radiance. The darkened rocks, the deeply shadowed masses of foliage, and the enclosed group of sleeping disciples compound the nocturnal character of the scene.

These generalities of mood along with evidence drawn from textual parallels suggest an approach to the *Agony in the Garden*, with its predella of the *Betrayal and Stripping of Christ*, as a graphic embodiment of the perpetually repeated prayers and liturgies which formed the core of monastic life—specifically, the Hours of Matins and Compline in the Divine Office and the liturgy of Maundy Thursday. For textual parallels the primary source is those verses of the Office in which a monk was steeped, in particular the Psalm texts which form the principal materials of the Canonical Hours and the Hours of the Virgin. As Dom Pierre Salmon has demonstrated in his comprehensive history of the breviary, a tradition in the choice of these texts for the Office prevailed since the early Middle Ages and was left undisturbed by the reforms of the Council of Trent.[16] In the *Rule*, Saint Benedict instructed: "At Compline let the Psalms be repeated every day," prescribing three as fitting meditations for this last division of the Day Office: Psalms 4, 90, and 133.[17] These three Psalms are replete with exhortations to the Lord for protection from one's adversaries and from the terrors of the night.

The first words of Psalm 133 strike the nocturnal chord immediately:

> Behold, bless ye the Lord, all ye servants of the Lord, which by night stand in the house of the Lord.

Psalm 4 evokes both trust in the Lord as the night approaches and the image of Jesus in the Agony, the Christ who grows in awareness of his tragic destiny:

> Hear me when I call, O God of my righteousness: thou hast enlarged me when I was in distress; have mercy upon me, and hear my prayer. ...

> But know that the Lord hath set apart him that is godly for himself: the Lord will hear when I call unto him.
>
> Stand in awe, and sin not: commune with your own heart upon your bed, and be still. ...
>
> I will both lay me down in peace, and sleep: for thou, Lord, only makest me dwell in safety.

And then, Psalm 90:

> He that dwelleth in the secret place of the most High shall abide under the shadow of the Almighty.
>
> I will say of the Lord, He is my refuge and my fortress: my God; in him will I trust.
>
> Surely he shall deliver thee from the snare of the fowler, and from the noisome pestilence.
>
> He shall cover thee with his feathers, and under his wings shalt thou trust. ...
>
> Thou shalt not be afraid for the terror by night; nor for the arrow that flieth by day;
>
> Nor for the pestilence that walketh in darkness; nor for the destruction that wasteth at noonday.

A Psalm so rich in contrasting temporal references lies at the very heart of the meaning of Compline, the last of the Day Hours, recited after night has fallen, then to be followed after a period of sleep by the Night Office of Matins, as another canonical cycle begins. In drawing these text and image analogies, I stop just short of suggesting that the angel's wings that crown Lorenzo Monaco's *Agony in the Garden* mirror verse 4 of Psalm 90: "He shall cover thee with his feathers, and under his wings shalt thou trust ... "

Thus far, the parallelism between Psalm texts used in the Divine Office and Lorenzo Monaco's *Agony in the Garden* has been in the realm of implied effect rather than specific reference. In order to define more concrete parallels between Psalm texts and images, I turn first to the Proper of Matins and closely associated Lauds for Maundy Thursday, parts of the Tenebrae of Holy Week. Two of the episodes depicted in Lorenzo's triad of Passion scenes—the *Agony* and the *Betrayal*—span the principal events of that day, transpiring between the Last Supper and the beginnings of the trial of Christ; for the episode of the *Stripping*, the drama shifts from the foot of the Mount of Olives to Calvary. Psalms 74, 75, and 50, the principal texts of the Proper of Matins and Lauds for Thursday of Passion Week, are rich in the imagery of the Agony and the Betrayal, the climactic events of Gethsemane. Psalm 74:8:

"For in the hand of the Lord there is a cup, and the wine is red; it is full of mixture; and he poureth out of the same: but the dregs thereof, all the wicked of the earth shall wring them out, and drink them."

Psalm 76, verses 1,2, and 6:

I cried unto God with my voice, even unto God with my voice; and he gave ear unto me.

In the day of my trouble I sought the Lord: my sore ran in the night, and ceased not: my soul refused to be comforted.

I call to remembrance my song in the night: I commune with mine own heart: and my spirit made diligent search.

The Ordinary of Matins, as well as the Proper of that Hour for Maundy Thursday, had traditionally been associated with the Betrayal, just as each of the Canonical Hours came to be identified with a specific moment in the Passion of Christ.[18] In Chapter 9 of the *Rule*, Saint Benedict prescribed for the opening text of Matins, Psalm 50, verse 15:

"O Lord, open thou my lips; and my mouth shall shew forth thy praise."

In illustrated French Books of Hours of the later fourteenth and fifteenth century, the richest body of imagery allied with breviary texts, either the scene of the Agony or of the Betrayal accompanies this verse from Psalm 50 recited as the opening of Matins: *Domine labia mea aperies, et os meum annuntiabit laudem tuam.* A miniature of the third quarter of the fourteenth century by the so-called Parement Master (Figure 11.7) reverses the emphasis given by Lorenzo Monaco in his three panels; now the Betrayal is the primary scene, and the Agony and the Payment of Judas are relegated to an initial and to the *bas-de-page*.[19] In that literally subservient position, they provide a kind of predella to the main image. Just as often, however, in French Books of Hours the Agony stands as the principal scene in relation to this same Matins text drawn from Psalm 50.[20]

The inclusion of the *Stripping of Christ* in the predella of the *Agony in the Garden* strengthens the bond between Lorenzo's sober icon and the liturgy of Passiontide (Figures 11.3 and 11.5). This episode of Christ's Passion was not frequently illustrated in medieval or later art, and there is no fixed iconography for rendering the event.[21] Lorenzo Monaco

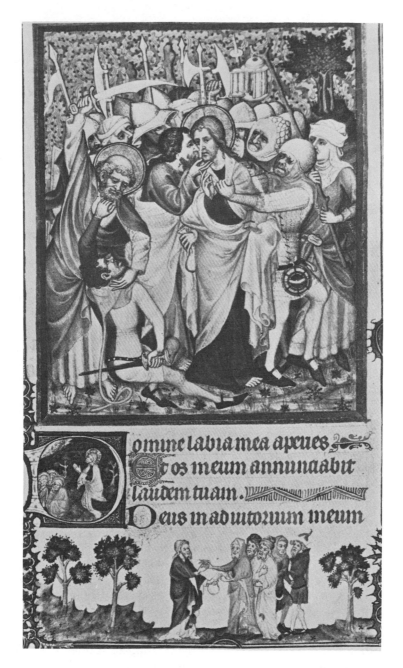

Figure 11.7. Parement Master and Workshop, *Betrayal of Christ; Agony in the Garden; Payment of Judas. Très Belles Heures de Notre-Dame.* Nouv. acq. lat. 3093, p. 181. *Bibliothèque nationale, Paris.*

adapted elements of the *Betrayal* for his depiction of the scene, with the tight knots of soldiers redistributed and Judas transformed into the executioner tearing the garment from Christ.[22] With so little tradition of representing this episode, why then was the Stripping of Christ included in Lorenzo's group of Passion episodes? Regardless of the fact the Stripping was prelude to the Crucifixion—the central event of Good Friday—here again I would propose a close alliance with the rites and liturgy of Maundy Thursday. Among the ancient rituals of that day, following the High Mass, is the Stripping of the Altars. Psalm 21 provides the litugical text, and while the rite is performed on Holy Thursday, the references of the text (Verses 1 and 18) are explicitly to the Crucifixion: "My God, my God, why hast thou forsaken me? ... They part my garments among them, and cast lots upon my vesture."

In lending such importance to the relatively uncommon theme of the Stripping of Christ, Lorenzo Monaco gave a visual concreteness not only to the liturgy of Maundy Thursday but also to the vivid description of the scene in the popular pseudo-Bonaventuran *Meditations on the Life of Christ*.[23] The inclusion of the sorrowing Virgin and Saint John, with the huddled presence of Mary's companions implied in a third linking halo, follows the text of the *Meditations*. And the trenchant detail of the executioner hammering the wedges to support the cross would seem to have a direct source in the "Meditation on the Passion at the Sixth Hour" where the reader, now led to Calvary, is told to envision "some thrusting the cross into the earth." The urgency with which the hammer-wielding figure performs his task captures the physical immediacy permeating the several "Meditations on the Passion."

One further detail of Lorenzo Monaco's *Agony in the Garden* allows another link to be forged between painted image and liturgical text. This is the stalking lion half hidden by a tree rising above the left shoulder of the sleeping Saint Peter (Figure 11.8). Both in the Ordinary of Compline and in the liturgy of the same Hour for Maundy Thursday, the short lesson is from the First Epistle of Peter (5: 8 and 9): "Brethren, be sober, be vigilant; because your adversary the devil, as a roaring lion, walketh about seeking whom he may devour: Whom resist steadfast in the faith." The proximity of the lion and the sleeping disciples in Lorenzo's panel provides an exact parallel to the rapid succession from the opening blessing of Compline to the warning lesson of Saint Peter.[24] That brief blessing precedes the Epistle: "May the Lord almighty grant us a quiet night and a perfect end." Sleep and death are identified, just as they lie at the emotive core in the sequential drama of Gethsemane. Thus, the hue of violet in the tunic of the sleeping Saint James was purposefully made so salient and

Figure 11.8. Detail of Figure 11.3.

central a chromatic note in Lorenzo Monaco's *Agony in the Garden* (Figure 11.3). Violet immemorially connotes suffering and sorrow and is the recurrent color of the vestments of Passion Week. Moreover, the drapery shrouding the hand of Saint James, as if it were the *capsula* veil protecting the consecrated Host, intensifies the reverential and sacramental aspects of the scene.

That this richness of liturgical allusion in Lorenzo Monaco's three episodes from the Passion is more than coincidental is further supported by the fact that this triad of scenes has never been conjoined as an independent entity in any other known work in the history of Christian art. This uniqueness in the alliance of subjects, the concentration on Christ's spiritual and physical isolation and the threat of his adversaries, and the close parallels in details of text and image, clearly convey conscious theological purpose. We do not know where Lorenzo's work would have been seen at Santa Maria degli Angeli, or whether it served as an altarpiece or simply as a devotional image to be approached, meditated upon and passed by the monks.[25] Whatever its location and function, this three-part cycle of Christ's Passion, with its layers of metaphor, stood as a constant reminder of Compline and the Night Office throughout the liturgical year, and most poignantly at Passiontide. Lorenzo Monaco's *Agony, Betrayal,* and *Stripping of Christ* arose out of the unflinching habits of liturgical recitation and the devotion which lay at the very heart of monastic life. His images of three aspects of Christ's Passion are a montage of monastic and liturgical allusion which for centuries lent visual resonance to thought, word, and chant at Santa Maria degli Angeli.

NOTES

1. For the history of Santa Maria degli Angeli and its artistic contents, see Walter and Elisabeth Paatz, *Die Kirchen von Florenz*, 6 vols. (Frankfurt a.M.: Klostermann, 1952–55) 3:107–47. The Codex Rustichi is partially published in Bernhard Degenhart and Annegrit Schmitt, *Corpus der italienischen Zeichnungen, 1300–1450*, 3 vols. (Berlin: Mann, 1968), Part I, vol. 2, no. 291, p. 376 and vol. 4, pls. 273 and 274.

2. For a succinct history and bibliography of the Camaldolese Order, see Bernardo Ignesti, "Benedettini Camaldolesi," in *Enciclopedia cattolica* II (Rome: Città del Vaticano, 1949), cols. 1246–48.

3. The artistic milieu of Santa Maria degli Angeli in the later Trecento is discussed in the following studies: Mirella Levi d'Ancona, "Don Silvestro dei Gherarducci e il Maestro delle Canzoni," *Rivista d'arte* 32 (1957): 3–37; Miklòs Boskovits, "Su Don Silvestro, Don Simone e la 'scuola degli Angeli,'" *Paragone* 265 (1972): 35–61; M. Boskovits, *Pittura fiorentina alla vigilia del Rinascimento* (Florence: Edam, 1975), pp. 111–16 and *passim*.

4. For evidence of the date of Lorenzo's death, see M. L. d'Ancona, "Some New Attributions to Lorenzo Monaco," *The Art Bulletin* 40 (1958): 175.

5. A document of 1391 from Santa Maria degli Angeli records: *partissi di ... di ... 13. ...* (Florence, Archivio di Stato, Conventi Sopressi 86, 85 [Registro Vecchio], f. 90v); the full text of the document is published in Osvald Sirén, *Don Lorenzo Monaco* (Strassburg: Heitz, 1905), p. 179, where the *13 ...* is omitted in the transcription of the document. Although the exact day, month, and year are omitted, this notice indicates that Lorenzo had left the monastery before 1400, which would mean at some time between February 26, 1396, when he was ordained deacon, and the end of 1399. Appended to the same document, in a different hand, are the words "*tornocci morto,*" but without the date recorded.

6. The text of the inscription is as follows: HEC TABULA FACTA EST PRO ANIMA ZENOBII CECCHI FRASCHE ET SUO IN RECOMPENSATIORE UNIUS ALTERI TABULE PER EUM IN HOC TEMPLO POSITA EST PER OPERAM LAURENTII JOHIS E SUO MONACI HUI ORDINIS QUI EAM DEPINXIT AN DNI MCCCCXIII MESE FEBR TPORE DONI MATHI PRIORIS H MONASTER.

7. The translation is from *The Rule of Saint Benedict,* edited and translated by Abbot Justin McCann (London: Burns and Oates, 1952), p. 129.

8. The *Agony in the Garden* was transferred from Santa Maria degli Angeli at the time of the suppression of monasteries in 1810, first to San Marco and then to the Accademia. By 1814 it was in the Uffizi, remaining there until 1919, when it was returned to the Accademia. Dimensions: Main panel, unframed, 108 cm. by 189 cm; Predella, each panel including the original quatrefoil frame, 50.5 cm. by 26.5 cm. The picture was cleaned and restored in 1957 by Messrs. Lo Vullo, Lumini, and Toschi for the Florentine Soprintendenza, at which time an overburdening nineteenth-century frame was removed.

9. This opinion is in contradiction to several attempts to attribute a number of heterogeneuus works to the early period of Lorenzo Monaco, that is, before 1400: Hans Gronau, "The Earliest Works of Lorenzo Monaco," *The Burlington Magazine* 92 (1950): 183–88 and 217–22; Federico Zeri, "Investigations into the Early Period of Lorenzo Monaco," *The Burlington Magazine* 106 (1964): 554–58 and 107 (1965): 4–11; Alvar González-Palacios, "Indagini su Lorenzo Monaco," *Paragone* 241 (1970): 27–36. An important early altarpiece for the Ardinghelli Chapel in the Carmine, Florence, documented from 1398 to 1400, is lost, perhaps destroyed in the fire of 1771 (for the documents, see Sirén, *Lorenzo Monaco,* p. 181).

10. For example, the Mourning Virgin in the cut-out *Crucifixion* group at San Giovannino dei Cavalieri, Florence (ca. 1415), and the cluster of mourning women in the *Three Maries at the Tomb,* one of the three pinnacles by Lorenzo Monaco (ca. 1420–22) above Fra Angelico's *Deposition from the Cross* in the Museo di San Marco, Florence. It is noteworthy that in the predella of the Accademia *Agony in the Garden* and in other works by Lorenzo Monaco and his contemporaries commissioned for monasteries or convents, the Virgin is depicted wearing a wimple: for example, Lorenzo Monaco, *Coronation of the Virgin* (London, National Gallery), for the Camaldolese monastery of San Benedetto outside Florence (see Martin Davies, *National Gallery Catalogues, The Earlier Italian Schools* [London: National Gallery, 1961], pp. 306–309); Agnolo Gaddi, *Coronation of the Virgin* (London, National Gallery), possibly from the Convent of the Minori Osservanti of San Miniato, Florence (see Davies, *Earlier Italian Schools,* pp. 208–209); and Spinello Aretino, Niccolò di Pietro Gerini, and Lorenzo di Niccolò, *Coronation of the Virgin,* dated 1401 (Florence, Accademia), from the Convent of Santa Felìcita, Florence (see Luisa Marucci, *Gallerie Nazionali di Firenze, I dipinti toscani del secolo XIV,* [Rome: Istituto poligrafico dello Stato, 1965], pp. 109–11). Millard Meiss noted the use of the wimple in works of Orcagna and his circle as a device lending an ascetic and monastic look (*Painting in Florence and Siena after the Black Death* [Princeton: Princeton University Press, 1951], p. 11).

11. Jacob Burckhardt, *Der Cicerone* (Basel: Schweighauser'sche Verlaghandlung, 1855), p. 154; John Ruskin, *Mornings in Florence* (Orphington, Kent: G. Allen, 1875), p. 60. Ruskin's mention was first noted by Gronau in "Earliest Works of Lorenzo Monaco," p. 185. In an afterthought, Ruskin suggested that the work, then in the Uffizi, was possibly by Lorenzo Monaco (p. 204).

12. Most notably, the *Agony in the Garden* by the mid-fourteenth-century Sienese Barna, part of his cycle of frescoes in the Collegiata, San Gimignano; see Bernard Berenson, *Italian Pictures of the Renaissance, Central and North Italian Schools*, II (London: Phaidon, 1968), figs. 333–35. For a list of further Italian examples from the eleventh through the fourteenth centuries, see Raimond van Marle, *Development of the Italian Schools of Painting*, 19 vols. (The Hague: N. Nijhoff, 1923–38) 6:41–42.

13. Both the *Presentation* and *Trinity* altarpieces were transferred to the Accademia from Santa Maria degli Angeli in 1810, at the time of the suppression of monasteries and convents; see Marcucci, *I dipinti toscani*, pp. 75 and 117, figs. 43–43b and 78–78c. In addition to these two altarpieces, at least two others with narrative central panels, works of the later Trecento and early Quattrocento, were on altars at Santa Maria degli Angeli: Niccolò di Pietro Gerini, *The Baptism of Christ with Saints Peter and Paul* (National Gallery, London) (see Davies, *Earlier Italian Schools*, p. 388); a master close to Andrea di Giusto and Paolo Schiavo, *Ascension of Christ with Saints Lawrence, John the Baptist, Benedict, and Romuald* (Accademia, Florence) (see Paatz, *Kirchen von Florenz* 3, pp. 128–29).

14. The expression of mid-century Dominican ideals in these stylistic modes was explored most extensively by Millard Meiss (*Painting in Florence and Siena after the Black Death*, pp. 9–26 and passim). See also Boskovits, "Su Don Silvestro … e la 'scuola degli Angeli,'" p. 39, for observations on the importance of Cionesque imagery at Santa Maria degli Angeli.

15. See Millard Meiss, *The Great Age of Fresco: Discoveries, Recoveries and Survivals* (New York: G. Braziller; Metropolitan Museum of Art, 1970), p. 54 (colorplate).

16. *L'Office divin, Histoire de la formation du bréviaire* (Paris: Editions du Cerf, 1959), p. 189.

17. *The Rule of St. Benedict*, ed. McCann, pp. 64–65. While the numbering of the Psalms cited here follows the system in the Vulgate, the English texts follow the Authorized Version (King James), with its different enumeration.

18. See Anne H. van Buren, "The Canonical Office in Renaissance Painting: Raphael's *Madonna at Nones*," *The Art Bulletin* 57 (1975): 41–42.

19. For the *Très Belles Heures de Notre-Dame*, attributed to the Parement Master and Workshop, see Millard Meiss, *French Painting in the Time of Jean de Berry, The Late Fourteenth Century and the Patronage of the Duke*, 2 vols., (London: Phaidon, 1967), text vol., pp. 107–18 and plate vol., figs. 6–28.

20. For example, Millard Meiss, *French Painting in the Time of Jean de Berry, The Boucicaut Master* (London: Phaidon, 1968), figs. 201, 232, and 309.

21. I have adopted the title for this episode used by the Index of Christian Art at Princeton University. In Gospel texts, the Stripping of Christ, immediately before the Crucifixion, is mentioned only in Luke (23:34). The two previous despoilings of Christ, with their Gospel sources, are the following, again adopting the terminology of the Index of Christian Art: Chris Despoiled of His Garments (Matthew 27:28) and Christ Despoiled of Purple (Matthew 27:31 and Mark 15:20). The Index lists sixteen examples of the Stripping of Christ in European art before 1400, eight of which are Italian. Lorenzo Monaco seems not to have depended on any known model. A feature of most medieval depictions of the scene, not included by Lorenzo, is the ladder leading up to the crossbar.

22. The closest resemblance to Lorenzo's rendering of the figures of Christ and Judas, although reversed, is in a panel by a Florentine master in the circle of Pacino di Bonaguida (see Mario Salmi's review of Richard Offner, *Studies in Florentine Painting*, in *Rivista d'arte* 11 (1929): 138, fig. 2).

23. For the pseudo-Bonaventuran text of the later thirteenth century, see *Meditations on the Life of Christ*, edited by Isa Ragusa and Rosalie B. Green (Princeton: Princeton University Press, 1961), p. 333 ("Meditation on the Passion at the Sixth Hour"). On the persistent question of whether the "Meditations on the Passion" within the *Meditations on the Life of Christ* should still be attributed to Saint Bonaventure, as the entire *Life* once was, see J. Guy Bourgerol, *Introduction to the Works of Bonaventure*, translated by J. de Vinck (Paterson, N.J.: St. Anthony Guild Press, 1963), p. 181. The Stripping is also described in the so-called *Gospel of Nicodemus*, or *Acts of Pilate* (see Montague Rhodes James, *The Apocryphal New Testament* (Oxford: The Clarendon Press, 1955), p. 104). Frederick Antal has commented on the rarity of the subject in early Florentine art, *Florentine Painting and its Social Background* (London: K. Paul, 1948), p. 348, note 39. For a discussion of the sources of that one version of the Stripping of Christ which has entered the canon of the history of art—El Greco's *Espolio*—see Harold E. Wethey, *El Greco and His School*, 2 vols. (Princeton: Princeton University Press, 1962), 2:51–52.

24. The image of the lion also appears in Psalm 21, verse 21, a text used in the ritual of the Stripping of the Altars on Maundy Thursday: "'Save me from the lion's mouth."

A miniature of the *Agony in the Garden*, attributed to the Seilern Master, in a Book of Hours formerly in the Seilern Collection, London, juxtaposes a lion and an adder on a rocky slope (see Millard Meiss, *French Painting in the Time of Jean de Berry: The Limbourgs*, 2 vols. (London: Thames and Hudson, 1974) text vol., p. 330; plate vol., fig. 631). While the miniature is related to the text for the Hour of Matins, the image of the lion and adder figures in the text of Psalm 90, verse 13, prescribed by Saint Benedict for Compline. The stalking lion in a grove of trees appeared in a miniature (fol. 56) of Saint John in the Desert, attributed to the Baptist Master, in the *Heures de Turin* (burned in 1904); see Meiss, *French Painting in the Time of Jean de Berry, The Late Fourteenth Century*, plate vol., fig. 29.

In various pilgrim accounts of the wilderness and plains of the Jordan, the existence of a lion was reported. Of particular interest is the account of Brother Felix Fabri of Ulm (ca. 1480), who adapted that same text of the First Epistle of Peter used at Compline: "Hereafter [the lion] was never seen in his wonted spot, but used to roam through the plains and woodlands of Jordan, going about roaring, seeking whom he might devour." See *The Wanderings of Brother Felix Fabri to the Holy Land*, 4 volumes, translated by Aubrey Stewart (London: Palestine Pilgrims' Text Society, 1893), 2: part 1, p. 27. I am grateful to Elizabeth H. Beatson for guiding me through the rich literature of pilgrim accounts.

25. W. and E. Paatz (*Kirchen von Florenz* 3: 129) indicate that the original location of the *Agony in the Garden* at Santa Maria degli Angeli is unknown. Surely in this Camaldolese monastery, where mystical devotion was so essential, there would have existed in corridors and cloisters a rich variety of images comparable to those with which Fra Angelico and his shop punctuated the Dominican environment of San Marco. The most important evidence of such imagery at the Angeli are the two frescoes of the *Crucifixion*, with the Virgin and saints, including Benedict and Romuald, early and late works by Andrea del Castagno later transferred from their original locations; see M. Horster, *Andrea del Castagno* (Ithaca: Cornell University Press, 1980), plates 17 and 109. The inclusion of the *Stripping of Christ* in the predella of Lorenzo Monaco's *Agony in the Garden* lends some possibility to locating the work in the church vestry, as is true of El Greco's *Espolio*, still in the sacristy of the Cathedral of Toledo; Wethey, *El Greco*, 2: 51.

The *Sacro Monte* of Varallo
Renaissance Art and Popular Religion

William Hood

The last historical chapter is William Hood's study of the Franciscan shrine at Varallo, north of Milan. Professor Hood shows how the pilgrimage site, a reconstruction of the Jerusalem *via crucis* and one of many similar Franciscan shrines in fifteenth- and sixteenth-century Europe, was designed to elicit that sense of emotional immediacy typical of monastic prayer. Hood's study resumes and illustrates in a sixteenth-century context several themes of this book: the sense of emotional immediacy in monastic art that William Loerke called "real presence"; the dependence of lay spirituality upon the monastic symbol world; and the origins of late medieval pietism in the affective mysticism of St. Bernard and other monastic spiritual writers.

William Hood teaches art history at Oberlin College.

I t is not surprising that a monument dating from about 1500 should be the subject for one of the last in a collection of essays that relate monasticism and the arts. And while it is not surprising, it is a little depressing, because it shows that, unlike other historians, historians of art still have not seriously challenged the romantic and by now atavistic categories inherited from the generation of Burckhardt and Ruskin, in which "Christian" and "medieval" were opposed to "secular" and "modern" as expressions of an unresolvable duality. It is of course a truism to say that monastic institutions played a vastly more forceful role in twelfth-century artistic culture than in that of the sixteenth. But it is equally true that great Renaissance art was made in the service of monastic communities, as witness Giulio Romano's San Bene-

detto Po, Palladio's San Giorgio Maggiore, Correggio's frescoes in the cupola of San Giovanni Evangelista in Parma, or Pontormo's at the Certosa di Galuzzo. North of the Alps, too, monasticism continued to provide artists with subjects and patrons long after the "monastic" centuries were past. A quick recollection of fifteenth-century Netherlandish portraits of Carthusians should be enough to reinforce that statement as well as to suggest that the hermit-as-patron is a social phenomenon both "Christian" and "modern," and perhaps even "secular." But whatever else it may be, it is decidedly not "medieval."

Perhaps the next Benedictine centenary will be celebrated with a volume whose chronological scope begins where this one so tantalizingly ends, at the period of the Catholic Reform. The most recent scholarship in this area finally puts to rest the old Renaissance notion of discontinuity between the medieval and modern worlds, whether that be articulated as pre- and post-Reformation in the north, or as pre- and post-Trent in Italy. What Heiko Oberman suggests for intellectual history is almost certainly also the case of art history,[1] namely, that "the late Middle Ages, the Renaissance, and the Reformation are not three different epochs, but represent three different perspectives addressed to the same sources."[2]

This essay on the *Sacro Monte* of Varallo advances a related theory. It is that a particular form of late-medieval unidealized three-dimensional verism, found particularly in German, Austrian, and Swiss *Andachtsbilder*, was incorporated into more rationalized Italian illusionistic systems like vanishing-point perspective as a propagandistic tool. One of its functions was to accelerate the diffusion of religious attitudes descending from twelfth-century monasticism. Under Franciscan patronage, artists were encouraged to perfect an almost hallucinatory style for the express purpose of educating the laity in a spirituality based on the writings of St. Bernard of Clairvaux and promulgated throughout the fourteenth and fifteenth centuries by the friars. Without going as far as Thode, who claimed that Renaissance art was at its center a visualization of the mendicants' aims,[3] I am led by the evidence of Varallo to conclude that a revision of traditionally held theories of the developmental and interdependent relationships of style and subject matter in Renaissance religious art is long overdue. It seems to me that a case might be made for the thesis that the unprecedented success of representational style in Italian art was assured by its capacity to respond to certain programmatic opportunities arising in popular culture, rather than by its status as a pre-scientific technology able to satisfy the eidetic tastes of an intellectual oligarchy. Testing that hypothesis (which will seem more outrageous to art historians than to other students of the period) is the burden of a full study presently under-

way. Here, I would like simply to outline a major feature of Varallo as I understood it, as an institution devoted to the popularization of Bernardian mystical piety.[4]

In late October 1584, the Cardinal Archbishop of Milan, Carlo Borromeo, made a retreat at the Sacro Monte of Varallo, a Franciscan sanctuary in the Valsesia near Lago Maggiore. Borromeo arrived at the Sacro Monte, so implies his biographer, physically and emotionally exhausted, his mind fixed on the suffering Christ whose shroud he had just venerated in Turin. But he entered at once upon a regimen of fasting, prayer, and meditation, stirring himself to a pitch of emotion characteristic for him and thus, probably inadvertently, preparing himself for the death that came only days later.[5]

This visit to Varallo was not his first: Borromeo had taken a lively interest in the sanctuary throughout his episcopacy, promoting its cult as part of the archdiocesan implementation of reforms mandated by the Council of Trent. And in the case of renovations proposed by Galeazzo Alessi in his 1566 *Libro dei Misteri*, the Cardinal prohibited the construction of chapels that in his view would contravene their original purpose.[6]

That purpose is easy to determine. Since its foundation in 1486 by the Observant Franciscan Bernardino Caimi, the promontory rising over Varallo had been taken as a surrogate Holy Land (Figure 12.1). Here pilgrims from all over Europe could venerate simulacra of the places which fifteenth-century Turkish advances in the Near East had made increasingly dangerous and difficult of access. Chapels, called *luoghi sancti* in the sixteenth century, were grouped along the slope topographically; that is, the chapel of the Annunciation was in "Nazareth," the Nativity in "Bethlehem," the Sepulchre in "Jerusalem," and so on. The primitive chapels at Varallo, those built in the 1490s, were adaptations of the actual sites as recorded in pilgrims' accounts of the Holy Land. Between 1493 and 1514 the number of chapels grew from three to twenty-eight; by Carlo Borromeo's day there were over thirty. Today forty-three chapels dot the hillside along paths leading from the entrance gate to the church of the Virgin, rising to the summit above a broad piazza ringed by chapels and souvenir shops.[7] Carlo's nephew Federigo, who succeeded his uncle as Archbishop of Milan, was an even more ardent supporter of the *sacro monte* idea. He caused the grander (and, it must be said, more beautiful) Sacro Monte of Varese to be built; and the total of at least thirteen sacri

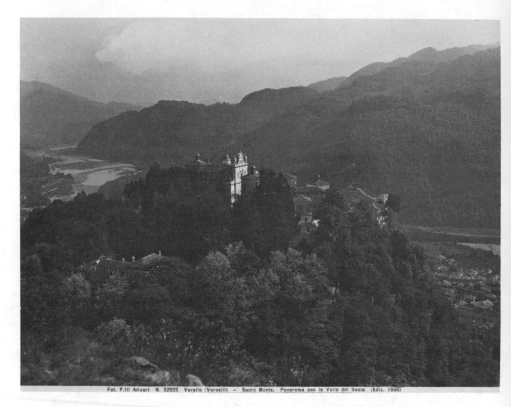

Fot. F.lli Adinari N. 52025 Varallo (Vercelli) - Sacro Monte. Panorama con la Valle del Sesia (Ediz. 1906)

Figure 12.1. Varallo, Sacro Monte.

monti that rose in Piedmont and Lombardy during the sixteenth and
seventeenth centuries proves their popularity and utility in that part of the
Italian church influenced from Milan.[8]

 Although it is no longer possible to know just what the earliest
shrines at Varallo looked like—those of Calvary, the Holy Sepulchre, and
the Ascension—the realization of the chapels as they appear today was the
achievement of the Lombard painter and sculptor Gaudenzio Ferrari. By
the 1540s Gaudenzio enjoyed a reputation sufficient to win him the task of
decorating with frescoes the Chapel of the Thorn in Milan's Santa Maria
delle Grazie, in collaboration with Titian, who painted as the altarpiece
the *Crowning with Thorns* now in the Louvre. But as a young and provin-
cial artist, in the early decades of the century Gaudenzio was associated
with the Sacro Monte. Under his direction Fra Bernardino's vision for the

sanctuary was expanded and systematized; numerous chapels were built and these were filled with the imagery for which Varallo, and its later daughter sites like the sacri monti of Orta and Varese, are well known.[9]

This realization depends for its effect on the viewer's controlled access to a highly illusionistic, one could even say literalistic, representation of a sacred story. The chapels, many of which are free-standing, independent structures recalling early sixteenth-century Lombard centralized churches, do contain doors and windows (Figure 12.2). These, however, are covered by iron or wooden grills that prohibit entrance but allow one to look in. What one sees on the interior are groups of lifesize, polychromed wood or terracotta figures, complete with glass eyes and hair wigs, arranged in tableaux representing the story. In addition, the back and side walls are painted in illusionistic frescoes that further reinforce the impression that one is beholding historical events being acted out by living people in actual locations (Figure 12.3).

If we take as a standard the generalizations about Renaissance art that students are likely to have heard in the classroom, there are some obvious chronological and stylistic anomalies in the Sacro Monte imagery. Students failing to date the Sacro Monte correctly or to identify its style as "renaissance" rather than, say, "baroque" would have based their opinion on the universally held formulation that, beneath its apparent fidelity to the transient vagaries of a fallen world, Italian naturalism preserves as though in amber the immutable perfection of a higher, redeemed nature. The figures in the Sacro Monte tableaux, with their insouciant expressions, clumsy gestures, and tacky wigs have no place in the company of such tremulous and supernal refinement. What is more, students would likely also have been taught, consciously or not, that the history of great (that is esthetically significant) art—especially Renaissance art—is the history of individual artists endowed with varying degrees of genius who practiced unique styles under the patronage of powerful groups or individuals. I would never claim that the art of the Sacro Monte compares in esthetic quality with work produced under these circumstances in, say, Rome, Florence, or Venice. But that is not the point. The point is, rather, that the traditional language of art history, developed first by Vasari in the mid-sixteenth century to account for central Italian styles, can never formulate the Sacro Monte's place in the history of style. The process whereby the central Italian idealized rationalization of sight—what we might call the Vasarian norm—came to be commonly regarded as the unifying enterprise of all Renaissance artists has been traced by Gombrich and needs no recapitulation here. It seems important to note, however, that in Lombardy and Emilia in particular, artists like Niccolò dell'Arca and Guido

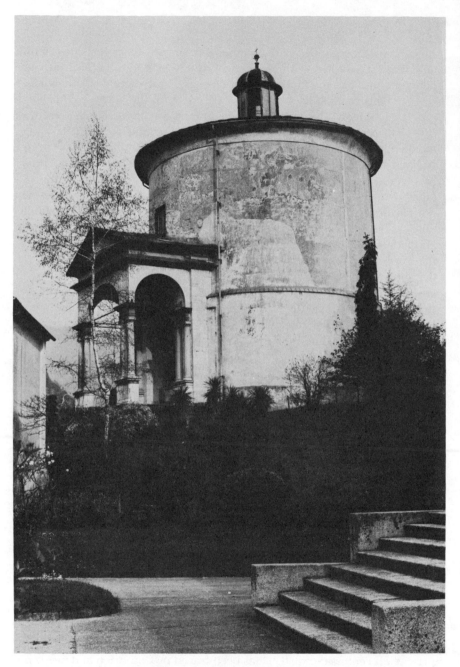

Figure 12.2. Varallo, Sacro Monte: Chapel of the Transfiguration, exterior. *Photo Richard Tuttle.*

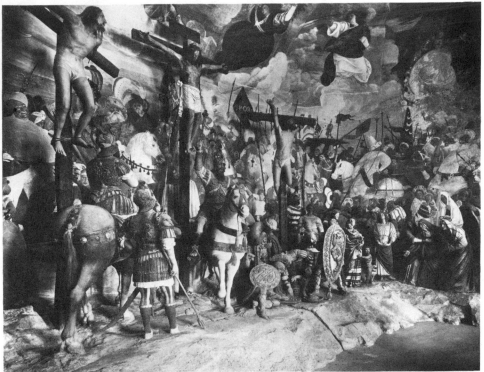

Figure 12.3. Varallo, Sacro Monte, Crucifixion Chapel, interior by Gaudenzio Ferrari and others.

Mazzoni catered to a strong predilection for representational art that was largely unidealized (Figure 12.4).[10] This is the art of the Sacro Monte. And it is this art, moreover, that found strong critical support in the literature of the Catholic Reform, written by clerics like Bishop Paleotti and Cardinal Borromeo himself.[11]

Paleotti's and Borromeo's support was based on pastoral rather than theoretical concerns. For them the primary function of Christian art was to further Christian ideals among the whole body of the faithful. In this they were far from the company of humanist critics like Vasari, for whom the numinous power of works of art was not a criterion of excellence and who, like most of the artists and patrons about whom they wrote, demonstrated not the slightest interest in art's popular appeal on

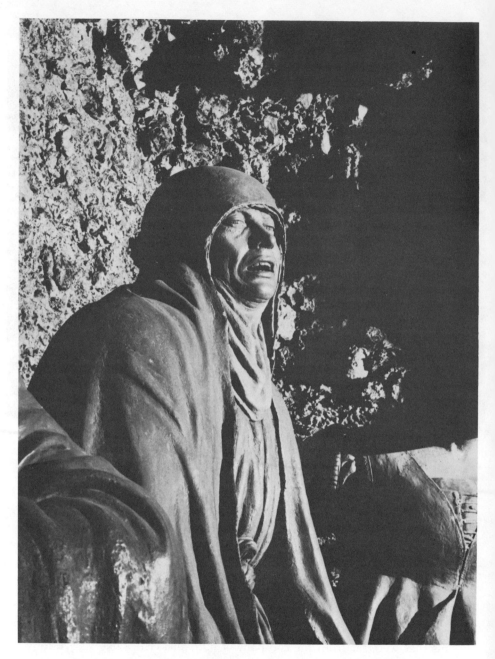

Figure 12.4. Guido Mazzoni, *Bewailing Over the Dead Christ*, detail of a female mourner. Busseto, Sta. Maria degli Angeli. *Photo Timothy Verdon and Helen Manner.*

any level. In this light, it comes as something of a surprise to realize that we have almost no evidence that works by artists like Michelangelo or Raphael even entered the religious consciousness of the *popolino*. Not surprising, on the other hand, is the fact that those artists' objective was to satisfy the theological and spiritual appetites of patrons whose interests, one supposes, were generally more sophisticated than those of the lower classes. And so it is that almost all we know about the place of images in the popular religion of Renaissance Italy clusters around works of art that for one reason or another ("vernacular style" being only one and not constant) do not generally find a place in the standard histories of the period.

While it is true that Gaudenzio established the manner whereby all subsequent chapels at Varallo were erected, his is really a common or "corporate" style—the Sacro Monte style, as it were. And it is ubiquitous, as the sacri monti of Orta, Oropa, and Varese make clear. We are therefore confronted with a characteristic Renaissance manner, i.e., illusionistic representation, strikingly devoid of the social and economic content with which its more elegant and urbane counterparts in places like Florence are laden. However, the Sacro Monte of Varallo—in fact, all sacri monti— seem not only to be a facsimile of something else, but also the reification of an interior journey, undertaken in common with others, through which ordinary people might temporarily enter the purgation of something analogous to the monastic life for the sake, not of salvation, but of sanctity. In this way, the sacro monte may be understood as a Franciscan institution, like the Third Order, whose purpose was to popularize, in the best sense of the word, the great traditions of monastic spirituality.

The evidence for this assertion is found in sixteenth-century devotional manuals for the Sacro Monte. These were not only itineraries of the sanctuary, invaluable for reconstructing its stages of development, but they also gave the pilgrim specific instructions about what to do, think, and feel at each station. Of course we have no way to determine how effective such directions were for most people; but we are fortunate to have the detailed account of Carlo Borromeo's final retreat of 1584 already mentioned. This account makes it obvious that the pilgrim was expected to undergo a profound inner conversion towards the crucified Christ, a conversion of remorse for sin into the beatitude of holiness. To be sure, Borromeo was no ordinary pilgrim; but faced with the lack of evidence from such pilgrims, we are entitled, I think, to assume Borromeo's experience to have been ideal, if perhaps not entirely typical.

Two different manuals were issued in the sixteenth century, both in the vernacular. The first was published by Gottardo Da Ponte in 1514

and is the earliest complete description of the sanctuary.[12] It exists nowadays in a unique copy purchased in Milan in 1521 by Fernando Colombo, Cristoforo's son. The second sixteenth-century guide survives in numerous copies of at least eight editions published between 1566 and 1599. Titled *Brief Description of the Sacro Monte of Varallo of the Valsesia*, it was the work of the Novarese publisher Francesco Sesalli.[13] Since we know from his biographer that Borromeo used written meditations in preparing to visit the chapels, this is the book he could well have used.

The 1514 book, written in forty-seven rhymed octaves with a concluding sonnet, describes twenty-eight chapels or *lochi sancti*. Mention of the Observant fraternity at the foot of the ascent follows two introductory octaves. Then comes a description of the Virgin's tomb, apparently located halfway between the convent and the sanctuary proper. Having entered the precinct, the pilgrim visited three chapels dedicated to Christ's infancy—the Annunciation, Nativity, and Circumcision—and then moved immediately to the first of seventeen *lochi sancti* illustrating scenes of the Passion, from the Last Supper to the Ascension. A chapel showing Jesus teaching the Our Father to the apostles, and an unfinished one of the Creed, separated the Ascension from the Pentecost tableau, thus interrupting the narrative sequence. Finally, four chapels concerning the life of the Virgin brought the pilgrim's journey to an end at a great fountain surmounted by a statue of the risen Christ, standing in the piazza before the bascilica. The selection and omission of scenes from Christ's life make it clear that the Sacro Monte's function was not to recall all the Gospel events. At this period, the infancy and childhood narratives were only barely represented, and there was not a single chapel devoted to the public ministry. Only in the seventeenth and eighteenth centuries were these chapters from the Lord's life amplified by tableaux representing scenes like the Healing of the Lame Man. Thus, nearly two-thirds of the chapels showed scenes from the Passion, and of the remaining nine, five showed Passion-related themes such as the Death of the Virgin. Therefore, and not surprisingly, the Sacro Monte by 1514 demonstrated thematic affinities with the widely circulated Passion editions of Schongauer and Dürer, which likewise used the infancy narratives only as a prologue and which doubtless provided the Sacro Monte artists with models for individual scenes.

The theme is set in the two prefatory octaves of the 1514 prayer book. In language that is almost surely a deliberate reference to the Cistercian hymn *Salve Regina*, the reader prays that the Virgin will serve as both model and guide on the pilgrimage, and that through her intercession he or she will be led to perfect contrition and purification at the journey's end.

Indeed, the concluding sonnet recalls these ideas. It promises that whoever undertakes the Sacro Monte pilgrimage with a pure heart will be rewarded with contentment and salvation at the last.

The kinesthetic responses to moving from place to place and to encountering tableaux populated with lifesize figures were as important to make the experience concrete as were the meditations provided in the devotional manuals. As the climax of the pilgrimage, the chapel of the Holy Sepulchre was particularly rich with psychological associations forced by the temporal sequence in which the pilgrim perceived the various episodes at that site. These begin with the burial of Christ and end with the angel's appearance to the Magdalene. The emotion of a nocturnal visit to this chapel can easily be imagined simply by reconstructing the events from the manual. One entered the chapel through a door so low that one had to stoop. The simulacrum of the Dead Christ could be approached and touched, and the pilgrim was encouraged to weep and to contemplate the crown of thorns and the nails held by a pair of angels at either end of the bier. On turning to leave, one saw a painting of the resurrected Christ; but going out, one saw a statue of the Magdalene kneeling and weeping. Consequently, the pilgrim became momentarily the first witness of the resurrection, by seeing Christ before the Magdalene did, in a brilliant passage of dramatic irony achieved by fragmenting the narrative described in John's gospel. Only then, having left the Sepulchre, did the pilgrim see the stone rolled away and an angel telling the Magdalene that Christ had risen. Putting oneself in the pilgrim's place, one could relate the events thus: "I entered the tomb and saw Jesus dead; then I turned and saw him resurrected; then I saw the Magdalene weeping, which means that *I* knew Christ had risen before *she* did." It is surely not an overstatement to suggest that for a moment, alone in the dark at Christ's tomb, the pilgrim could forget the time and place, and perhaps even his or her identity, in being thus caught up as an actual witness to the central mystery of the Christian faith.

Emotional, if not physical, solitude is assumed throughout the written meditations, as indeed was necessary for the pilgrimage to have had its greatest efficacy. This sense of personal detachment from human society and the concomitant attachment to mystical society is likewise reinforced by the language of the manual. It is written in the familiar second-person singular, and its instructions are couched in personal, even intimate terms. This is consistent with confessional manuals appearing at the same time. Whatever may have been their theological and moral goals, these books encouraged the individual Christian to seek, above all else, a *sensed* experience of contrition and forgiveness.[14] Indeed, all late-medieval

affective piety stresses the importance of the imagination, perhaps even over the will and the intellect. And its point, of course, was the soul's union with Christ, and particularly for this period, with the suffering Christ. It is typical of the epoch that the Sacro Monte pilgrimage exhibits those same highly personalized characteristics found in the popular spiritual literature of the period. Indeed, so intense was the relation of the soul and Christ that the bizarre anamnesis surrounding the visit to the Sepulchre, almost a dramatization of the true Anamnesis prayer of the Mass, was the psychological vehicle for the whole pilgrimage. And the simulacra themselves, placed as they were in recreations of the holy places, were sufficiently veristic to obliterate any subject/object distance that could separate the devout observer from the realities conveyed through the language of symbols.[15]

Although the 1514 manual survives only in a unique copy now in Seville, Francesco Sesalli's guidebook, published regularly from 1566, exists now in multiple copies. Carlo Borromeo may well have used this and the prayers for various chapels appearing in editions from 1570 on, to prepare his meditations. It would not contribute anything to my point to examine Sensalli's guide in any detail. It is lengthier and perhaps more verbose than Da Ponte's; its *ragionamenti*, or meditations, also rhymed octaves, are certainly more objectively descriptive of the tableaux, and its language is less urgent. But its aim is identical with that of the earlier one: to lead the pilgrim through a sequence of powerful psychological experiences in order to cause him or her to forget for a moment the transitory exigencies of mundane life for the sake of a purifying, if temporary, identification with Christ.

The earliest surviving account of a visit to the Sacro Monte is a letter dated 29 September 1507. Written by the Milanese chancellor Gerolamo Morone, it says that Morone visited the chapels at night and that his meditations led him to tears.[16] These are interesting bits of information, particularly the mention of nocturnal visits, but they do not tell us a great deal. Much more elaborate—in fact one could hardly ask for more— is the description of Carlo Borromeo's retreat. It comes to us in Carlo Bascapé's *De vita et rebus gestis Caroli ... Cardinalis* of 1592. This chapter from the saint's life can be measured against the more generalized pious exercises set out in the prayer books. Notwithstanding what we know from other sources to have been Borromeo's habitually fervid response to meditation on the Passion, I suggest that he exemplifies an ideal pilgrim to the Sacro Monte. Bascapé's narrative makes this obvious:

> Having arrived at the mountain, and having chosen for his room a little cell in the monastery, he began to treat his body very severely. He slept on

a plank under a single blanket. He refreshed himself only with bread and water. He disciplined himself with great severity, shirtless so that one saw the lashes tinted with blood. And then he set himself to study, to prepare himself for confession, and to meditate. ... Every day he meditated on certain themes at certain hours; and at night he went to meditate at that chapel, and before those images, that he thought would be the most fruitful. ... In those first days the Cardinal limited himself to six hours, partly by day, partly by night, of prayer and contemplation. The rest of the time he spent in preparing for confession, in bodily necessities (as briefly as possible) and in business that could not be put off. It was truly a grace-filled sight, and full of devotion, to see that great prelate, without companion, carrying a little lantern under his cloak along the paths and at the summit, going by night to visit first one and then another of those chapels. ... The fourth day after his arrival he made his confession with such devotion, remorse and tears, that his confessor was forced to weep. ... [It became clear to all that] he had that illumination and resolution of soul which despises all worldly things, even life itself, and which is turned to God alone. ... All these things were very appropriate to his coming death; most useful of all was the inclination he got from the written meditations [to contemplate] the death and burial of the Lord and to visit the image of his sepulchre. ... [17]

The thematic outlines of Borromeo's retreat are clear, even in this abbreviated version. First, he became a temporary religious, with a cell in the convent, and he was provided with a confessor who directed his exercises. I should say quickly that it seems to me unlikely that all visitors to Varallo received such hospitality. Borromeo was, after all, a ranking prelate. But in all other respects it is reasonable to suppose that the features of his stay were typical. Thus, the bodily mortification by fasting and discipline, the examination of conscience, the Passion meditations—all these led to the Cardinal's extreme compunction during confession and the consequent purgation and purification he experienced at the end.

One aspect of Borromeo's retreat is specially relevant to the Sacro Monte imagery. Bascapé tells us that the Cardinal devoted himself by day to written meditations, and that by night he visited the chapels whose tableaux illustrated the themes of his daily reading. Ideally, then, the pilgrim was advised to stir himself to devotion through the written word during the day and then, in the evening, to visit the chapels by the light of a lamp, whose low, flickering intensity would unite him to the image and separate them, together, from the enveloping darkness.

In a longer study one would want to investigate the relationship between the Sacro Monte imagery and parallel instances of Renaissance literalism, something already begun by Timothy Verdon in his book *The*

Art of Guido Mazzoni.[18] This entire genre of image-making needs clearer understanding with regard to its connection with other forms of popular imagery like the theatre, on the one hand, and with technical developments in polychromed sculpture and perspective painting on the other, to say nothing of its place in the firmament of Italian art theory in the Renaissance. Further, one wants to know more about the simultaneous efflorescence of Passion iconography both north and south in the period. These, like the historiographical problems raised at the beginning of this paper, are concerns of art history, and are perhaps thus of limited interest to students of European social history, except insofar as they impinge on larger and more general problems such as the relation of the visual arts to popular piety or Christian pilgrimages.

But I cannot do more here than suggest where a fuller treatment of the subject might go. Therefore I would like briefly to try to place the Sacro Monte of Varallo within just one of its broadest historical fields, the one most appropriate for a book concerned with monasticism and the arts; that is, the role of the Franciscan institutions as disseminators of traditional Benedictine spiritual values.

Although my thoughts on the Sacro Monte are very much open to revision, it is my present understanding that we are dealing here with a monumental complex that does not readily lend itself (as I have already suggested) to traditional conceptions of Renaissance artistic change. It goes without saying, of course, that Fra Bernardino's vision could never have been actualized much before the last decade of the fifteenth century. Technical and stylistic developments in sculpture, as the work of Niccolò dell'Arca and Guido Mazzoni shows, could have provided the figures as early as about 1460. But it was not until the 1480s that architects and painters could have matched the sculptors in verisimilitude. In my view, the location of Varallo in the archdiocese of Milan is crucial in this regard. Bramante's and Leonardo's experiments there in the 1480s and 1490s with ideal plans and special illusionism underscore Milan's importance as the center of such concerns until both artists left the city in 1499. Bramante's astonishing architectural illusionism in the perspective choir of Santa Maria presso San Satiro, for example, opened the way to the even fuller realizations at the Sacro Monte. And it is perhaps no accident that Bramante's project was completed only about five years before Fra Bernardino, then the guardian of Sant'Angelo in Milan, conceived his idea for the New Jerusalem of Varallo. Visually, therefore, the Sacro Monte stands on the most forward advance of sixteenth-century illusionism. And some may infer that it may have been more formative for fully baroque, seventeenth-century illusionism than has previously been imagined.

The new ability of artists to make what then seemed to be exact facsimiles of life thus coincided with the Franciscan popularization of Passion-oriented spirituality, at a time when military and political shifts in the Near East must have pressed such issues on the European population with renewed urgency. In other respects, however, the Sacro Monte was not new nor did it provoke change. To begin, the Franciscan use of simulacra for devotional purposes was already well established in the thirteenth century, and subsequent sacri monti were, like Varallo, Franciscan establishments. The friars' apostolic zeal in encouraging pilgrimages to the Holy Land itself is one of their oldest traditions and is a matter of record. Further, the Sacro Monte of Varallo is only the largest and most complex instance of similar Calvaries, Stations of the Cross, and related sculptural groups that sprang up all over Europe in the fifteenth century. These endeavors are all related to the characteristic Franciscan emphasis on a life of charity that drew on the energy generated in sustained affective meditations—meditations as vivid as possible—on the events of Christ's earthly life, and in particular on his Passion.

It is certainly not fortuitous that such life-like stimuli to a system of mental prayer aimed at leading the individual Christian to conscious union with Christ and to a profound acquiescence in his love were consistently established by Franciscans on remote mountain tops. The paradigm for all the sacri monti and similar shrines is surely the mountain of La Verna, where St. Francis was stigmatized in 1224, two years before his death. Accounts of this event and those leading up to it vary in early Franciscan sources; but the one closest to what I have put forth as being the norm for meditation at the Sacro Monte is found in the latest of these, *The Little Flowers of St. Francis*, compiled some time after 1322.[19]

In it, we are told that St. Francis and three companions retreated to the mountain of La Verna for fasting and prayer. A few days before the feast of the Holy Cross in September, we read "as St. Francis was standing beside the ... cell, considering the form of the mountain, and marvelling at the exceeding great clefts and caverns in the mighty rocks, he betook himself to prayer; and then it was revealed to him by God that these clefts ... had been miraculously made at the hour of the Passion of Christ, when, according to the gospel, the rocks were rent asunder. And this, God willed, should manifestly appear on the mount of La Verna, because there the Passion of our Lord Jesus Christ was to be renewed, through love and pity, in the soul of St. Francis." On the feast itself, the chronicle goes on to say, St. Francis prayed that he might share in Christ's sorrow and that he might feel the love that impelled Jesus to suffer. Then, "St. Francis ... began to contemplate most devoutly the Passion of Christ and His infinite love; and

the fervour of devotion waxed so within him that through love and through compassion *he was wholly changed into Jesus* [italics mine]." That St. Francis was mythologized as the *alter Christus* in the Order's official biographies, beginning with St. Bonaventure's written between 1260 and 1263, is a commonplace in the literature and needs no further substantiation here. What should be pointed out, however, is that Carlo Borromeo (and by extension all pilgrims to Varallo) can be seen at the Sacro Monte as an *alter Franciscus*. Lombard altarpieces by artists like Tanzio da Varallo and Daniele Crespi make it clear that this association was widely accepted in the region. Successful meditation at Varallo therefore led not only to union with Christ, but also with him whose life and teachings were everywhere regarded as the model of Christ-likeness. What is more, the contemplative rather than active St. Francis was the model. And this model was in its turn deeply informed by the Cistercian spirituality of St. Bernard of Clairvaux.[20]

The character of Franciscan piety—its focus on the suffering humanity of Christ, its stress on solitude, its insistence on conscious experience, and its goal of spiritual union through love and contrition—has recently been seen by Francis Oakley as what it is, a revival of twelfth-century Cistercian spirituality.[21] In his chapter for this volume, Professor von Simson pointed to some specific legacies in late-medieval iconography of Cistercian doctrine. More broadly, St. Bernard's sermons on the Song of Songs are full of observations and attitudes that make it obvious that much of fourteenth- and fifteenth-century piety is a popularized simplification of monastic themes. With regard to images of Christ, for example, St. Bernard says that "if you carry him where your eyes can rest on him you will find that the sight of his afflictions will make your burdens lighter, helped as you will be by him who is the Church's bridgegroom, God blessed forever."[22] And to rationalize the efficacy of meditation on Christ's humanity, rather than on his "higher" attributes, as should be the subject of contemplation for monks advanced in the spiritual life, St. Bernard, in Sermon 20, outlined three sources of love: the heart, mind, and strength.[23] While love of the mind was better than love of the heart because it is rational, and love of the strength or will is higher still because it is spiritual, beginners should concentrate on the affections, on love of the heart. Although it is, according to St. Bernard, carnal in its way, love of the heart helps those "who [are] unable to love in any other way, by first drawing them to the salutary love of [Christ's] humanity." So far as I can tell, there is no indication in the popular literature of our period that love of the affections was regarded in any way as base, though in late sixteenth-century Carmelite literature that may be the case. This is of course a

development that would be worth tracing in detail, for it forces the assumption that St. Bernard was prescribing this kind of love for the laity, reserving development of the higher loves for contemplative religious, that is, the monks. But at Varallo, laypeople became temporary monks and nuns anyway.

However isolated and personal the mystical experience at Varallo was intended to be, there can be little doubt that pragmatic considerations alone would have prompted visits to the sanctuary in groups, as they do today. This leads us, in conclusion, briefly to consider the social aspects of the Sacro Monte pilgrimage, what I would call in this context aspects of Christian community. Monastic values were popularized by the Franciscans not only through meditation and mental prayer, but through corporate institutions as well. Chief among these is naturally the Third Order Secular, established in 1221 at Faenza. Founded by St. Francis himself at the request of laypeople, the purpose of the Order was to give the laity "a Rule of life which was near to the evangelical precepts, and closely approximated the religious life, and still did not destroy family life."[24] What is more, the Third Order was not just a confraternity or pious association of some kind; instead, it was a true Order, according to Pope Benedict XIII, in that it had a rule, a novitiate, habit, and profession of a specific form.

I suppose that many pilgrims to Varallo were Franciscan tertiaries. They numbered in the thousands, and it is reasonable to assume that they would have visited one of the Order's most famous Italian shrines. But whether bound by formal ties to a religious Order or not, all visitors to the Sacro Monte, like visitors to the Holy Land proper, were pilgrims and temporary religious moving in temporary religious communities. My authorities for this assertion are Victor and Edith Turner, who have elucidated the social factors at work in any Christian pilgrimage at any time.[25] Chief among their concepts for my purposes here is that of "liminality," the quality of being at the threshold or periphery of traditional, familiar society. The Turners argue, if I understand them correctly, that the Christian's decision to embark on a pilgrimage (which is, of course, an analogue of the interior and spiritual journey that is the pilgrimage's real purpose) requires before all else a fundamental detachment from the ordinary supportive environment of occupation, home, and place of origin. In their words, "the pilgrim is an initiand, entering into a new, deeper level of existence than he has known in his accustomed milieu. ... And at the end the pilgrim, like the novice, is exposed to powerful religious sacra ... the beneficial effect of which depends upon the zeal and pertinacity of his quest. Tribal sacra are secret; Christian sacra are exposed to the view of pilgrims and ordinary believers alike. ... What is secret in the

Christian pilgrimage, then, is the inward movement of the heart."[26]

Having for a time renounced the comfort and security of normal life for the sake of the purgation and sanctification accomplished through the Sacro Monte journey, pilgrims were, like monks, united with each other solely, or at least primarily, through their common experience of liminality, detachment from the world. Entering together into the "novitiate," so to speak, they first entrusted their journey to the Virgin's protection. Proceeding thence through all the events of Holy Week, they were led to a form of the monastic "mystical death" by identifying themselves—in the company of their model, St. Francis—with the crucified Savior. Finally, refreshed by the vision of the resurrection and by the water flowing from the fountain surmounted by the Risen Christ, they enjoyed the serenity that came from a taste of contemplation, won at the cost of bodily and spiritual discipline.

The Sacro Monte's medieval content, expressed in a Renaissance visual idiom, resulted in a monument which, as I have said, defies Vasarian and even Panofskyan notions of what Renaissance art is about.[27] The seeming anomaly is symptomatic, I believe, of a need for art historians of the period to reconsider received traditions about the content of Renaissance religious art. One way to look at the fifteenth-century enterprise in verisimilitude is to see it, not unlike Vasari did, as a chapter in the history of communication. The Sacro Monte's visual language is a vernacular that made the imaginative forms of the contemplative life fully accessible to the nonspecialist. Like the printed word, whose advent only barely antecedes fully developed illusionism, representational art made it possible for artists and their patrons to standardize the personal visual imaginations of members in a corporate body and thereby to create a new kind of religious community, based on the common and overt perception of interior, mystical verities. Again like the printed word, naturalism could perpetuate the life of such communities through time, since it was relatively free from the limitations of an abstract symbolic system that is legible only to those who share a visual culture endemic to a specific chronological period or language group. These considerations, it seems to me, go a long way towards explaining the consistent use of Gaudenzio's manner at all the sacri monti in northern Italy, as well as the fact that it was used, unaltered, from the early sixteenth century well into the nineteenth. Finally, the success of such a total system of illusionism is witnessed by the fact that, to this day, hundreds of pilgrims visit the sacri monti during the summer months, five hundred years after Varallo was established.

The content of this language, as we have seen, predates the Sacro Monte by an almost equally long time. Thus, late fifteenth-century experi-

ments in veristic representation were immediately drafted into the service of pious habits that arose in twelfth-century monasticism and were popularized in the thirteenth- and fourteenth-century mendicant movement. I fully agree with Oakley, who argues that the Franciscans actually established a continuity between the High Middle Ages and the early modern period which scholars of both cultures have tended to overlook.[28] The transformations in European culture attributable to Franciscanism, which Delaruelle rightly calls neither a theology nor a juridical reality so much as a "state of the spirit," are of course much vaster, more complex, and more diffuse than the single instance of Varallo would suggest on its own.[29] However, within the sphere of the two Borromeo archbishops' infuence, it and the twelve subsequent Lombard and Piedmontese sacri monti functioned in the Catholic Reform as major conduits through which monastic values were channeled into the world of laypeople.

NOTES

This essay was written in memory of Damasus Winzen, O.S.B. I wish to acknowledge here, with warm gratitude, my debt to the Research and Development Committee of Oberlin College for support of my research thus far, and to the National Endowment for the Humanities for a year's fellowship to continue my study of Varallo. I owe special thanks as well to David Freedberg, Kathleen Weil-Garris, and Timothy Verdon.

1. See H. Oberman, *In Werden und Wertung der Reformation: Vom Wegestreit zum Glaubenskampf,* 2nd ed. (Tübingen: J. C. B. Mohr, Paul Siebect, 1979).

2. Hans J. Hillerbrand, review of Oberman, *Werden und Wertung,* in *Renaissance Quarterly* 33 (1980): 84. Professor Oberman spoke at length on this topic in a series of Mead-Swing lectures at Oberlin College in the autumn of 1979.

3. H. Thode, *Franz von Assisi und die Anfänge der Kunst der Renaissance in Italien* (Berlin: Grote, 1885).

4. On St. Bernard's mysticism, and its initial influence on popular piety and art, see Chapter 5 by Otto von Simson in this book.

5. See C. Bascapé, *De vita et rebus gestis Caroli S. R. E. Cardinalis, tituli S. Praxedis archiepiscopi Mediolani. Libri Septem* (Ingolstadt: D. Sartorius, 1592); see also the Italian translation, *Della vita di San Carlo ...* (Bologna: G. Rossi, 1614), pp. 561 ff. For Borromeo's tendency to be strongly emotional, see especially Book 7, chapter 14, pp. 659–65, "Come fosse dato alla contemplatione, & oratione."

6. See the preface by Anna Maria Brizio to Galeazzo Alessi, *Libro dei Misteri. Progetto di pianificazione urbanistica, architettonica e figurativa del Sacro Monte di Varallo in Valsesia (1565–1569),* 2 vols. (Bologna: Forni, 1974), 1:3–10.

7. Other than sixteenth-century guide books, which will be discussed below, some major references are: the fundamental study by P. Galloni, *Sacro Monte di Varallo. Atti di fondazione. Origine e svolgimento delle opere d'arte,* 2 vols. (1909–14; reprint ed., Borgosesia:

Libreria P. Corradini, 1973); A. Durio, "Bibliografia del Sacro Monte di Varallo e della Chiesa di Santa Maria delle Grazie annessa al Santuario: 1493–1929," *Bollettino storico per la provincia di Novara* (1929): fasc. 1: 357–405; fasc. 2: 82–94; fasc. 3: 453–98. See also Brizio's preface to Alessi, *Libro dei Misteri*, and, more recent and important, the series of studies by Casimiro Debiaggi, in *Bollettino storico per la provincia di Novara* 66 (1975), 67 (1976), 68 (1977), and 69 (1978).

8. Besides Varallo and Varese, there are *sacri monti* at: Arona, Crea, Domodossola, Ghiffa, Graglia, Isola Comacina, Locarno, Monta, Oropa, Orta, and Valperga Canavese. A useful tourist guidebook, with bibliography, is S. Langé, *Sacri Monti piemontesi e lombardi* (Milan: Tamburrini, 1967). There is also an early sixteenth-century sanctuary in Tuscany; see *Religiosità e società in Valdelsa nel basso medioevo. Atti del convegno di S. Vivaldo, 29 settembre, 1979*, Biblioteca della "Miscellanea storica della Valdelsa," no. 3 (n.p., 1980).

9. See three articles by A. Brizio: "La più antica veduta del Sacro Monte di Varallo," *Bollettino della Società Piemontese di Archeologia e di Belle Arti, 1954–57*, n.s. 8–11 (1959): 3–5; "Configurazione del Sacro Monte di Varallo nel 1514," *ibid.*, pp. 6–11; and "Il Sacro Monte di Varallo: Gaudenzio e Lotto," *ibid.*, n.s. 19 (1965): 35–42. See also C. Debiaggi, "La primitiva cappella dell'Annunciazione al Sacro Monte di Varallo," *Arte lombarda* 40 (1974): 175–78.

10. E. Gombrich, *Norm and Form. Studies in the Art of the Renaissance* (London: Phaidon, 1966), pp. 81–98: "The Stylistic Categories of Art History and Their Origins in Renaissance Ideals." On the illusionistic realism of the fifteenth-century Emilian tradition, its meaning and relationship to Central Italian art, see Timothy Verdon, *The Art of Guido Mazzoni* (New York: Garland 1978), Introduction and Chapter 1.

11. G. Paleotti, *Discorso intorno alle imagini sacre e profane*, 2 vols. (Bologna, 1581–82). These are reprinted in P. Barocchi, ed., *Trattati d'arte del cinquecento*, 3 vols. (Bologna: Laterza, 1960–62), 2: 117–509; see also C. Borromeo, *Instructiones fabricae et suppellectilis ecclesiasticae* (Milan, 1577), reprinted in Barocchi, *Tratatti*, 3: 1–113.

12. See A. Durio, "Il Santuario di Varallo secondo uno sconosciuto cimelio bibliografico del 1514," *Bollettino storico per la provincia di Novara* 20 (1926): 117–39; see also Brizio, "Configurazione del Sacro Monte."

13. F. Sesalli, *Breve descrittione del Sacro Monte di Varallo di Valsesia …* (Novara: Sesalli, 1566); see also Durio, "Bibliografia del Sacro Monte."

14. This observation is based on a sampling of thirty-one manuals published between 1491 (*Ammonitioni del Beato Bernardino Aquilano da Fossa …* [Venice]) and 1569 (Desiderio Anichino, *Modo di prepararsi alla confessione [Ancona]*). The study by T. Tentler, *Sin and Confession on the Eve of the Reformation* (Princeton: Princeton University Press, 1977), does not seem to address this issue.

15. The subject/object relationship is the kernel of the Sacro Monte's profound enigma as a monument of Renaissance art. Its emotional content and lack of distance between the perceiver and the thing perceived, to say nothing of its temporal sequences and character as a *Gesamtkunstwerk*, associates it most readily with seventeenth-century Roman art, and especially with complexes like the crossing of St. Peter's or Bernini's Cornaro Chapel in Sta. Maria della Vittoria. Fifteenth- and sixteenth-century Italian artists, on the other hand, particularly in major centers like Florence, expressed their increasing professional pride and self-consciousness through works of art that remain wholly *other*, regardless of their compelling psychological force. Donatello's *St. Mary Magdalene*, or Michelangelo's *Moses*, come to mind as examples of this Florentine approach. Thus, depending on one's attitude, the Sacro Monte artists' utter disregard for the canons of idealized Renaissance beauty is either stylis-

tically anachronistic or it is prophetic. My thoughts on these matters began to develop in a series of courses in Italian sculpture given by Professor Irving Lavin at the Institute of Fine Arts, New York University, between 1969 and 1971.

16. Letter 65, in *Miscellanea di storia italiana edita per cura della R. Deputazione di Storia Patria* 2 (1863): 148.

17. Bascapé, *De vita et rebus gestis Caroli*, 7, 14.

18. T. Verdon, *The Art of Guido Mazzoni*. Verdon devotes considerable attention to the links between popular religious drama and the stylistic, iconographical, and what one would have to call motivational background of this kind of illusionism.

19. See the recent edition of the original text in *Fonti francescane* (Assisi and Bologna: Movimento francescano, 1977), pp. 1441–1624, with an introduction by S. da Campagnola, pp. 260–70.

20. For St. Francis' debt to St. Bernard, see E. Delaruelle, *La Piété populaire au moyen âge* (Turin: Bottega d'Erasmo, 1975), pp. 230 ff. A fully developed treatment of this theme, the imitation of Francis, will appear in my book.

21. F. Oakley, *The Western Church in the Later Middle Ages* (Ithaca: Cornell University Press, 1979), pp. 81–82.

22. *Sermon* 43, 5, in *On the Song of Songs*, translated by K. Walsh, 2 vols., Cistercian Fathers Series nos. 4 and 7 (Spencer, Mass. [vol. 1] and Kalamazoo, Mich.; London; Oxford [vol. 2]: Cistercian Publications, 1971; 1976), 2: 224.

23. *Sermon* 20, *ibid.*, 1:147–55.

24. See G. Reinmann, *The Third Order Secular of St. Francis* (Washington, D.C.: The Catholic University of America, 1928), p. 79.

25. V. Turner and E. Turner, *Image and Pilgrimage in Christian Culture* (New York: Columbia University Press, 1978). The subject of pilgrimage has received much attention recently; my interest in it here is as a conscious metaphor of the spiritual life, a theme developed in Delaruelle, *Le piété populaire*, chapter 8, pp. 555–61, "Le pèlerinage intérieur au XV siècle."

26. Turner and Turner, *Image and Pilgrimage*, p. 8.

27. Erwin Panofsky, *Renaissance and Renascences in Western Art* (Stockholm: Almqvist and Wiksell, 1965), pp. 108–13 especially.

28. Oakley, *Western Church*, pp. 113–30.

29. See Delaruelle, *La piété populaire*, p. 229. L. Gillet, *Histoire artistique des ordres mendiants* (Paris: H. Laurens, 1912), p. 305, says: *"Si Varallo n'existait pas, il manquerait une étape suprême à leur* [the Franciscans'] *recherche obstinée de la réalité."*

Chapter 13

Contemporary Monastic Architecture and Life in America

R. Kevin Seasoltz, O.S.B.

In this final chapter, or epilogue, Father Kevin Seasoltz draws upon his personal acquaintance with the individuals and communities responsible for commissioning important monastic structures during the last three decades to interpret the symbolic values which the buildings convey. He provides an insightful picture of the concerns and aspirations of monastic men and women in the second half of the twentieth century, and in the process helps the reader enter the realm of sensibility which has probably always characterized monastic art. The structures he discusses illustrate moreover the rich diversity in approach to traditional monastic living that is possible in the modern milieu.

R. Kevin Seasolz is a monk of St. Anselm's Abbey, Washington, D.C., and teaches in the School of Religious Studies of the Catholic University of America.

In a book called *The Land*, Walter Brueggemann reflects on the meaning of place as gift, promise, and challenge in the context of biblical faith.[1] In the Bible, land is the physical foundation of fertility and life; it is the place where people gather their hopes for freedom. But the biblical themes of gift, promise, and challenge are always held in tension with greed, presumption, and complacency. Brueggemann seeks to bring the biblical tradition into dialogue with the contemporary industrialized world, plagued as it is with rootlessness and anomie while both individuals and groups are dissociated from the land.[2] In the light of biblical insights, he likewise seeks to illuminate our under-

standing of the so-called third and fourth worlds, where masses of
humanity struggle for an engagement with the land which will not only
assure survival but also promote growth.[3]

Benedictine communities stand in the biblical tradition; but as
Christians, their members are called to bring that tradition into dialogue
with contemporary culture as they seek to be responsible for the place, the
environment which is their gift, their promise, and their challenge.[4] In
their more faithful periods, Benedictine communities have tried to
respond to the biblical teaching on landedness through their vow of sta-
bility,[5] their commitment to simplicity and sharing of goods,[6] and their
policy of hospitality.[7] They have tried to realize that the world is not
simply something given to people for utilitarian purposes; it is home at the
present time, even for pilgrim people on their way to the Father's house.[8]

Writing for cenobites, Benedict stressed the community's respon-
bility to share its goods with the poor and the stranger.[9] His concern was
for reverence, proper care, and appropriate use of material things.[10] He
seemed to grasp the importance of a certain rootedness, a grafting on the
particular locality in which the community finds itself.[11] The attitude
toward the world that he tried to instill was one of stewardship, inspired
by the second chapter of Genesis in which humans are placed in the
garden, not as masters but rather as stewards.[12] As a result, Benedictine
communities throughout history have sought to establish creative, harmo-
nious relationships with their environments. They have related to the
physical universe as farmers, artisans, builders, and scholars. While
affirming the primacy of the human person over the rest of creation, they
have enhanced their surroundings. But in the same way as they have
regularly humanized their environment, so also has the environment
humanized them.[13]

The Benedictine tradition has something important to say about
human life in the modern world, plagued as it is with problems of pollu-
tion, energy, and consumption.[14] In seeking to establish a balanced order
of relationships between humanity and the rest of creation, among human
beings themselves, and between humans and God, Benedict stressed the
importance of reverence for the physical world and the role of a humane
environment in helping monks develop as people whose lives are com-
mitted to the search for God.[15] Throughout history, of course, the imple-
mentation of Benedict's teaching has been conditioned by both cultural
and ecclesial factors.

The early Benedictine communities of men and women in the
United States consisted in many ways of pioneering people who did much
for the area where they first put down roots in the last century—in Penn-

sylvania, Minnesota, Kansas, New Jersey, Indiana, Missouri, Oklahoma, and Oregon.[16] Of necessity they adapted the *Rule* to their own time and place as they established monasteries, parishes, farms, hospitals, and schools. There is no doubt that through pain and struggle they did much to humanize their environments and were themselves humanizing influences in the lives of the people they served. Their original buildings were generally simple, functional structures, designed, built, and appointed either by members of the community or by lay-people of the area. Local materials were regularly used throughout. They built well and their structures endured for a long time. Significant developments occurred, however, in American monasteries following the Second World War. It is some of these developments that I would now like to chronicle and illustrate in a selective way.

With the end of the Second World War, monastic communities in this country launched extensive building programs for a variety of reasons.[17] Financial restrictions caused by the Depression of the 1930s and the shortage of materials caused by the war meant that even needed buildings had been frequently delayed. The end of the war brought pressures for expansion as the number of candidates for monastic life dramatically increased, along with the number of students enrolled in monastic schools. In general the buildings put up soon after the war were erected in the same style as their predecessors, the traditional Gothic or Romanesque style.[18] As a result of greater reflection on the various roles played in liturgical celebrations, however, and increasing awareness of both liturgical and architectural developments in Europe, monastic communities encouraged their church architects to depart from the longitudinal plan according to which the pews in the nave, the choir stalls for the monks, and the altar ran along a single axis.[19] Efforts were made to accommodate large congregations, especially in those monasteries committed to school work. Likewise, special attention was given to the placement of the monastic choir which generally distinguishes monastic from parochial churches. Efforts were made to locate the choir so that it related to the rest of the worshiping community without standing as a barrier between the congregation and the altar.[20]

The first monastic church in the United States to depart from the longitudinal form was that erected at Mount Saviour Monastery in Pine City, New York (Figure 13.1). The monastery was founded in 1951 by Damasus Winzen, a monk of Maria Laach in Germany. In laying plans for his new community, he proposed a monastery without school or parish

Figure 13.1. Exterior view of the chapel at Mount Saviour Monastery, Pine City, New York.

commitments. He stressed simplicity of life and hospitality for guests whom he wanted drawn into the community's worship and work.[21]

To design a temporary, low-cost chapel which would be useful after the completion of a permanent monastery, Winzen turned to Joseph Sanford Shanley of New York.[22] It was Winzen's own theological, monastic, and liturgical background, however, which determined the design of the new chapel. To avoid stratification of clerical and lay areas so prominent in longitudinally planned churches, Winzen proposed an octagon, permitting the altar to be central. All could gather round it, the monks forming an inner circle with the guests close behind.[23] In Shanley's original plan the chapel occupied the southern corner of a square, with the other monastic buildings jutting out at the northwest and northeast. No attempt was

made to adopt a consciously modern style; a simple building was designed to rest on top of rolling hills.[24]

Mount Saviour experienced a steady growth throughout the 1950s, so in 1958 the monks set about developing a total monastic plan, lest the buildings develop in chaotic fashion.[25] The central area of the property was divided into nine squares with the chapel occupying the central square; the four corner squares were assigned to other buildings. In Winzen's mind the altar was the center of monastic life; it was appropriate then that all other buildings and activities be built around the altar. The chapel as a whole combined the octagon, a Christian symbol of resurrection, with the form of a cross. The southeast square of the plan contained an existing guest house. A house for oblates and novices was projected for the square at the southwest.[26] The most secluded square to the northwest was set aside for an inward-looking building housing the monastic dormitory and library. A more open building was planned for the northeast corner, housing the busy activities associated with the kitchen, refectory, chapter room, and laundry.[27]

The new buildings which were finally erected were designed by Ronald Cassetti. He respected Shanley's earlier work on the chapel but expanded its capacity. It was ready for use by Christmas, 1963. The dormitory-library building is an enclosed square with a completely glazed circular court and a horizontal roofline. The other building is square, but the lines are more active and outward-looking. The chapel is obviously central and dominant; its horizontal roofline, stretching outward from the central spire, ties the building to the ground. The interior has a sense of simplicity and clarity. A pair of stairways in the northern arm of the chapel descend to the crypt, which houses both the Blessed Sacrament and a fourteenth-century madonna. The overall monastic complex communicates tranquility and peace.

Since the community had grown in numbers, the monastic chapter at Mount Saviour decided in 1964 to make a foundation in New Mexico.[28] Winzen sent Father Aelred Wall to explore possible sites. He chose a 115-acre ranch in the canyon of the Chama River, thirteen miles by dirt road from the nearest highway. Wall contacted George Nakashima, a long-time friend who had designed many of the church furnishings at Mount Saviour, and asked him to plan a series of simple, inexpensive buildings for the property in New Mexico, since the monks hoped to concentrate on primitive monastic ideals. The buildings were designed around an existing farmhouse on a parched slope rising from the flat bottomland along the

Figure 13.2. Exterior view of the chapel at the Monastery of Christ in the Desert, Abiquiu, New Mexico.

river and extending to the foot of the steep, craggy, rust-colored canyon walls. The original farmhouse was converted into a kitchen, refectory, provisional chapel, and guest house. Five two-celled adobe units were built behind the farmhouse for the monks. All structures were constructed of adobe, since the community wanted to link itself with the culture and traditions of the Southwest.[29]

The monastic church (Figure 13.2), a tower-like structure, rests on somewhat higher ground above the cells. Stark and stately in its simplicity, the interior of the building is flooded with light (Figure 13.3). A square, red sandstone altar table is set on a base of cut fieldstone from the monastery grounds. Two statues in the chapel, one of Our Lady and the other of John the Baptist, were executed by sculptor Ben Ortega of Tesuque, New Mexico. They preserve much of the natural contour of the gnarled juniper out of

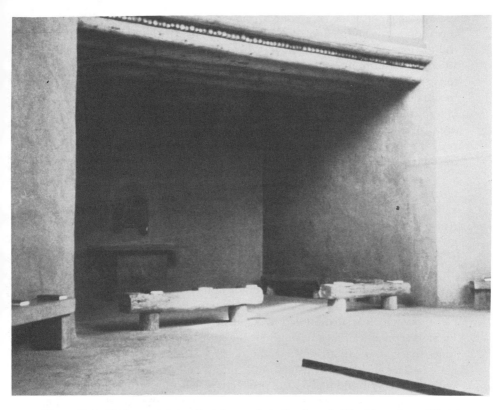

Figure 13.3. Niche containing the tabernacle in the chapel of the Monastery of Christ in the Desert, Abiquiu, New Mexico.

which they were carved. The well-known artist Ben Shahn, a personal friend of Nakashima, designed a wood processional cross with a relief figure of Christ which was executed by Shahn's son, Jonathan.[30] An adobe guest house has been erected at some distance from the other buildings.

Between 1958 and 1963 a number of other Benedictine monasteries engaged in extensive building programs, including St. Gregory's Abbey in Portsmouth, Rhode Island; St. John's Abbey in Collegeville, Minnesota; Annunciation Priory in Bismarck, North Dakota; and St. Louis Priory in St. Louis, Missouri.

Monks settled at Portsmouth in 1919 and opened a boys' school in

1926. Located near the shore of Narragansett Bay, the physical facilities of the monastery and school developed in the early years around an old manor house built in the 1860s.[31] When Aelred Graham became prior in 1951, the community began to discuss plans for a new church and monastery. After considering several architects, the community chose Pietro Belluschi, the dean of the school of architecture at MIT. Since the existing heterogeneous buildings precluded extensive new construction in the same area, a site was chosen on higher terrain under a ridge screening the property from the main highway. Plans were also made for a students' dining room, operating from the same kitchen as the monks' refectory.[32]

By 1957, Belluschi presented his plans for an octagonal church with a gallery for enlarged assemblies and a retrochoir behind the altar.[33] While the plan was accepted by the community, the arrangement unfortunately failed to integrate the choir sufficiently with the rest of the congregation in the nave. As finally constructed, the choir and sacristies form a link with the three-story monastery wing behind and to the north of the church (Figure 13.4). To the south the monastery connects with the students' dining room. In the church eight laminated wood bents mark the corners of the inner octagon and rise through the gallery to an octagonal clerestory which is surmounted by a needle-like spire. A wire sculpture by Richard Lippold radiates throughout the nave and concentrates the whole inner space on the altar.

The church, monastery, and dining hall are scaled in sympathy with the earlier buildings on the property. Color and texture are provided by the blue-gray local stonework of the lower walls, the dark brown stain of the vertical wood siding, and the copper roofing. The elements are modestly sized, avoiding a monumental appearance. In more recent years, a number of other impressive school buildings have been designed by Belluschi and built in the same style.

There is no doubt that a major accomplishment in the history of monastic architecture is the church at St. John's Abbey in Collegeville, Minnesota.[34] Both the monastic community and the university expanded considerably after the Second World War. Consequently, before attention could be given to a new church, the community had to settle on a comprehensive plan for the campus that would meet the diverse needs of both abbey and school.[35] In 1953 twelve distinguished architects from various parts of the world were invited to prepare a comprehensive plan.[36] The community decided to work with Marcel Breuer, the Hungarian who had

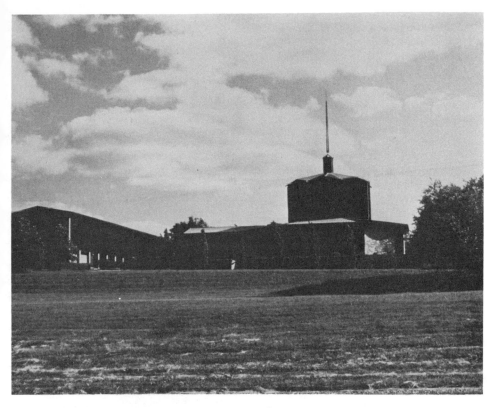

Figure 13.4. Exterior view of monastery and chapel at St. Gregory's Abbey, Portsmouth, Rhode Island.

been associated with Walter Gropius and the Bauhaus and who later was head of the graduate school of design at Harvard.[37] The monastic wing, the first unit constructed, was completed in 1955.

Although Abbot Baldwin Dworschak surely played a key role in securing the community's acceptance of Breuer's imaginative designs for the new church,[38] the community's long-time involvement in liturgical and theological scholarship was a critical asset. As completed, the church is a trapezoid covered by a thin concrete shell which is pleated into deep folds on either side.[39] The shell rises from the ground by means of narrow concrete piers; the intervening space is closed with plate glass windows looking into enclosed gardens, which in turn are closed off by parallel cloister corridors linking the church and the new monastery. A chapter house, of kite-shaped form, is attached to the east cloister.

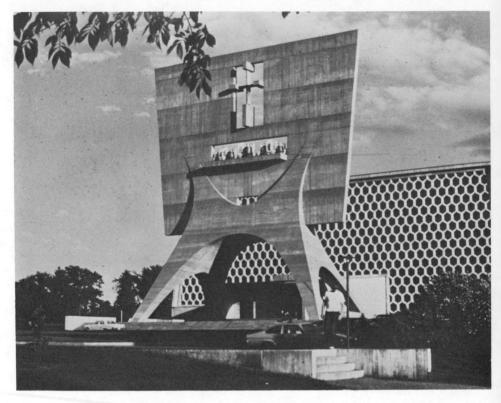

Figure 13.5. Exterior view of the church at St. John's Abbey, Collegeville, Minnesota.

 In the church, the altar, located along the central axis, divides the
plan into two similar trapezoids. The choir stalls are arranged around the
altar, with the abbot's place facing across the altar toward the nave. The
wider end of the main trapezoid is occupied by the congregation. At the
rear of the nave is a balcony raised on concrete piers independent of the
walls. The north wall is a textured screen resembling a honey-comb. It is
filled with stained glass designed by a local artist, probably the least
impressive element in the ensemble.[40] Abutting the north wall is a low
atrium housing a depressed square baptistry. Before the atrium stands the
bell banner, the most memorable feature of the church (Figure 13.5). It
provides a striking entrance to the church under its sweeping parabolic
arch and reflects the sunlight into the north stained-glass wall of the

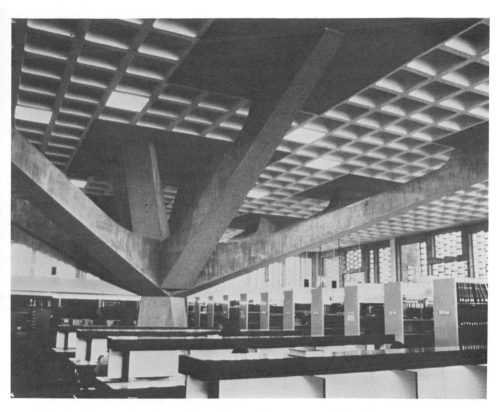

Figure 13.6. Interior view of the Alquin Library at St. John's Abbey, Collegeville, Minnesota.

church. Holding aloft both the bells and a cross, in a single gesture it proclaims faith and inspires hope.[41]

The church was consecrated in 1961.[42] At that time no one suspected the complex developments in religious and liturgical life which would be set in motion by the Second Vatican Council. The same church building undoubtedly would not be built today because the celebration of the liturgy has been simplified so that the whole community, including the non-ordained monks and the laity, might fully participate as a unified assembly. Likewise, the monks no longer think of the abbey primarily in hierarchical terms but rather as a fraternity whose symbol of unity and direction is the abbot. Hence, the abbot uses the throne only for the most solemn celebrations and even then he does not wear à mitre or ring.

There are various accommodations that have already been made and others yet to be made so that the church might serve the changing needs of both the monastic community and the university. For example, the Blessed Sacrament is no longer reserved on the main altar but is housed in a small, temporary chapel at the rear of the church. A more permanent placement is yet to be arranged. At the weekly Eucharist, the principal celebrant presides from a chair placed near the altar, facing the choir stalls rather than the nave; both monks and guests take their places in the stalls. The regular practice of concelebration has eliminated the need for the numerous small private Mass chapels in the crypt. In themselves, these chapels are truly gems, housing as they do beautifully designed altars, crucifixes, and pieces of sculpture executed by some of the most admired contemporary artists.

Breuer also designed a number of other buildings for the monastic community, including a library (Figure 13.6), science hall, dormitories for the university students, and an ecumenical center. The whole campus is integrated, practical, and impressive. The process by which these buildings have been realized has probably been more significant for the monks than the completed buildings themselves. Their successful collaboration with a distinguished architect has encouraged other communities to commission outstanding architects and consultants so as to secure designs which not only serve the community's needs effectively but which also stimulate and inspire.[43]

Impressed by the work at Collegeville, the Benedictine Sisters at Annunciation Priory in Bismarck, North Dakota, asked Breuer to help them plan a new monastic complex on a site five miles north of the city, overlooking a branch of the Missouri River.[44] The land still has an almost primitive beauty; the low hills are worn smooth by strong winds, with few trees on the exposed slopes. There is a sense of great space and distance. Initially Breuer designed a convent and a girls' school. The elements of the complex are connected by covered but open walkways which serve to pull them into unity and also to define courtyard spaces and give the scheme an appropriate human scale. The bell tower (Figure 13.7) rises above the rest of the construction; from afar it makes a distinctive silhouette in the otherwise fairly empty landscape, and from nearby it marks the approach to the chapel.[45] At the left there is a convent wing and sisters' community room; adjacent is the main chapel. Next to that is a smaller chapel for the students, flanked on either side by the sisters' refectory and the students' dining room, and to the left is the college wing.

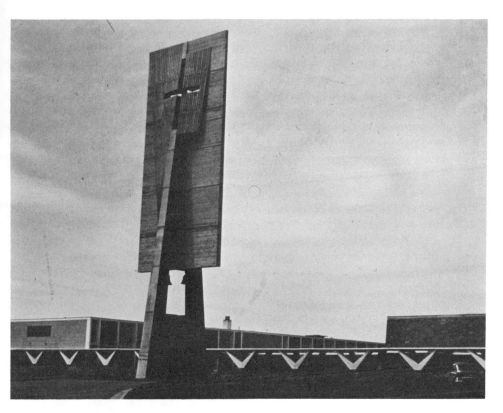

Figure 13.7. Bell-banner in front of the buildings at Annunciation Priory, Bismarck, North Dakota.

The exteriors of the convent and student wings show an interesting juxtaposition of forms, patterns, materials, and textures (Figure 13.8). The basic pattern is rectilinear, made up of projecting slabs and columns of white-painted concrete, which casts sharp shadows into the in-filling panels. These are alternately of black shade-screening for windows and light buff-colored local brick, which blends well with the concrete. The concrete is used four ways in the project: as a white-painted modulation of the building plane; as a sculptural material for fireplaces and stairs, where it is bush-hammered to reveal aggregate; as a patterned natural surface of controlled texture and recessed lines; and as an expression of generating geometry, as in the bell tower.[46]

The exterior buttresses of the main chapel are of rough concrete and take the lateral thrust of the chapel roof, which is painted white on the

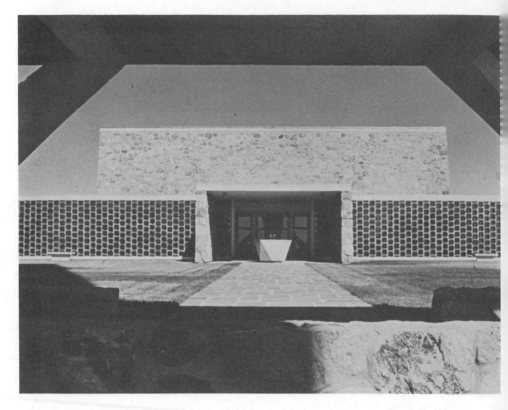

Figure 13.8. Exterior view of the church at Annunciation Priory, Bismarck, North Dakota.

inside, along with the fieldstone walls. The reredos screen is gold leafed; the baldachino is lacquered primary blue; the floor is polished black brick; and the pews and choir stalls are of dark-stained oak. There are glass-in-concrete windows, designed by the architect, on either side of the choir area. These replace the transept as a means of marking off the choir area from the nave. The west window is predominantly amber in color; the one in the nave is rose. A plaster screen wall at the left permits the sick and infirm sisters to join in the celebrations; the screen at the right encloses the sacristy.

The materials used had such quality that applied finishes were not necessary. The factor of availability in the sparsely settled region was important. Also it was thought desirable to use materials that would have

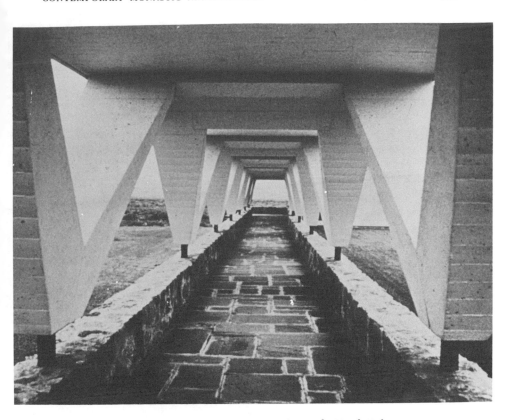

Figure 13.9. Walkway at Annunciation Priory, Bismarck, North Dakota.

the character of permanence and that would age gracefully.[47] After finishing the main monastic complex, Breuer also designed a number of other buildings for the college. He was convinced that contemporary architecture should show organic growth but not be a replica of the past. Each building should be young and living, expressing the culture of its own time.[48] Surely this conviction shows through this work (Figure 13.9).

Unlike the buildings at Mount Saviour, Collegeville, and Bismarck, the monastic and school complex at St. Louis Priory in St. Louis, Missouri, seems to have been designed primarily on the basis of esthetic and functional principles rather than clearly delineated theological and liturgical

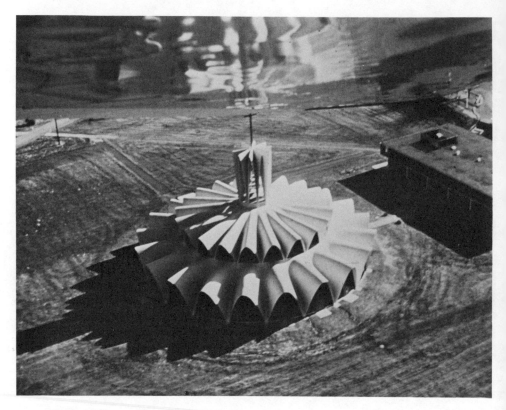

Figure 13.10. Aerial view of the church and monastery at St. Louis Priory, St. Louis, Missouri.

grounds (Figure 13.10). Founded in 1955 by monks from Ampleforth Abbey in England, the new community engaged Gyo Obata, a Japanese-American architect, to design buildings to serve the monastic community and an upper and lower school. A monastic wing, a church, and a number of school buildings have been erected; however, it is the church, consecrated in 1962, which has attracted most attention.[49] Obata proposed a circular plan which the monks decided to use in a congregation-altar-rectrochoir sequence, with the altar in the center. The covering concrete shell is composed of two superimposed circles of twenty parabolic vaults each, supported by twenty parabolic ribs containing a skylight. The lower and larger of the circles of vaults shelters an ambulatory marked off from the seating area partially by a screen and also by the choir stalls and benches. Certainly one has an immediate feeling of closeness to the altar,

but it is difficult to orient oneself to liturgical actions elsewhere in the building. The obvious problem in a geometrically-centered sanctuary is that celebrants cannot avoid having half of the assembly behind them. Although the church space at St. Louis Priory may be experienced as sacred in some sense, on the liturgical level the building raises serious problems which have not been solved, in spite of the fact that modern architecture is generally adaptable.

The Second Vatican Council raised complex questions for monasteries in this country, not only in the area of liturgy but also in the broader area of monastic life and its relationship with the Church and the world. For example, it stressed the value of monastic enclosure, the contemplative dimension of monastic life, and the primacy of liturgy and personal prayer over ministry outside the monastery. It also called for the integration of what were formerly called lay brothers and sisters into the unity of the community so they might be more closely united with the life and work of the abbey. Some of these issues were already being discussed when Victor Christ-Chaner of New Canaan, Connecticut, was commissioned in 1961 to draw up a master plan for St. Mary's Abbey in Morristown, New Jersey. A new abbey and church were built there between 1964 and 1966. Christ-Chaner thought of monastic life as basically inward-looking; hence the wings of the monastery are turned in on one another around small courts, with narrow windows recessed into broken wall surfaces.[50]

The church is square, surrounded by protrusions serving as ventilation and stair wells. The building serves as a circulation center for monks and students descending to the lower level, which houses the monastic common room, refectory, kitchen, and students' dining room. The architect carved out a church area within the church building by means of a curved, six-foot-high wall surrounding the actual space for liturgical celebrations (Figure 13.11). One enters the church by way of a small cube containing a large holy water font. In the church itself, a congregation-altar-choir sequence has been followed, with semicircular tiers of choir benches behind the altar. A Blessed Sacrament chapel and a Lady chapel stand as white prismatic enclosures on either side of the sanctuary. The jutting in and out of the walls within the interior and the marked contrast between the white walls within and the dark mahogany furniture and the red-brick primary walls of the building do make for a rather busy space, but the monks have tried to use it intelligently.

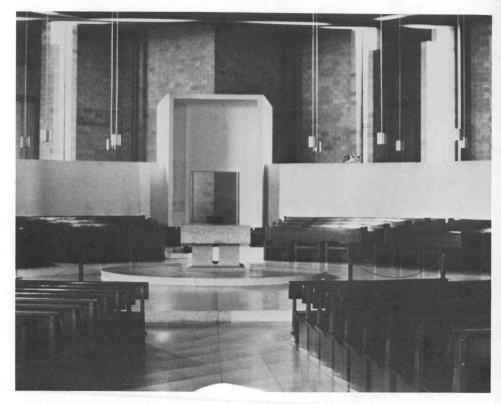

Figure 13.11. Interior of the church at St. Mary's Abbey, Morristown, New Jersey.

In contrast to the rather monumental buildings I have just discussed stand the much simpler buildings at Weston Priory in Weston, Vermont. Founded in 1953 by Leo Rudloff, the community has sought to discard the nonessentials that tend to clutter human life. They seek to support themselves through small industries, such as wood work, crafts, and gardening, appropriate to the rural area.[51] The original building at Weston was an old farm house and attached barn. During early renovations, the small barn was converted into an unpretentious, rustic chapel. In 1960 a dormitory wing was added to the side of the chapel opposite the original house. Four years later, a Burlington architect, Julian Goodrich, was asked to add a nave to the original chapel, which in turn would become the choir. Using native fieldstones from the property and old barn timbers, he fashioned a worship space that is both hospitable and modest. The monks line the

walls of the choir with the altar in their midst, while the congregation occupies a narrow nave flanked on the right by an aisle and on the left by a cloister corridor. The Blessed Sacrament chapel is a small room, two steps down from the head of the right-hand aisle, with a pleasant chapter room beyond it.[52] To accommodate the large number of guests who come to celebrate liturgy with the monks in pleasant weather, they have developed a barn chapel which opens up to welcome overflowing crowds. None of the buildings is architecturally sophisticated, but the beauty and honesty of natural materials generally used very well are in themselves inspiring (although there are those who find the complex at Weston to be somewhat affectedly simple).

The Second Vatican Council encouraged a stronger emphasis on people, acknowledging their greater importance relative to the institutions of any authentic religion. This is clearly reflected in many of the buildings that have been erected by monastic communities in the last fifteen years. The primacy of persons is surely evident in the new monastery at St. Vincent Archabbey in Latrobe, Pennsylvania. Founded in 1846, the community is the oldest Benedictine foundation in the United States. Over the years the monks erected numerous buildings to accommodate a very large community, a seminary, and a college. In 1963, however, a serious fire destroyed a sizable section of the monastery. Under the leadership of Archabbot Rembert Weakland, the community commissioned Tasso Katselas to design a new monastery building. Finished in 1967, the edifice groups on seven floors an immense network of cells, common rooms, chapels, and accommodations for the aged and infirm. Conscious that the building would serve a busy community deeply involved in academic and pastoral work where the stress is apt to be on individual apostolates, the architect concentrated on the cenobitic dimensions of Benedictine life and sought to create an interior environment which would synthesize respect for persons and at the same time would support and encourage communication among the brethren.[53]

Special attention was given to the design of the two hundred cells. Katselas realized that a monk spends much of his life in his cell; hence he sought to create a space that functioned favorably for the individual. He felt that the cell of a monk engaged in work which necessitates much contact with the larger world and church should foster a contemplative spirit and should focus attention inward. Hence as one enters a cell in the monastery, an exterior view is denied; it is only suggested. One must make a special effort to walk to an elevated window niche which is V-shaped. Light floods the room, but it can be controlled by a drape which may be drawn to cover the niche. The closet in each cell projects into the corridor,

sculpting the corridor space so that a definition of the cell and the corridor is established from within as well as without. In the same way as the exterior surfaces of the building have been broken up by the projecting window niches, so have the corridors within the building been broken up by the projecting closets.[54]

The recreation floor has rooms for personal enrichment as well as for community exchange. It is raised above the terrace level with a deep overhang and is oriented toward an adjacent lake. It captures a panoramic view as opposed to the controlled view from the cells. The terrace level itself opens out onto gardens and a private sitting area. There is also a roof terrace for walking. A keen sense of circulation both within and outside the building has been fostered. The new monastery is linked with the complex of older buildings by means of a concrete bridge.[55]

Since the new monastery does in fact function well, many of the architect's goals have been achieved. However, from the exterior the edifice is rather overwhelming. If the design had been more discreet, the building would have been less monumental and probably would have been integrated more effectively with the other buildings on the campus. The highly sculptured surface communicates a sense of complexity and generates a busy atmosphere rather than a climate of simplicity and peace. Katselas has designed other buildings for the community, including a science hall for the college and a new main entrance to the administrative wing. In his renovation projects throughout the campus, he has been careful to retain what is good and useful so as to assure a sense of continuity and order for the community.[56]

Among the most handsome buildings erected by monastic communities since the Second Vatican Council are those designed for the monks of St. Procopius Abbey in Lisle, Illinois. Founded from St. Vincent Archabbey in 1885, the community eventually opened a college (now called the Benedictine College of Illinois) on a large campus in the Chicago suburb of Lisle. By 1964 they had decided to build a new monastery and church on a wooded hill across from the college campus but equidistant from the college and high school conducted by the monks. Edward Dart was selected to design the buildings. His impressive structures present themselves as an ascending, well-integrated spiral which calmly leads its twelve construction units to the chapel; hence one has the impression of a small village rather than an institution. The whole is carefully related to the countryside. The residential blocks, each containing eight to twelve rooms, harmonize with one another so as to form dwellings which are expansive but not grandiose. One senses a profusion of air and space, rather than embellishments.[57]

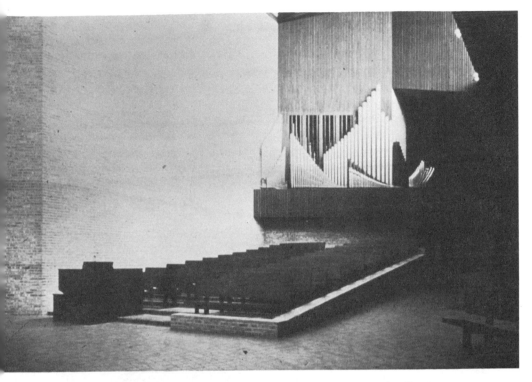

Figure 13.12. Interior view of the church at St. Procopius Abbey, Lisle, Illinois.

A visitor approaches the church through a sheltered court and enters a one-story, glass-walled narthex beyond which rises an open belfry directly above the Lady chapel. Walking through the main doors one stands in a low-beamed space that functions as a foyer both to the monastery to the left and to the church. Straight ahead is a holy water font cut from a large block of red-gray granite. The church itself is designed as two distinct spaces, a room within a room. The highest portion exends over the altar and the choir (Figure 13.12). This area is bathed in light from a large clerestory window. The monks occupy benches facing the altar, similar to those used by the lay community in the lower space. The monks wanted a flexible choir arrangement; hence they opted against traditional choir stalls. The present arrangement, however, is not without problems. It makes antiphonal singing difficult, and it tends to inhibit a sense of community among the monks when they gather for the liturgy of the hours,

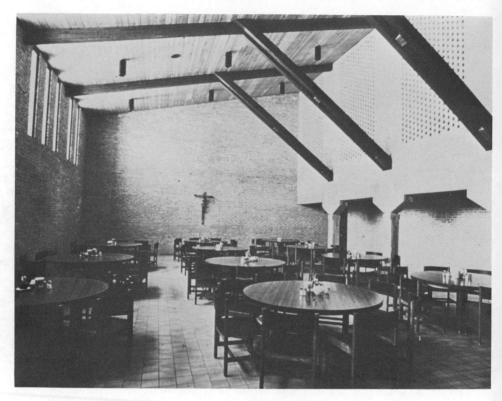

Figure 13.13. Refectory at St. Procopius Abbey, Lisle, Illinois.

since they are strung out in a bank of benches where they see only the backs of the monks in front of them.[58]

The altar, ambo, and presider's chair, all simply and directly constructed of heavy oak, are movable within the asymmetric sanctuary. A similar concern for detail and for beauty is manifested also in the monastic refectory (Figure 13.13) and chapter room. Dart's buildings are both strong and tranquil; they are intrinsically discreet but naturally elegant. It is with good reason that the project at St. Procopius was awarded the highest architectural honor by the American Institute of Architects in 1973.

Because of the current renewed interest among contemporary architects and historians of architecture in the work of the Finnish architect, Alvar Aalto,[59] attention should be drawn to the impressive library which he designed for the monks of Mt. Angel Abbey near Salem, Oregon.

It was dedicated in 1970. In the 1940s and 1950s, while his colleagues in architecture were espousing a machine esthetic, Aalto defended human presence in buildings.[60] His concern for detail and sense of integrity and beauty are obvious in his work. He was convinced that work is an essential part of the human condition, and that it keeps people close to nature; hence his philosophy resonated well with the tradition of his Benedictine clients at Mt. Angel.

Before the library was built, the beauty of Mt. Angel rested above all in its setting, situated as it is on an isolated plateau rising in the center of the plain of Salem at the center of a ring of mountains. Great volcanic peaks stand in the distance. Aalto maintained that if possible libraries should be built facing north; hence it is the northern end of the Mt. Angel library which affords the most spectacular view.[61]

Constructed primarily of buff brick and teakwood, the building itself is rigorous and yet modest. Its fan-shaped plan is quite characteristic of Aalto's style. Organic unity, another characteristic, is evident above all in the interior. Standing at the library control area, one senses the volume of the building with its rhythms and counter-rhythms, its overhead and lateral lighting, and the cascade of various floor levels. One gets the impression of standing on a ship and looking at the various decks below. Aalto surely exploited the ground levels of the property effectively.[62]

The building and its function are unified. It is all library— a place for people who want to explore the world of books and who want to be enriched by that experience. Aalto sought to relate that new world of knowledge to the old world of nature which one can admire through the numerous bay windows in the building. Likewise, he wanted to relate that new world to the familiar world of other people, whom one can see at the various reading desks and in the conference room which opens onto the main entrance.[63] His concern for people is manifested in the attention he has given to details. The designs of door handles, book shelves, storage units, lighting fixtures, chairs, tables, and desks are all informed by concern for the users.[64] The library is a superb example of a humanizing environment which promotes the best in the Benedictine tradition: a deep commitment to what is good, what is beautiful, and what is true.

In concluding my chronicle, I would like to comment on projects that have been implemented in two Cistercian abbeys, which also stand in the Benedictine tradition. In the past twenty years they renewed their old monastic buildings rather than build new ones. The first is the Abbey of

Our Lady of Gethsemani in Kentucky. Since the size of the community increased considerably after the Second World War, extensive architectural renovation was necessary throughout the abbey. In 1962 two of the lay brothers went to consult William Schickel, a designer and architectural consultant, at Loveland, Ohio. They acknowledged that there was much going on in the world of design and planning about which they knew little or nothing; hence they wanted to work out a relationship with Schickel which would bring fresh influence to bear on the developments in the monastery. At first, Schickel simply designed furniture which could be made by the monks in their shops. Out of this association grew some general design consultation about interior planning on projects already in progress. The relationship between Schickel and the monks gradually enlarged so that he eventually got involved in the renovation of the monastery church, cloister, and courtyard.

As Schickel has written, three main concerns influenced the accommodation of the traditional, one-hundred-year-old, pseudo-Gothic church and its adjoining cloister and courtyard into a suitable environment for a large, vital community: monastic and liturgical usefulness, excellent esthetic quality, and economic feasibility.[65] In executing the program, all concerned tried to realize that honest renewal always involves a certain collaboration with one's ancestors. They also acknowledged that all human works should contribute positively to human evolution; hence they must be related to the best in contemporary culture. A basic principle underlying the work was expressed in Alfred North Whitehead's statement that the art of progress is the ability to maintain order amidst change and change amidst order.

A number of polarities, then, had to be fused into a unified whole. There was, on the one hand, an existing hundred-year-old structure, molded by various historical assumptions and psychological factors. On the other hand was a large community, searching for God amidst the complex culture of the 1960s. The old abbey buildings had come into being in an American wilderness; their design was without question influenced by Shaker architecture of the last century in the Kentucky area. The founding monks had built in a very sensible fashion; but when it came to the church, they attempted within a basic rectangular building, constructed on the practical premises of brick walls and hand-hewn timber, to build by means of lath and plaster the interior shell of a neo-Gothic church. It was probably for the monks of that time something awesome and deeply religious because of its pseudo-elegance, but it was a building that was culturally nostalgic and regressive. As such it burdened the monastery for a hundred years.

What seemed most desirable in the 1960s was a light and airy space, a building standing without sham and looking toward the future. Accordingly, the plaster replicas of a Gothic interior were torn down, which immediately brought the shape and form of the interior into a close, honest relationship with the rest of the monastery buildings. The same basic approach was taken in the renewal of the cloister and the courtyard. It was no small achievement that a larger community of varied backgrounds and ages could arrive at a consensus to take the drastic actions that were necessary to revolutionize their surroundings. That is in itself a tribute to the adaptability and resilience of the Benedictine spirit.[66]

In 1973, the Cistercians at the Abbey of Our Lady of New Melleray in Dubuque, Iowa, voted to remodel the north wing of their monastery for the permanent location of their church. The monastery was founded in 1849 by monks from Mount Melleray Abbey in Ireland. Following the Civil War, the community engaged a local architect, John Mullany, to design a complex of permanent buildings. Mullany had been associated for a time with Augustus Welby Pugin, the distinguished English architect well known for his neo-Gothic structures. Mullany's designs reflect Pugin's influence in his preference for pitched roofs and arched windows, and his use of assymetry and vertical forms. By 1875 the north and east wings were occupied by the monks. Their church was temporarily located on the second floor of the east wing, until it was moved in the 1920s to the second floor of the north wing. Mullany's plans called for a permanent church as the south building running parallel to the north wing; however when construction was resumed on the south wing in the 1950s, the original plans for the church were set aside. When the monks turned their attention to a permanent church in the 1960s, it was suggested that the north wing be razed and a circular church built in its place, but those plans were not accepted by the community. By 1973 they decided instead to remodel the north wing to house a permanent church and hired Willoughby Marshall, Inc., to draw up the original architectural plans.

A second floor was removed from the north and old kitchen wings so as to allow the use of the full height of the north wing for the church and of the old kitchen wing for a chapter house. (The monks themselves removed the plaster and interior moldings.) As a result, an open space of great simplicity and beauty was created (Figures 13.14 and 13.15). Under the direction of Frank Kacmarcik and Theodore Butler, the project was carried through to completion. The overall effect of the renewal project is both powerful and formative. The buildings are now austere but warm, rather massive but not harsh. They communicate an immediate sense of integrity and reject all that is false and ostentatious. The project was given

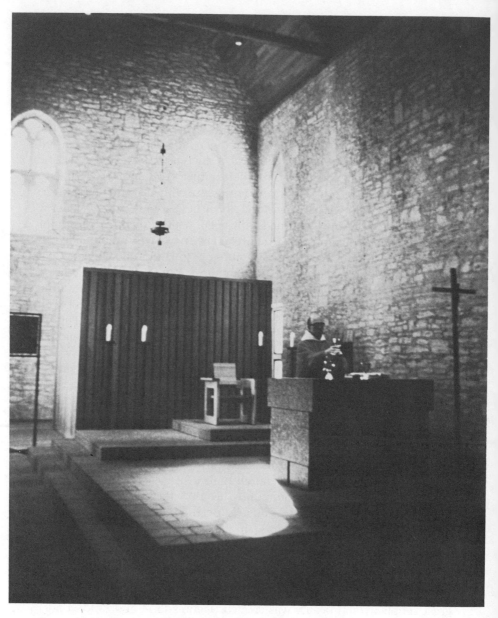

Figure 13.14. Sanctuary area of the church at the Abbey of Our Lady of New Melleray, Dubuque, Iowa.

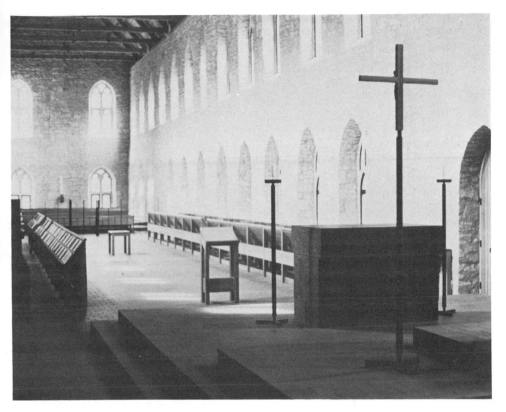

Figure 13.15. Choir and guest area of the church at the Abbey of Our Lady of New Melleray, Dubuque, Iowa.

an honor award by the American Institute of Architects in 1977.[67] Renovation continues now in other parts of the monastic complex.

This brief chronicle has shown that since the Second World War various monastic communities in this country have struggled to understand what it means to be grafted on a locality, what it means to be heir to a living Benedictine tradition, and what it means to be part of a contemporary Church and world. They have struggled to be responsible for their landedness as gift, promise, and challenge, and have tried to come to grips with the temptation to greed, presumption, and complacency. Historically, Ben-

edictines have had a tradition of creative architecture. At one time William of Volpiano, Lanfranc, and Suger of St. Denis were the European leaders in architectural developments. They were outstanding leaders precisely because they looked to the future and refused to be limited by the accomplishments of the past.[68] In our own era, American monastic communities have made a positive contribution to that living tradition. But in times of great cultural uncertainty and insecurity like our own, there is a strong temptation to indulge in romanticism and nostalgia, to settle for forms that are known and familiar, and to abdicate one's responsibility to share in the creation of a new future. Speaking in June 1979 in Milwaukee at a symposium on environment and art in Catholic worship, Archbishop Rembert Weakland, the former archabbot of St. Vincent Archabbey and later the abbot primate of the Benedictine Confederation, seemed to be well aware of the temptation when he warned that "the further Church art, architecture, and music are removed from the contemporary idioms and styles of our time, the more likely it is that they will be sterile and artificial."[69] The challenge that confronts us was put in even a more provocative way by Armand Veilleux, the former Cistercian abbot of Mistassini and an expert on primitive monasticism:

> The only way to belong to a community, a church, a civilization is to help build it. Are we going to be part of the new humanity, or shall we be found cultural runaways once more one revolution behind? In world evolution one assists in every epoch of in-depth change at the emergence of new species but at the same time at the forming of vast fields of fossils. The question facing every community, every monastic order, at this turning-point in human and ecclesial history is as follows: Shall we choose to be members of the new species or shall we rather go to enrich the collection of fossils? The latter alternative is not wanting in attractiveness, for fossils are sought after and marvelled at. May we at least have the courage to make our choice in full cognizance rather than let ourselves be passively pigeon-holed by history.[70]

NOTES

1. (Philadelphia: Fortess Press, 1977). See also Hans Eberhard von Waldow, "Israel and Her Land: Some Theological Considerations," in *A Light unto My Path*, edited by H. N. Braem, R. D. Heim, and C. A. Moore (Philadelphia: Temple University Press, 1974), pp. 493–508; Jacob Neusner, *American Judaism: Adventures in Modernity* (Englewood Cliffs, N.J.: Prentice-Hall, 1972), pp. 87–116; and Hans Reudi Weber, "The Promise of the Land," *Study Encounter* 7 (1971): 1–16.

Index

MONASTICISM AND THE ARTS

was composed in 10-point Linotron 202 Zapf International Light and leaded two points,
with display type in American Unical, Caxton, and Zapf Book Light
by Utica Typesetting Co., Inc.;
printed by sheet-fed offset on 50-pound, acid-free Warren Eggshell Cream paper stock,
Smythe-sewn and bound over binder's boards in Joanna Arrestox,
also adhesive-bound with paper covers
by Maple-Vail Book Manufacturing Group, Inc.;
and published by

SYRACUSE UNIVERSITY PRESS
SYRACUSE, NEW YORK 13210